Please remember that this is a library book,
and that it belongs only temporarily to each
person who uses it. Be considerate. Do
not write in this, or any, library book.

Knowth

NEW ASPECTS OF ANTIQUITY

General Editor: COLIN RENFREW

Consulting Editor for the Americas: JEREMY A. SABLOFF

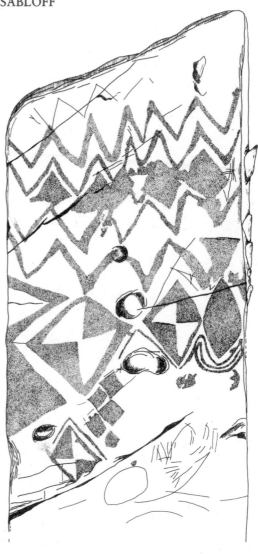

GEORGE EOGAN

Knowth

and the passage-tombs of Ireland

with 180 illustrations, 11 in color

THAMES AND HUDSON

For Fiona, James, Maeve, Deirdre and Clíona,
who shared the pleasures of excavating at
Knowth

Frontispiece: The angular style, substyle c: orthostat 48 in the eastern
tomb, Knowth Site 1. (Reproduced to the same scale as *figs. 60–72.*)

© 1986 Thames and Hudson Ltd, London

First published in the United States in 1986 by Thames and Hudson Inc.,
500 Fifth Avenue, New York, New York 10110

Library of Congress Catalog Card Number 86–50218

Printed and bound in the German Democratic Republic

Contents

General Editor's foreword

It is rarely given to any man to enter, for the first time in centuries or millennia, a well-preserved structure from the prehistoric period which is actually older than the Pyramids of Egypt by several hundred years. That is precisely what George Eogan did, with his excavator colleagues, on 11 July 1967 when, as he describes here, he located the stone-built passageway which led a distance of 34 m into the western side of the great earth mound at Knowth, and discovered the megalithic tomb at its centre, hitherto unknown to science.

An even more striking discovery was to come. For on 30 July of the following year, another long passage was discovered on the eastern side of the mound. And, on 1 August, Professor Eogan had the remarkable experience of entering, for the first time, the great corbelled eastern chamber at Knowth, and of discovering the carved stone basin which still lay within it.

Knowth is one of three great mounds in the prehistoric cemetery at the Bend of the River Boyne. Newgrange has been justly famous since the discovery in AD 1699 of the chamber tomb within it, and it was systematically investigated in recent years by the late Professor M. J. O'Kelly, whose full account, *Newgrange: Archaeology, Art and Legend*, was published in 1982 in the present 'New Aspects of Antiquity' series. The third mound, Dowth, was partially investigated in the last century. In view of the chamber tombs within the two other mounds, it was no surprise that Knowth too should contain a burial chamber. But the discovery of *two* chambers, situated back-to-back, as it were, as well as their scale, and above all the richness of the decorative art on the stones, was something which could not have been anticipated.

As Professor Eogan describes, these were no chance discoveries. He began work at Knowth in 1962, devoting his attention first to the interesting series of smaller megalithic tombs which surround the great mound. Although none of these stands complete, in the way the two burial chambers in the main mound do, they are of considerable interest for the light which they shed on how the site was used and developed, and indeed for our understanding of the use of the whole remarkable cemetery of the Bend of the Boyne. No fewer than twenty-four seasons' work have gone into the very comprehensive project at Knowth, and as the photographs clearly show, the mound itself and the area surrounding it was very thoroughly investigated. The full and detailed account by Professor Eogan of the excavation is to be published by the Royal Irish Academy in a number of monographs, of which the first has recently appeared.

The art of the Boyne cemetery is one of its chief glories, and indeed represents one of the most remarkable artistic achievements of prehistoric Europe. The decorated stones of Newgrange have long been known and admired, and it came as no surprise that further examples should emerge when Knowth was systematically studied. No-one could have predicted, however, that the site would yield so many sculptured stones, and in such variety, a corpus of art works actually far larger than that at Newgrange. In this book many of them are published for the first time, with a discussion of the art of the Boyne as a whole, and of its origins and chronology.

The important new discoveries at Knowth have made necessary a re-evaluation of the Irish passage-tombs as a whole, and that is what Professor Eogan here undertakes, with a thorough consideration of their construction, their chronology, of the finds made within them, and of their use.

For many readers, however, as for myself, one of the great pleasures of this book will be the way it allows one to relive the moments of these great discoveries, and to visualize very clearly the nature of this splendid monument, its construction and its art. Back in the summer of 1982 I had the privilege of accompanying Professor Eogan down the long entrance passage into the great eastern chamber at Knowth, and it is an experience which I shall never forget. It is a pleasure to see this remarkable discovery so clearly described here, and so effectively set within its wider context in Irish and indeed in European prehistory.

Colin Renfrew

Preface

The low ridge of Knowth in eastern Ireland was first used by man at some time around 3000 BC, and had a remarkable history during the course of subsequent millennia. Even today it continues to attract our attention and fascinate us with its riches. While the great mound, a prominent feature of the local landscape, was suspected for centuries to be an antiquity, our knowledge of the archaeology of Knowth was virtually nonexistent until the present campaign of excavations commenced in 1962.[1]

plate 3

The stimulus to excavate at the site came in 1960–61, when a nearby tomb at Townleyhall was investigated.[2] Knowth was at that time the largest unopened mound in Ireland, if not in western Europe. From the beginning, we were conscious of the responsibility that we assumed, as well as of George Coffey's sensible remark in 1892: 'It is to be hoped that no hasty attempt will be made to open this important tumulus, and that nothing will be done in that direction without competent supervision.' Seventy years later, archaeology had become a mature science with a body of data and training facilities – while the Megalithic Survey of the Ordnance Survey, and excavations of numerous tombs and some settlement sites, had clarified several issues and paved the way for future research. Scientific aids, both pure and applied, had revolutionized the possibilities for wider interpretation. Archaeology is, of course, a rapidly developing subject, and conditions for embarking on large-scale research projects, especially those based on excavations, are never ideal. Despite that, it was decided to make a start at Knowth.

The main mound was acquired by the State in 1939, and further lands surrounding it were obtained in 1967 and 1980 (as National Monument No. 147). Excavations began on 18 June 1962. Since then, an extensive area has been uncovered, including not only the main mound (Site 1) but an area of 3.6 hectares (9 acres) around it. This has brought about physical changes but, above all, dramatic progress in our knowledge of the site and the people who utilized it. We can now more readily appreciate and understand the Neolithic, or Late Stone Age, inhabitants of four to five thousand years ago who built these great monuments. In addition to that period, Knowth has cast new light on many aspects of Irish archaeology – the Beaker 'Folk' (c. 2000–1800 bc), the Late Iron Age in the first centuries of our era, the mature Early Christian period in the eighth to eleventh centuries, and the Normans in the late twelfth to early fourteenth centuries.

This book is concerned with the initial, Neolithic, phase at Knowth, between about 3000 and 2000 bc (lower-case 'bc' indicates that these are uncalibrated dates from radiocarbon measurements, in our case several centuries later than the corresponding calendar dates BC.) It was the period of the most spectacular monuments at the site, which were some of Europe's finest at that time. Their story is worth relating in its own right, but their evaluation and explanation call for a wider approach. Accordingly, the passage-tombs of Knowth will be considered in the wider context of Neolithic Ireland. The passage-tombs of Ireland as a whole vividly illustrate the remarkable human achievements of Late Stone Age society. Such constructions demanded extraordinary commitment from what must have been an imaginative, intelligent, and inventive people, whose efforts enriched contemporary culture and, indeed, brought about a renaissance that expressed itself not only in religious values, but also in arts and crafts, and very probably in learning.

Twenty-four seasons' work, of around three months each, have by now gone into the excavations. On average, twenty workmen and twelve students took part at any one time. Without their unstinting support, research of this magnitude could not have been carried out. It is invidious to mention names, but anonymity does not mean that their help and assistance is less appreciated. Ample financing has been provided continuously by the State, through the National Parks and Monuments Branch of the Office of Public Works, on the recommendation of the National Committee for Archaeology of the Royal Irish Academy. I am further indebted to the Commissioners of Public Works for permission to excavate at a National Monument under State ownership, and to successive Directors and staff of the National Parks and Monuments Branch for their assistance and to Mr Jim Bambury for photographs.

Before the Commissioners acquired several acres of land surrounding the main mound, the landowners – the Robinson family – were most generous in allowing excavations to take place on the property, and in their hospitality. Both in the field and during subsequent work in the Department of Archaeology at University College, Dublin, on the preparation of the text and illustrations for this book, much appreciated help has been given by Eoin Grogan, Helen Roche and Finola O'Carroll. Most of the line drawings were prepared by John Aboud. Invaluable technical assistance was lent by Albert Glaholm. University College, Dublin has over the years afforded great material as well as spiritual support. For providing C14 determinations thanks are due to the Biologisch-Archaeologisch Instituut, Groningen, Holland and Dr Jan Lanting. The study of the megalithic stones at Knowth in relation to their geological setting by Drs M. McCabe and G. Nevin, University of Ulster, Jordanstown, is much valued and appreciated. Throughout, Professor G. F. Mitchell has assisted in numerous ways. Finally, sincere thanks are due to the editor of this series, Professor Colin Renfrew, for his lively interest in the work and his continued stimulation.

1 The background

Knowth and its local setting

Knowth lies about 8 km from the sea in the valley of the river Boyne in eastern
Ireland. The fertile soils here allow some of the best farming in Ireland; indeed,
it is an optimal agricultural area. To the south and west stretches the flat
countryside of County Meath, which is well watered by the Boyne and other
rivers, and was apparently settled intensively by the builders of Neolithic
passage-tombs. In addition to those at the Bend of the Boyne, including
Knowth, passage-tombs in Meath are found on the coast near Gormanstown,
a little farther inland at Fourknocks, and in the northwest at Sliabh na
Caillighe (Loughcrew). There are also isolated examples at Tara and
Broadboyne[1] around the centre of the county. *fig. 1*, plate 39

The region of immediate relevance to Knowth is about 8 km in length and 3
km in maximum width. Geologically, as Professor G. F. Mitchell has shown,[2]
this region consists largely of an east–west ridge of carboniferous shales. But
the general environment is low-lying, and the shales form three hills which
reach only some 60 m above sea level. It was the presence of the shale ridge that
caused the eastward-flowing Boyne to bend sharply to the south, a few km
downstream from the village of Slane. Soon the river straightens out again and
runs parallel to the ridge, before turning abruptly to the north and flowing
through a gorge formed by glacial meltwater, then takes a fairly direct course
to the sea.

Overlying the shales is a mantle of glacial deposits, which produced good
agricultural land. The whole district has a trend from north–northeast to
west–southwest, followed by the various low ridges and valleys. On the
northern fringes of the Bend of the Boyne cemetery, the altitude increases and
the land declines in quality. The underlying rocks are Silurian sandstones and
slates, covered by a thin layer of glacial drift with boulder clay and sand. To
the south of the Boyne, there are large expanses of fertile land, not entirely flat
but interspersed by ridges, many of them limestone.

Palaeobotanical investigations carried out by Professor W. Groenman-van
Waateringe at Knowth,[3] and by Professor Mitchell at nearby Townleyhall,[4]
indicate that a diversity of trees once grew in the region – pine, birch, elm, oak,
alder, hazel, willow or poplar, and hawthorn. Before Neolithic people started
forest clearance, there must have been oak woods on the heavier lands. Hazel
would have grown on the podsoils and brown earth, while alder thrives on

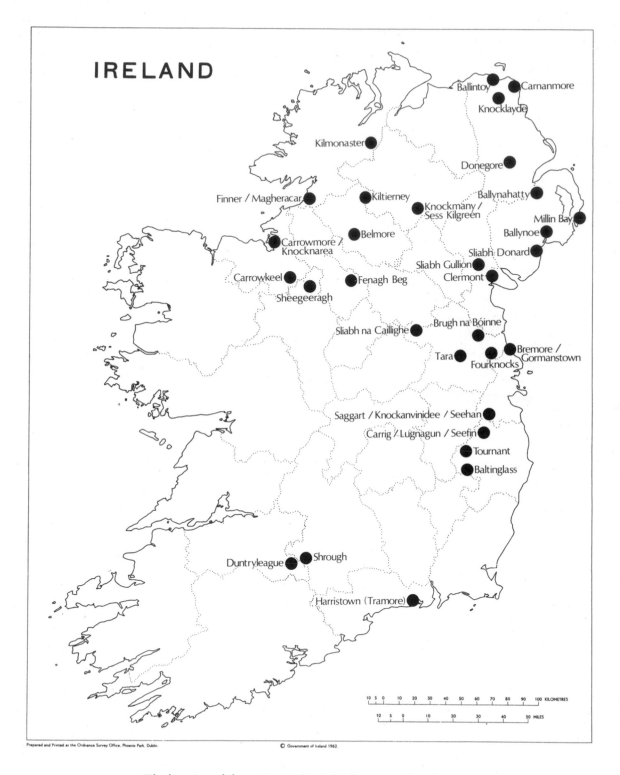

1 *The location of the major sites in Ireland mentioned in the text.*

gleys. But at Knowth, the evidence shows that considerable forest clearance had taken place for agriculture by the time that the tombs were built. The number and variety of herbs and weeds suggest that there was extensive clearance on the higher grounds, in particular. It seems that, during the mature Neolithic, the only true forest occurred in the river valley. This consisted mainly of hazel and birch, in contrast to oak and elm at higher levels.

The area used as a cemetery was bordered on three sides by the river.[5] *fig. 2* Today, the remains of up to forty round mounds survive. Their core is situated on the Knowth-Dowth ridge, and between it and the river Boyne, although at least two sites occur to its north – that at Townleyhall, and a round mound at Monknewtown. Within the core, clusters of sites can be seen. Knowth, with up

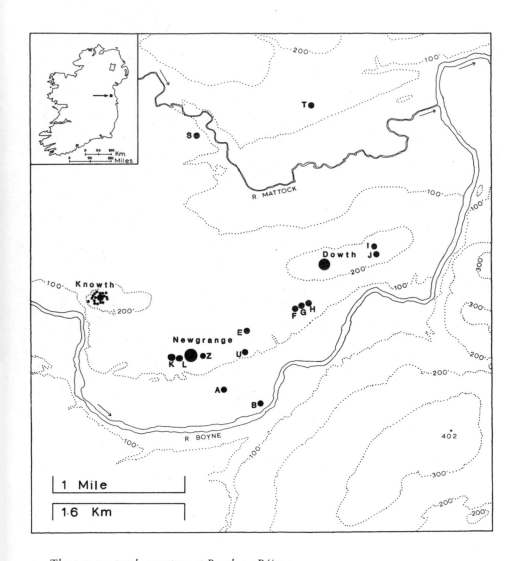

2 *The passage-tomb cemetery at Brugh na Bóinne.*

to twenty sites, is the largest and most integrated cluster. Besides the tomb of Newgrange, three smaller sites exist, and a further three are on the Dowth ridge. On the lower land to the west of Dowth lie three more sites together (F, G, and H). Between these and Newgrange, there are four dispersed sites (A, B, E, and U), of which A, B, and E are well-preserved mounds and are unopened, A and B being also the lowest-lying sites in the cemetery. Site E is surrounded by a kerb. Site U has, however, been damaged.

Apart from the sheer number of sites, the cemetery is distinguished by the size and prominence of three of the mounds – Dowth, Newgrange and Knowth. Each covers over an acre of ground, is perched on the highest point of its respective ridge, is visible from the other two, and displays sophisticated design and construction.

fig. 3, plate 4 Although the large mound at Dowth has been badly mutilated as a result of 'diggings' in 1847–48, it nevertheless remains an impressive monument, about

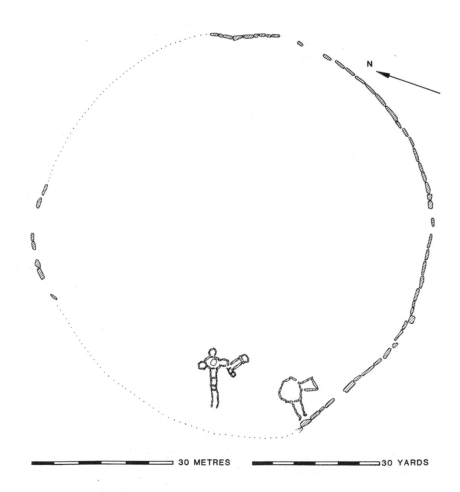

3 *Ground plan of Dowth.*

85 m in diameter and 13.4 m in height, covering three-fifths of a hectare (nearly 1.5 acres).[6] It is surrounded by a kerb of some 115 stones, and has two tomb-chambers facing westward. The passage of the northern tomb, 8.2 m long, leads into a cruciform-shaped chamber with a corbelled roof, 3.85 m long by 6.25 m wide. In this structure, thirty-six stone orthostats and about eight lintels were used. Four huge pillars at the corners of the chamber are a noteworthy feature. A gap in the wall, at one of the inner angles in the right-hand recess, leads into an L-shaped annex, built of eleven orthostats and three capstones. The mound's southern tomb has a short passage of 3.3 m, leading into a circular chamber 4.5 m in diameter. A recess opens off the right-hand side. Twenty-one orthostats and five capstones over the passage were used. The other two sites on the Dowth ridge lie towards its eastern end. One (J) has a chamber with a corbelled roof and, at ground level, the chamber seems to divide into compartments formed by stones set on edge. The destroyed megalithic structure at Cloghalea, a few hundred metres to the north, may have been a further passage-tomb.

The best-known of all Irish passage-tombs is the large one at Newgrange, a perpetual source of interest and excitement for visitors as well as archaeologists.[7] Due to recent excavation and conservation, it now has a well-tended appearance. The kidney-shaped mound, measuring 79 m (NW–SE) by 85 m (NE–SW), is delimited by a kerb and occupies an area of half a hectare (over an acre). The mound, about 11 m in height, is composed largely of water-rolled stones, but narrow layers of sod occur in places. Of the 97 kerbstones, set end-to-end, the largest is 4.5 m long and the smallest 1.7 m. The combined length of the passage and chamber is 24 m, and 60 orthostats were used in its construction. The corbelled roof is 6 m high. In addition to this mound, there are three smaller adjacent tomb sites, L with a cruciform chamber, and K and Z with undifferentiated chambers.[8]

fig. 4

plate 5

figs. 5–7

Knowth itself is located on the western end of the shale ridge. Part of this ridge, measuring about 800 by 340 m, is slightly higher than the 60 m contour. It was at the northeastern extremity of the area that these tombs were erected. There is a rather commanding view from the site, particularly southward over the flat lands of Meath to the Dublin and Wicklow mountains. Closer, to the southeast, lie the Bellewstown and Ardcath ridges, while Bellewstown blocks out the Fourknocks ridge. Another landmark, to the southwest, is the Hill of Tara. High ground restricts the view northward, where the Hill of Slane, Sliabh Breagh, and the Collon hills are prominent.

It may well be asked why this part of the Boyne Valley was selected as a cemetery. There were probably several reasons. The region is rich in agriculture, and a sound economic basis was essential to the erection of passage-tombs, for which a great number of people had to be fed and sustained. The cemetery area lay near a plentiful supply of good building-stones in the Palaeozoic deposits, although their availability did not influence the precise location: for otherwise the tombs would have been placed a few km

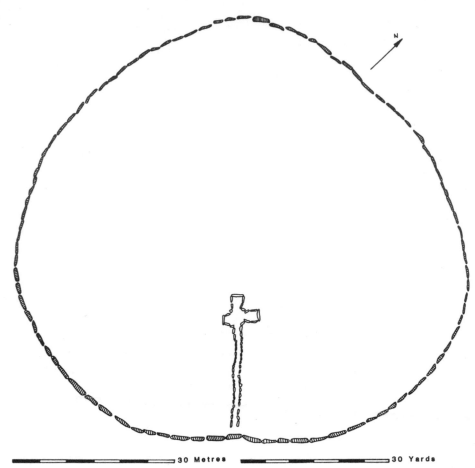

4 Ground plan of
the large mound at
Newgrange.

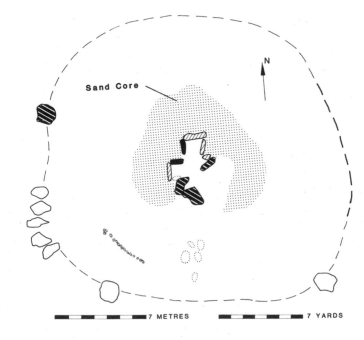

Sand Core

5 Newgrange Site L,
ground plan.

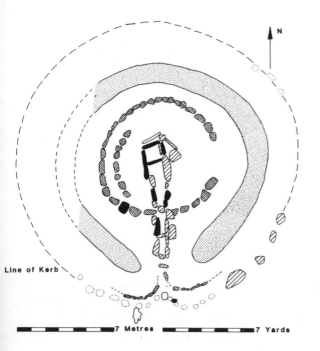

Line of Kerb

7 Metres 7 Yards

6 *Newgrange Site K, ground plan.*

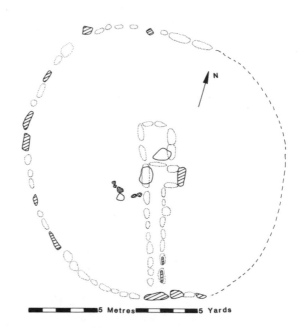

5 Metres 5 Yards

7 *Newgrange Site Z, ground plan.*

to the north or northeast, where the ground is also much higher than in the Boyne valley. The river, too, was presumably important for traffic and communication, and it delimited on three sides a conveniently shaped area of land. The possibility even exists that the Boyne had already acquired a ritual significance.

Early research on Irish passage-tombs

Nearly 1,400 megalithic tombs exist in Ireland today. These great structures have fascinated and bewildered observers for centuries. One of the earliest accounts of such a tomb is that of Newgrange by Edward Lhwyd in 1699. Lhwyd, a Welshman, was Keeper of the Ashmolean Museum in Oxford. While travelling north from Dublin toward the Giant's Causeway in County Antrim, he remarked that 'the most remarkable Curiousity we saw on the way was a place called *New Grange*'. We do not know how he heard about the site, but – as he relates – some workmen employed by the local landowner, a Mr Charles Campbell, were removing stones from the mound and had discovered its entrance, so there was probably local gossip. Lhwyd described the site and his draughtsman, William Jones, prepared a plan. He noted the finding of a Roman coin on top of the mound, but concluded that the site was older than

the Roman period, since its rude carvings seemed to 'denote it a Barbarous Monument . . . some place of Sacrifice or Burial of the ancient *Irish*'.

Interest in Newgrange continued and, in 1725, Dr Thomas Molyneux, Professor of Physick in Dublin University, wrote *A Discourse Concerning the Danish Mounts, Forts and Towers of Ireland*.[9] In this he described the site and attributed its construction to the Danes. He also mentioned Knowth and Dowth, yet considered them smaller in size, and thought that they were the burial places of children.

Newgrange, together with Dowth and other megalithic sites, was later visited in 1770 by Thomas Pownall, a former Governor of the state of Massachusetts. He wrote a long descriptive account full of strange ideas, such as a claim that the related art was Phoenician and – most peculiar of all – that Newgrange incorporated pieces of a marine or naval monument which had, long before, been erected by 'some Eastern people' at the mouth of the Boyne.[10] At about the same time, Charles Vallancey, a military engineer, became interested in Newgrange, especially in its art. He regarded the site as a Mithraic temple of the Roman period, and some of the art motifs as belonging to ogham, a form of writing that dates to the early centuries AD.[11]

All these early accounts of megalithic tombs concentrated on Newgrange, with limited reference to other sites. Indeed, tombs elsewhere in Ireland did not arouse interest until the end of the eighteenth century. In 1779, William Burton Conyngham, the son of Lord Conyngham of Slane Castle near Knowth, and a founder of the Royal Irish Academy, sent an artist – Gabriel Beranger – to record megalithic tombs in the counties of Mayo and Sligo, including some of the Carrowmore passage-tombs.[12] In 1828, L. B. Beaufort dealt with megalithic tombs in a section of his paper entitled 'An Essay upon the state of Architecture and Antiquities, previous to the landing of the Anglo-Normans in Ireland'. Its only merit is that it mentioned tombs from different parts of the country. The descriptions themselves are inadequate and, when interpretations of tomb use are given, these generally follow Biblical lines. The dolmen (or crom-leac), for instance, was considered 'as a transcript of the ancient patriarchal altar, as recorded in the holy writ'.[13]

But around this time occurred an event of substantial significance for megalithic and, as a whole, Irish studies: the establishment within the Ordnance Survey of a section for antiquities and place-names. As a result, descriptions of numerous field monuments were prepared, and thousands of them were recorded on maps. Part of the work was a survey made by George Petrie of the Carrowmore cemetery in 1837. Although some of the sites had been mentioned before, only during the 1860s did a local inspector of schools, Eugene Conwell, bring to light the important cemetery of passage-tombs at Sliabh na Caillighe (Loughcrew) in County Meath.[14] In the west of Ireland, a landowner and retired army colonel, W. G. Wood-Martin, worked on descriptions of megalithic tombs, largely in his own County Sligo and on the Island of Achill in Mayo. His accounts were published in the *Journal of the*

Royal Society of Antiquaries (18, 1887–88, pp. 367–81) and were reprinted under the title *Rude Stone Monuments of Ireland* (1888).

The first attempt to produce an overall study of Irish megalithic tombs was that of William Copeland Borlase, whose three-volume work *The Dolmens of Ireland* appeared in 1897. Borlase described around nine hundred sites, not all of which were megalithic tombs. During the 1890s, the first full account of Newgrange and Dowth emerged as well. Its author was George Coffey, Keeper of Irish Antiquities in the National Museum of Ireland. The main significance of this paper lay not only in providing a description of sites, but also in isolating and discussing a hitherto neglected aspect of them – the art. Coffey continued his researches into the problems of passage-tombs and their art, culminating in 1912 with his classic *Newgrange and other Incised Tumuli in Ireland*. In 1911, Macalister, Armstrong, and Praeger discovered another prominent cemetery at Carrowkeel,[15] County Sligo, and investigated several of its sites.

The 1930s were a decade of rapid advance in megalithic studies. Work emanating from Belfast, under the leadership of Oliver Davies and Estyn Evans, was laying the foundation for subsequent research.[16] Davies and Evans excavated a number of tombs and carried out surveys, which led to progress in classification, and to their recognition of a new group of tombs called 'horned cairns', now known as court-tombs (see below). During the late 1930s, T. G. E. Powell was involved in surveys and excavation, and in 1938 he published the first general account of Irish passage-tombs. Isolating various regional groups, he listed forty sites where such tombs occur. In 1949, Powell wrote a paper with Glyn Daniel on the origins and chronology of passage-tombs. They accepted that such tombs in Ireland and Britain were part of a wider West European pattern, but dated them to the second millennium BC, conventionally in the Early and Middle Bronze Age. Shortly afterwards, in 1954, Stuart Piggott firmly placed these tombs in the Neolithic period.

The first major effort to provide a detailed *corpus* of the megalithic tombs of Ireland was begun in the late 1940s by Ruaidhri de Valera, then Archaeological Officer to the Ordnance Survey. It was continued by him in partnership with the Ordnance Survey after his appointment to the Chair of Archaeology in University College, Dublin, in 1957, until his death in 1978. This survey has occasioned many outstanding papers and other publications including four survey volumes on groups or aspects of megalithic monuments,[17, 18] by the late Professor de Valera and by Dr Seán Ó'Nualláin. The past thirty years have, in fact, seen a steady stream of excavations of individual tombs of all classes, such as the court-tomb at Audleystown in County Down, the portal-tomb at Ballykeel in Armagh,[19] and the wedge tomb at Island in Cork.[20] The first comprehensive excavations of passage-tombs were conducted at Fourknocks, County Meath, in 1950–52 by P. J. Hartnett, who also listed many potential passage-tombs in the area.[21] Other excavations have followed, as has a synthesis by Michael Herity in 1974.

The passage-tomb cemetery in the Bend of the Boyne is among the most important in Europe. Indeed, its status may have lingered on during the succeeding Bronze Age, for an area called Brugh na Bóinne was often mentioned in the written history that arose in the latter half of the first millennium AD. This area was one of a number of royal cemeteries of the pagan period, and a great burial place of the early Irish kings. However, the first detailed account of it is not found until the late eleventh or early twelfth century AD, in a manuscript called *Leabhar na h-Uidhre* (the Book of the Dun Cow), which has a section entitled 'Seanchas na Relec' (History of the Cemeteries), and is based on older lost works.[22]

According to this source, the nobles of the Tuatha De Danann were buried at Brugh. The area included the two paps of Morrigan, the graves of Boinn, Esclam, and Aedh Luirgnech, the mound of Tresc and that of the Bones, the monuments of Cirr, Cuirrell, Cellach, and that of the seed of Cineadh, the cave of Buailcc Bec, the pillar stone of Buidi 'where his head is interred', and the Caisel of Aengus. Certainly it appears that the account refers to a group of monuments. Since the last century, due mainly to the work of George Petrie,[23] it has been usual to equate this with the group in the Bend of the Boyne.

The excavation of Knowth

From the archaeological point of view, it was George Coffey's work of 1892 and 1912 that clearly indicated the extent and nature of the Boyne Valley cemetery. Furthermore, the art was then considered for the first time, and this has subsequently become a cardinal aspect of passage-tomb studies. Newgrange and, to a lesser degree, the neighbouring monuments were next evaluated in 1964, by Seán Ó'Ríordáin and Glyn Daniel. Very little archaeological excavation was done in the cemetery before 1960. During that year and the following one, Townleyhall was uncovered, while in 1962 investigations commenced at both Knowth and Newgrange.

Many of the early antiquarians suspected that the great mound of Knowth was an ancient site. In the last century, pioneers in the field such as William Wilde,[24] T. J. Wakeman,[25] W. C. Borlase,[26] and George Coffey assumed that it was a man-made construction,[27] not a natural feature. Its close proximity to Newgrange and Dowth, both known passage-tombs, led to the suggestion that it, too, might cover a burial chamber. This was a factor in prompting R. A. S. Macalister, the first Professor of Archaeology in University College, Dublin, to initiate a small-scale investigation in July 1941. His work confirmed that the mound had a delimiting kerb of large stones, and that most of these were highly decorated. No hint of a chamber emerged, but the mound was shown to be of Neolithic date. Macalister's work also indicated that a small tomb might lie adjacent to the large mound, and that the hilltop was inhabited long afterward during Early Christian times.[28]

The 1962 excavations were not begun with the primary purpose of discovering an entrance to the main mound, or even with the intention of investigating other aspects of it. The original aim was, rather, to confirm whether or not smaller, but independent, passage-tombs existed beside the large one and, if so, what their form and type might be.

An impetus had been the study of the small passage-tomb at Townleyhall, a few km away. This site, excavated by the writer and Professor G. F. Mitchell in 1960–61, was damaged and lacking in burial deposits, grave goods, or other finds. But the tomb, with its somewhat rectangular structure, had an unusual *fig. 8* ground-plan: from the entrance inwards, the sides diverged slightly instead of remaining parallel. As there was no clear division between the passage and the chamber, this type came to be called an undifferentiated passage-tomb. The Townleyhall tomb overlay a Neolithic occupation site, which yielded a radiocarbon date of 2680 ± 95 bc. The absence of any demarcating feature between the two periods of use, such as a naturally formed layer of sod, indicated that the tomb was built immediately after the abandonment of the settlement, suggesting that the tomb itself was of Neolithic date.

At the time of this excavation, such a date seemed contrary to the general opinion that undifferentiated tombs were built only later, during the Bronze Age. Moreover, the presence of such a tomb was an oddity in the Boyne Valley, where the tomb with a cruciform-shaped chamber, majestically represented at Newgrange, was considered the classic type. This raised a series of questions, such as the chronology of undifferentiated tombs, their relationship to the

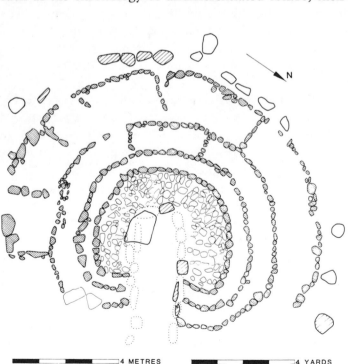

8 *Ground plan of Townleyhall 2.*

4 METRES 4 YARDS

latter type, their status within the cemetery complex of the Boyne Valley (Brugh na Bóinne), and their integration into the overall family of Irish passage-tombs.

In 1961, the writer and Professor G. F. Mitchell – who has been a constant source of support throughout this long campaign – carried out a surface examination of the various small sites that form part of the Brugh na Bóinne cemetery. We came to the conclusion that Knowth might shed some light on the above problems. The only certain monument as yet was the large grass-covered mound (Site 1), with a regular hemispherical profile, in a flat field that was used for grazing. There was no clear evidence for other sites, especially smaller tombs close to it. However, a strong hint that minor mounds may have existed was provided by Professor Macalister's excavation, just outside the main mound on the northern side, of what he called a 'minor grave-monument', which he described as a cist with a passage leading into it (Site 14).

Another such hint was the presence of four large boulders on the northwestern side, 15 m from the perimeter of the large mound – a feature already noted by Coffey. Could these belong to a small independent tomb and, if so, might it prove to be a passage-tomb of the undifferentiated variety? An excavation was made to test the issue. We were fortunate in our choice, for not only did the site (now designated Site 12) turn out to be an undifferentiated passage-tomb: part of the kerb of another small tomb (Site 11) began to emerge alongside, and with it the extraordinary richness of the site. Site 11 was examined during the next year, 1963, demonstrating that most of the kerb survived, whereas the chamber had been completely destroyed. For the 1964 season, we moved on to Macalister's structure. The 'passage and cist' were shown to be a fine example of an undifferentiated passage-tomb. Wider investigation revealed the extent of its covering mound, and the half or so of its kerb that remained.

In view of the information that Knowth was now yielding, it was decided to plan a programme of research over a number of years. The aim was to study a substantial area outside the main mound, so as to establish the presence or absence of smaller tombs and their relationship to that mound. In addition, we hoped to excavate at least a portion of the main mound.

plate 1

For the purpose of controlling our excavation and recording data, a base-line was laid out on all four sides of the large mound, enclosing a rectangular area 116 by 104 m. The excavated sectors within this area varied in form, but

plates 1, 2

most of the flat ground was investigated by a grid method in squares of 4 by 4 m. Cuttings 4 m wide were made into the large mound at right angles to the relevant base-line, or diagonally at the cardinal points in order to cope with the curve of the mound. The large mound has been numbered Site 1, the smaller

fig. 9

passage-tombs Sites 2–18.

As each season got under way, new and exciting discoveries came to light. It soon became apparent that the site was of immense complexity, with features spread over several acres and representing diverse cultural phases. The

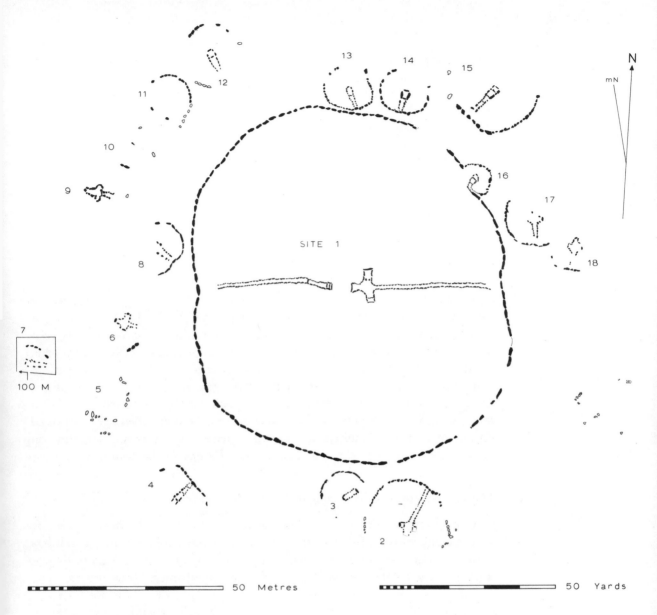

SITE 1

N

mN

100 M

50 Metres 50 Yards

9 The passage-tomb cemetery at Knowth.

monuments ranged from Neolithic tombs of the third millennium bc to simple houses of the nineteenth century AD, virtually a microcosm of Irish archaeology. Even in our wildest dreams we had not expected such an array of finds and contexts.

The flat field adjoining the main mound had been an area of intense activity. During the Neolithic, it held up to twenty passage-tombs and a settlement. In the Early Bronze Age, habitation by Beaker people occurred at four places. Knowth was abandoned for the remainder of the Bronze Age, but began to be used again towards the end of the Iron Age, as is shown by a series of

inhumation burials. Possibly also around this time, the large mound was transformed into a well-protected settlement. Two penannular ditches were dug, one at the base just inside the kerb, and the other around the top edge. Thus the site became a large ring-fort, with the entrance on the southeast side. At a later stage, from about AD 800, Knowth was an even more important settlement, consisting of thirteen rectangular houses, nine souterrains, a bronze-working area, and three iron-smelting areas. There was also clear testimony for the role of agriculture in the economy of the inhabitants.

Between the ninth and twelfth centuries AD, Knowth had definite significance as a sort of small village. It was 'open' or unditched, largely occupying the hollowed or flattened areas which had been created at the base of the mound, and around the top edge, by a partial natural filling-in of the ditches. Its role in this period is amplified by history. The researches of Professor Francis Byrne have shown that Knowth,[29] in about the ninth and tenth centuries, was an important political centre and the 'royal residence' of the Kings of Northern Brega. One of its kings, Congalach Mac Maelmithic, or Congalach Crogba, who died in 956, became High King of Ireland. But Knowth passed out of Irish hands about 1175. It was made a Norman centre, granted by Hugh de Lacy to one of his leading Barons, Richard de Flemming, while the adjacent lands became part of the grange of the recently founded Cistercian Abbey of Mellifont. The Norman settlement lasted for over a century, until sometime between 1300 and 1400. Knowth never again attained prominence or its former greatness and, when used, it was only for the odd peasant dwelling. The site was just a green hillock in the countryside.

The classification of Irish megalithic tombs

Our background to the earliest evidence at Knowth must now be supplemented with a fuller outline of the enormous contribution which has been made by research in the past half-century or so to an understanding of such passage-tombs, as well as other forms of megalithic tombs. The classification and terminology followed here is due to Ruaidhri de Valera,[30] and divides the tombs into three main classes: the passage-tomb, long-barrow tomb, and wedge tomb.

The *passage-tomb* consists basically of a parallel-sided passage leading into a distinct chamber. The chamber often has a cruciform plan because of a recess in each side and in the far end. The undifferentiated form of tomb has a passage with sides that gradually diverge towards the chamber. In some cases, a transverse sillstone demarcates a chamber area. The tomb is covered by a round mound, which is normally delimited by a kerb. Passage-tombs were usually built on elevations and grouped in a cemetery. The burial rite was cremation, and the deposits often contained more than one individual. The grave goods were almost exclusively personal items such as beads, pendants, and pins. There are at least 150 proven passage-tombs in Ireland, and an equal

number of round mounds – with hilltop settings or relevant features such as a kerb – which may also be passage-tombs, making a possible total of about 300. These tombs are concentrated in the northern part of the island, north of a line from County Wicklow in the east to Sligo in the west.

The *long-barrow tomb* is represented by over 500 examples, which can be subdivided into *(a)* court-tombs and, developing from these, *(b)* portal-tombs.

A *court-tomb* has a long cairn, trapezoidal or rectangular in shape, generally 25–35 m in length with a broad end facing east. The cairn is usually edged by individual stones, but dry-stone walling was also used. The characteristic feature is an unroofed court, probably used for ritual purposes, and delimited by upright stones or, rarely, by dry-stone walling. When 'open' *fig. 11* or 'partial', the court may be oval, circular, semi-circular, or U-shaped, and it lies at the broad end of the cairn, except in 'dual-court' tombs which have a court at each end of a rectangular cairn. There is a burial chamber, or in rare instances two, leading off from the central part of the court's curve, and along the line of the cairn. When 'full', the court may be somewhat oval or sub- *fig. 10* rectangular, and it lies around the centre of the cairn with access from the side, or else near the broad end with access from that end. Here, the burial chamber may extend from one or both ends of the court. A burial chamber tended to be rectangular, and was divided into two or more segments by means of a sill between jambstones. The chamber was roofed by transverse lintels, resting directly on the side orthostats or on a slight corbelling over them. A number of court-tombs also have subsidiary or lateral chambers, located towards the

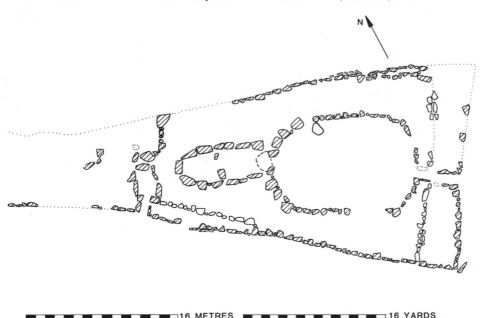

16 METRES 16 YARDS

10 *Ground plan of the full court-tomb at Creevykeel, Co. Sligo.*

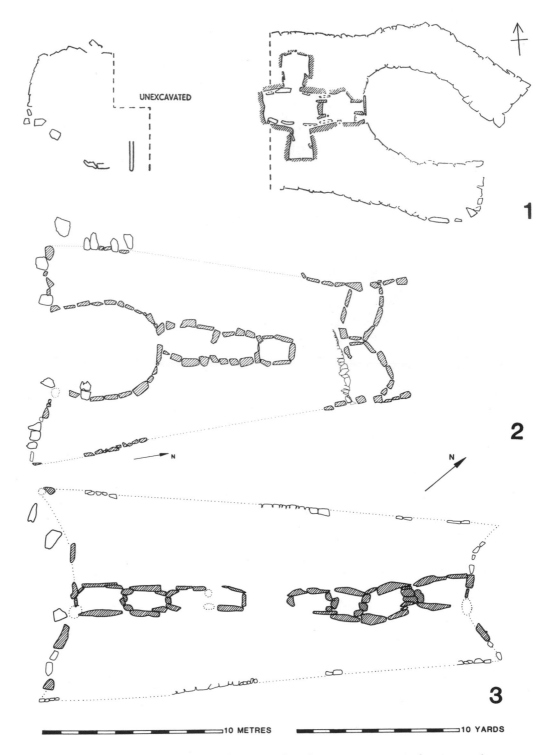

11 Court tombs: 1, transeptal court-tomb, Behy, Co. Mayo. 2, single court-tomb, Annaghmare, Co. Armagh. 3, dual court-tomb, Audleystown, Co. Down.

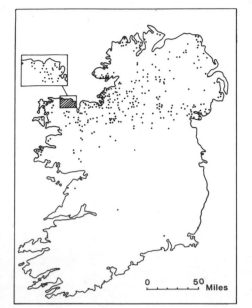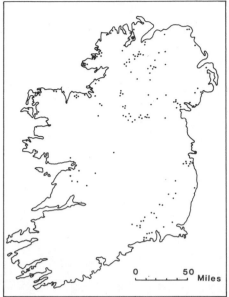

12 *Distribution of court and portal tombs.*

narrow end of the cairn, at right angles to its long axis, with the entrance on the long side. The burial rite was predominantly cremation, sometimes of individuals. Collective burial was practised as well, but the number of individuals was small. The grave goods included round-based pottery vessels (either bag-shaped or shouldered), stone axes, flint artefacts – notably rounded and hollowed scrapers and blades – and occasionally stone beads. Court-tombs occur singly, but not on high elevations. There are about 370 in Ireland, nearly all north of a line across the island's middle from Dundalk Bay to Connemara. They are also found in western Scotland and the Isle of Man.

fig. 12

A *portal-tomb* consists of a small, generally rectangular chamber, formed by a stone on each side and an end stone. The entrance area, at the eastern end, has a porch-like feature which is recessed inward from the line of the chamber wall, with a portal-stone on each side and a transverse sillstone between these. The roof is a massive capstone with one end poised high over the portal-stones. An associated mound is seldom attested but, when present, it is long and the tomb is at the eastern end. In the main, the burial rite was cremation and sherds of round-based pots, stone axes, and flint scrapers occur as grave goods. About 170 portal-tombs are known, chiefly in the northern part of Ireland, but some were built in Leinster and as far south as Waterford. Others are found across the Irish Sea in western Wales and Cornwall. The type may be regarded as an insular development from court-tombs, especially from their lateral chambers.

fig. 13 (1–3)

The *wedge tomb* has an elongated cairn, but there are various forms such as a short oval or D-shape. The length also varies, rarely exceeding 10 m. The

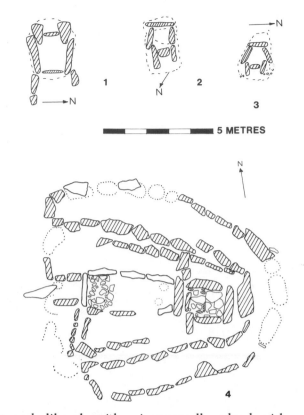

13 *Portal tombs (1–3) and a wedge-tomb (4). 1, Brennanstown, Co. Dublin. 2, Knockeen, Co. Waterford. 3, Gaulstown, Co. Waterford. 4, Ballyedmonduff, Co. Dublin.*

fig. 13 (4)

front of the cairn is straight and, like the sides, is normally edged with boulders. At the entrance end of the tomb is usually an antechamber or portico, while some tombs have a closed end-chamber. The main chamber tends to have parallel sides, although in numerous examples it becomes narrower and lower from the entrance inwards. Its roofing slabs rest directly on the orthostats. Often one or more rows or wallings of upright stones occur within and under the cairn, but parallel to the tomb axis. The burial rite consisted of both cremation and inhumation, and communal burial took place. The finds are sherds of fine beaker pottery, flat-based vessels of coarse ware, and flint artefacts – principally barbed and tanged arrowheads, and rounded scrapers. At least 400 wedge tombs are known. Isolated, and usually on good pasture lands, they are distributed predominantly in the western coastal counties from Cork to Derry.

fig. 14

In addition to the above, there are about 100 tombs which cannot be classified due to poor preservation. There is also a type of tomb that lacks a passage but displays, at least in some cases, megalithic proportions of the chamber and its stones. These tombs, sometimes called 'Linkardstown Cists', tend to have a polygonal-shaped chamber in the centre of a round mound that is often delimited by a kerb. The side stones of the chamber are supported by outer slabs that lean inward, and the roof consists of two or more overlapping capstones. The predominant burial rite was inhumation, most commonly of

an adult male. The grave goods are highly decorated round-bottomed bowls, sherds of plain decorated 'Western' Neolithic vessels, pins or toggles usually with a mushroom-shaped head, flint leaf-shaped arrowheads, jet ornaments, and stone axes. About a dozen such tombs are known, concentrated in southern Leinster and to a lesser extent in northern Munster. Their full range and distribution have not yet been established.[31]

A megalithic tomb is not just an architectural form that emerged by chance, say as a reflection of some regional ritual idiosyncracy, it is intimately linked with the development of society. The construction and use of such tombs brought about the emergence of specific occupations, not only physical but also intellectual and ideological. In particular the passage-tomb may document the existence of an elite, or at least people with distinctive values as displayed by their tombs and their possessions too, some of which were of special excellence.

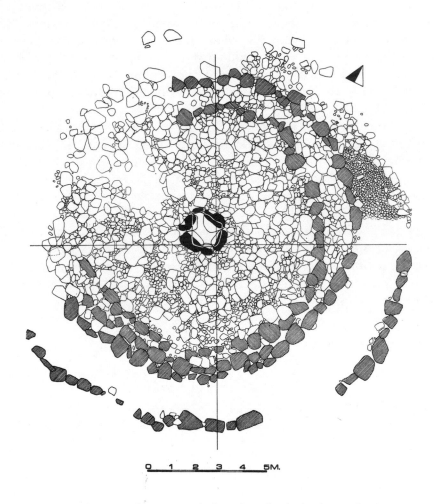

14 Baunogenasraid, Co. Carlow. Ground plan of 'Linkardstown' type cist.

2 The great mound and its tombs

The most spectacular of the twenty or so tombs discovered during the excavations at Knowth is certainly the great mound (Site 1). Occupying the highest part of the ridge, it has a smooth profile when viewed from some distance. But close examination showed that the surface was irregular in *plate 3* places. There was a large pit in the centre, about 2 m deep, possibly dating from the early nineteenth century, when W. F. Wakeman recorded that stones were being removed for house-building and road repairs.[1] A ditch, perhaps a fairly modern field-boundary, crossed the mound from south to north. Elsewhere, especially along the northwestern side, the tips of kerbstones could be detected.

These stones were separated from the base of the mound by a flat berm-like area. Excavation soon revealed the reason. During the Late Iron Age or the beginning of the Early Christian period, as already noted, ditches had been dug around the top and bottom edges of the mound. Occupation on and near the mound further altered its appearance during the first and early second millennia AD. Material from the basal ditch, primary slippage from the mound, and other accumulation had thus increased the surrounding surface level. As a result, the mound appeared smaller than it actually was. The true external measurements, to the outside of the kerbstones, are 80 m (east–west) by 95 m (north–south). It covers 6,080 square metres, about three-fifths of a hectare (1.5 acres), and is 9.9 m in height.

Discovery of the tombs

Initially there was no evidence that the mound contained tombs. Having begun *fig. 15* to excavate on its northern side, we gradually moved westward and, by the end of the 1966 season, had reached a point on the western perimeter. Larger and more highly ornamented kerbstones were being uncovered. Some set stones also started to emerge outside the kerb, but these were suspected at the time to be associated with one of the nearby small passage-tombs (Site 8). Further work there exposed a spread of quartz and granite boulders on the old ground surface. Inside the kerb, a settlement site of the Early Christian period was found, overlying the basal ditch, with hints of a souterrain to its south. Yet,

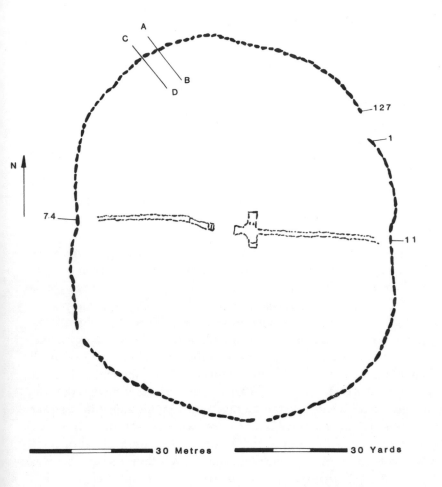

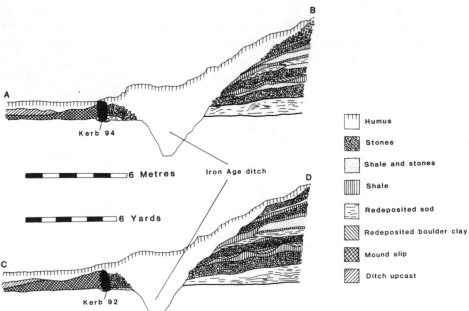

15 *Ground plan of Knowth Site 1.*

16 *Section of the main Knowth mound near the edge at A–B and C–D in fig. 15.*

127

1

7.4

11

30 Metres

30 Yards

A

C

B

D

B

A

Kerb 94

6 Metres

6 Yards

Iron Age ditch

D

C

Kerb 92

Humus

Stones

Shale and stones

Shale

Redeposited sod

Redeposited boulder clay

Mound slip

Ditch upcast

leaving the site in August of that year, we had no definite clue as to the location of an entrance into the mound.

Operations resumed in this area for the summer of 1967. After some time, it became clear that the kerb was curving in from both sides toward a point occupied by a uniquely decorated stone. The suspected souterrain was confirmed and associated with it we then found the top of what resembled a dry-stone wall leading into the tumulus, followed by part of a parallel wall on the southern side. Loose stone fill was removed between and around the walls, bringing to light a capstone. Beneath this lay a solid fill of dark, generally loose, stoneless earth. The capstone had prevented it from extending far inward and, after less than a metre was excavated, a cavity appeared.

By the afternoon of 11 July the cavity had become larger. I asked the youngest and smallest workman on the site, Martin Colfer of Slane, to try and look in. Getting his head and shoulders through, and using a torch, he announced that he could 'see in for 20 yards'. As the news seemed too good to be true, it was accepted with caution. Even so, I thought, the structure might be only a large souterrain, and the passage which we were excavating was plainly the work of souterrain builders. Therefore, normal investigation of the drystone passage's fill proceeded until evening. An entrance was now visible, about 70 by 70 cm, between two dry-stone walls and roofed by a smallish capstone. I could easily look in with a torchlight, and saw immediately that the passage led far – perhaps indeed for '20 yards'. But most exciting was that the dry-stone walling, after a short distance, gave way to a monumental passage built with orthostats on the sides and roofed with substantial capstones. Equally important, one of the orthostats on the left side bore megalithic art.

At last I was convinced that the entrance had been found. As the time was 6.30 pm and the day's work was about to stop, I came out, delighted but speculating as to how far the parallel-sided passage might extend. Student helpers were told of the discovery and, with Quentin Dresser in the fore, we soon set out on our hands and knees to investigate. It proved to be a thrilling, if also rather worrying, experience. About 10 m from the entrance, we had to crawl under an orthostat that had partly fallen inward. Next it was necessary to wriggle through a pool of muddy water on the floor beneath a couple of leaning orthostats. Loose stones on the floor made our crawling rather uncomfortable, and it grew difficult to judge how far we had gone, yet there was no sign of an end to the passage.

Eventually the roof began to rise in height and we could almost stand upright. Nearly all the orthostats appeared to be decorated, and the whole structure was much more impressive. At one point a stone basin lay in the passage. Then, coming to a stone sill, we illuminated the orthostat on its inner right side and beheld what seemed to be an anthropomorphic figure with two large, staring eyes. This ghostly guardian suggested that we were approaching the inner sanctum. But we still had several metres to go, now walking erect and easily except for some boulders on the floor. The end of the passage was finally

reached: an undifferentiated chamber with two sillstones. The outer sill and the rear stone of the chamber were decorated, apart from the vertical line, in a manner similar to that of the kerbstone before the entrance – with concentric rectangles.

We remained speechless for some time and marvelled at the achievement of these anonymous passage-tomb builders. Here was truly one of their great enterprises of close to 5000 years ago. In order to measure the real length of our tomb, Quentin Dresser went back for a tape, as well as to inform our three presumably worried helpers. He returned with Fiona Stephens, Tom Fanning, and Seán Galvin, who entered the chamber as much amazed as Quentin and I. The five of us gazed at the structure and its art for an indefinite length of time, before leaving with the fact that the tomb was about 34 m long. What a day!

plate 7

However, archaeological excavation is not tomb-robbing. A study of the primary structures had to be preceded by removing the later layers which, as we already knew, represented various cultural phases. During the following season in 1968, we continued to examine the area outside and around the perimeter of the great mound. On the northeastern side between the mound and the roadway, a low bank enclosing a rectangular area – like the bailey of a Norman moat – had shown up on air photographs. Investigation of this 'earthwork' was firstly carried out, not only so as to determine its nature, but also to clear what could have been an area used for dumping material excavated from the mound. But it soon proved to be complicated, and the remains of a number of smaller passage-tombs were revealed.

Thus, our attention shifted to simultaneous excavations extending onto the large mound. Several cuttings were opened on its eastern side at the beginning of July. Under the natural sod layer was soft dark earth, punctured by rabbit burrows, and obviously accumulated through occupation on the mound. Beneath this, in turn, was a stony layer with cavities, suggesting the presence of a souterrain (No. 4). These finds, and their location opposite the previous year's tomb, led us to speculate on the existence of a second passage-tomb in the mound. But in view of the former's size, such an idea could not be seriously entertained.

plate 14

On Tuesday 30 July, a hole appeared just to the south of souterrain 4. As the hole was at a much lower level, it could not have been a continuation of the passage of that souterrain. We enlarged it and, the next day, saw that it was due to a collapsed lintel. In the evening, I slid down into the hole, and was surprised to land at the junction of an elaborate complex of four passages. Three were constructed with dry-stone walling, indicative of souterrains, and they had large capstones, like those in passage-tombs. Yet the fourth had orthostats, arousing suspicion – and one of these, very near the beginning, bore some art. This passage was initially hard to assess, as it might have been a more elaborately built souterrain, utilizing stones from the damaged small tombs. Since the capstones had partly fallen in two places not far from the entrance, danger was avoided by postponing exploration to have them propped up.

The task was resumed at midday on 1 August. By good fortune, Jim Bambury of the National Monuments Branch of the Office of Public Works arrived to take photographs, bringing a small portable generator which the Branch had bought for our study of the previous year's tomb. Pushing a torch before me, and dragging a lead from the generator, I again entered the hole, followed by a workman, John Rock. One of the four passages, dry-stone built, was evidently the blocked-up entrance to a complex of further passages. Another led not towards the souterrain noted initially (No. 4), but to its left and at a lower level, heading somewhat into the mound (souterrain 2). We could only go along this passage for a few metres, whereafter it was blocked by slipped lintels and rubble. The third passage led downwards into a well-preserved beehive-shaped chamber (No. 1).

It was now time to explore the fourth and most substantial passage of all, 1 m wide and a little over 1 m high at the point where I entered. After a couple of metres, progress became difficult due to orthostats leaning inwards and to a shifted capstone. Getting beyond these obstructions, and at a point which would prove to be about a third of the way in, we came upon a well-preserved stretch and felt growing excitement. Soon we were on hands and knees again, though the floor was littered with stones – no doubt fallen from between the tops of the orthostats and the capstones – but, two thirds of the way in, it was almost possible to stand up. I noticed a cracked capstone and, flashing my lamp to check its trustworthiness, saw that it was elaborately decorated with chevron ornament (No. 43). The orthostats to left and right were also decorated. For the first time I was certain that we had another tomb.

Not knowing that there was so much more to come, I continued in astonishment, and with increasing trouble from inward-leaning orthostats. These touched at their tops, producing an inverted-V cross-section, but the drystone walling which was placed above remained largely intact and as a result I found it easier to proceed on top of the orthostats than on the stony floor underneath. My course sloped gradually upwards, then stopped as if in mid-air. Before me in the lamp's beam was the most amazing sight of my life. About 2.5 m below lay a large chamber, whose great corbelled roof rose around me, spanned by a single capstone up to 4 m above. My 'passage' over the orthostats was roofed by vast lintels, some of which were decorated. After a while I dropped down into the chamber, noticing its cruciform plan with a number of decorated orthostats. The right-hand recess in this plan was 'guarded' by two large jambstones. Looking between them, I saw a uniquely ornamented stone basin, with horizontal and vertical scorings on the outside and, just opposite the recess opening, a composition of concentric circles with flankers at the bottom. The inside of the basin, and the rear stone of the recess, were decorated as well.

What a structure and what a surprise! Since the previous year's great discovery, I had never expected a second tomb in the main mound, let alone a much more impressive one. And, having wriggled through some difficult parts

in the passage on my way in, my presence alone in the tomb – despite its massiveness – gave me a sense not of isolation, but of security.

The eastern tomb

The two tombs in the mound had been placed back to back, one opening east and the other west. As mentioned previously, during the Late Iron Age or the beginning of the Early Christian period, 4–5 m of the outer parts of the passages were destroyed by the digging of a large ditch. In mature Early Christian times, around the ninth to eleventh centuries, the entrance areas to both tombs were altered, and became parts of settlement sites.

 There is no evidence that the eastern tomb was used by the people who dug the basal ditch. Later, during the ninth to eleventh centuries, the chamber was accessible and occupied, so that a thick layer of dark earth accumulated over its central portion, extending into the recesses. The modification of the entrance area at that time involved a re-setting of orthostats 1–3, and of 94 which is now at a slight angle to the original line of the passage, while the tomb was incorporated into a souterrain complex. At the time of discovery, small stones lay scattered over the floors of the passage and chamber. These had probably been on top of the orthostats to provide a level platform for the lintels and corbels, becoming dislodged due to adjustment of the roof.

 A large number of the passage orthostats were found slanting inwards. In some instances, the stones were only slightly off the vertical, but in others (4 and 92, 5 and 90, 13 and 82, 17 and 77), the stones met at the top in the inverted-V shape already referred to, especially along the innermost few metres of the passage. This settling also caused several of the capstones to crack. Yet in view

fig. 17

plate 14

plate 19

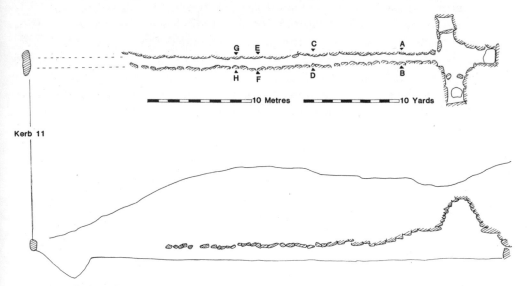

17 *Ground plan of the eastern tomb (top) and longitudinal section over the passage of the eastern tomb, Knowth Site 1.*

35

*18 Sections across the passage
of the eastern tomb at points
indicated on fig. 17.*

of its age and the enormous weight it had to carry, the tomb itself survived well
and could be entered easily enough by us. Inside, orthostats 37 and 57 were
leaning inwards at an angle of 20°, whereas 43 and 51 did so more slightly. The
external pressure from the cairn pile would have focused on these four
orthostats in particular. Apart from the course of corbels just above them,
little other adjustment had occurred, leaving the roof intact.

Three passage orthostats (96–98) were found in the bottom of the basal-
enclosing ditch, and must have been thrown in when the ditch was dug. About
4 more orthostats on each side of the passage were removed during Early
Christian times. However, it has not been established how many orthostats
were removed, or whether the passage extended out to the back of the
kerbstone (No. 11) before the entrance. If it did, some 14 orthostats must have
been removed, 7 from each side. This would imply a total length of 40.4 m for
the tomb, the passage extending 34–36 m, with 21 orthostats in the chamber
and 87 in the passage. What survive in the passage are 36 orthostats on the left
side (1–36) and 37 on the right (58–94).

The passage has a constant width of 85 cm, except for the innermost 4 m or
so, where it narrows at ground level to about 60 cm since the orthostats now
lean inwards. At its surviving outer end, the orthostats are *c.* 1.50 m in height
above the old ground level. The passage maintains a fairly uniform height of
1.60 m until the innermost 11 m, but thereafter it rises until the innermost
capstone at a height of 2.70 m. The orthostats were set in a trench 30–40 cm
deep, which was back-filled. In some cases stability was increased by adding
small 'packing' stones (*c.* 20 cm long) to the fill. The orthostats were set fairly
close together, and in some instances the slight gaps between them were filled
with small stones. Generally rectangular, the orthostats were set on their long

axis and average 1.15 m in length, although Nos. 5, 10, and 88 were twice that size. The inner face is flat, due to natural cleavage, not subsequent dressing.

The capstones of the passage now total 52 (Nos. 1–52), but would originally *plates* VIII, IX have been about 56. The outer 13 were disturbed, and possibly reset, during the construction of a souterrain. No. 2 is larger, 1.70 m long, while Nos. 6 and 9 are shorter, than normal. The capstones were placed transversely, side by side, and usually each extended between two opposing orthostats. In many cases, the capstones rested directly on the orthostats, but details of roofing varied. In the outer part, where some of the orthostats are not evenly matched in height, the intervening spaces were filled by stones, some being substantial rectangular flags up to 1 m long, others being small stones 15–20 cm long. The flags were normally laid horizontally with the flat edge over the orthostats and projecting back into the mound. Sometimes subsidiary flags were placed *fig. 18* beneath the main ones, behind the orthostats, to give additional support.

Closer to the chamber, taller orthostats were used, but did not suffice to provide the required height, so that extensive drystone walling was needed, with up to five layers in some places. The increase of height begins with capstone 46. From there inwards the passage roof is stepped, the inner edge of each capstone overlying the one below it. This gives an elongated corbel effect, and the passage roof merges neatly into the corbelled roof of the chamber. A curious feature is capstone 45, which projects downwards at a point 6.5 m out from the chamber. It looks like a sill in reverse, and its position resembles that of the outermost sillstone in the western tomb. However, it may have served a structural function, as an anchor for the beginning of the roof elevation. A parallel feature exists in the large tomb at Newgrange (No. 12).

The eastern tomb chamber

The cruciform shape of the chamber is formed by the three recesses opening *fig. 19* from its central area. In general, the eastern side of the chamber – to right and left of the entrance – is straight. The widening of the central area was achieved by the insertion of two orthostats, which opened the angles between the end recess and each side recess. Twenty-one orthostats (Nos. 37–57), all in sockets or a trench and averaging 1.65 m in height, make up the ground plan. They were closely set, but the contours of their sides left gaps in places. Internally, the chamber measures at most 8.16 m from north to south (between the backstones of the left and right recesses) and 5.6 m from east to west (from the backstone of the end recess to a point midway between orthostats 37 and 57).

Each recess was formed by five orthostats – two on each side and a backstone. These, and in particular the backstones, were rectangular. The left and right recesses were rectangular in plan, while the end recess was wedge-shaped and widened towards the back. Internally, the left recess is 2.2 m long *plate 20* (from the outer edges of orthostats 38 and 42 to the backstone) and 1.15 m wide, with a sillstone dividing its inner and outer portions. The end recess, 1.8 *plate 21* m long, widens from 1.2 m at the junction with the chamber's central area to

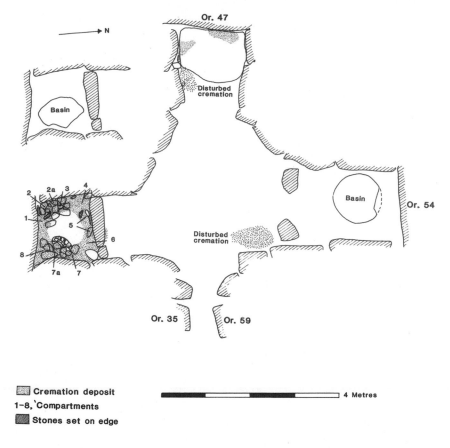

19 *Ground plan of the eastern chamber, Knowth Site 1. For the location of cremation burials in the right-hand recess, see fig. 20.*

Or. 47

N

Disturbed cremation

Basin

2 2a 3 4

1

5

6

8

7a 7

Disturbed cremation

Basin

Or. 54

Or. 35

Or. 59

▨ Cremation deposit
1–8, Compartments
▨ Stones set on edge

4 Metres

plate 24

1.62 m at the backstone's inner face. The right recess is separated from the central area by an entrance 54 cm wide between two large jambstones, 2.2 m high. From there to the inner face of the backstone, this recess is 2.5 m long and averages 1.6 m wide internally.

In all three recesses, the height of their sides, and especially that of their backs where lower orthostats were used, was increased by placing slabs horizontally over the orthostats. The slabs over the backstones, notably in the left and right recesses, are larger than elsewhere and look like horizontal slab walling. In general there are two courses of slabs above the orthostats of each recess. The slab faces do not make a vertical facing over the backstones, as each course slightly oversails the one below it.

In addition, the capstones slope up towards the central area of the chamber. The left recess is roofed by two capstones. The inner one rests directly on the slabs over the backstone. The outer one is set horizontally at a higher level, and partly overlaps the inner one, not resting directly on it but propped up by three courses of small stones. This capstone blends in with the corbelling over the chamber's central area. Both the end and right recesses are roofed by a single capstone, resting directly on the upper slabs over the backstones, and tilted upwards. The outer faces of all capstones coincide with the third and fourth courses of roof corbels, yet are thicker. Likewise, the last capstone of the passage (No. 52) is part of the third course.

The beehive-shaped roof of the chamber was constructed by corbelling. Its lower courses lay directly atop the orthostats. From there, it narrowed towards the top, culminating in a capstone. The corbels had a rectangular outer face, and were largest in the bottom layers, with 1.8 m average length, their size gradually decreasing in the upper layers. The roof was heptagonal at its base, but a subsidiary row of corbels was added to make it octagonal in the fourth to seventh courses. The corbels of this row were less than half the size of the others. This row, and one other, merge into the remaining six rows at the seventh course, and the final course – the ninth – is pentagonal. Between the corbel courses are a number of small flattish stones, about 15 cm long. These provided a level base for each course, and also enabled the correct tilt of each corbel to be achieved.

The roof reaches 5.9 m over the centre of the chamber. This splendid structure is perfectly preserved and, apart from some adjustment in the bottom two courses, none of the corbels have suffered damage. The small stones between the corbels also appear to be undisturbed. The roof's construction had been regular, and the junctions between the corbels are usually above each other. The skill of the builders is demonstrated, too, by the fact that there is a tendency to carry upwards the width of the end recess. *plate* VII

Burials in the eastern tomb chamber

The only evidence of burials in the central area of the chamber was found in a small place around the entrance to the right recess, and can be considered an extension of the burial deposits in that recess. Otherwise, burials were confined to the three recesses. Except for a few pieces of disarticulated bone, the rite was cremation. Anatomical examination of the bones has not been completed. *fig. 19*

The Early Christian activity disturbed some of the burials, particularly those in the end recess. Part of the disturbed deposit was discovered outside the flagstone, on the old ground surface, indicating that the disturbance occurred at an early stage of the chamber's use by Early Christian people. In the central area of the chamber lay numerous pieces of cremated bone, part of a pestle pendant, and parts of one or two antler pins, scattered through the Early Christian occupation levels. It is unlikely that there were burials over the floor of the chamber, as some positive evidence should then have survived. At least the primary deposits around the entrance to the right recess were undisturbed.

In the left recess, burials were located mainly between the sillstone and the backstone. On the inside of the sill, the centre of this area was slightly hollowed, but devoid of cremation, and probably held the basin to be described below. A number of stones, about 20 by 15 cm, lay on the old ground surface around the edges, without formal arrangement, tending to enclose small places or hollows. There were ten 'compartments' varying in size, from *c.* 15 by 10 cm, to 35 by 30 cm. A general blanket deposit of cremation, 3–15 cm deep, existed all around the sides of the recess, abutted directly onto orthostats

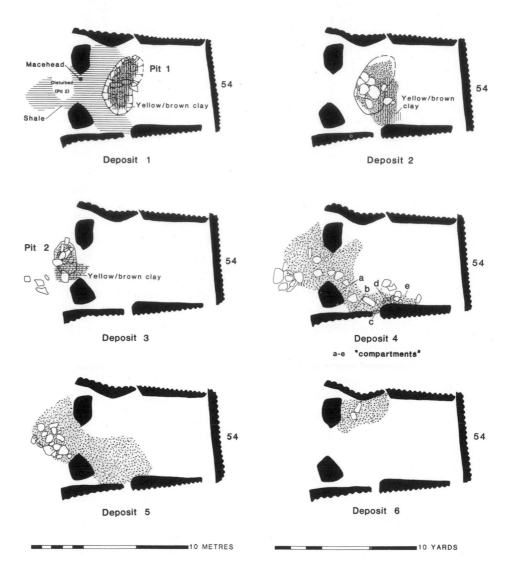

20 *Location of the cremation burials in the right-hand recess of the eastern tomb, Knowth Site 1.*

39–41 and the sillstone, and extended into and over the hollows. Whether the latter originally contained individual cremations separate from the main deposit could not be established. In one hollow, some unburnt or partly burnt bones were mixed in with the cremated deposit.

Grave goods here consisted of two pestle pendants, parts of two mushroom-headed pins, and parts of five other pins seemingly of the skewer type. A thin layer of dark earth, Early Christian in date, overlay the burials. The stone basin was on top of this layer, upturned, and a portion had been broken off. The sandstone selected for it had a natural curve on both sides, giving a bowl-shaped profile, while the original upper face had been dressed by pocking. The

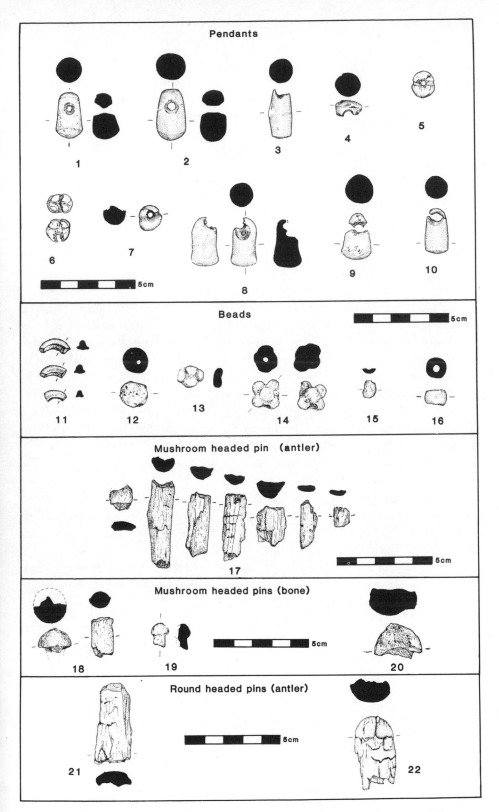

Pendants

1 2 3 4 5

6 7 8 9 10

5cm

Beads

5cm

11 12 13 14 15 16

Mushroom headed pin (antler)

17

5cm

Mushroom headed pins (bone)

18 19 20

5cm

Round headed pins (antler)

21 22

5cm

21 *Grave goods from the eastern tomb, Knowth Site 1. 1–3, left recess (1–2, primary cremation deposit; 3, disturbed). 4, end recess, disturbed context. 5–10, right recess (5–7, deposit 4; 8, deposit 5; 9–10, disturbed). 11, end recess, disturbed. 12–16, right recess (12, 13, 15, deposit 4; 14, deposit 5; 16, disturbed). 17–19, left recess, primary cremation deposit. 20–22, right recess, deposit 4.*

surviving portion of the basin had maximum dimensions of 1 m length, 70 cm width, and 24 cm thickness. In the outer part of the recess, on the original surface next to the sill, was a small amount of cremated bone, which may be the remnants of a more extensive primary deposit.

Of the end recess, the inner part is almost completely occupied by a large, roughly rectangular flagstone, lying on the old ground surface, wedged in position by three inner orthostats. A slight dishing in the flag's upper surface was a natural feature, but the surface was partially pocked and also bears some art. The flag measured at most 1.52 m long (east–west across the width of the recess), 1.20 m wide, and 25 cm thick. A thin layer of clear yellow sand, apparently deliberately deposited, overlay an area 73 by 24 cm on the northwestern edge of the flag, and filled the small gap between the flag and the backstone, along whose edge it was deepest, 3 cm thick. A cremation deposit overlay the flag, but the outer part was disturbed.

The right recess has a stone basin centrally placed in the inner part. This was an original feature of the tomb, as it is too large to have been positioned in the recess after the passage was built or, indeed, after the jambs flanking the recess entrance were erected. The basin is 1.20 m in diameter, and a small piece of its rim is missing. Sculpted from a block of sandstone, it was highly decorated by pocking within and without. On the outer face is a central motif of three concentric circles, flanked at each side by two arcs, and nearby at the top is a small circle. Seven horizontal bands surround the body, the uppermost pair being continuous. The other five are interrupted by the central motif, and at two further points by vertical lines, four at one side and three at the back. On the inner face, a line runs around the inside of the lip, and in the centre is a concentric circle flanked at each side by six lines, five long and one short, radiating to the edge. These are delimited on the outside by a line and, in one section, by two parallel lines. Between the radiating clusters in one place is a motif of four arcs.

Another object that dates from the beginning of the use of the recess is a flint macehead. This was found on the floor of the tomb between the jambstones. It

<div style="float:left; margin-right:1em;">plate VI</div>

<div style="float:left; margin-right:1em;">plate 22</div>

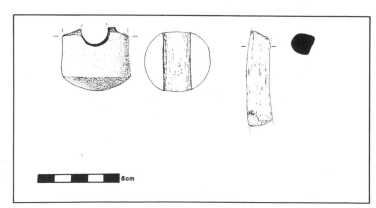

22 *Pestle macehead and stem of an antler pin from the western tomb, Knowth Site 1.*

lay on one broad face with the perforated end towards the recess, and was covered by a layer of shale. Burial took place within the recess, and in the adjoining part of the central chamber. There were six deposits, most inserted in stratigraphical order, and, after each burial, the deposit was covered by a thin layer of earth or small flat stones. The associated finds included pieces of antler pins, stone beads, and pendants of different forms.

fig. 20

fig. 21

The western tomb

From the inside of the kerbstone before its entrance to the inner face of the backstone in its chamber, this tomb is 34.2 m long. About 4 m of the outer end of the passage was destroyed by the digging of the Iron Age ditch. A few of the orthostats thus uprooted have survived, since they were thrown outside the kerb along with other removed material such as cairnstones. The tomb was constructed from orthostats, and would have had around 94 if the passage extended to the kerb. Its preserved portion has 80 orthostats – 39 on the left, 40 on the right, and the backstone. These were erected with the longer face towards the passage, and average 80 cm in height. Several stand vertically, but others lean into the passage, in some cases touching at the top and creating an inverted V.

fig. 23

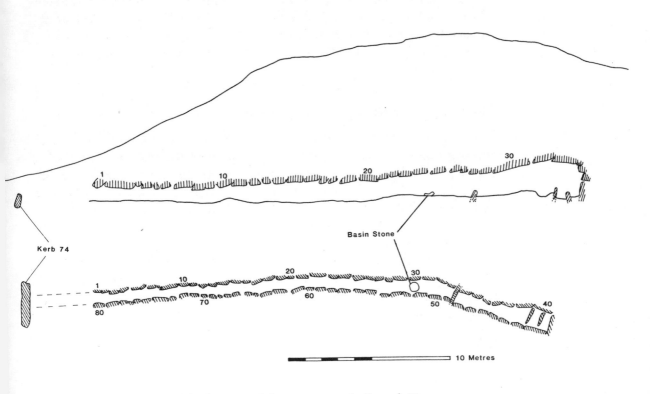

23 *Ground plan and longitudinal section of the western tomb, Knowth Site 1.*

The roofing was straightforward. Lintels were transversely placed across the passage, usually resting directly on top of the orthostats. The backstone is lower than the sidestones, and here an increase in height was achieved by using two flagstones. The spaces in between, especially above the top of the backstone, were filled with smaller stones. The flags project inwards slightly to produce a corbelled effect. A massive capstone, about 2 m long, roofs the chamber.

plate v

As the tomb has not yet been excavated, exact measurements cannot be given. There is a layer of silt-like material over the floor and, when this is removed, the present entrance will apparently be about 1.10 m high and 60 cm wide. The passage is straight and parallel-sided for about three quarters of its length, then bends a little to the right, widening slightly at the bend. Not far beyond the bend is a sillstone, and further along the passage narrows to 40 cm. Finally, it expands on the left and the interior – the chamber proper – is rectangular, internally measuring 1.30 m wide and 1.50 m long. This inner area is well defined by two large sidestones, the backstone, and the outer sillstone. Another sill lies in the middle of the chamber. At about 22 m in from the entrance, the passage begins gradually to increase in height, and reaches its maximum of at least 2 m over the floor of the chamber.

plate 11

plate 12

plate 13

Flakes of cremated bone are noticeable in the fill of soft earth over the floor. This area also yielded part of a stone pestle or macehead, and part of the stem of a large antler pin. A sandstone basin, c. 70 cm in diameter, stands in the passage, 25.20 m from the entrance, which does not seem to be its original position. It may have stood in a hollow that now exists just on the outside of the outer sillstone in the chamber.

fig. 22

The mound and the sequence of construction

Work started with the tombs. To begin with, sockets or trenches were dug, and the orthostats erected in them. As it is unlikely that the corbelled roof of the eastern tomb could have been built and retained without external support, the building of both tomb and mound must have proceeded together from an early stage. Indeed, it appears that the area around the chambers was consolidated first with a great pile of stones averaging 35 cm in diameter and generally larger than those used in other parts of the site. Although this is not a well-defined core, a building stage is nevertheless indicated since it is around this point that the roof of the passage starts rising, where capstone 42 partly overlaps capstone 43 and a layer of earth which covers the inner capstones, from 42 inwards, terminates. In turn this earth layer is partly overlapped by another layer of earth which covers the capstones from here outwards.

The outer part of the mound is of more complex construction. Its basal layer consisted of redeposited sods, except for an area on the eastern side. Today, this layer thickens from about 50 cm behind the kerb to 1.50 m at the inner edge, which is some 36 m from the kerb – but originally the height would have

been much greater. Professor Mitchell considers that these sods were stripped from grassland that had a liberal scattering of nongraminaceous species. Here and there, pieces of twigs were mixed through the sods, suggesting that some of them came from an area with scrub vegetation. The sods must have been dug by a wooden spade. In certain instances they were thickly cut, up to 15 cm, and some of the underlying shale is attached. Most were laid horizontally with the humus portions face-to-face, but in places they lie at an angle, possibly due to the manner in which they were tipped. The material around a part of the eastern tomb's passage was different. Its composition has not yet been fully studied, but preliminary work by Professor Mitchell indicates that it might even be material collected from a farmyard, for it contains grains of weeds, especially nettle and dock.

The capstones on the eastern passage from 42 outwards, after being laid, were covered by a thin spread of small flat stones. The latter, at some points, extended beyond the projecting ends of the capstones, being larger and more rounded than those directly overlying the capstones. This spread, in turn, was covered by an upper layer, now 10 cm thick, of the basal material. The result would have been to prevent material higher up from filtering down into the passage, but the chief aim may have been to hinder seepage of water. Due to the subsidence of the basal layer on each side of the passage under the immense weight of the mound, the cross-section is hog-backed. The subsidence seems to have been the initial cause of the inward leaning of a number of the orthostats in the outer portion of the eastern passage, while the consequent adjustment of the capstones caused several of them to crack.

After completion of this detailed work, the main mound between the central cairn and the kerb was finished. A layer of sods formed the base of the mound, except around the outer part of the passage of the eastern tomb, where material resembling farmyard manure was used. Above the sods were layers of loose stones, generally water-rolled, although one layer consisted largely of quarried stones. These alternated with layers of shale, redeposited boulder clay, sod, and a mixture of shale and stones. The layers sometimes interlock, yet were laid mostly in stratigraphical order. They do not extend into the centre, and were thus probably not for drainage purposes, but may have served to retain the edge, preventing or at least minimizing slippage. Each layer gradually thickens from the edge inwards and, in view of the fair consistency throughout, the mound appears to have been built as part of a single operation. The layers' inward thickening also makes it likely that the edge of the mound sloped gradually inwards from the top of the kerb. The nature of the edge cannot be determined, as it was removed by the digging of the basal ditch, early in the first millennium AD. The basal layer outside the kerb may have been slip from the mound, tapering from the top of the kerb to an average distance of 6 m from the kerb.

plate 17

plate 18

fig. 16

plate 26

The kerb

plate 11

plate 10

plate 25

A series of 127 continuous stones gave the mound an impressive edging. Only three (Nos. 20, 37, 62) are missing, and four (21, 43, 44, 76) have been damaged. The rest are well preserved and nearly all stand upright in their original positions. On some, the top and the nearby part of the face are weathered, no doubt due to exposure in the past. The only original gap in the kerb occurs on the northern side, where Site 1 abutted onto the already existing Site 16. There, the kerb deviated inwards from its normal curve to accommodate the earlier tomb (see below). A slight indentation occurs on the northern side next to Site 13, which is also earlier than Site 1, indicating another effort to avoid altering an older tomb. The kerb is roughly circular, and measures 80 m (east–west) by 95 m (north–south) externally. Regularly curved on the northern and southern sides, it bends inwards on the eastern and western sides to form, in each case, a shallow recess where the innermost kerbstone (11 and 74) is the stone before the entrance to one of the two tombs.

As was the case in the passages and chambers, considerable care was also taken in selecting the kerbstones. Of the 124 surviving examples, 95 are Lower Palaeozoics – greywacke, green cleaved grit, or related rock. Harder than either limestone (18 examples) or sandstone (9 examples), they weather better and provide flat surfaces which were ideal for decorating. The kerbstones are generally oblong in shape and average 2.5 m in length. The largest stones were used near the tomb entrances. On the northern side, adjacent to Sites 13 and 14, a stretch was formed from much smaller stones, 30 cm high and averaging 1.75 m long. Among these, limestones predominate and very few are decorated. Great attention was given to their placement, erection and equalization of height, so as to provide a regular profile and appearance for the kerb. For instance, along the southwestern side, some of the stones were sunk into sockets, while others were sitting on a foundation of small stones above the old ground surface, although all had the same horizontal line at the top. Indeed, in each instance the size and shape of the stone was taken into account, and those factors dictated the presence or absence of sockets.

Features outside the entrances

On both sides of Site 1, there are various features in the recessed areas before the tomb entrances. They include stone settings, standing stones, and a general spread of 'exotic' stones – quartz, granite, and banded mudstone.

fig. 24

Seven settings exist on the eastern side. Basically, each consists of an area delimited by stones averaging 37 cm long and set end-to-end on edge. Settings 1, 2, and 7 were roughly circular, whereas Nos. 3–6 were U-shaped. All were on the old ground surface, arranged symmetrically around the entrance. The edging stones used in Nos. 1–4 and 7 were smooth, but in Nos. 5 and 6 they were rectangular quarried shales.

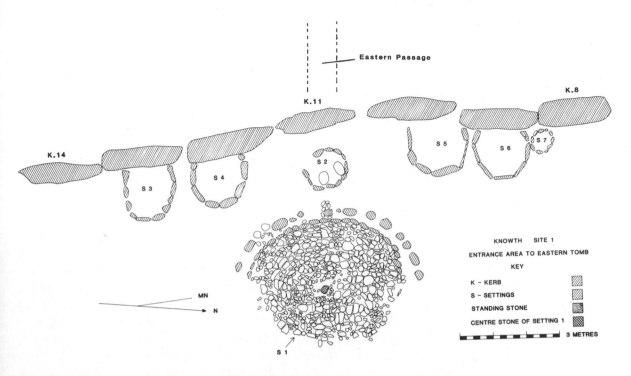

24 *Entrance area to the eastern tomb, Knowth Site 1.*

Setting 1, the principal example, lay directly opposite the tomb, and was dished or saucer-shaped. Its centre was about 4.5 m from the outer face of the kerbstone before the entrance, and 22 cm below the old ground surface. The main part was a circular area 4.2 m in diameter, paved with stones that were mostly small and flat, derived from broken or quarried stones, and averaging 15 by 10 cm. Some rolled stones and quartz were included. In places, particularly in the western side, there were two layers of paving. The paving stone in the centre was largest, being square, made of grey limestone, and most firmly secured. Overlying the paving, but not continuously, was a spread of small quartz chips.

plate 15

Part of this setting was surrounded by an edging of twenty-three smooth stones, all glacial erratics, and by an outer row of spaced stones, the latter generally having flattish bases and consisting of clay ironstone nodules. On average, the erratics measured 35 by 15 cm, and the spaced stones 40 by 20 cm, with a separation of 25 cm between the two rows. Both the erratics and the spaced stones were set end-to-end with their long axes on the circumference of the respective row. These rows were absent on the eastern side of the setting, but may have been roughly circular like the paved area. The present ends of the edging coincide with a cobbled area of Early Christian date, and the edging may have been removed when the cobbling was laid down.

Setting 2, circular with an average diameter of 1.25 m, was edged by ten smooth erratics, and its interior was flat with a rough paving of rolled stones. Settings 3–6 are U-shaped, the open side abutting onto the kerb, and average 1.40 m in length, with edgings of elongated stones set end-to-end. No. 7 is a small circular setting, 70 cm in diameter, whose central area has a rough but level cobbling of fist-sized angular stones.

Immediately to the west of Setting 1 was a fallen limestone pillar, 1.60 m long by 23 cm wide and 20 cm thick. It apparently stood upright in an irregular but roughly square pit beneath its western end. Lying directly on the old ground surface, or over the various features around the entrance, was a spread of unusual stones – an irregular mixture of quartz, water-rolled granite, local water-rolled erratics, local quarried stone, banded ocean-rolled stones, and earth. This spread extended between 20 m to the north, and 18 m to the south, of the entrance stone. It was lunate in shape, with a maximum of 12 m opposite the entrance and narrowing to a couple of metres at each end. Reaching a maximum depth of about 40 cm in the entrance area where it abutted onto the kerbstone, it thinned to the edges. Predominant were quarried and rolled limestone erratics in its upper 20 cm, and the more unusual types of quartz granite and banded stones in its basal portion. There was a predominance and, in some places, an exclusiveness of the more unusual stones towards the base, and in some areas these formed discontinuous patches on the old ground surface. Otherwise, the spread had no discernible pattern. The standing stone had fallen after some of this material accumulated, but before the entire depth had built up.

The spread may have originated as primary slip from the mound. If so, the side of the mound near the entrance was embellished with unusual stones, predominantly of quartz. These would have been first to slip, causing the preponderance of exotic stones on and above the old ground surface. Later, the edge of the mound was eroded, bringing down the common mound stones, including quarried ones, which would explain why such stones are found more frequently in the higher levels. However, excavation has not produced enough evidence wholly to confirm this theory, and we cannot rule out the likelihood that this spread, or at least its lower part, was a deliberately laid feature (Chapter 8).

fig. 25 The features on the western side are largely similar to those on the eastern side. There are six settings, all on the old ground surface, delimited by smooth stones which, in some cases, leaned outwards. Setting 1, opposite the entrance, is more oval than circular, measuring 2.25 by 1.80 m, with a gap now on its east and west sides, and a fill of quartz stones in its centre. Nos. 5 and 6, also in front of the entrance, are circular but have incomplete edges, probably due to subsequent (Early Christian?) disturbance, and they too have a spread of quartz in the centre. Settings 2, 3 and 4 are U-shaped and abut onto kerbstones 73, 75, and 76, while the centres of Nos. 2 and 4 were hollowed and held dark earth.

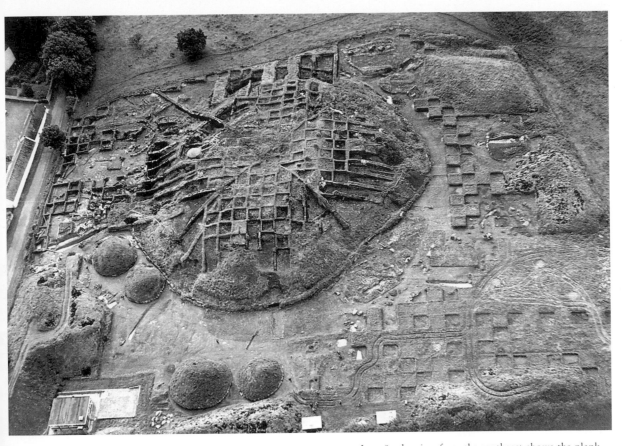

Knowth from the air

1 Excavations in progress in 1973, seen from the northwest.

2 In 1985 the view from the southeast shows the plank walkway used to remove spoil from the excavation of the eastern passage. On the opposite side of the mound, note the re-erected standing stone at the entrance to the western tomb.

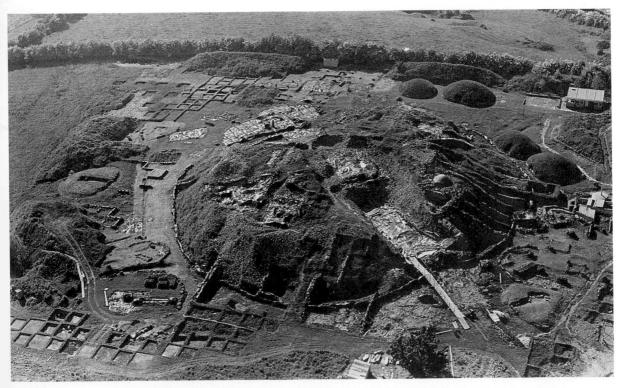

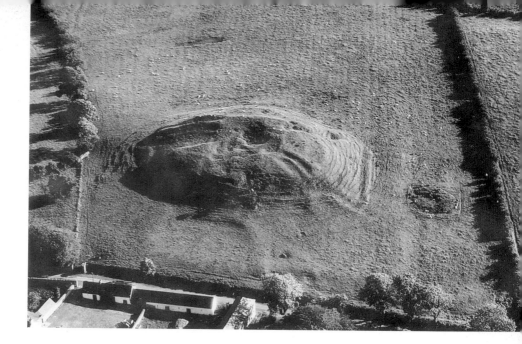

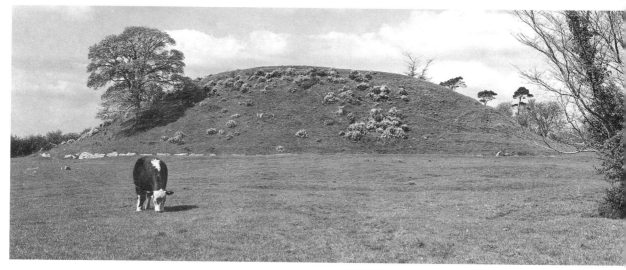

Knowth, Dowth and Newgrange

3 Knowth from the northeast in 1963, a year after excavations had begun.

4 The Dowth mound from the south.

5 Newgrange from the northeast, showing excavations in progress at the large mound and at Sites K and L in the background.

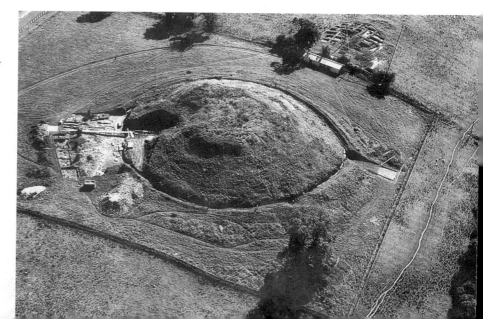

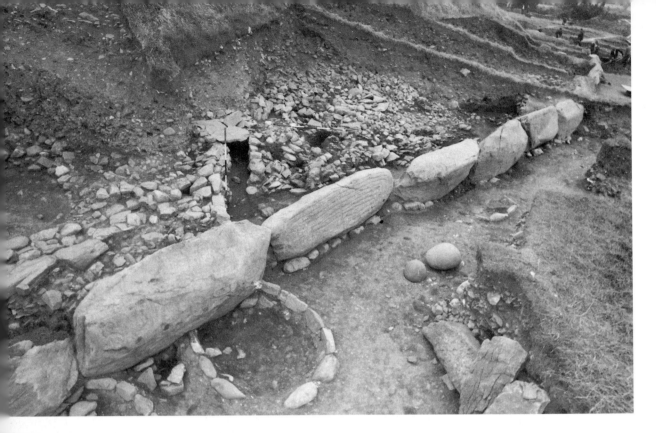

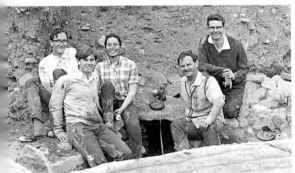

Knowth: the entrance to the western tomb

6 The entrance area at an early stage of excavation. Note the line of kerbstones, especially the entrance stone (centre). The part of the passage visible is an Early Christian re-modelling (*c.* 9th–10th centuries AD). The spread of stones to the left is an Early Christian house and those to the right cover a souterrain, also Early Christian.

7 Discovery of the western tomb, 11 July 1967. The author is second from right.

8 The entrance stone (kerb 74), with its prominent central groove marking the axis of the western tomb.

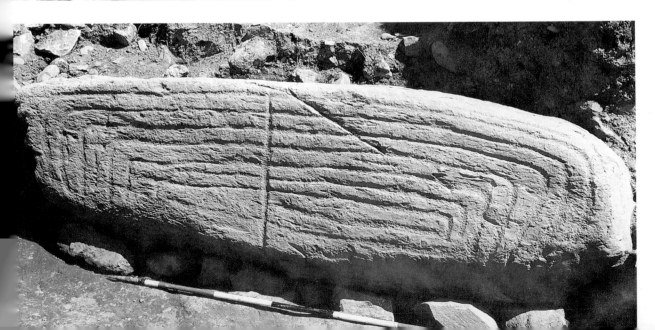

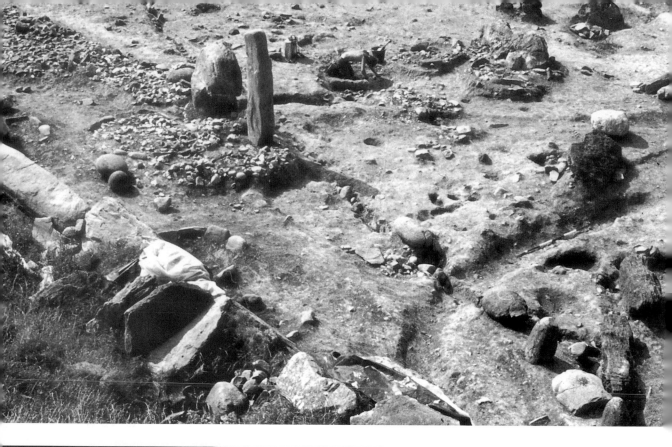

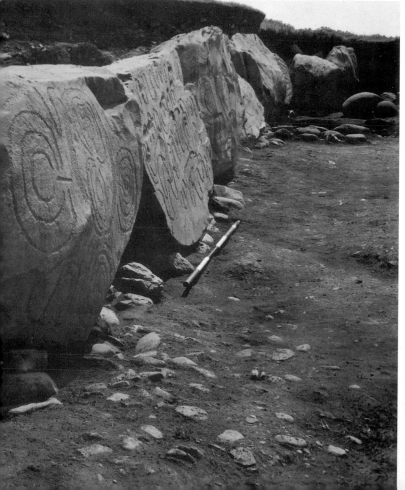

9 A late stage of excavation of the entrance area to the western tomb, after re-erection of the standing stone. The kerbstones run diagonally across the bottom left of the photograph.

10 Kerbstones on the northern side of the western tomb entrance area. Kerb 79 is in the foreground, with 78 and 77 behind. In the background are some of the features at the entrance to the western tomb.

Inside the western passage and tomb

11 (*opposite, above*) Orthostats 47–50 at the bend in the passage. Decorated in the rectilinear style, they seem to 'guard' the chamber beyond. Note the sillstone at the very bottom of the photograph.

12 (*opposite, left*) View back down the passage, towards the entrance, from two-thirds of the way in. The displaced basin stone is visible in the foreground.

13 (*opposite, right*) The chamber of the western tomb, with the sillstone in the foreground. The backstone orthostat is decorated in the rectilinear style; the sillstone (not yet fully exposed) seems to have similar ornament.

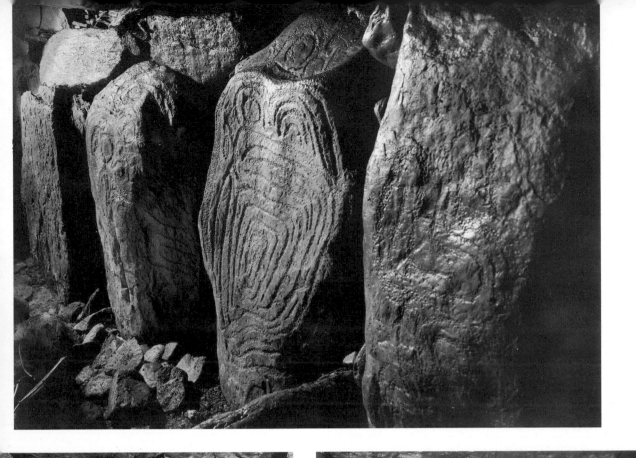

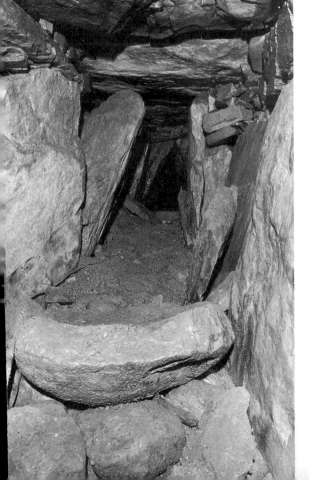

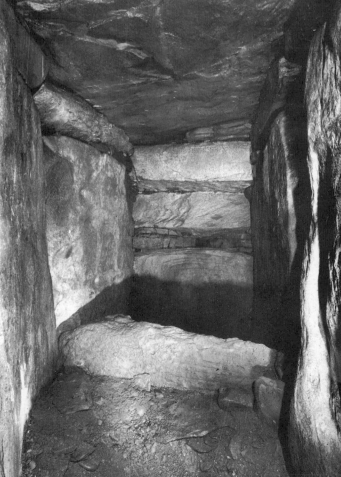

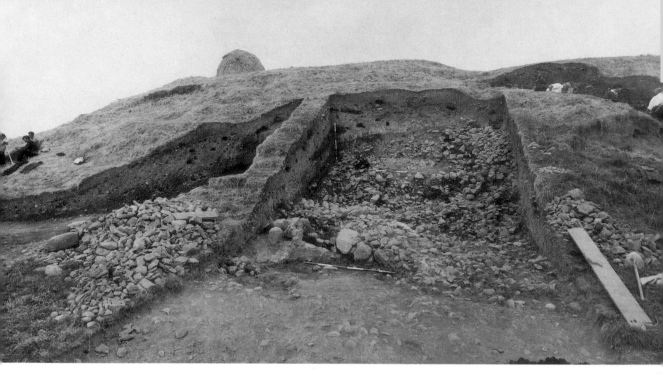

The eastern passage and entrance: exterior

14 Excavations in progress on the eastern side in 1968.

15 Setting 1, one of the primary features at the entrance to the eastern tomb. At the top is a prostrate standing stone in front of which a smaller stone setting (no. 2) is visible.

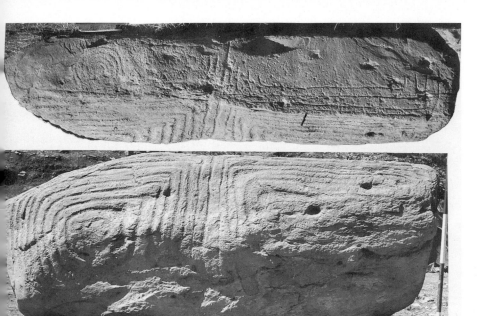

16 Entrance stone to the eastern tomb, kerb 11. Both the outer face (below) and upper face (top) are decorated in the rectilinear style.

17 Excavations of the eastern tomb, seen from the chamber (western) end. The clay covering of the passage has been sectioned to reveal a layer of smaller stones over the capstones. The capstones over the outer 17 m of the passage are completely exposed.

18 View of the outer two-thirds of the passage from the chamber (western) end. By now the capstones covering the passage have been exposed. The drystone walling at the top left of the photograph is a souterrain of Early Christian date (9th–10th centuries). See colour plate VII for a later stage of excavation.

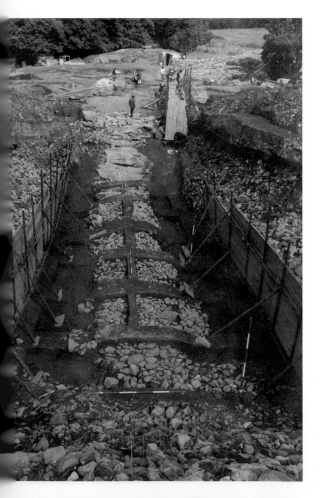

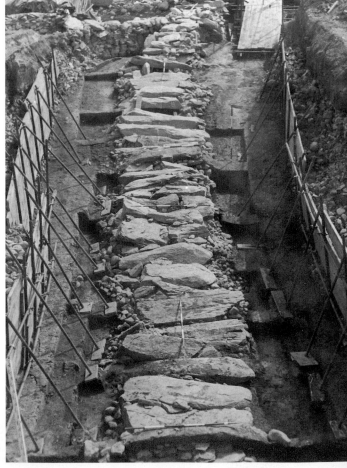

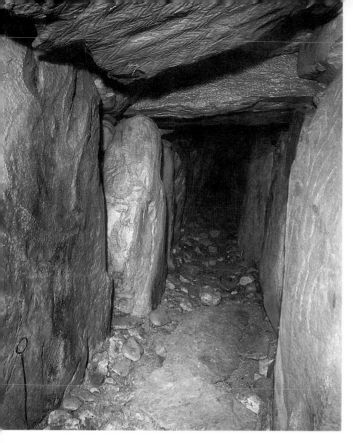

Inside the eastern passage and chamber

19 (*left*) The passage 27 m from the entrance, seen from the chamber side. Capstone 42 is decorated, as are orthostats 68 and 69 (left), and orthostat 26 (right). The scatter of stones over the floor infiltrated as a result of settlement of the structure in ancient times.

20 (*below left*) The left (southern) recess in the eastern tomb.

21 (*below right*) The end (western) recess with part of the corbelled roof rising above it. Orthostat 50 (plate 23), to the right of the recess, is decorated.

22 (*opposite, above*) The interior of the basin in the right (northern) recess, as found on the day of discovery of the tomb, 1 August 1968.

23 (*opposite, below left*) A closer view of the ornament on orthostat 50 in the end recess.

24 (*opposite, below right*) The right (northern) recess in the eastern tomb. Two jambstones flank the entrance; between and beyond them can be seen the decorated basin stone (plate 22). See also colour plate VI.

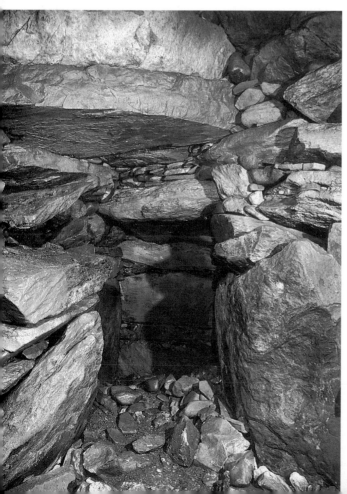

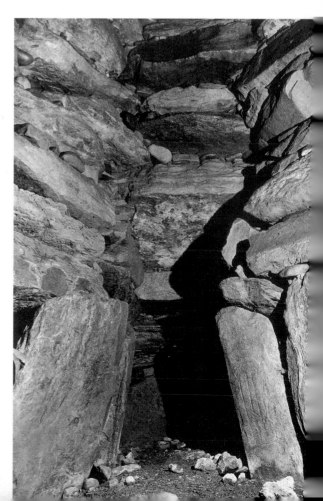

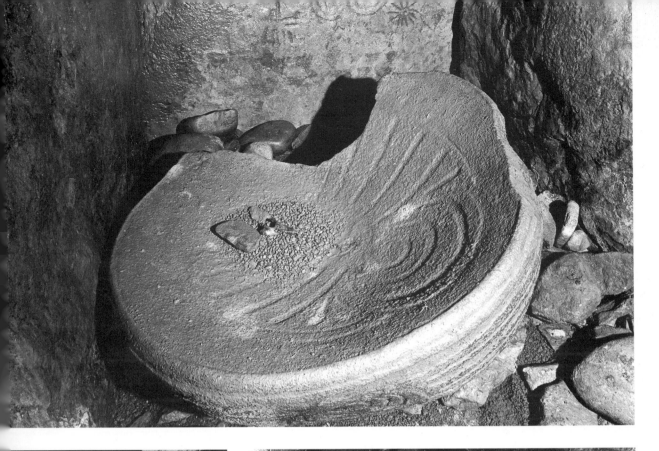

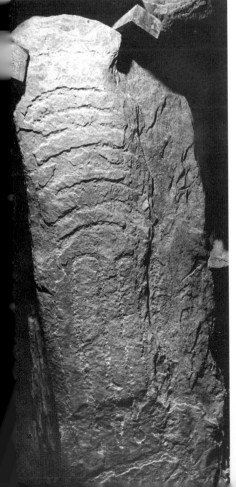

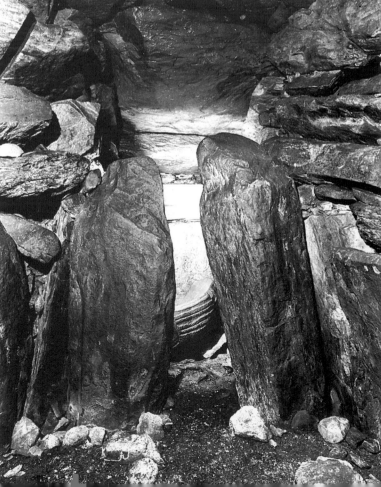

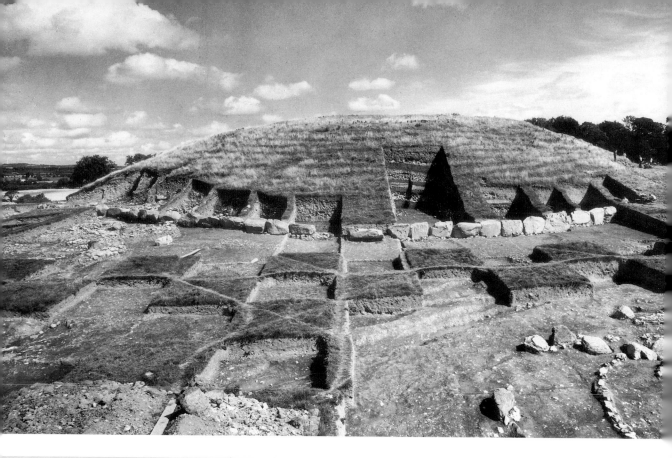

The construction of the mound

25 The main mound from the southwest in 1967, with (from right to left) kerbstones 50–75 uncovered. In the right foreground, part of Site 4 with its stone settings on the old ground surface is visible.

26 Stratification of the mound on the northwestern side. Kerb 93 is in the left foreground. On the inside of the kerb, part of the Late Iron Age ditch which surrounds the base of the mound is visible. The flat area is the old ground surface on which the mound was built. Above thi can be seen the basal layer of redeposited sods, followed by alternating layers of stones, boulder clay and shale.

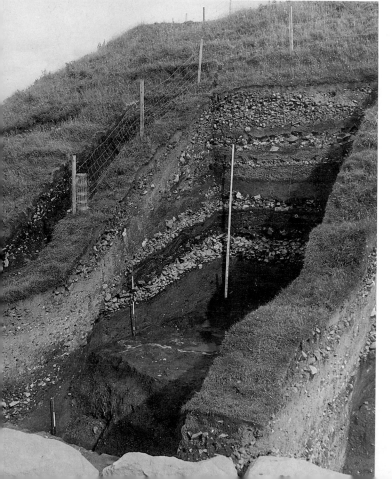

The smaller tombs at Knowth

27 (*opposite, above*) The kerb of the main mound, Site 1 (on the northern side), curves inwards so as to limit damage to a smaller but earlier passage-tomb, Site 13.

28 (*opposite, below left*) Site 2 from the south. The damaged cruciform chamber is in the foreground. Note the stone basin in the western recess.

29 (*opposite, centre right*) The stone basin from the western (right) recess, Site 2.

30 (*opposite, bottom right*) The 'baetyl', or fashioned stone, as found near the entrance to Site 12.

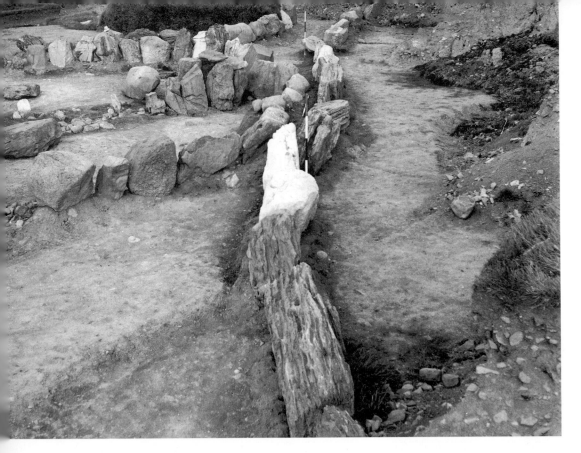

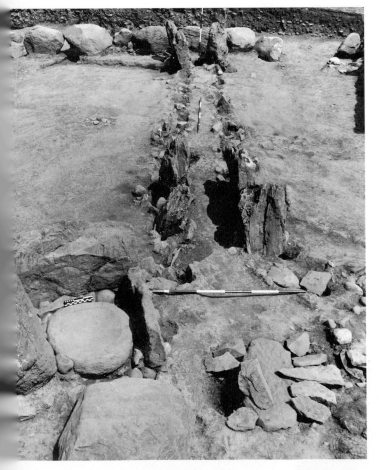

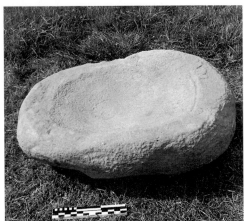

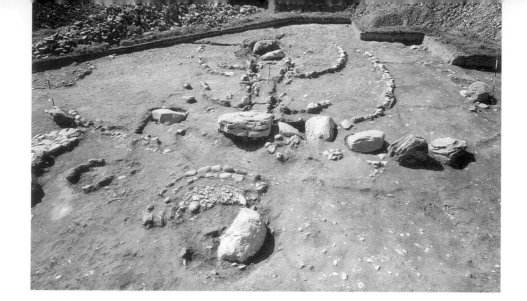

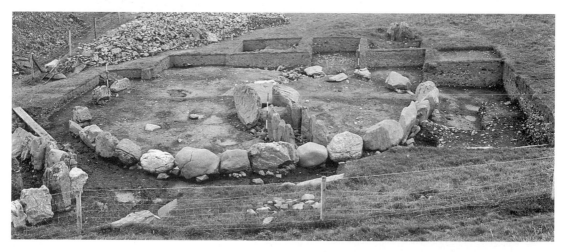

31 Site 4 from the northeast. Beneath the mound were arcs of stones and in front of the entrance a stone setting, damaged by the digging of a pit into which one of the kerbstones had been rolled. The tomb is undifferentiated in plan.

32 Site 14, general view from the southwest after excavation.

33 Site 3 from the southwest after excavation. One orthostat (No. 1) survived intact (top of picture). Stumps of two others (Nos. 3 and 6) were also present. Sockets of the remaining ten orthostats are clearly visible.

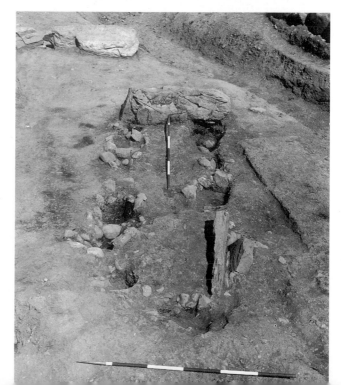

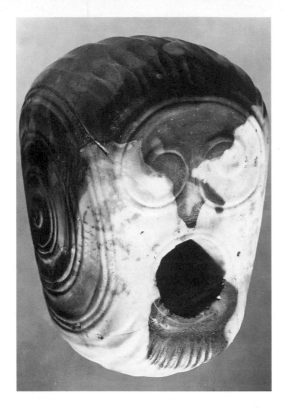

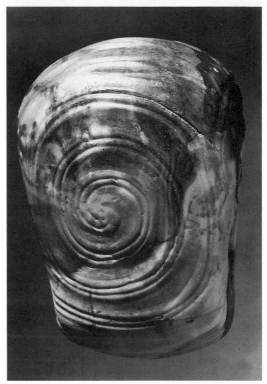

The ceremonial macehead

34–37 Four sides of the unique carved flint macehead, 79 mm long, found in the right-hand recess of the eastern tomb chamber. It would originally have been mounted on a wooden handle through the large hole. This is undoubtedly one of the finest works of art created by the passage-tomb builders of western Europe.

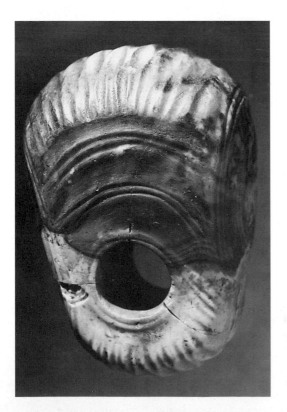

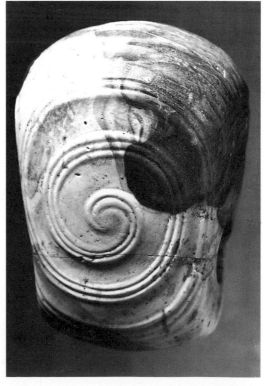

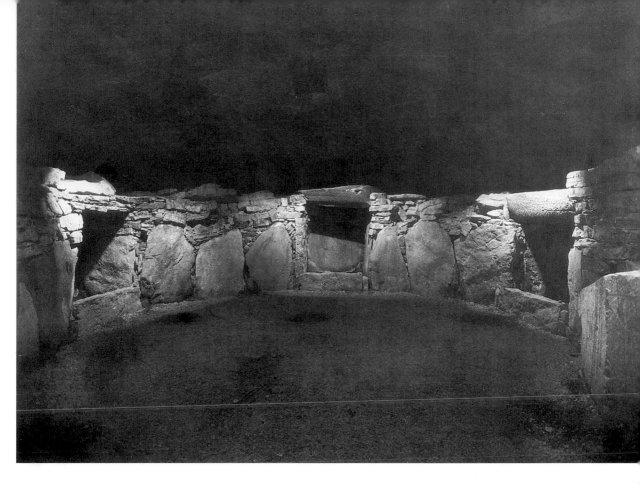

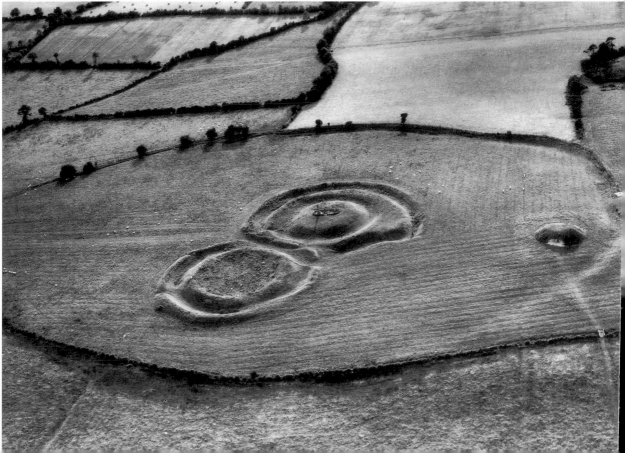

Other Irish passage-tombs

38 (*opposite, above*) Fourknocks 1, Co Meath:
the chamber of the cruciform tomb with its three
recesses.

39 (*opposite, below*) Tara, Co. Meath. The
passage-tomb, Mound of the Hostages, lies to
the right, within the boundaries of a much later
Iron Age hill-fort which also incorporated two
smaller Celtic ring-forts (centre), Forradh and
Teach Cormaic.

40 Sliabh na Caillighe (Loughcrew), Co. Meath.
Carnbane West from the air. The large cairn in
the foreground is Site L.

41 Sliabh na Caillighe (Loughcrew), Co. Meath.
Carnbane East from the air. The large cairn is
Site T.

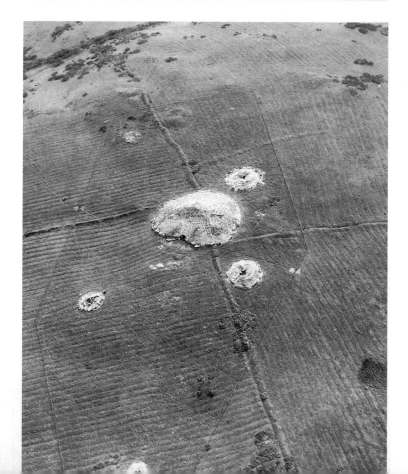

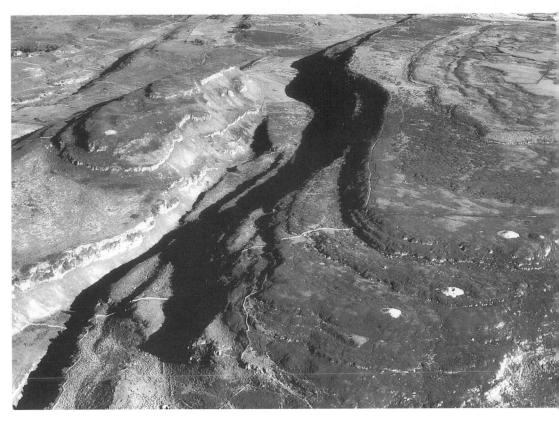

42 Part of the Carrowkeel passage-tomb cemetery, Co. Sligo. On the right-hand side Sites G, H, K are visible as white cairns. To the left of the gorge, Site O lies perched on a hill-top, with part of a settlement area (Mullaghfarna) visible beneath it to the left.

43 Knocknarea, Co. Sligo. The large cairn is Miosgán Meadhbha; up to five smaller passage-tombs are close by. The Atlantic Ocean can be seen in the background.

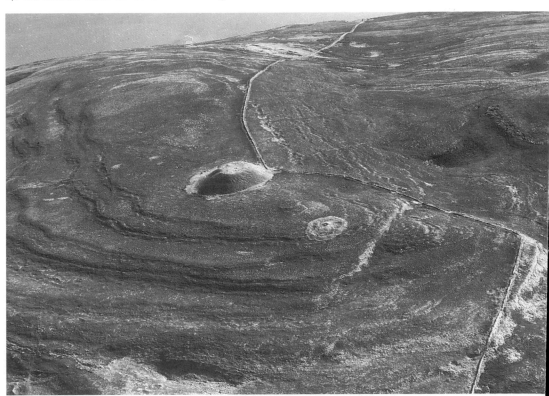

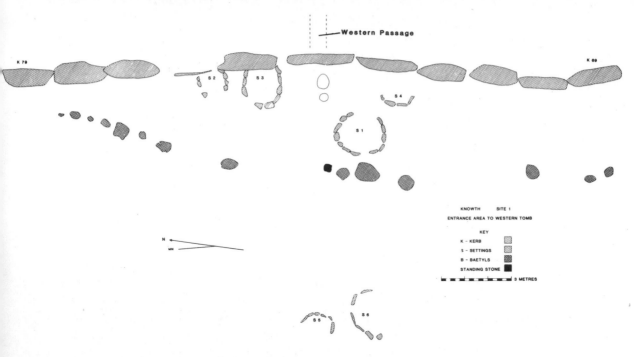

25 *Entrance area to the western tomb, Knowth Site 1.*

A standing stone was directly opposite this entrance, towards which it had plate 9
fallen or been laid down during ancient times. Its western end concealed the
polygonal socket. The stone, of coarse yellow quartso-sandstone, has a
rectangular cross-section and is 2.56 m high, 37 cm wide, and 35 cm thick. Its
eastern face and parts of the other faces were artificially smoothed. The stone
stood about midway along a row of stones which extends across the entrance
area, almost touching the kerb at the northern end and running southwards
away from it. Of the row's fifteen stones (A–O), most are clay ironstone
nodules. Some are set upright on their long axes, while others are flat and are
laid in the same line as the row itself.

A spread of stones, resembling that in front of the eastern tomb but smaller
in area, occurred in the recessed entrance area of the western tomb. Quartz,
granite, and banded stones predominated at its base, whereas the more plate 9
common cairn stones formed the bulk of the upper levels. The spread extended
between about 6 m to the north, and 10 m to the south, of the entrance stone
(74). Its farthest extent outwards from the kerb was some 7 m from the
entrance stone. It does not reach as far as Settings 5 and 6, nor was it present
beneath the mound of Site 8. It lay directly on the old ground surface or over
the settings, and had accumulated after the standing stone fell. As with the
eastern side, no definite explanation for this spread has yet emerged. However,
its absence beneath the prostrate 'standing' stone may be more indicative of
slippage from the mound's edge than of a deliberately laid entrance feature.
But then perhaps this stone and its opposite number served as 'standards' that
were lowered after each ceremony and raised for the new ceremony.

3 The smaller tombs at Knowth

Excavation has established that seventeen smaller tombs existed, but hints of the former presence of two or three more sites have also emerged. Coffey mentioned stones outside the main mound (Site 1) to the north,[1] and wondered if these could have been an entrance. This area was partly investigated by Professor Macalister, and from his work it could be shown that the remains were those of a passage-tomb (now numbered Site 14). In addition, before our excavations began, some large stones were visible a short distance to the northwest of Site 1, and on excavation they, too, proved to be the remains of a tomb (Site 12). Yet apart from these features, there was no surface evidence for the complex which we subsequently revealed.

All the tombs have been damaged, in some cases extensively. For instance, no remains of chambers survived in Sites 5 and 11, while in Site 9 all the structural stones had been removed. In these sites, virtually all evidence for the covering mounds had also disappeared. In other cases, such as Sites 14–16, the chambers and the kerb were fairly intact. Signs of alteration go back to the passage-tomb period itself. The building of Site 1 necessitated the removal of parts of Sites 13 and 16. It is also possible that, at the time Site 17 was being constructed, a portion of Site 18 was altered. A Beaker burial was inserted into one tomb (Site 15), and the Beaker people entered Sites 6 and 18 as well.[2]

During the Early Christian period, rather extensive destruction of the tombs took place. A number of the souterrains contain stones, some of them decorated, which were removed – most probably from the small ones, as interference with the large site was minimal. Such stones are flat and would have originally served as orthostats or capstones, not as kerbstones since these are generally rough blocks. Mounds were also lowered at this time, for Early Christian deposits were found overlying the surviving portions.

Among the smaller tombs, five had cruciform-shaped chambers, ten were simple or undifferentiated tombs, and in two examples the tomb was completely destroyed. The smaller tombs are grouped around the hilltop close to the large site: some adjoin it, while others are within a few metres of it. Only one site, No. 7, is some distance away, but, to judge from the stones which once stood at Knowth House, another tomb may have existed there (see below). In only seven sites (2, 9, 12, 15–18) was there evidence for a natural sod layer under the mounds. It is not known whether the sod had been stripped by the builders and incorporated in the mound, or whether the sod was removed

as a result of other activity such as cultivation. In other words, the tombs may have been built over recently cultivated land, although no evidence for plough marks came to light.

Cruciform tombs

SITE 2

The mound of this site was about 20 m in diameter, and its surviving part was 80 cm high at the maximum. It was composed of a mixture of sods and boulder clay, but there were also thin layers of shale. The kerb is incomplete, and would originally have been about 22 m in external diameter. Forty-two stones survive, and the northern side has an almost intact arc. Apart from a couple which were inserted into shallow pits, the kerbstones were sitting on the old ground surface, and some had packing stones at the base. Various rocks were used, most commonly dolerites and agglomerates.

fig. 26

The tomb was entered from the northeast and aligned towards the southwest. Most of the orthostats and all the capstones had been removed. The passage, 9.50 m long, widens from 50 cm at the entrance to 75 cm at the inner end. It was built with fourteen orthostats on the eastern side and sixteen on the western side, but only ten survive and six of these have been damaged. The stumps of four further orthostats remain. The sockets average 25 cm in depth, and the orthostats were secured by packing stones, as were those in the chamber. Orthostats 12–14 were set in a trench, not in individual sockets. To judge from the surviving orthostats, the passage averaged 1 m in height.

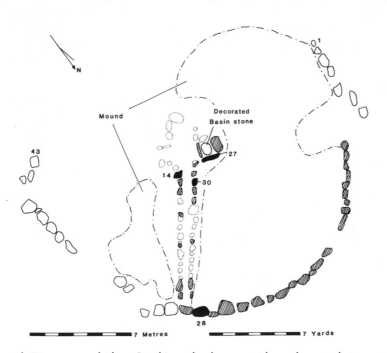

26 *Knowth Site 2, ground plan. On this and subsequent plans, decorated stones are shown in solid black.*

plate 28

The centre of the chamber tends to be circular, about 2 m in diameter, but the digging of a pit destroyed part of the floor and most of the left-hand recess, including the socket of its backstone and the inner part of the socket on each side. The end recess was apparently formed from two stones on each side and a backstone, but the digging of another pit ruined most of it. A single stone on each side and a backstone were used in building the right-hand recess, but one of the side stones has fallen outwards and the roof is missing, while orthostats 26–28 were in a trench. Internally this recess measures 95 by 105 cm. Across its front was a sillstone, and a similar stone – found lying flat – seems to have served the same function in the left recess.

Overall, it appears that the chamber measured about 4 m wide and 4 m long internally. There was no evidence for a roof, but it was probably corbelled like other cruciform tombs. After the erection of at least the orthostats, clay was filled in around the tomb, and topped by a thin layer of stones. This feature has the character of a core in the mound, and may originally have acted as a support for the passage and chamber.

plate 29

Burial was attested by scatters of cremated material in the chamber area, including the centre as well as the recesses. Some burials, and probably all, were disturbed due to the damage. The remains of both children and adults occurred, but numbers cannot be determined. (All anatomical identifications were made by Dr Blanche Weekes, Trinity College, Dublin.) There is also a fine sandstone basin, measuring 1 m by 80 cm externally, with a hollow 25 cm deep, in the right-hand recess. Around its inner edge is a pocked line. Isolated finds, probably once grave goods, consisted of a sherd of 'Carrowkeel' ware and two chalk balls. In addition, a hoard of sixteen flint flakes was found under a corner of kerbstone 26. Most of these were rough-outs for hollow scrapers.[3]

Site 6

fig. 27

Here the mound, about 14 m in diameter, had been almost completely destroyed. The small surviving portion, 40 cm in maximum height, consisted of boulder clay. Only three kerbstones are definitely in their original positions, as may be another, while five rather large stones in the area may also have served as kerbstones. None of the orthostats of the tomb survive. About 8 m long, it was entered from the southeast and aligned towards the northwest. The outer portion of the passage had been badly damaged, leaving only traces. But the inner half was better preserved, with four well-defined sockets on each side. The socket on either side at the junction with the chamber is the largest, the others varying in shape and size. The passage had a constant width of about 50 cm.

The chamber, 2.80 m long and 4.40 m wide internally, had thirteen sockets, all with packing stones. The left-hand and end recesses are of similar size and construction, both formed from an orthostat on each side and another at the end. The digging of a pit damaged the inner part of the left recess. Largest is the right-hand recess, almost 2 m long and 1.20 m wide, with two sockets on each

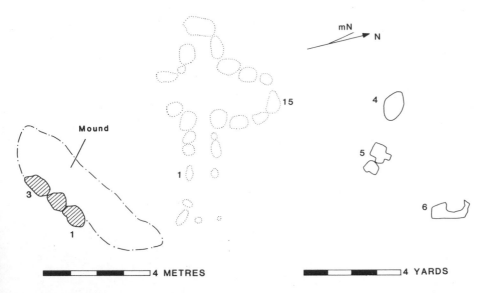

27 *Knowth Site 6, ground plan.*

side and a back socket. There were two burial deposits of cremated bone, the most extensive being in the right-hand recess and representing several individuals, mainly adults, as well as at least one child about three years old. The grave goods consisted of part of a pottery bead with hour-glass perforation, a bone pendant, a piece of bone from an object of uncertain form, and a triangular piece of flint slightly worked along one edge. The deposit in the left-hand recess was small, and no pieces could be identified.

SITE 9

The mound originally covered an area at least 13 m in diameter, but this has been reduced to 12 by 11 m with an average height of 15 cm. It was composed of boulder clay, with a thin layer of shale at one point on the southern side. Sitting on this layer, not far above the old ground surface, was a line of boulders, averaging 37 cm long by 32 cm wide. A large stone lying close to the site may be a displaced kerbstone. The tomb is entered from the east and aligned towards the west. The digging of a ditch – possibly within rather recent centuries – destroyed the outer part of the passage. All orthostats had been removed, but nine sockets remain, of which five had packing stones. From an internal width of 1 m at its outer end, the passage narrowed slightly to the junction with the chamber, where a socket for a sillstone spans its full width.

fig. 28

Internally the chamber measures about 3.80 m wide and 4 m long. The only vestige of orthostats is a stump in one of the sockets. Both the left and right recesses were formed from two orthostats on each side and a backstone. The left recess, 1.10 m long and 90 cm wide internally, was slightly smaller than the right. Three sockets of the right recess were damaged by the insertion of an inhumation burial, perhaps during Iron Age times. The end recess is the

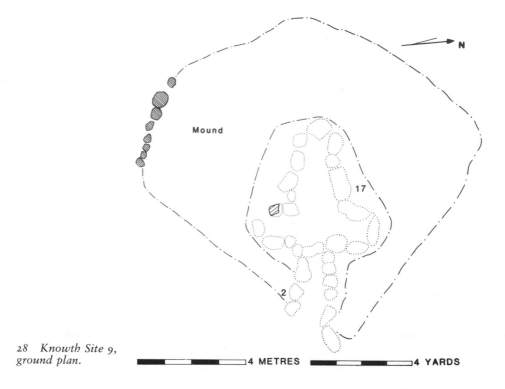

28 *Knowth Site 9, ground plan.*

4 METRES 4 YARDS

largest, 2.80 m long and narrowing internally from 1.40 m at the chamber junction to 78 cm at the back. In ground plan it had a backstone, four orthostats on the left side, and three on the right.

In the centre of the chamber were a number of small flat stones, possibly from the roof, which was presumably corbelled. Scattered around the tomb lay flakes of Lower Palaeozoic rock, very likely the remains of orthostats. The burial deposits were two cremations in the end recess. One, in the inner end, held at least the remains of a child, and a smaller number of bones from an adult. The other, partly disturbed by the inhumation burial, was in the outer portion of the recess, and contained at least one young adult and a child.

SITE 17

This mound covered about 14.5 m in diameter, and survives over most of that area to a maximum height of 70 cm. It consisted of boulder clay, but some sods may have been mixed through it. An area around the tomb, while also of boulder clay, was of different composition, being less gritty and thus distinguished from the main body of the mound. Apparently the construction of the mound and tomb went on simultaneously. An 'open' area was left around the tomb during this time, and was filled in when building work finished. A fairly large section of the kerb survived on the southwestern side, forming an arc of twenty-one stones, all on the old ground surface. Two other loose stones might be displaced kerbstones. A rough piece of flint with slight

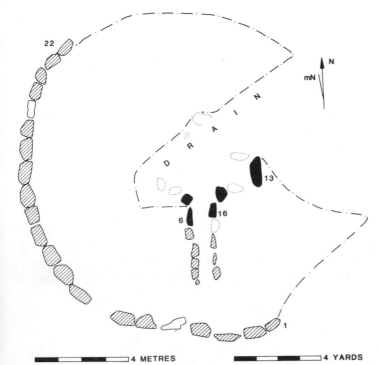

4 METRES

4 YARDS

29 *Knowth Site 17,*
ground plan.

secondary working along the edges, and some potsherds, were found in the
mound. One sherd may have come from a vessel of the 'Carrowkeel' type, but *fig. 29*
both faces are worn away. The other three sherds are of uncertain type.

The tomb was entered from the south and aligned towards the north. There
is a gap of about 1.60 m between the back of the kerbstone before the entrance
and the beginning of the passage. The latter had seven orthostats on the
western side and six on the eastern, but one was missing and one had
collapsed. The remainder were leaning and some had been damaged. From the
entrance, the orthostats increased in height. All had packing stones at the base.
Outside the passage on the western side, there was a flagstone in a disturbed
position, which may have been a removed capstone. The megalithic passage
was 4 m long, and widened from 70 cm at the entrance to 1 m at the junction
with the chamber; if it extended to the kerb it would have been about 5.60 m
long.

The chamber, measuring 3.60 m wide and 3.20 m long internally, was
damaged. Only one orthostat survived, but there were remains of six sockets.
The left-hand and end recesses were represented only by two sockets each. The
right-hand recess had an outward-leaning backstone, flanked by two sockets
which yielded flakes of Lower Palaeozoic rock. Cremation burials were
attested in various places. A probable portion of a primary deposit, perhaps
the remains of a child, was spread along the inner edge of the back socket of the
end recess. There was also a scatter of bone, representing an adult and a child,

in disturbed material at the inner edge of the passage. This could have been derived from a chamber deposit. At a high level in the fill of the passage, shortly in from the entrance, was a further spread. It, too, was in a secondary position, and contained at least the remains of a child. A couple of pieces of flint were found on the floor of the passage and in the mound a couple of sherds of pottery, one Carrowkeel ware, and scraps of flint. There was also a sherd of pottery, two flint scrapers and two scraps in disturbed material.

SITE 18

This mound was removed completely in its northeastern sector, and elsewhere it had been reduced to a maximum height of 30 cm. It consisted of boulder clay and, within it on the western side, near the edge but only 8 cm above the old ground surface, was a short setting of fifteen stones, averaging 34 by 28 cm in size. Evidence for the kerb is provided by five stones, while two depressions
fig. 30 may indicate the position of two further examples. Four of the kerbstones are contiguous and form a straight line across the entrance. The kerb could have been about 15 m in external diameter.

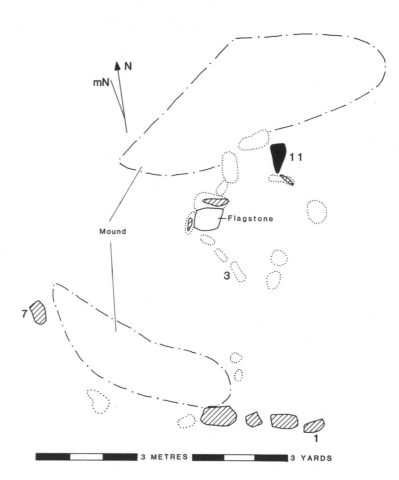

30 *Knowth Site 18,*
ground plan.

3 METRES 3 YARDS

The tomb was badly mutilated and no complete orthostat survived. It is entered from the south and aligned northwards, with an overall length of 7.80 m, the chamber being 3.00 m long and 3.02 m wide internally. Fifteen sockets came to light, four having stumps of orthostats. Packing stones occurred in the sockets, and one stone (No. 7) also had a packing stone under its western edge. The left-hand recess, 90 cm square, had a flag of Lower Palaeozoic rock, 80 by 70 cm, which would have been intended for burials, although none survived. The effects of the disturbance penetrated down to, and below, that level all around the area. There did remain, however, a later deposit of charcoal, pottery sherds, flints, a fragment of a human skull, and animal bones. These apparently formed a homogeneous deposit, with the pottery indicating a Beaker date.[4]

A small amount of cremated bone, representing at least one adult, occurred in part of the right-hand recess, yet does not seem to be in an original position. The flat stone in the left recess sealed a cremation deposit. This lay on the old ground surface and represented at least one individual, an adult. It extended over most of the recess and into the fill of sockets 6 and 7; the latter extension could have been the result of disturbance that took place when the orthostats were removed.

If the mounds of Sites 17 & 18 were circular, they would have impinged on each other, unless part of one mound was removed or greatly reduced in size so that the other mound could be round. Destruction has made it difficult to resolve this uncertainty. Study of the relevant area has shown that the stratification consists of a basal layer, brownish in colour and composed like boulder clay. In fact, this is part of the mound of Site 18. The layer is overlaid by another, which is greyish in colour and more sod-like in composition, seemingly part of the mound of Site 17. Thus, it appears that Site 18 is earlier than Site 17, and the mound of Site 18 could have been lowered along the western side to facilitate the construction of a round mound at Site 17.

Regarding further sequences of construction, one of the kerbstones on the southwestern side of Site 17 is sitting on a spread of stones. These might have slipped from Site 1. However, due to the absence of shale and boulder clay – the other materials that are found in the outer structural layers of the mound – it is impossible to prove that these stones are slip. If they were, then Site 1, too, is earlier than Site 17.

Undifferentiated tombs

SITE 4

Originally this mound covered a circular area about 16 m in diameter. Most of it had been removed, and the surviving portion was not over 40 cm in maximum height. The mound was stratified with a yellowish basal layer of boulder clay overlain by shale. Extending outwards, claw-like, from the tomb was a series of stone arcs on the old ground surface. In general the stones, *fig. 31*

73

averaging 30 cm long, were placed one after the other, but at some points there was a doubling-up. The arcs varied in length, some being quite short, one having only five stones, although damage has prevented determination of the full length of some of the arcs. Only three kerbstones were *in situ*, but about a dozen other stones, which must have belonged to the kerb, were lying around or partly buried in pits, while packing stones indicate the former positions of some kerbstones. There is a hint that the kerb flattened before the entrance.

plate 31

The tomb was entered from the northeast and aligned towards the southwest. A small portion of its inner end had been destroyed by the digging of a large pit. Apart from a stump, all the orthostats were removed, but twenty sockets clearly indicated the tomb plan. Nearly all of these had packing stones around the edges. There were also sockets for four sillstones, one of which lay across the entrance only a short distance in from the kerb. The stone held by this socket, if substantial, would have created a double kerb effect. The other three sockets were at roughly equal distances up the passage. Moreover, lying in the pit in the chamber area was a large stone, almost 1.50 m high, with its pointed base towards the innermost sill socket. The latter stone, decorated on both faces and across the top, thus appears to have been a sill or septal, rather than a backstone. Its positioning would have created a well-formed chamber. A spread of cremated bone occurred in the centre of the passage, not far from

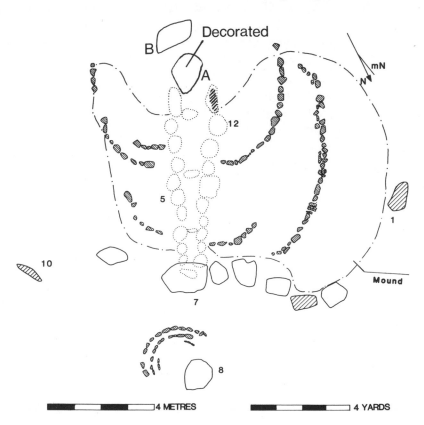

31 Knowth Site 4, ground plan.

the entrance side of this sill. These remains could not be identified due to their fragmentary state.

Directly in front of the entrance, about 2 m out from the kerb, was a circular setting nearly 3 m in diameter. This consisted of an area of quartz paving, surrounded by two concentric rings of small stones, which averaged 20 cm in length and were placed end-to-end on the old ground surface. The inner ring was some 20 cm from the outer ring. Nearly half of the setting was destroyed by the digging of a pit, into which one of the kerbstones was dumped.

SITE 7

This mound would originally have covered a circular area about 10 m in diameter. The surviving portion, D-shaped and 20 cm in maximum height, *fig. 32* consisted of shale-like material. There are five kerbstones, four being contiguous. Due to damage and the uneven nature of the subsoil, it was not possible to uncover the complete plan of the tomb. Only four definite sockets were discovered, and these had packing stones. Eight other holes existed, but whether all or any were original features could not be established. What survives is sufficient to show that the tomb was entered from the east and aligned approximately on an east–west axis. No evidence for burial survived, and the only find was a double hollow scraper in the mound.

SITE 8

The preserved portions of this mound reached only 50 cm in maximum height. It covered an area of about 12 m and the material used was boulder clay, with *fig. 33* an overlying layer of shale at a point just to the right of the entrance. Up to half of the kerbstones, none of them in sockets, were found *in situ*. The entrance stone is recessed, and the adjoining kerbs curve inwards to articulate with it. When complete, the kerb would have measured 14 m externally.

The digging of a drain had removed part of the passage, and the interior was destroyed by a pit and other holes. A large stone, probably a rolled-in kerbstone, was lying in the pit, and along the northern edge were two upright stones, of which the southernmost might have been a re-erected orthostat. Eleven sockets – or parts of sockets – were discovered, most of them with packing stones. The tomb would have been at least 6 m long, and was aligned westward with the entrance at the east. No evidence for burial, or of finds, came to light.

SITE 10

This tomb had been extensively damaged. A ditch and drain were dug across the site, and the mound was entirely removed. Two kerbstones were in their *fig. 34* original positions on the old ground surface. Continuing the line of these kerbs to the east and west are three holes, but it has not been proved that these held stones. There is a stone lying in the upper part of the fill of the ditch, and another towards Site 11; it is possible that these are removed kerbstones.

The meagre evidence suggests that this was an undifferentiated passage-tomb and was aligned northwest to southeast. Its entrance would have been on

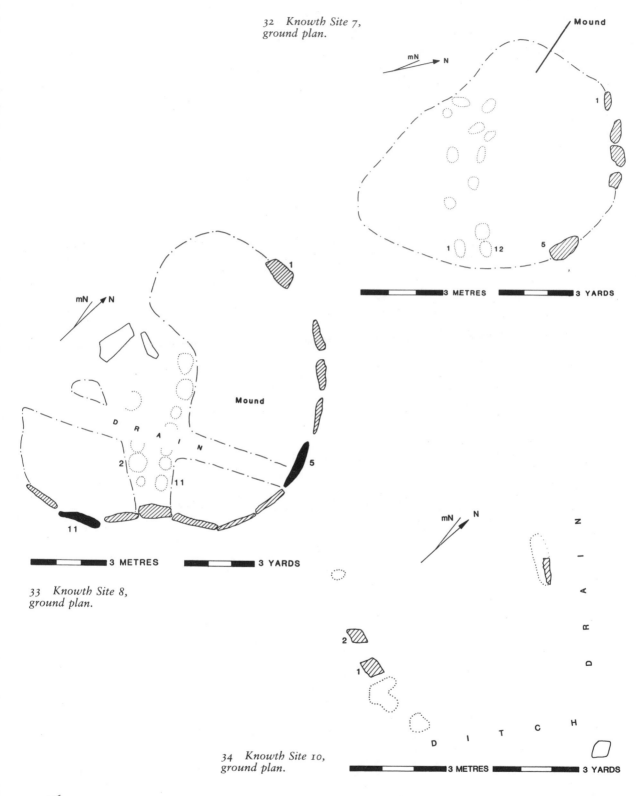

32 *Knowth Site 7,*
ground plan.

Mound

mN N

1

1 12 5

3 METRES 3 YARDS

1

mN N

Mound

D R A I N

2

5

11

11

3 METRES 3 YARDS

33 *Knowth Site 8,*
ground plan.

mN N

N

D
R
A

2

I

1

N

D I T C H

34 *Knowth Site 10,*
ground plan.

3 METRES 3 YARDS

the latter side. The only trace of the tomb itself is provided by a pit, which contained the stump and several chips of an orthostat; nearby there was a shallow hole. The pit is a little over 4 m long, but part of this could be due to disturbance caused when the orthostats were removed. Fragments of cremated bone in the fill were the only remaining sign of the burial deposit.

SITE 12

The first step taken in the covering of this tomb was the erection of a low cairn around it, not over 50 cm high. The cairn tended to be oval in shape. The edge *fig. 35* was irregular on the western side, but on the other sides – apart from a gap on the east, caused by the construction of a fairly modern hearth – there was a definite edging formed by stones larger than those used in the cairn. The earthen mound survived over most of the area within the kerb, but was reduced to 75 cm in maximum height. The material was mainly dark-coloured and shaly in composition but, especially on the western side, the lower 20 cm or so was sticky and tended to be greyish, suggesting that sods were incorporated, although there was no clear evidence of stratification.

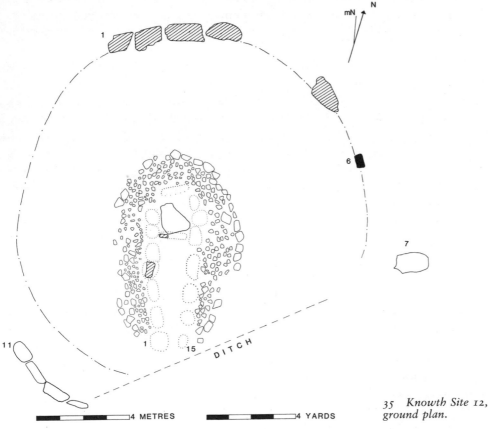

35 *Knowth Site 12, ground plan.*

Six kerbstones were *in situ*, sitting on the old ground surface, with packing stones at the base. There were additional stones which may have been disturbed kerbstones, four on the southern side and three on the eastern, while small stones on the northeastern side may have been packing stones for a removed kerbstone. Externally, the kerb would have been about 15 m across (east–west). If it was circular, a gap would have existed between the end of the passage and the line of the kerb. The digging of a modern ditch might have destroyed part of the passage, but the passage probably did not narrow any further, for otherwise the tomb could not have been entered. Perhaps the kerb was flattened or incurved on that side or, as at Site 17, a gap may have been left between the outer pair of orthostats and the kerb.

The surviving remains are those of a tomb, internally 7 m long, which was entered from the south and aligned northwards. Evidence for fifteen sockets came to light and, apart from the back socket, all had packing stones. Only the backstone, which had fallen inwards, and two orthostats survived, one of the latter being incomplete. About three-quarters of the way in, a sillstone was found in a socket, secured by packing stones, but part was broken off and removed. The chamber – the area within the sill – contained some cremated bone and two unburnt bones. The remains of at least one infant and an adult were present, but it was impossible to estimate the total number buried or their age or sex. The deposit was accompanied by pieces of two bone pins.

SITE 13

The surviving portions of this mound, which was 12 m across and made from redeposited sod, are confined to the southern part of the site, and reach 80 cm in maximum height. An arc of thirty-three kerbstones (including two sockets) was still in place on the southern half of the site. There are four further stones on the northern side, and another to the south of the tomb, all being displaced

fig. 36 kerbstones. The kerbstones were in sockets, and most were also secured by packing stones. The exceptions, seven stones on the southwestern side, were much smaller and, in order to reach the same height, they were placed on a deposit of rubble-like material. In fact this is an ancient reconstruction, because that portion of the kerb was removed during Neolithic times, so as to facilitate the building of the kerb of Site 1. The kerb tended to be flat on the southern side, making the enclosed area somewhat D-shaped. Its external measurement was 12.5 m (east–west) by about 13 m (north–south).

The tomb, 5.60 m in internal length, is entered at the south–southeastern end and aligned towards the north–northwest. A sillstone divides the tomb into passage and chamber. The passage, 3 m long with almost parallel sides, was built from six orthostats on the left side and five on the right. Beyond the sill, the sides widen outwards to form the chamber, 2.50 m long, built from four orthostats on each side and a backstone. About midway along the chamber, extending across part of it from the right-hand side, is a row of four small stones. The function of this setting is unknown. Over the floor of the

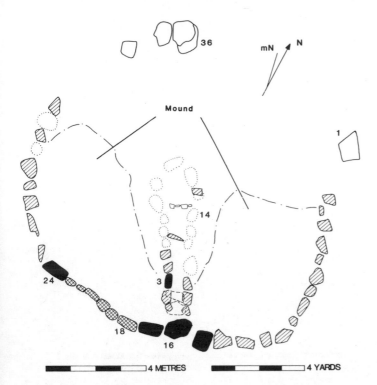

36 *Knowth Site 13,
ground plan.*

chamber was a thin spread of cremated bones, but these were too small and fragmentary for identification.

In the outer part of the passage are five intact orthostats and portions of three more. There is a capstone over each of the surviving pairs of orthostats, while between the outer pair of orthostats and the kerbstone before the entrance is another stone in a nearly vertical positon. The precise purpose of the latter stone cannot be determined. It might have been moved from a place further along the passage at the time of destruction, or it may have been a blocking stone at the entrance.

SITE 14

The chamber of this tomb had already been investigated by Professor Macalister. The mound, of boulder clay, was some 12.50 m in diameter. The basal portion survived over most of the area, but its maximum height was at most 60 cm. The kerb was 13.2 m in external diameter, and about three quarters of it – twenty stones – survive. Except for one, all these were *in situ* and there is a complete sequence in the southern half. The stones are on the old ground surface, and some had packing stones at the base.

The tomb, 5.40 m long internally, is entered from the south–southwest and aligned towards the north–northeast. Its passage is 3.40 m long, and was constructed from eleven orthostats, five – one now missing – on the left and six on the right. The base of No. 1 was sitting on the old ground surface, and No.

plate 32

fig. 37

79

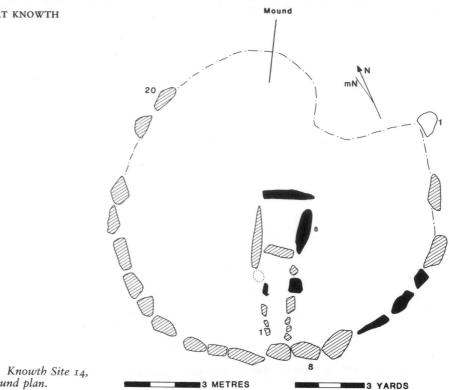

37 *Knowth Site 14,*
ground plan.

10 sat in a very shallow scoop, secured by packing stones at the base. The other orthostats were placed in sockets which also had packing stones. At a short distance inside the entrance, seven small flat stones were lying on the surface of the passage, probably as paving. A sillstone delimited the passage from the chamber.

plate 32

The chamber, 1.67 m long by 1.60 m wide internally, was formed from two massive stones on each side and a backstone. The latter, and the sillstone, lacked sockets, but the side stones were in sockets and had packing stones as well. There was a deposit of cremated bone over the chamber floor. The only trace of a roof was a displaced capstone, outside one of the orthostats on the right-hand side. At the entrance to the passage was a pit, which contained dark earth and charcoal. Another pit lay under the mound outside the chamber to the north, and a fireplace was not far to the east of the inner part of the passage. It has not been established whether these features are contemporary with the tomb or antedate it.

SITE 15

This circular mound was about 20 m in diameter, but survived only to a maximum height of 90 cm. Portions of it, especially on the western side, had been totally removed. It was built in two main stages. Initially a core was constructed around the tomb, made chiefly of sods with some boulder clay mixed through them, and was covered by a thin band of shale. At the entrance area, the core extended to the kerbstones; otherwise it was delimited at the

base by a setting, 40 cm in average width, of small angular stones. As the core is missing from the northern and western sides, its extent cannot be determined, but from the evidence it could have been 16 m wide. These features were covered by the main body of the mound, consisting of boulder clay overlaid along the edge behind the kerbstones by a shale layer, 20 cm in maximum thickness. This layer tapers as it slopes upward, and merges with the inner layer of shale that overlay the core.

fig. 38

At a point about midway along the tomb, a short straight setting of small stones, sitting on the old ground surface, extends out to each side. Nearly half of the kerb survives, with twenty-one stones and five settings of packing stones which indicate the former positions of kerbstones, all on the southern and eastern sides. About a third were in sockets, the remainder sitting on the old ground surface with packing stones at their bases. The kerbstones are largest at the entrance, averaging 1.40 m long, and decrease in size from there. The kerb would have been approximately 23 m in external diameter, and was slightly flattened along the front.

The tomb, 9.20 m in internal length, was entered from the southwest side and oriented towards the northeast. At least twenty-one orthostats were used, of which nineteen survive and sockets for two exist. The first orthostat on the left side was moved around and is now in a transverse position. There may once have been another orthostat on the opposite side. The first two orthostats on the left side, and the first on the right side, were sitting on the old ground surface, the rest being in sockets. In the inner end of the tomb, the sockets tended to merge into each other, and packing stones were liberally used at their

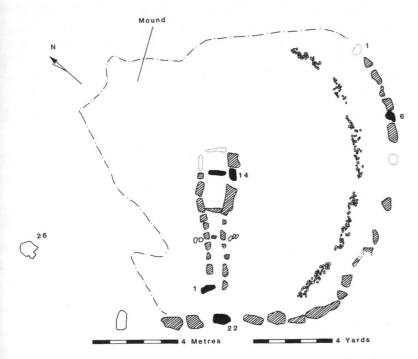

38 *Knowth Site 15, ground plan.*

bases. A number of orthostats were erected with the narrow end downwards, and they increase slightly in height from the entrance inwards. Three sillstones divide the tomb into four segments. The outer two, which have about the same height, sit on the old ground surface, but the inner sill is in a socket and is twice as high as the outer ones. This sill closes off the inner segment, which is rectangular.

Burials were found in the inner and the adjoining segments. However, part of the deposit in the inner segment was removed, probably when the orthostats were taken out. This cremation was placed on the old ground surface, and seems to be a single deposition; at least two individuals are represented, a child and a young adult. Two flints were associated, a scrap and the pointed part of a blade. There were two successive cremations in the adjoining segment. The primary one, containing the remains of at least a child, was covered by four small flat stones. The secondary deposit was larger, but whether it represents a single or successive burial is not certain. At least two adults and one or more children were represented, with two associated bone beads.

Finds also came to light under and in the mound. On the old ground surface were a body sherd of pottery of unusual ware, and a fragment of flint. Six sherds of 'Carrowkeel' ware occurred in the mound, including both body and rim sherds. Also discovered were twenty-six flints, one being a hollow scraper, another part of a round scraper, and a third from a blade. The remainder are scraps.

SITE 16

This, like Site 13, was interfered with at the time of the construction of Site 1. Parts of the mound and (we presume) the kerb on the southern side were removed, and a secondary entrance passage was built at right angles to the primary passage.

In constructing the mound, a stone core was first built around the chamber and the inner end of the passage. This was circular, 4.25 m across and 55 cm in maximum height. It has a flattish top, and its edging consisted of three layers of stones with a slight batter, the bottom layer having the largest stones. The digging of a trench at the back of the orthostats damaged a small portion of the core at the inner end of the passage. The upper part of the overlying mound had been removed, and what survives is composed of boulder clay, with a layer of shale on top that varies in thickness from 5 to 40 cm.

fig. 39

There were five stone settings in the mound, laid concentrically to the kerb, their individual stones averaging 22 cm in length. Two of them, on top of the layer of redeposited boulder clay, and stratigraphically lower than the other three, are short settings and occur only on the western side of the chamber. The upper settings are sitting on the shale layer. Two are fairly extensive, with gaps which could be due to damage, while the third is short and confined to the western side of the tomb. It is likely that all of the settings were more extensive, at least on the western side, but that portions were lost when the mound was

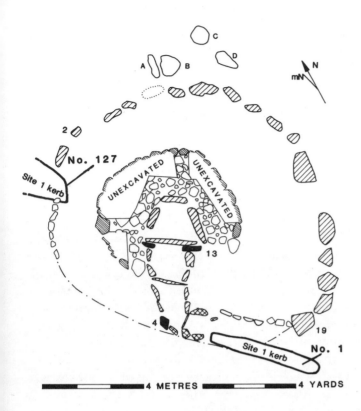

39 Knowth Site 16, ground plan.

partially removed during the remodelling of the site and, subsequently, when a large ditch was dug around the base of Site 1, possibly in late Iron Age times.

As a result of interference, the mound is somewhat D-shaped. The curved portion is surrounded by a nearly complete kerb, 8.60 m in maximum external dimensions. There are sixteen kerbstones in position, all with packing stones at the base, seven being in sockets. Gaps, including two with sockets, indicate the former presence of three more kerbstones. Nearly all the kerbstones were leaning outwards.

The tomb is entered at the south-southwest end and aligned towards the north-northeast. Its trapezoidal chamber, with the narrow end at the back, was constructed from a single stone on each side and a backstone. These were in sockets and supported by packing stones at the base. Between the chamber and passage is a sillstone, and the division is further emphasized by the fact that, just outside the sill on each side, an orthostat is set at right angles and has the form of a jambstone. The roof had collapsed, but it appears to have been corbelled, or the height of the sides was raised by dry-stone work: at least there is a largish stone on top of each of the side stones. Above the stone on the left-hand side were three smaller flat stones, which projected slightly inwards. There were also six largish stones in the fill of the chamber. These, and others outside it at the junction with the passage, must have been collapsed roof stones.

As mentioned, the passage consisted of a primary and a secondary portion. On the evidence of other passage-tombs, it can be assumed that the passage was straight, but probably 1.5 m of it was removed by the builders of Site 1. What survives is 2.60 m long. In addition to the sillstone at the junction with the chamber, another midway down the passage – and a third, at the junction with the primary and secondary passage, may originally have been in the primary passage. If so, the passage was divided into at least three segments. There are eleven orthostats, placed longitudinally except for the two 'jambstones'. All were in sockets, like the sillstones, and used packing stones. A trench was dug along the back of the orthostats, seemingly with the intention of removing them, and in the process some were damaged by sledging. No capstones were in position.

The secondary part of the passage, 3.5 m long, was at right angles to the primary portion, and its entrance was on the eastern side. The original mound along this side was not totally removed by the builders of Site 1, and as a result the floor is on mound material. The inner portion is formed from orthostats, three on one side and two on the other. They were in sockets, yet all leaning inwards. At the junction between the passages is a sillstone. It is possible that the orthostats, like the outer sill, were part of the original passage but were reutilized. Although no capstones survived, it is assumed that the inner part was roofed and the outer part was left open. One side of this outer portion was formed by a kerbstone of Site 1 (No. 1), and the other by dry-stone work which was backed against the mound and leans slightly outwards, probably as a result of adjustment to the material behind it. This facing, and kerbstone 1 of Site 1, are sitting on top of the surviving part of the mound.

Burials were found both in the chamber and in the inner segment of the primary passage. The rite was cremation, and there were three stratified deposits in the chamber. The earliest was on the old ground surface, occupying most of the chamber area. Its remains are of several individuals, including at least four children and two adults. The only grave good was part of the stem of a pin made from the leg of a small bird. This deposit was covered by a flagstone, resting on small stones which were placed at the corners of the chamber. In turn, the flag acted as a receptacle for the next deposit, which was spread over it and contained the remains of at least a baby, two young children, and an adult. Associated with this deposit was a perforated bone object, made from the legbone of a small mammal. This is now incomplete, but it may have belonged to a pendant or pin. The burial was overlaid by a paving of small flat stones. These also acted as a base for the third deposit, which held the remains of at least a child and an adult. With the two bones were two fragments of flint. There was no evidence for upper protection. The burial was overlain directly by disturbed material.

The primary burial in the inner segment of the passage was on the old ground surface, and confined to the inner half. On the outside, a sort of edging was provided by a transverse stone. The remains of at least four individuals are

represented. The burial was covered by a flagstone, spaces between this and
the orthostats being filled by smaller flat stones. On top of the flag was another
burial of at least one adult, covered by a paving of small flat stones.

Finds also occurred beneath and in the mound. On the old ground surface *fig. 40*
were sherds of 'Carrowkeel' ware, including both rim and body sherds, and
probably representing three or four vessels. Five pieces of flint lay at the same *fig. 41*

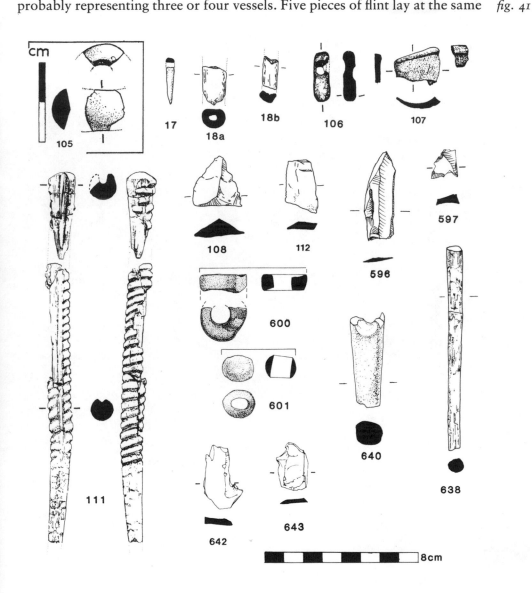

40 *Grave goods from the smaller tombs at Knowth. 111, 112 from Site 3. 105–108, Site 6.*
17, 18A, 18B, Site 12. 596, 597, 600, 601, Site 15. 638, 640, 642, 643, Site 16.

41 (overleaf) *Finds from the mounds of the smaller tombs at Knowth. 47 from Site 7.*
21–26, Site 12. 11, 13, Site 13. 7, Site 14. 604, 606, 607, 610–623, Site 15.

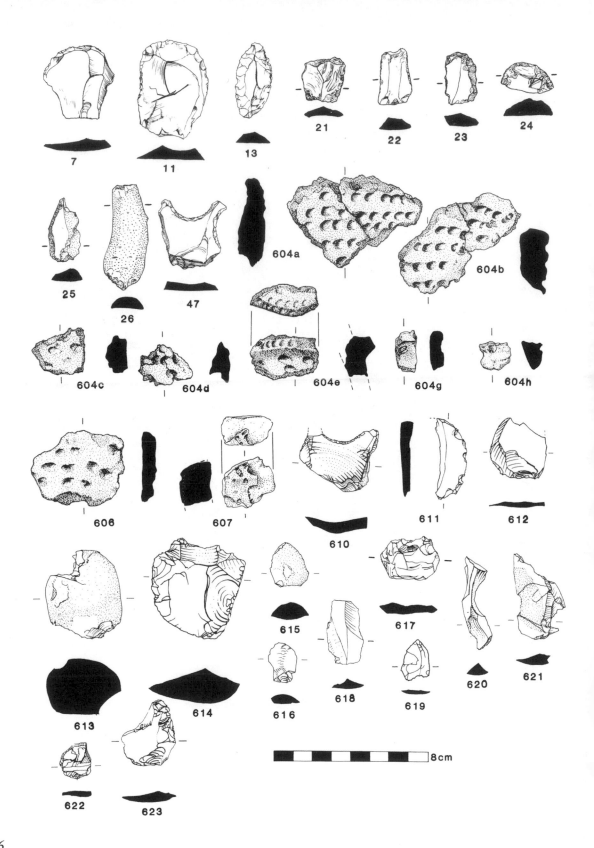

7 11 13 21 22 23 24

25 26 47 604a 604b

604c 604d 604e 604g 604h

606 607 610 611 612

613 614 615 616 617 618 619 620 621

622 623

8cm

level. A couple of featureless sherds of coarse pottery, and fifty-five flints, also turned up. Apart from two blades, a rough thumb scraper, and part of a hollow scraper, the remaining flints were scrap.

Other sites

SITE 3

Here the mound was reduced to a small portion that reached a maximum height of only 40 cm. The presence of mound material around the northeastern end of the chamber shows that, if a passage existed, it would have led in from the southwestern side. The original surface had been interfered with in this area, as a result of the digging of drains and other disturbances. Nevertheless, it is surprising that no evidence for a passage survives.

 The mound was stratified, with a basal layer of redeposited sods covered by a layer of boulder clay. Above this, but only in a small area inside the kerb on the northeastern side, was a layer of shale. About a third of the kerb remains, forming an arc of ten stones on the northern side. A couple of other stones lying about may have come from it. Apparently it was circular and some 11–12 m in external diameter. The parallel-sided chamber, aligned northeast to southwest, was placed in the centre of the mound, internally measuring 3.50 m long by 90 cm wide. It contained thirteen sockets – five on one side, six on the other, and one across each end – but only one, the northeastern end stone, was seemingly intact. The latter is rather low, 43 cm in height, if the chamber was to have been entered, even if only during the time of construction it would have

fig. 42

plate 33

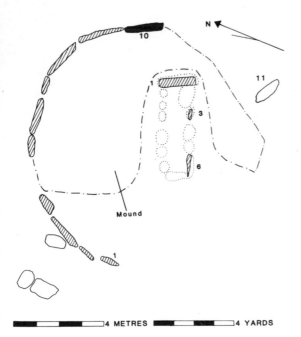

42 *Knowth Site 3,*
ground plan.

4 METRES 4 YARDS

been necessary to use dry-stone walling to increase the height. Stumps of orthostats occur in two other sockets, all with packing stones.

A burial deposit of cremated bone, near the northeastern end of the chamber, lay on the floor and, although the material above was disturbed, it appears to have been in its original position. The remains belonged to a person aged nearly 20. A decorated bone or antler object, damaged by heat, and a chip of flint accompanied the deposit. Isolated finds consisted of two sherds of 'Carrowkeel' ware and three irregular lumps of chalk.

SITE 5

fig. 43 This area has been so badly damaged that no evidence for a tomb survives; indeed one may wonder if the stones are a scatter due to removal from another tomb such as Site 6. However, there is a deposit of boulder clay over a small area on the northern part of the site, inside the most northerly kerbstone, this is overlaid by a thin deposit of shale. There are nine boulders which could have served as kerbstones, but only two (shown hatched in *fig. 43*) appear to be in their original position. Some flat stones, including a large flag which might have served as a capstone, are also lying about.

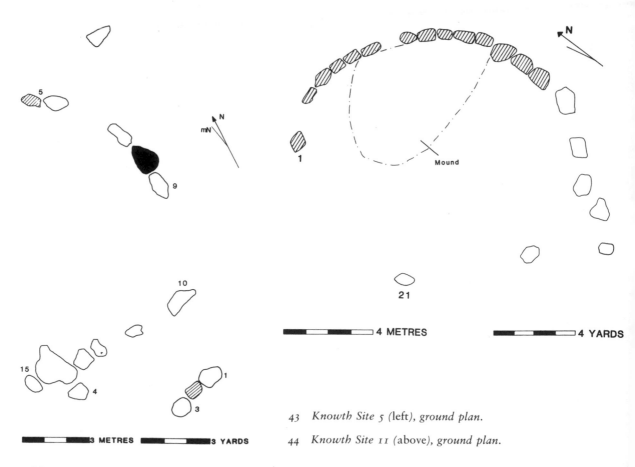

43 *Knowth Site 5 (left), ground plan.*

44 *Knowth Site 11 (above), ground plan.*

Site 11

Similar damage has occurred in this area, which has twenty-one boulders. Fourteen of them are *in situ* and form a fairly complete arc on the northern and northeastern part of the site. A number were secured by small stones at the base. Settings of small stones on the eastern side may have been packing stones of removed kerbstones. The kerb was circular, about 11.50 m in external diameter. It was difficult to establish whether remains of a mound existed. In certain areas, particularly the northern half, there are deposits of brown-coloured soil. On the eastern side, immediately inside the kerb, a small portion of the layer was covered by a thin band of shale.

fig. 44

Possible tomb remains

About twenty large boulders were scattered over an area 30–40 m from the kerb of Site 1 to the east and southeast. All are glacial erratics, similar to stones used in the kerbs of several of the smaller tombs. Numerous flakes, about three hundred, of Lower Palaeozoic rock, a type frequently used in the kerbs or orthostats, were scattered over a comparable area. All of this points to the existence of a tomb or tombs. The area was considerably interfered with in recent centuries, as by cultivation and the planting of fruit trees, some of which still survive.

On the northern side of the public road, built into a fence, is a large boulder which could have served as a kerbstone. It might be a rolled-out kerbstone from some of the known sites, for example Site 14 or 15, or it could have been the sole remains of a destroyed site. Early in the last century, there were two large stones, around 2 m high, standing on the site of Knowth House about 65 m away from Site 1. These could also be traces of a tomb.[5]

4 Knowth and other Irish passage-tombs

The tombs of Knowth can be considered to belong to the wider family of Irish passage-tombs. In addition to what has already been noted, there are important features of Knowth, including the hilltop setting, cemetery grouping, morphology of tombs, art, and burial customs, which have parallels at other sites in Ireland. Comparisons and contrasts will now concern us.

Distribution of tombs

As was pointed out in Chapter 1, there may be some 300 passage-tombs in Ireland. They generally occur in the northern part of the country, north of a line from Wicklow in the east to Sligo in the west. Sites are rare to the south of that line, and the Duntryleague (Limerick) and Shrough (Tipperary) tombs are very much outside the main concentration. Also known are a couple of simple passage-tombs, the so-called entrance graves, in the Tramore area of County Waterford, but it is unlikely that these tombs are part of the main sequence (see below).

fig. 45 In the principal area of distribution, tombs occur widely, yet it does contain regions which are devoid of tombs. One such region is a diagonal band extending across the country, from southern Louth in the east to Donegal in the northwest. Tombs occur along the coast as at Bremore (Dublin), Gormanstown (Meath), and in north Antrim. Located almost at the water's edge are tombs at Bremore, Knocklea, a destroyed site at Gormanstown, Millin Bay (Down), and Magheracar (Donegal), while in north Antrim the sites are on the high ground overlooking the coast. This setting adjacent to the sea is dramatically displayed in the placement of the great cairn, and the smaller tombs next to it, on the summit of Knocknarea, County Sligo, at an altitude of 329 m, surveying the broad expanses of the Atlantic Ocean.

Siting

Bremore, the Carrowmore cemetery, and other sites are positioned on low-lying land, but the general rule was to build tombs on eminences. Even in the low lands of the Boyne Valley, the three main tombs at Dowth, Knowth, and Newgrange are situated on the maximum elevations at 61 m. However, in the northwest of Meath, the builders of the Sliabh na Caillighe (Loughcrew)

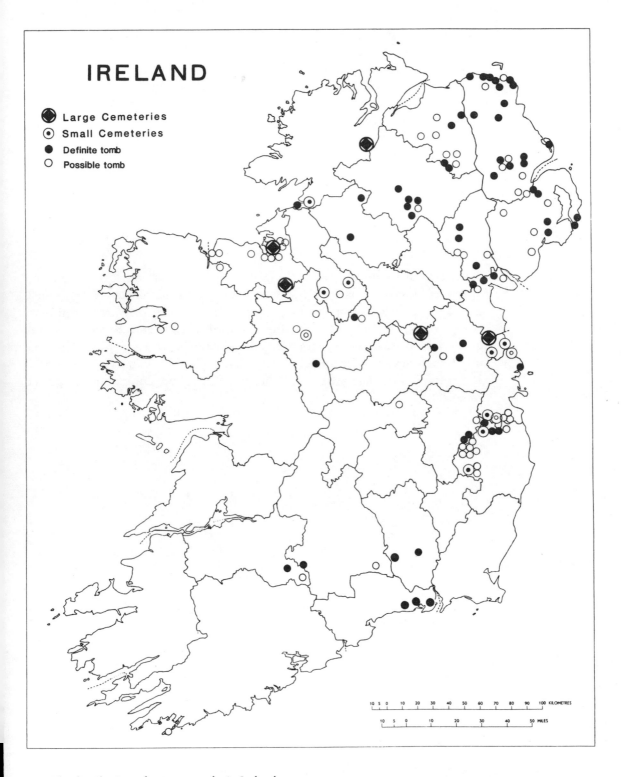

IRELAND

◈ Large Cemeteries
⊙ Small Cemeteries
● Definite tomb
○ Possible tomb

10 5 0 10 20 30 40 50 60 70 80 90 100 KILOMETRES

10 5 0 10 20 30 40 50 MILES

45 *The distribution of passage-tombs in Ireland.*

tombs selected the highest ground in that county. Indeed, mountaintops were frequently used. Such are the locations of the Wicklow sites, the Carrowkeel and Knocknarea cemeteries (Sligo), and individual sites at Belmore (Fermanagh), Sliabh Gullion (Armagh), Clermont (Louth), and Knocklayde (Antrim). The summit of Sliabh Donard in County Down has the passage-tomb with the highest elevation, being at 825 m.

Apart from elevation, there is no clear association with a particular natural feature. The Brugh na Bóinne tombs overlook a river and, a few miles further upstream, a site at Broad Boyne lies at the top of the scarp. The Fourknocks tombs are on one side of a broad river valley. Yet a connection between tombs and river valleys was not usual.

Cemeteries

The twenty or so tombs at Knowth formed a closely knit, nucleated cemetery. Moreover, they are part of the larger Brugh na Bóinne cemetery which originally consisted of up to forty sites. The grouping of passage-tombs in cemeteries is characteristic of this class of monument. Some are large concentrations, whereas others are small clusters of three or four sites. The large cemeteries are nucleated, but others, such as those in north Antrim or in the Seefin-Tournant area of County Wicklow, constitute dispersed cemeteries.[1]

The cemeteries that are comparable to Brugh na Bóinne are those of Sliabh na Caillighe (Loughcrew), Carrowkeel, and Carrowmore-Knocknarea. The

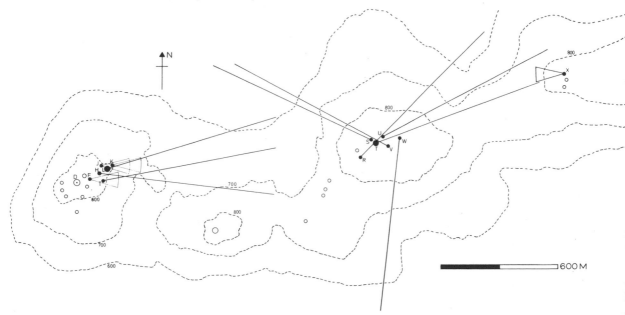

46 *The distribution of tombs in the Sliabh na Caillighe (Loughcrew) cemetery, Co. Meath. Solid lines indicate the orientation of each tomb.*

first, lying about 40 km west of Brugh na Bóinne, has the remains of thirty-one sites, spread over an area some 3 km long. Four of the hills in this range are higher than 240 m. One hill has only a single tomb, but the other three hold the main concentrations: fourteen sites on Carnbane West, seven on Carnbane East, and five at Patrickstown. The remaining tombs are off the summits, yet none is below 213 m in elevation.

plates 40, 41

fig. 46

The Carrowkeel cemetery is situated on spurs of the Bricklieve mountains. Here the tombs are concentrated on a plateau divided by rifts. All tombs are above 213 m, and some are over 305 m. The main concentration at Carrowkeel consists of twelve sites, but other sites exist in the vicinity, including a couple between Carrowkeel and Keshcorran, and two on Keshcorran itself. Carrowmore is a low-lying gravelly area with the largest of all the cemeteries. The remains of fifty to sixty sites are grouped near each other in an area just over 1 km long and 600 m in maximum width. Originally there were around a hundred tombs. A few km to the west lies Knocknarea, with its great unopened cairn (Miosgán Meadhbha) and seven smaller adjacent tombs.

plate 42

fig. 47

fig. 48

plate 43

fig. 49

A fairly extensive cemetery at Kilmonaster in County Donegal, in hilly countryside between the rivers Deel and Finn, has the remains of twelve tombs, nearly all of them badly mutilated. The main concentration of seven tombs is in low terrain at an elevation of 30–60 m. The cemetery is, however, overlooked by a cairn on Croaghan Hill which rises to 221 m.[2]

There are about a dozen smaller cemeteries, each consisting of three to eleven tombs, the average number being five. On the seacoast near the mouth of the River Devlin at Gormanstown (Knockingen) were four tombs, while a group of five mounds is at Bremore a few km further down the coast.[3] Apart from the two excavated sites, other round mounds exist in the Fourknocks area, and some of these may be passage-tombs. To the south of Dublin city, on Saggart Hill, is a group of three sites and other round cairns, while Montpelier Hill (Hell-fire Club) has the remains of two mounds. Not far away, on Knockanvinidee and Seehan mountains, are four cairns, whereas five cairns occur in the Lugnagun/Carrig area and southwards in the Seefin-Tournant area.[4]

Small cemeteries are also found to the west. There are two sites at Fenagh Beg in Leitrim, and three cairns at Sheemore a few km away. Groups of three sites also occur at Sheegeeragh in County Roscommon, in south Donegal, near the coast at Finner, at Sess Kilgreen in County Tyrone and nearby, and in County Antrim at Donegore and overlooking Whitepark Bay. Baltinglass is unusual in having three tombs as a result of accretion.

fig. 52

As at Knowth, another feature is a huge dominating mound with small mounds in its immediate vicinity. This is seen at Newgrange and at Sliabh na Caillighe; at the latter site Cairn T dominates the group on Carbane East, while Cairns D and L form the central part of the clusters on Carbane West. At Carrowmore, a similar function is served by Site 51, Listoghill, and at Knocknarea by the great cairn. Indeed, Miosgán Meadhbha can be regarded as

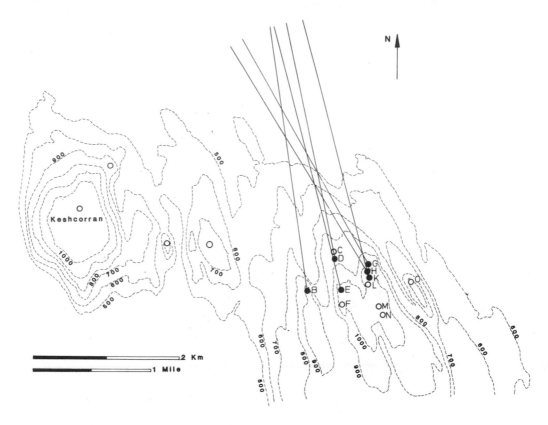

47 *The distribution of tombs in the Carrowkeel, cemetery, Co. Sligo. Solid lines indicate the orientation of the tombs.*

48 *The distribution of tombs in the Carrowmore-Knocknarea cemetery, Co. Sligo.*

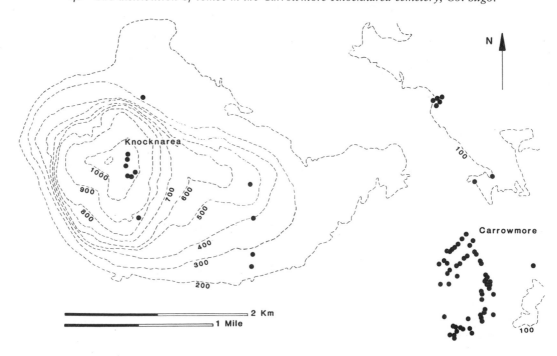

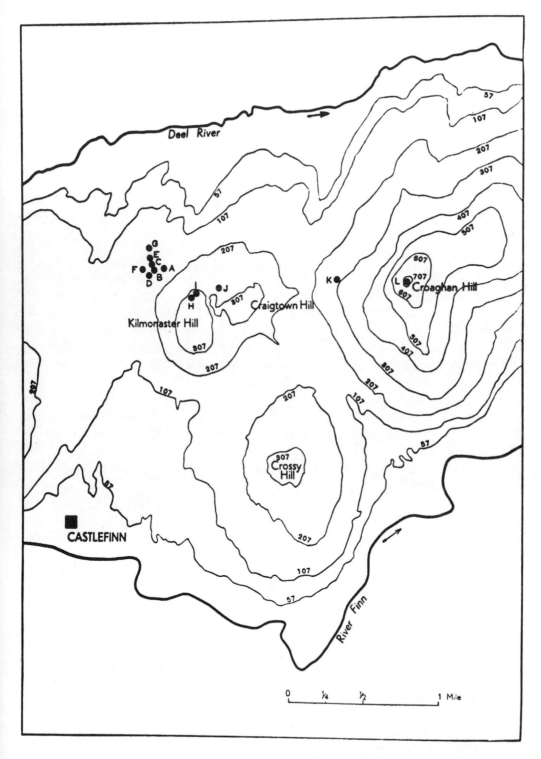

49 *The distribution of tombs in the Kilmonaster cemetery, Co. Donegal.*

the dominating site for Carrowmore as well as for the Knocknarea group. It is also interesting that the Kilmonaster cemetery is dominated by the cairn on Croaghan Hill.

The siting and cemetery grouping were significant aspects of tombs. Burenhult considered that the grouping of tombs into a cemetery, instead of building single spaced-out mounds, reflects a specific system of subsistence and settlement, but that view is based on the concept of local development. It is more likely that the passage-tomb people needed a ritual area and, at the same time, valued the visual appearance of the monuments; such 'high places' were a feature of many ancient cultures. These aspects may, of course, be inherited, as cemeteries and prominent locations in the landscape are characteristic of some Iberian tombs and to a lesser extent Danish ones.

Orientation

fig. 50

At Knowth Site 1, as we have mentioned, the cruciform tomb faces east and the undifferentiated tomb west. The smaller tombs are less regular in orientation, but all face within the semicircle between north-northeast and south-southwest, and the majority between east and south-southwest. The four sites at Newgrange are within the arc of southeast to south-southwest. On the other hand, the Dowth tombs face west, the Carrowkeel sites northwest, the Fourknocks sites north, and Tara east. At Sliabh na Caillighe, where information is available, the entrances to the sites on Carnbane West face east, while on Carnbane East two sites face northwest, three northeast, and one south. Information exists for only one of the sites at Patrickstown, which faces west.

Thus, passage-tombs do not have a consistent orientation, although most sites generally face eastwards. Perhaps the sun influenced the orientation (see Chapter 8). But there are tombs, such as Sites 2 and 4 at Knowth, and Fourknocks 1, which are north of the west-northwest to east-northeast arc, and could face neither a rising nor a setting sun, so they may have been aligned towards some other celestial body.

Other factors could have played a role in orientation. The undifferentiated tombs at Knowth face towards the hilltop, while only two of the five cruciform tombs do. Possibly the intention was that the undifferentiated tombs should face the large mound, which lies on the hilltop. However, as it has been shown that the main mound is later than at least two of the smaller sites, it could not have served as a focal point for them. Alternatively, there may lie buried under the main mound some undiscovered hilltop feature, such as a small 'founder's tomb' or a house. The cruciform tombs are 'aimed' at an area on the southeast of the large mound. This area might also have held a focal feature of importance for the builders of the cruciform tombs, but this area has been excavated and nothing significant was found.

At Sliabh na Caillighe, the sites on Carnbane East are not consistent in

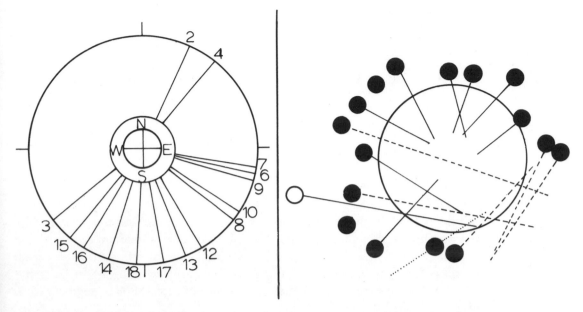

50 Orientation diagram for Knowth. (Left) Each radius represents a tomb. (Right) The orientation and location of the smaller tombs in relation to Site 1. The undifferentiated tombs have solid lines, the cruciform tombs dashed ones. The dotted line represents the possible orientation(s) of Site 3, and the open circle Site 7.

orientation; but Carnbane East itself may have been a focal point, because tombs on Carnbane West and Patrickstown site XI face towards it. The northwestward orientation of the Carrowkeel sites is towards Knocknarea, about 22 km away. It therefore seems possible that some key point or site may have served as the focus for tomb entrances, such as the hilltop at Knowth, Carnbane East at Sliabh na Caillighe, and Knocknarea for Carrowkeel.

Types and morphology of tombs

In addition to the two main types represented at Knowth – the undifferentiated and cruciform tombs – there are other forms of passage-tombs in Ireland. Typological differences occur even within the defined groups. But common to all these forms are structural features – orthostatic design, a round mound, a kerb of large stones – as well as ritual features in art and grave goods.

At Knowth, Site 1 is distinguished by its sheer size and magnitude, and in having two tombs placed back to back. The mounds of the other tombs vary in diameter, from a little less than 9 m to about 22 m, a range rather similar to that in the majority of Irish passage-tombs. There is also considerable variation in tomb area as the following selection shows (dimensions in square metres):

Site	Chamber	Passage	Total
Knowth 1, East	20.21	c. 30.00	c. 50.21
Fourknocks I	41.92	5.67	47.59
Newgrange	16.50	14.78	31.28
Sliabh na Caillighe I	20.54	2.81	23.35
Gavr'inis (Brittany)	c. 5.44	15.40	c. 20.84
Dowth South	15.21	5.46	20.67
Knowth 1, West	1.30	19.30	20.60
Barclodiad y Gawres (Wales)	12.64	6.65	19.29
Sliabh na Caillighe L	c. 14.00	3.17	c. 17.17
Pedra Branca (Portugal)	c. 8.94	5.63	14.57
Carrowkeel F	c. 10.45	1.17	c. 11.62

But the type of tomb does not affect the mound size, nor was it determined by the number of individuals buried. Internal arrangement of space must have been a factor which brought about the emergence of different tomb types. Besides the general layout, more definite differentiation or internal demarcation of space was provided by the use of recesses or by segmentation of the passage.

Among the undifferentiated tombs, the western tomb in Site 1 has a parallel-sided passage, bending to the right towards the end. In the smaller sites, the sides widen outwards from the entrance to the interior. In Nos. 4, 7, and 8, the splay is even on both sides, but in the others there is a slight curve – while No. 13 in particular, and to some extent No. 15, tend to be bottle-shaped. A defined inner compartment was standard, and tended to be squarish or slightly rectangular, although trapezoidal in No. 16.

The orthostatic passage continued out to the kerb in Sites 2, 4, 8, 13, and 14. There is a gap between the end of the passage orthostats and the kerb in Sites 15, 17, 18, and possibly 12. If this is an original feature, the outer part of the passage would have been simply a gap through the mound. However, the outer orthostats of the passage of Site 15 are sitting on the old ground surface and, if they had been removed, evidence for their former presence would not have survived. No evidence for a passage came to light in Site 3.

Regarding internal arrangement in these Knowth undifferentiated tombs, the western tomb in Site 1 has a sill in the passage about two-thirds of the way in, and another delimits the outer part of the interior of the chamber, which is subdivided by a further sill. In Sites 12–14, there is a single sill, isolating the inner part of the tomb and forming a chamber. This distinction is also emphasized in Site 14 by two massive orthostats flanking the chamber area. Site 4 has four sills dispersed equally along the passage, and Sites 15 and 16 have three. In Site 16, the inner sill is arranged in association with a jamb on each side. The inner sill in Site 4 is high, and the equivalent sill in Sites 15 and 16 is higher and more substantial than the outer ones.

The ten undifferentiated tombs at Knowth constitute the largest such group in Ireland. There are only seven other known examples, three being within the

Brugh na Bóinne cemetery – two at Newgrange (Sites K and Z) and one at Townleyhall. The remainder are Carrowkeel B and H, the Mound of the Hostages at Tara, and Magheracar in County Donegal.[5] They differ in tomb plan: Tara is almost rectangular, whereas the others tend to widen gradually from the entrance to the inner end. About two-thirds along the way, a recess opens on the right-hand side in Newgrange Z and Carrowkeel B. Newgrange K has a small angular compartment outside the right-hand side of the chamber. As was the case at Knowth Sites 1 (western), 4, and 12–16, all the others except Townleyhall have sillstones. Again as at Knowth 1 (western), 4, and 12–16, a single sill defining the chamber occurs in Newgrange K and Z, Carrowkeel B and H, although in Tara the chamber is divided by sills into three segments. Newgrange K and Carrowkeel H have curving passages, but the outer part of the passage at Newgrange K may have been a later addition. As at Knowth, the mounds of undifferentiated tombs are generally round, while at some sites the kerb flattens or curves inward at the entrance, which is cuspate at Newgrange K. Internal features such as stone settings in or under the mounds are more common in undifferentiated than in cruciform tombs.

In discussing undifferentiated tombs, reference should be made to the small group of tombs termed 'entrance graves' in the Tramore area of County Waterford. The passage usually widens slightly from the entrance to the interior, but it extends for a greater distance into the mound than it does in the undifferentiated tombs. The example at Harristown has a sill just inside the *fig. 51* entrance. Such tombs also occupy a greater area of the mound. Nevertheless, they are set in a round mound which is delimited by a kerb. The burial rite is

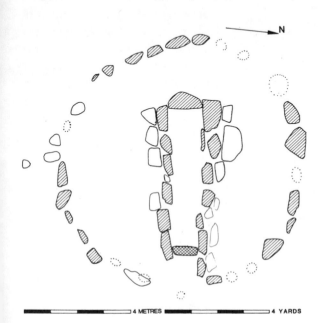

51　Ground plan of the 'entrance' passage-tomb at Harristown, Co. Waterford.

4 METRES　　4 YARDS

cremation, but none of the standard grave goods of the 'Boyne culture' are present, nor are the hilltop setting and the cemetery grouping. As T. G. E. Powell originally observed,[6] these tombs are typologically close to tombs in the Isles of Scilly and western Cornwall. It is most likely that the Tramore group reflects a different, possibly later, tradition of tomb-building.

Tombs with recesses

As noted above, two undifferentiated tombs – Newgrange Z and Carrowkeel B – have recesses, but there is also a series of tombs with particularly well-defined recesses. These occur in all the main cemeteries as well as in isolation, and are the most widespread type, close to thirty being known. The passage is usually straight and parallel-sided, as at Knowth Sites 1 (eastern), 6, and 18. Yet in some examples, it widens from the entrance to the chamber. In some examples the chamber is well defined, as at Knowth 1 (eastern), 2, 17, and 18; the widening may be slight, as at Newgrange (large), or it may simply be a continuation of the passage, as at Knowth 6 and 9 and at Belmore.

The recesses vary in shape, size, and number, but in the leading sites the right-hand recess is the biggest. Square or rectangular forms are the most common, while the end recess of Knowth 9 narrows from the chamber to the end. This recess is also much bigger than the end recesses of the other tombs. In relation to the overall size of the chamber, the recesses in Fourknocks I are small. As to numbers, Dowth south and Sliabh Gullion have a single recess, whereas the most common are cruciform tombs – with a recess on each side and one at the end. The side recesses are usually at right angles to the line of the passage, but sometimes they are set askew.

plate 38
figs. 3, 55, 56

About half-a-dozen tombs are more complex, having multiple recesses. For instance, in Site L at Sliabh na Caillighe, the somewhat rectangular chamber is divided into eight recesses: the end, three on the left side, and four on the right. The recesses vary in shape and size, and are separated from each other by an inward-projecting slab, set at right angles to the line of the wall. Site G has a rather heel-shaped chamber divided internally into seven compartments by six slabs projecting out from the sides. At Carrowkeel F, there is no central widening of the chamber, and there are two recesses on each side with a fifth at the end. This tomb, unlike those of Sliabh na Caillighe, does not have dividing stones. Each recess is a unit, and the same plan exists at Seefin.

Sillstones occur frequently. They were placed at diverse points in the passage, while in the chamber they are mainly found across the entrances to one or more of the recesses. At Knowth, both tombs of Site 1 have internal divisions. The entrance to the left-hand recess of the eastern tomb has a sill, and a pair of jambstones is in an equivalent position at the right-hand recess. As stated previously, the western tomb has a sill across the main part of the passage, and another at the outside of the inner part of the chamber, while a further sill subdivides this inner part. As for the smaller Knowth sites, the cruciform tomb (Site 2) had a sillstone across the entrance to each side recess,

and in another cruciform tomb (Site 9) there was a sillstone at the junction between the passage and chamber.

Tombs with simple circular or polygonal chambers

An incoherent group is formed by some tombs, such as Baltinglass 1 with a *fig. 52* rounded chamber. Many of the Carrowmore tombs have a polygonal chamber roofed by a prominent capstone sitting directly on the orthostats. A number of quite small passage-tombs also tend to have a polygonal chamber – the 'B dolmens' of the older literature. These sites are most common in the northeast, within Counties Derry, Antrim, and Down, usually near the coast. Typical examples are the 'Druid Stone' at Ballintoy (Antrim) and Ballynahatty 1 (Down). While more oval in plan and slightly larger, the passage-tombs in County Tyrone are not too far removed in form, Knockmany and Sess Kilgreen being typical. A few sites, not confined to any geographical area, have a rectangular chamber. Good instances here are Knocklea in County Dublin and Carnanmore in Antrim, both with corbelled roofs.[7]

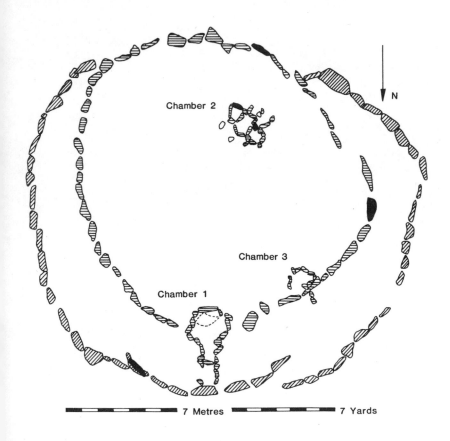

52 *Ground plan of*
Baltinglass Hill, Co. Wicklow.

Unusual tombs

fig. 53 Fourknocks II is a composite site, consisting of three elements: a bell-shaped cairn, a trench and, leading into this at right angles, a megalithic passage. All were covered by a mound. As at Knowth 3, there are other tombs without a passage, including about three examples of figure-of-eight tombs at

fig. 54 Carrowkeel, and the 'long cist' at Millin Bay in County Down.[8]

Carrowkeel H is a long cairn, Millin Bay is oval, and Fourknocks II is ovoid. But otherwise the mounds of passage-tombs are circular or nearly so. As at Knowth 15, 17, and 18, the kerb flattens slightly in the entrance area at Newgrange L. Parallels to the inward curve of the kerb before the entrances to Knowth 1 and 8 occur at Newgrange (large) and Sliabh na Caillighe (T and L). There is a recessed kerbstone before the entrance to Sliabh Gullion. A sharp in-turning of the ends of the kerb occurs at Fourknocks I and Newgrange K, while Duntryleague has a funnel-shaped entrance.

53 *Ground plan of Fourknocks II, Co. Meath.*

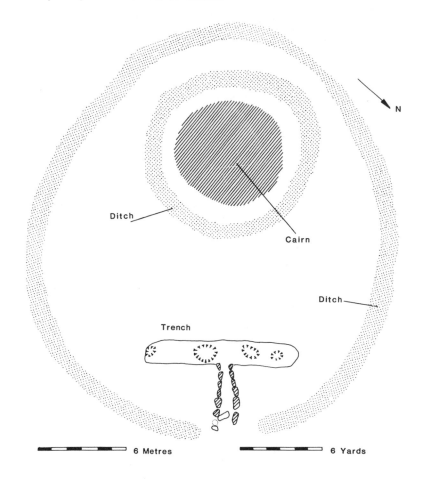

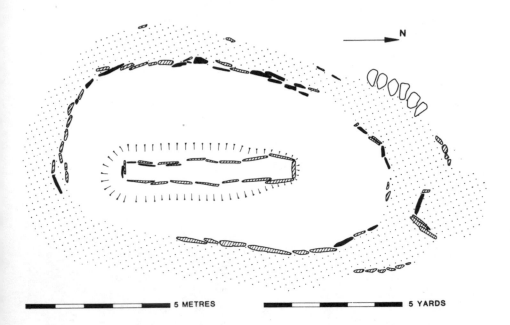

5 METRES 5 YARDS

54 Ground plan of Millin Bay, Co. Down.

55 Ground plan of Sliabh Gullion, Co. Armagh.

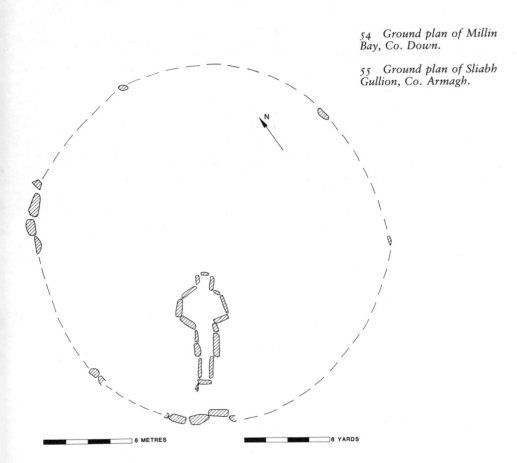

8 METRES 8 YARDS

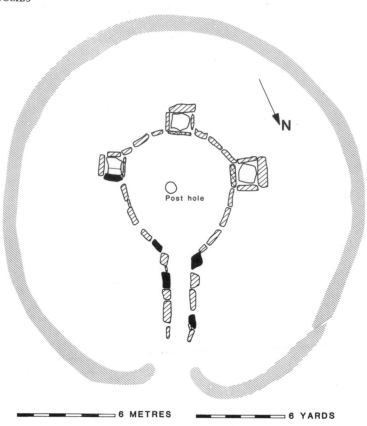

56 *Ground plan of*
Fourknocks I, Co. Meath.

Post hole

■——————————————■ 6 METRES ■——————————————■ 6 YARDS

Colour plates *(pages 105–108)*

I Air view of Knowth from the west, showing excavations in progress in 1976.

II The main Knowth mound from the southwest, with kerbstones exposed.

III Kerbstone 56 from Knowth Site 1, decorated in the spiral style.

IV Kerbstones at the entrance to the western tomb, Knowth Site 1. See also plate 6.

V The chamber of the western tomb, with the sillstone in the foreground. Compare plates 11–13.

VI The chamber of the eastern tomb: view of the front face of the basin stone in the right recess. Note the decoration on orthostat 54 behind. Compare plates 19–24.

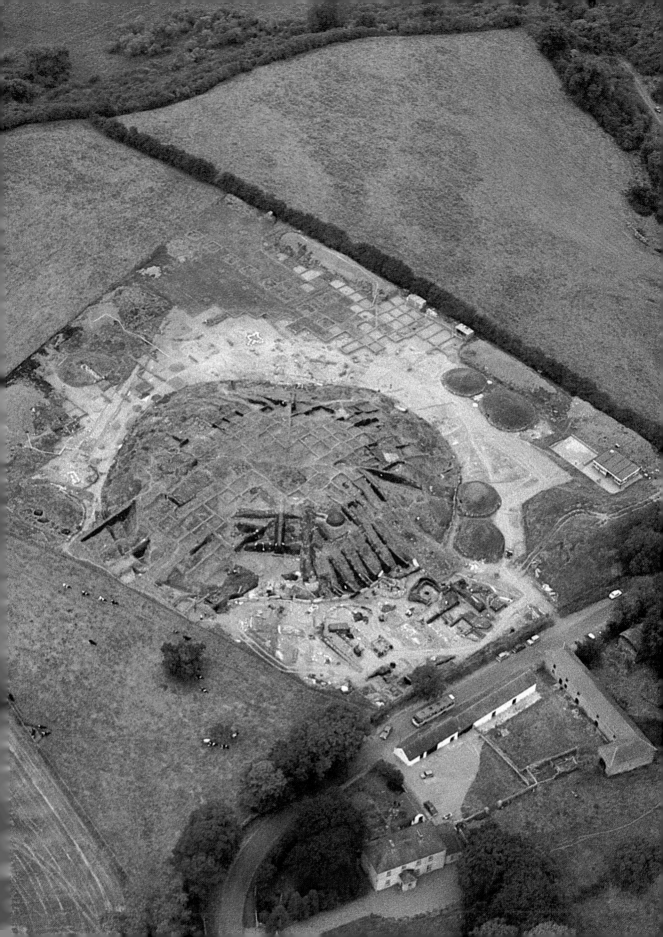

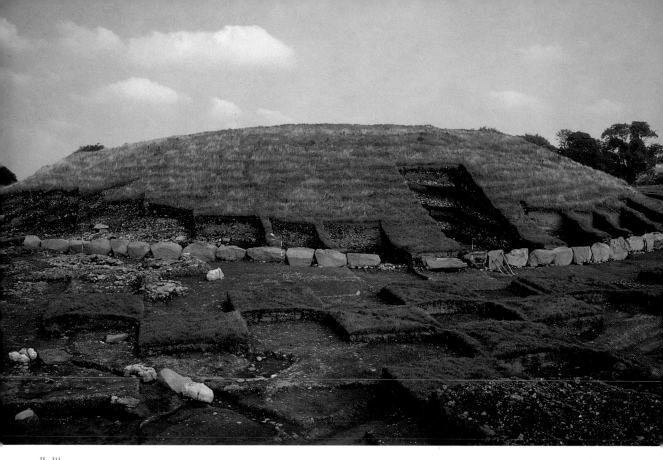

II, III

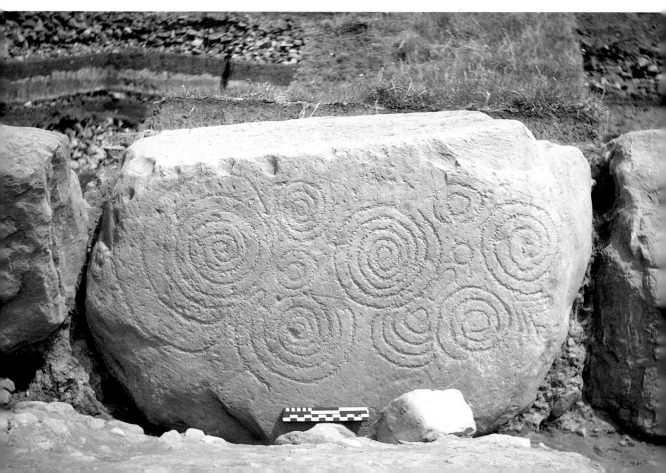

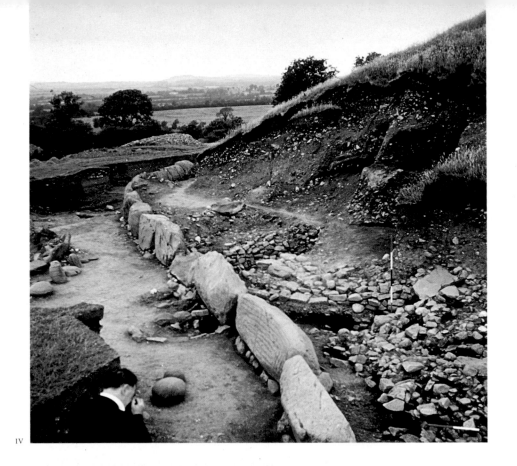

IV

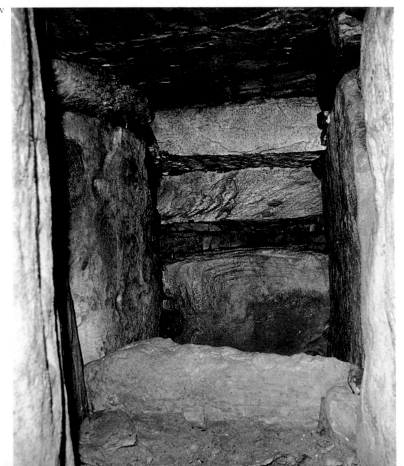

V

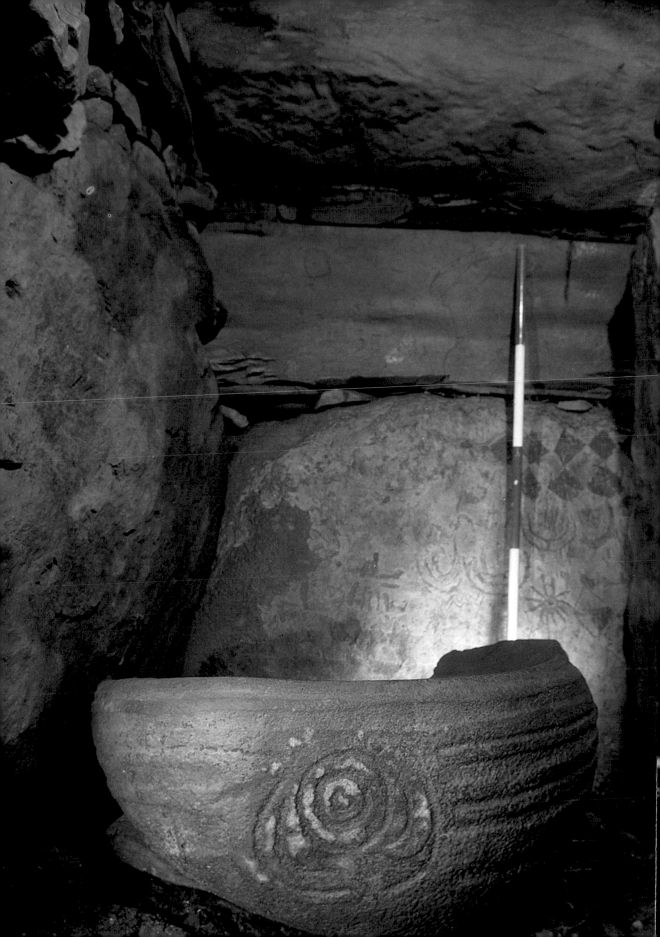

Other features

At Knowth, apart from a small area of paving just inside the entrance of Site 14, there is no evidence for a laid-down floor, although rubble was scattered over the floor of the passage in the eastern tomb of Site 1. Evidence for flooring is also sparse elsewhere. A small patch of paving exists in the passage at Fourknocks I and Sliabh Gullion. The site with the best floor is Carrowkeel K, whose passage and chamber both have paving. A flagstone covered the floor of each segment in the Mound of the Hostages at Tara, and the floor at Millin Bay was paved with thin flags. Flooring by flags is seen at Sliabh na Caillighe Site I. At the latter, and at Millin Bay, the floor stones were sitting on a prepared foundation layer of smallish stones. As already pointed out, sillstones are common in the passage and chamber of all types of tombs. The freestanding pair of jambs at the right-hand recess of the eastern chamber in Knowth 1 is unparalleled, but the two orthostats, one on either side of the entrance to the end recess, in Carrowkeel G are also prominent. The jambs in Site 16 can be compared to those in Carrowkeel H. There is a pillar in the chamber of Carrowkeel F.

Knowth has preserved the remains of a mound at all sites except No. 10. Stones predominated in Site 1, but boulder clay was the main material used in constructing the small mounds. In some sites (2–4, 8, 9, 15, 16), a limited amount of shale was also used, being deposited in layers. Again, stones predominated at Newgrange, and apparently nothing else was employed at Sliabh na Caillighe and Carrowkeel. At Fourknocks I and II, and at Townleyhall, sod or boulder clay was used.

The mound has a core in Knowth Sites 12, 15, 16, and possibly 2. The core, made of stones in Sites 12 and 16, encloses the tomb in Site 12 but only the chamber in 16. The core in Site 15 also encloses the tomb, but occupies a larger area than does that in 12. This core is composed of a mixture of boulder clay with sods, and is delimited at its base by a setting of small stones. In the chamber area of Site 2, a thin layer of stones occurs within the boulder clay mound. From the old ground level, this layer slopes inwards and upwards to the chamber. There is, however, no difference in the material above and below the stony layer.

Apart from Knowth, knowledge of cores at other sites is restricted. At Newgrange (large), it seems that the chamber was built as a free-standing structure. This, in turn, was surrounded by a small cairn, which was covered by a layer of rounded boulders. At Newgrange L, there was a core of sand, and at Townleyhall a heel-shaped core of earth surrounding the inner part of the tomb was delimited by a setting of small stones.

Such settings, about 20 cm in average length, occur under or within the mounds at three Knowth sites. At Site 4, arc-like settings of different lengths were on the old ground surface on both sides of the tomb. At Site 16 the settings were within the mound, as was the short arc at Site 9 although only a few cm above the old ground level. Site 15 had a short setting which extended

out from the tomb at about the midpoint of the southeast side. Site 18 had an arc of small stones inside the line of the kerb along the western side, but its location differs from those in the other sites.

It has been suggested that the inner setting at Newgrange K was the kerb of a primary tomb that was subsequently enlarged. There is also a setting on one side of the chamber, perhaps the base of a core. Site 27 at Carrowmore had a circle of stones concentric to the kerb and about 3 m in from it. This delimited an 'inner stone packing', possibly a core. Site 7 had an arc of ten stones on the northern side. There were two rings of stones at Site 4, considered by Burenhult as representing phases of enlargement, but they too may be symbolic. At Newgrange and Carrowmore, Townleyhall 2, and Knowth 4 and 18, the settings were on the old ground surface, and they were in the mound but only some cm above the old surface in Knowth 9 and Newgrange K. At Townleyhall 2, the top of the core had a stone setting on its outer edge. The setting on the old ground surface at the base of the core in Knowth 15 resembles the 'kerb' at Fourknocks I. The cairn at Fourknocks II also had settings of stones underneath. Settings were found at the large Newgrange tomb as well, but these appear to have been functional, since they delimited the ends of the individual layers.

Kerbs existed at all passage-tomb mounds where evidence is available, apart from the Mound of the Hostages at Tara. In the first stage of Newgrange K and Fourknocks II, the kerb consisted of a ditch. At Fourknocks I, small stones were grouped together to form a 'symbolic' kerb, and a somewhat similar arrangement is found at Knockmany. At other sites, the standard kerb was made of large stones. At Knowth I, Newgrange (large), and Dowth, well-shaped large blocks around 2 m long were chosen – and at other sites, such as Sliabh na Caillighe T, well-formed stones were also used. However, in the small Knowth tombs and at sites such as Carrowmore, more mundane blocks or glacial erratics were employed.

While the kerbstones provided, of course, an edging to the mound, they were also intended to give an impressive appearance, as was the case with some of the kerbstones at Knowth I. In addition, it seems that care was taken at Carrowmore 7 to provide a horizontal line along the tops of the kerbs. At that site, the ground sloped slightly but, in order to ensure a level kerb, the stones were sunk into the ground on the east side, whereas the ground on the west side was built up and the stones were placed on top of it.

5 Materials and construction at Knowth

It can be assumed that only imperishable materials have survived in the tombs of Knowth. For instance, large quantities of timber must have been used when the tombs were built, but no traces remain. Stone was the commonest material, and a feature of the site is that the builders were discriminating in their selection. Moreover, considerable forethought and planning went into the design of passage-tombs at Knowth and elsewhere. How much the recent excavations and studies have revealed about such techniques will be surveyed in this chapter.

Materials

As has already been pointed out, the tombs were constructed on a ridge of black shale which has only a thin covering of drift. Along the flanks, however, there are thicker deposits of boulder clay and some gravel. Such natural deposits have a limited range of stone, yet the selection made was of various distinctive stones that were not of immediate local origin. Some stones, especially the smaller ones, might have been secured from the glacial drift, but not all could have been.

Among the smaller stones which cluster around the entrances to both tombs at Site 1, Professor G. F. Mitchell has identified a number as being non-local. He reports that 'several of the angular quartz blocks have patches of crystalline muscovite (white mica) adhering to them, suggesting a granitic source, possibly in the Wicklow mountains. Others have adhering patches of dark fine-grained material, indicating an origin in metamorphic rock.'

The well-rounded boulders are of 'granite'. Their shape suggests prolonged abrasion in a beach environment, but the great majority have lost most or all of their primary polished surface. This may be due to the action of ground water during their thousands of years of deposition. Their petrology and shape indicate that the boulders might have been collected from beaches to the north of the estuary of the Boyne. Today, examples can be found especially in the Cooley peninsula east of Dundalk, where they appear to have been removed from the morainic boulder clay by wave action. However, while generally rounded, most of these boulders do not have the very regular oval form that

was evidently sought by the tomb builders. X-ray fluorescent scanning (kindly carried out by Dr Ian Meighan, Geology Department, Queen's University, Belfast) of a boulder selected at random showed that it was a granodiorite, probably from the Newry plutonic complex, and was neither Mourne nor Leinster granite.

Remarkably well-rounded and naturally polished elongated-oval cobbles of siltstone, banded green and white, about 15 cm in length, are common at Knowth, but I have not seen them at Newgrange. A cobble selected at random was kindly examined by Professor Chris Stillman (Geology Department, Trinity College, Dublin), who reported that it was of fine sandstone/siltstone, similar to that in the Lower Palaeozoic area of Longford/Down. Such rock was also looked for on the beaches, and was rare to the south of Dundalk, although reasonably common on the Cooley beaches. But only one cobble was found that could match those at Knowth in the fullness of its rounding. All the other pieces, while polished and having rounded edges, remained essentially sub-angular in shape. The largest piece seen was a block about 30 cm long. It is difficult to avoid the inference that the cobbles had attained their rounded shape before they were picked up and transported by ice.

Other sedimentary rocks were also collected. Outside the western tomb are several large nodules of clay ironstone. Though not apparent today, such nodules might conceivably be found in the Upper Carboniferous shales that form the knoll on which the mound itself stands. They could also come from further afield, in the Kingscourt area of southeast Cavan/northeast Meath, or around Lough Allen in County Leitrim.'

The building of the Knowth tombs and the acquisition of materials constituted a formidable task, particularly when stones had to be taken to the site. The tombs used up to about 1,600 large stones, varying in weight from nearly a ton to several tons. In addition, the main mound consumed hundreds of tons of loose stones and other materials such as sods, boulder clay, and shale. Considerable quarrying as well as large-scale transportation were evidently involved in supplying these stones.

For the structural stones, sedimentary rocks, sandstones, and limestones were used. Their origin can be found respectively in the Upper and Lower Carboniferous of the area. Limestone outcrops occur a few km away at Slane. Sandstone is known from south of the Boyne, although the large pillar opposite the western tomb in Site 1 might have been taken from as far away as the Kingscourt area 30 km to the northwest (on information from Professor Mitchell). Glacial erratics were used more commonly in the kerbs of the small tombs. However, Lower Palaeozoic rock was the usual stone for structural purposes in both the kerb and tomb of the large sites at Knowth, including varieties such as greywacke or green grit. This rock was also used for many orthostats of the small tombs and, on limited occasions, in the kerbs. It is, moreover, the predominant stone used at Newgrange and Dowth. In fact, it was the most favoured stone of the passage-tomb builders of Brugh na Bóinne.

Quarrying of large stones

Professor O'Kelly thought that the large stones used in the building of Newgrange were collected locally.[1] But as the great sites at Newgrange and Dowth have on average 200 large stones each, the three major sites together with the small Knowth tombs must have used around 2000. It is very unlikely that so many large stones had been naturally deposited at the end of the Ice Age in the immediate area. Their acquisition might therefore have entailed collection and transportation over a substantial area. But in fact there is good reason to believe that the majority of the Palaeozoic stones at Knowth were quarried.

Drs Marshall McCabe and Graham Nevin, at Ulster University, are carrying out research on this problem, and their results will be fully published at a later date. Meanwhile, they point out that Palaeozoic rocks are hard, mechanically strong, and resistant to weathering, and cleave in a manner which provides flat smooth faces that are ideal for ornamenting. Lower Palaeozoic is not native to the immediate area of Brugh na Bóinne. It is, of course, possible that some could have been deposited as dispersed erratics in the area by glacial activities, but they do not occur in the drift. Indeed the lack of scour detail, the preservation of deliberate primary bedding plane features, and their exceptional size preclude a drift origin for most of them. Thus, it seems that they were quarried.

As McCabe and Nevin indicate, 'greywacke and related rocks can be found in the Lower Palaeozoic Silurian zone of Longford/Down, whose southern extremity extends to within about 5 km north and east of Knowth. Outcrops exist even today in that region, and it may have been somewhat similar outcrops, still more common in early times, that provided the source for the megaliths. The Lower Palaeozoic greywackes in this zone occur in a repeated sequence of graded beds, which may be separated by layers of shale or mudstone. This produces two contrasting lithologies. The greywacke is hard, but the intervening strata are softer and usually develop a slaty cleavage, or natural planes of weakness, along which fractures can be induced easily. The alternating strong and weak lithologies of these strata, combined with tectonic jointing, will therefore result in tabular blocks of massive greywacke, the largest of which will have approximately the same dimensions as the kerbstones at Knowth.'

McCabe and Nevin further point out that the 'nature of the stratification would have facilitated simple quarrying. Starting at the face of an outcrop, it would not be hard to excavate the shale and expose, or undermine, larger areas of a slab. Wooden levers could then be used to detach blocks, and the undermining might allow some to topple under their own weight. Certain stones at Knowth have fractured surfaces, and may be due to activities aimed at splitting the rock away from the outcrop along bedding planes. In a few cases, the upper faces and edges of the kerbstones are bevelled, and show signs of glacial abrasion. However, one would expect the upper edges of steeply

dipping joint blocks in an exposed situation to exhibit such characteristics. Thus, the presence of glacial scouring on some of the upper faces of the kerbstones does not point to a drift source for the stones. It would actually be a typical feature of quarried joint blocks whose upper surfaces were already glacially scoured.

In order to produce the number of large stones required, a great deal of smaller material would also have been obtained from the more thinly bedded and closely jointed parts of the outcrop. Much of this must have been discarded but, as the heaps of broken rock will have offered a ready source of material for more recent surfacing and stone wall construction, its absence at the present time raises no serious problem.'

The essence of the quarrying technique suggested by McCabe and Nevin is that it exploits the natural form of the outcrop and, in addition, the existence of bedding planes weakened by the weathering of the finer-grained components of the rock sequence. 'The potential production from any one site is consequently limited by its morphology and, more directly, by the penetration of weathering along the bedding and joint planes. This is difficult to express quantitatively, but the maximum depth of the excavation need not have been more than about 3 m. Given such a limitation, along with the restricted occurrence of suitably sized joint blocks, it follows that exploitation of very many sites would have been necessary to provide the number of stones required for the kerbs and passages of the tombs. With the rate of degradation of small, unmaintained excavations which is apparent from a comparison of geological survey records with present-day exposures, it seems likely that these primitive quarries would be scarcely noticeable features of the modern landscape.'

Transporting the stones
In view of the evidence outlined above, it does appear that large stones, some exceeding four tons in weight, were transported to Brugh na Bóinne from at least 3–5 km away. The local terrain, though not arduous, is by no means flat. Between the area of outcrops and the sites is a broad valley, through which the River Mattock flows. From there, the stones would have had to be hauled uphill, and it may be noted that nearly all the tombs occupy the highest points. Wheeled transport or horses for traction did not exist in Ireland at that time, and there is no evidence for the use of oxen. Thus, people were probably the agents of transportation, either by carrying stones or by dragging them – directly on the surface, or on wooden rollers, or mounted on a sledge.

As Professor John Coles of Cambridge University has observed, carrying is the simplest method.[2] Experiments have shown that a stone weighing up to two tons could be lifted by thirty-five men with rope slings and shoulder poles. Still heavier stones must have been dragged. During the excavations of the eastern tomb in Site 1, some capstones averaging about a ton in weight were easily removed by a dozen men, pulling each stone by ropes over movable

wooden rollers. This, however, was on flat ground. At Bougon in western central France, a number of the large stones used in building the passage-tombs there had to be brought from 4–6 km away. In experiments organized by Jean-Pierre Mohen,[3] it was possible for 200 people to pull a stone weighing thirty-two metric tons. Sections of wooden trackway were laid down, consisting of transverse rounded timbers placed on lengthwise timbers. Ropes were then tied around the stone to pull it along over these. For erection, the stone could have been positioned so that one end overlay the lip of the socket, and levered upwards by means of fairly long tree trunks.

Experiments carried out by Professor Richard Atkinson,[4] at Stonehenge in southern England, have shown that it is possible to move large stones over great distances on both land and water. On land, they could be pulled over timber rollers (as postulated for Bougon), or bound to a sledge that was dragged over a somewhat smooth surface. However, it would have been more efficient to pull the stone on a sledge over timber rollers, also enabling the hauling ropes to be attached to the sledge rather than to the stone. A considerable amount of timber, generally oak, would be needed, and had to be cut up and dressed. For Stonehenge, Atkinson speculated that the hauling ropes were made from twisted or plaited hide thongs, and much animal fat would have been required to keep these supple and waterproof.

Atkinson estimated that, to move a stone weighing one ton, twenty-two men would be called for. An increase in the stone weight meant a corresponding growth in the work-force. The average rate of progress was about 0.8 km per day. On these figures, it would take, for example, eighty men up to four days to bring a four-ton stone to Knowth from a quarry 3 km away. Even if one supposed that, on average, forty men would transport a stone every four days, the 400 or so large stones used in the construction of Site 1 at Knowth would have occupied forty men for 1,600 days, or slightly over four years. On the other hand, J. E. Garfitt has argued that just three men could move a ton 8 km in a single day![5]

Other sources of materials

Most of the cairnstones at Knowth are rounded. These could have been collected as surface material, and glaciations would have left a scatter of such stones over the countryside as a part of moraine deposits. A further place of collection could have been the bed of the River Boyne. But some of the cairn stones were quarried and, as they have a sandy composition, their origin probably lay to the south of the Boyne, although some could have originated as waste, a bi-product of quarrying the Lower Palaeozoic rocks.

The additional materials used in mound construction at Knowth – sods, boulder clay, and shale – are precisely the ones which occur naturally. In order to acquire sufficient sods, several acres of land must have been stripped. There must also have been a fair amount of horizontal and vertical digging, so as to

obtain enough clay and shale. Where this took place is not known. A couple of hundred metres to the south, a large pit exists which could have provided those materials, although there is no evidence for its date and it could even be modern. On the northern edge of the site is an escarpment, whose face could have been exploited particularly for shale.

Elsewhere in Ireland, the passage-tomb builders used the rocks that were most readily available. At Fourknocks I and II, the bulk of the orthostats and roof lintels are of carboniferous limestone. These could have been derived from outcrops beside the sites. But at Fourknocks I, apart from one example, all of the decorated stones are green gritty 'sandstones' which could have come from the local Lower Palaeozoic (Silurian) formations. At Carrowkeel, limestone was again the predominant rock used. Outcrops that would provide suitable material occur at several points all over the mountaintop there. Boulders were employed extensively at Carrowmore and, as this is a gravelly area, such boulders would be readily available – indeed, similar boulders can be found in the region today. The tombs at Sliabh na Caillighe (Loughcrew) and Sliabh Gullion could have been built using stone obtained in the immediate locality.

Constructional features and comparisons

The design of passage-tombs such as those of Knowth achieved a balanced layout for both kerb and tomb. Great thought and care went into this; for instance, the large stone basin would have been too big to be brought into the eastern tomb after the passage's construction, so instead the tomb was designed around it. The circumference of a circular kerb could be established by using a string tied to a central peg, although other methods had to be employed in tombs where the kerb curved inwards. There is no evidence that the structural stones were shaped or altered for purposes of building. Flakes were detached from a number of them, but this could have been due to quarrying. On several structural stones, 'pick dressing' is seen, especially at Knowth and Newgrange; yet it may be part of a decorative design, rather than a structural modification (Chapter 7).

Basic to the construction of a passage-tomb was the erection of upright stones – tomb orthostats and kerbstones. It would have been possible to lever a large stone into position by skilful use of rollers and ropes, as Richard Atkinson has demonstrated.[6] In some instances, orthostats such as Nos. 1–2 of Site 15, and much more often kerbstones, were placed on the old ground surface. When this was done, small wedge-like stones were normally inserted along the base so as to stabilize the stone. Certain kerbstones of Site 1 at Knowth were actually sitting up on propstones. In building the tombs, the standard method was to place the orthostats lengthwise in holes or in a trench which was then backfilled.

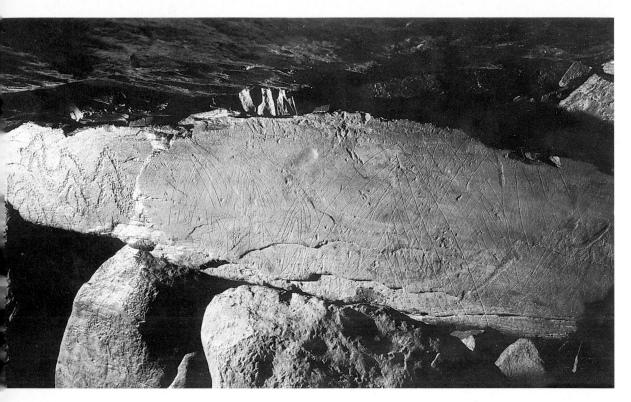

Techniques of decoration at Knowth

Corbel 41 over the inner orthostats on the left-hand side of the western tomb chamber, Site 1, showing angular designs in both the incised (centre) and picked (left) techniques.

45 Detail of decoration on kerbstone 73, Site 1, to show the technique of close picking. Note that the main design cuts across earlier motifs. There is a band of pick-dressing along the top.

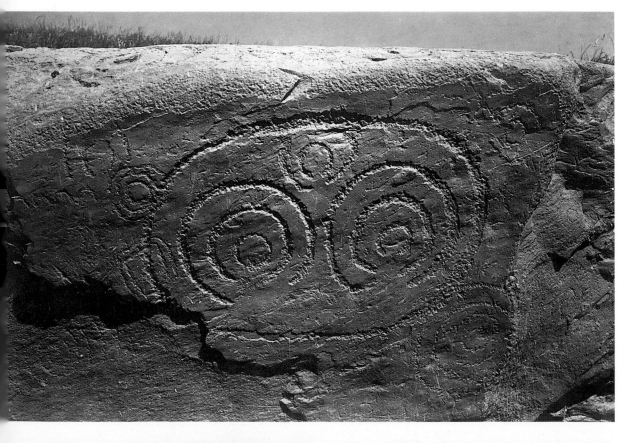

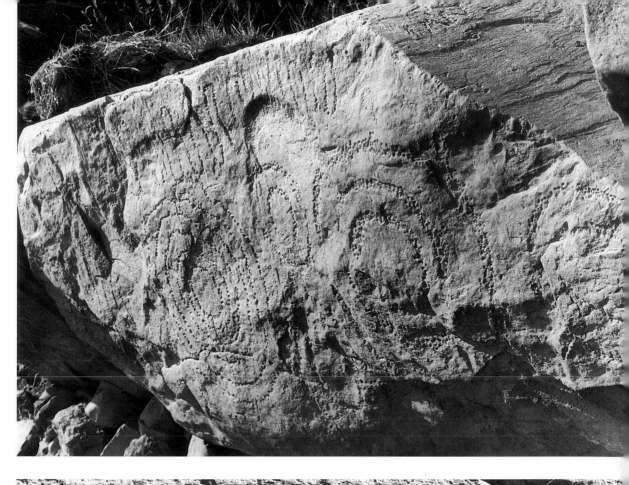

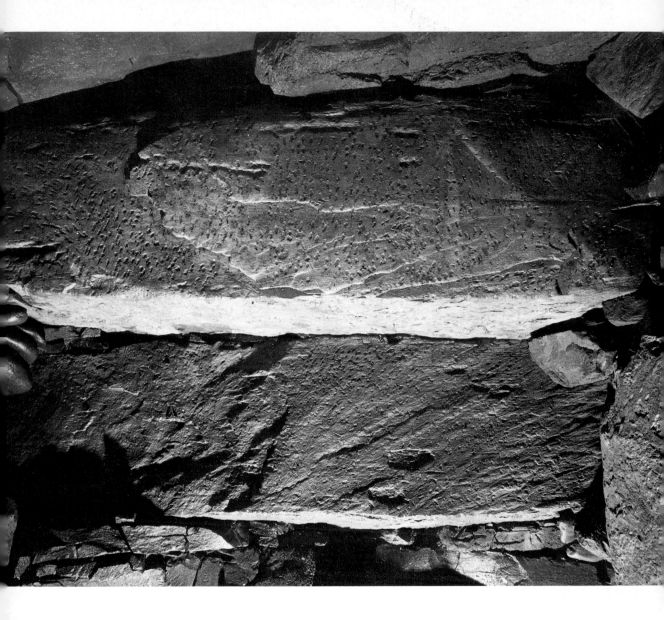

6 Kerbstone 4, Site 1, is predominantly decorated in the rcular style. The technique involved the use of a pointed unch'; within each line the marks are slightly dispersed, either ultiple or single.

7 A detail of kerbstone 74, the entrance stone to the western mb, Site 1, showing the use of a chisel-like implement.

8 Corbels over the end-stone of the western tomb chamber, te 1, showing the technique of pick-dressing loosely dispersed.

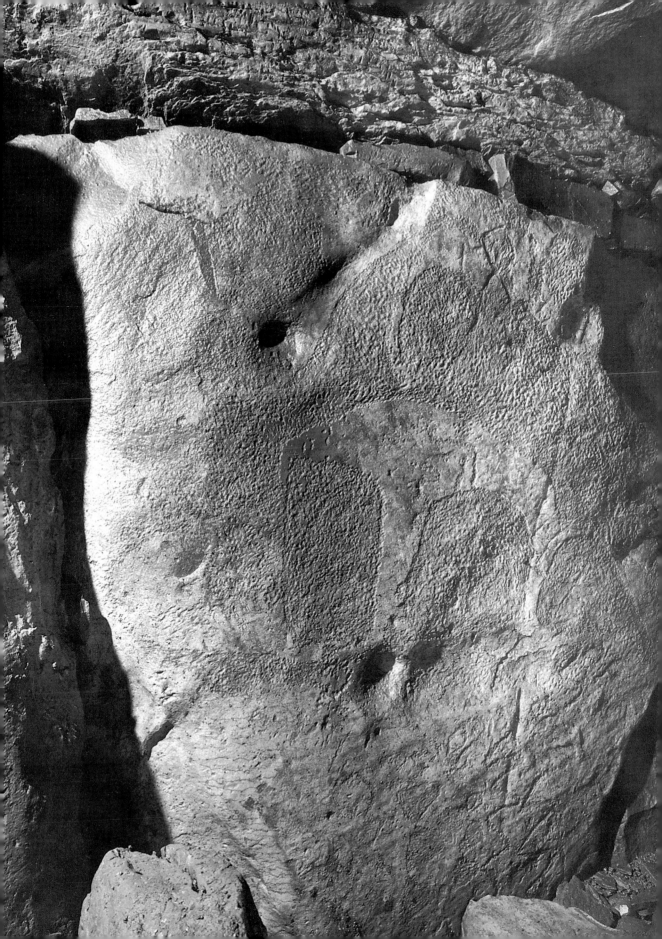

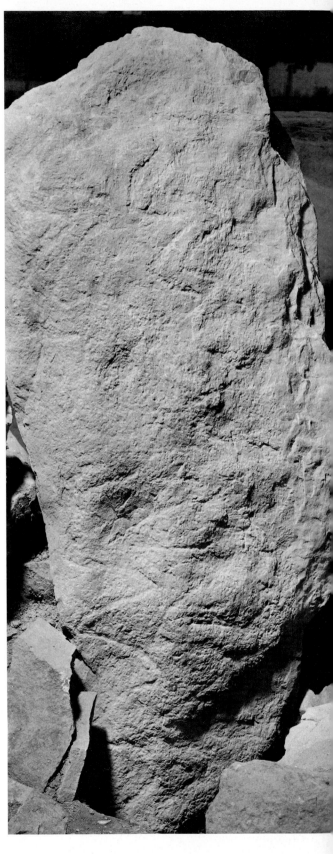

(*opposite*) The innermost orthostat (No. 41) on the left-hand
of the western tomb chamber, Site 1, at right-angles to the end-
e. Close pick-dressing obliterated part of an earlier design in the
lar style; the area in the centre was left untouched and thus
me a new motif.

e angular style

(*above*) Angular style 1f: north face of orthostat 13, Knowth
16.

(*right*) Angular style 1d: orthostat 9, Knowth Site 16.

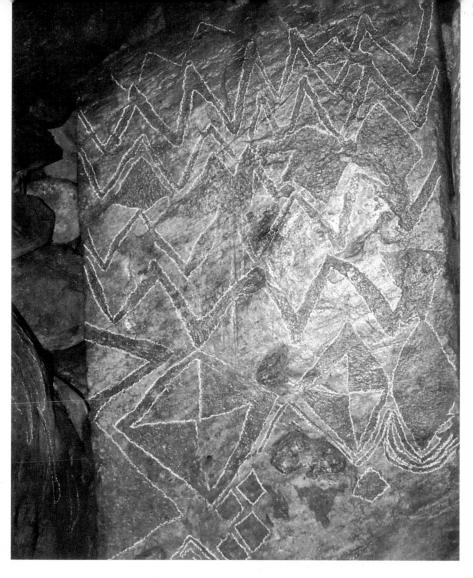

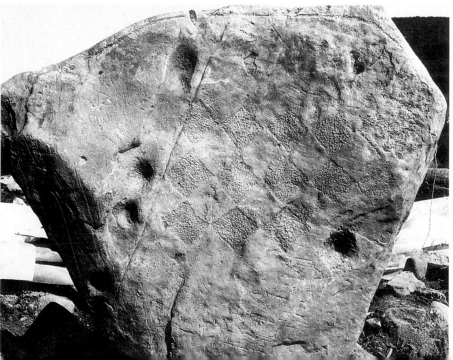

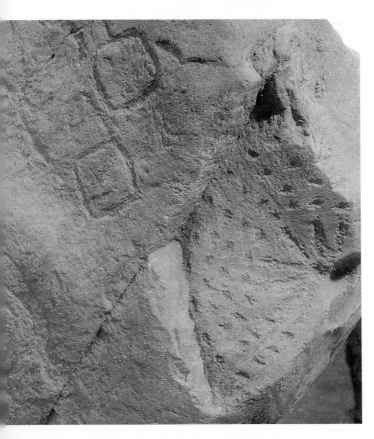

52 (*opposite, above*) Angular style
1c (chalked in): orthostat 48 in the
eastern chamber, Site 1, at Knowth.

53 (*opposite, below*) Angular style
1e: Stone A face 2, Knowth Site 4.

54 Radial motif (right of picture):
orthostat 8, Knowth Site 14.

55 Angular style 1b: corbel 6A in the
eastern chamber, Site 1, at Knowth.

The angular-spiral style

56 Angular-spiral style: capstone 32
in the eastern passage, Site 1, at
Knowth.

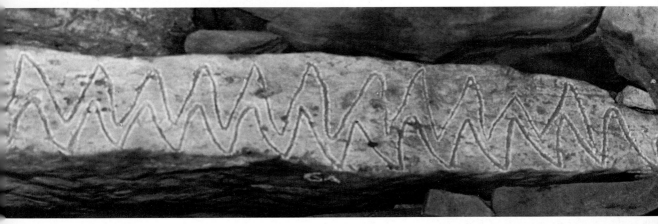

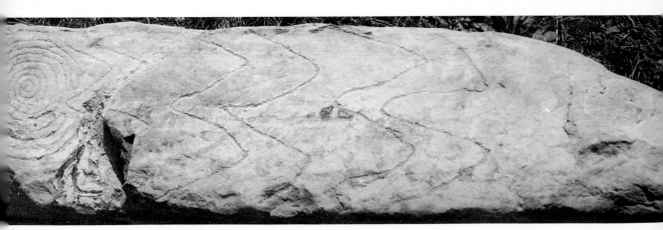

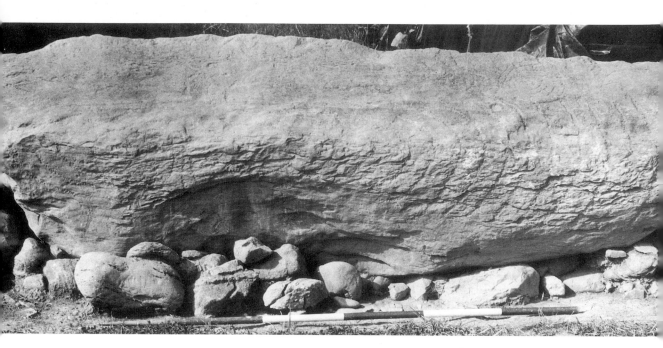

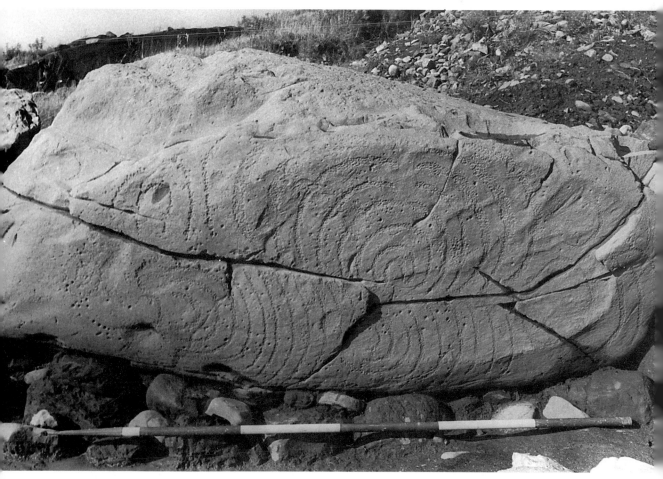

The nested arc style

57 Large nested arcs: kerbstone 2, Knowth Site 1.
58 Large nested arcs (related tradition): kerbstone 16, Knowth Site 1.

The serpentiform style (*opposite*)

59 Kerbstone 17, Knowth Site 1.
60 Kerbstone 57, Knowth Site 1.
61 Kerbstone 14, Knowth Site 1.

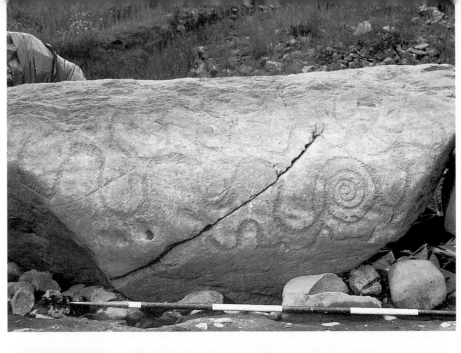

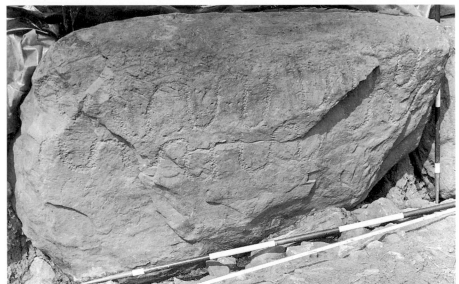

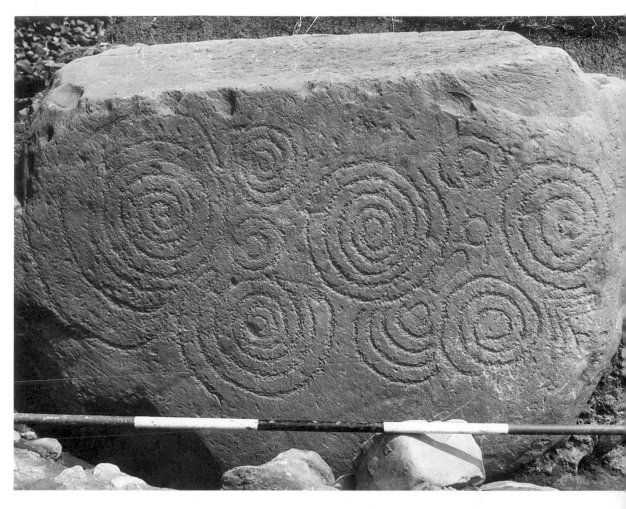

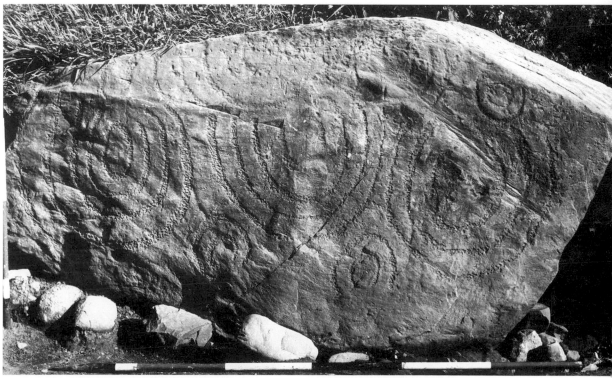

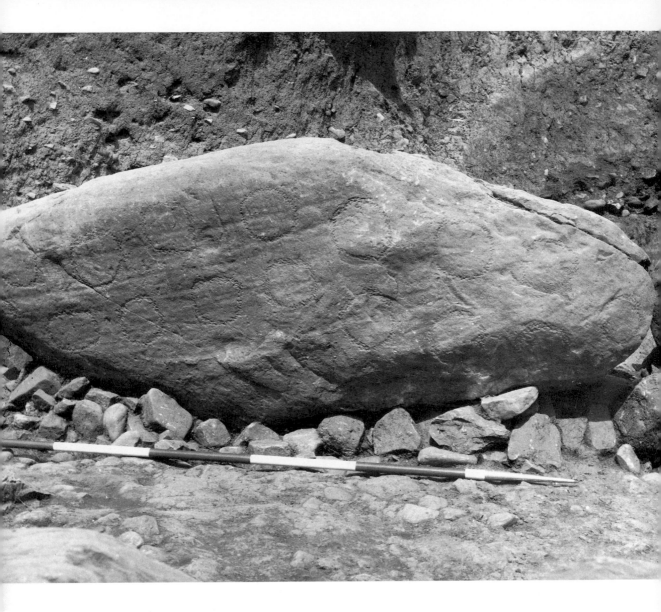

...e spiral style

Kerbstone 56, Knowth Site 1.

...e circular style

Kerbstone 94, Knowth Site 1.

...e dispersed circle style

Kerbstone 42, Knowth Site 1.

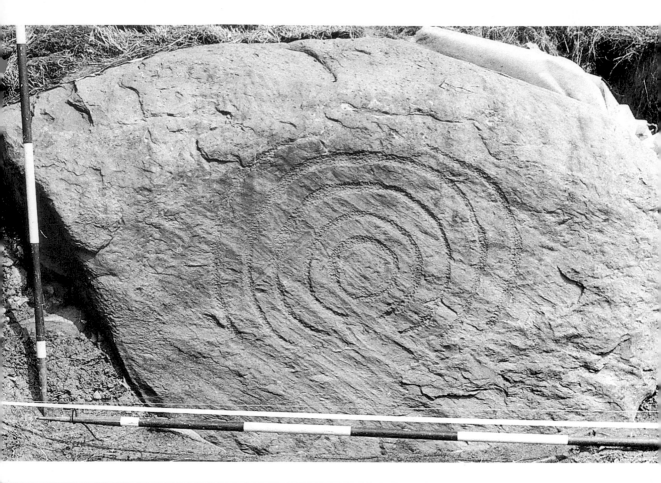

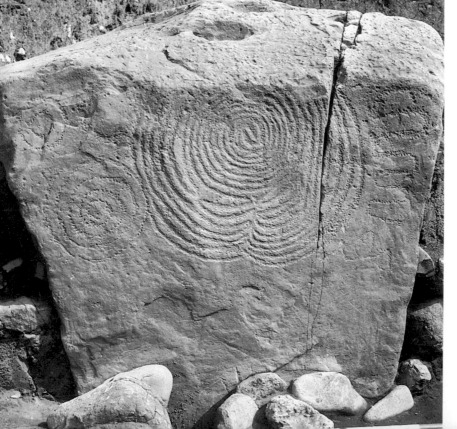

The prominent central motif style

65 Kerbstone 69, Knowth Site 1.

66 Kerbstone 51, Knowth Site 1.

The opposed C's style (*opposite*)

67 Kerbstone 86, Knowth Site 1.

68 Opposed C's (related style): kerbstone 5, Knowth Site 1.

69 Opposed circles (related style): kerbstone 79, Knowth Site 1.

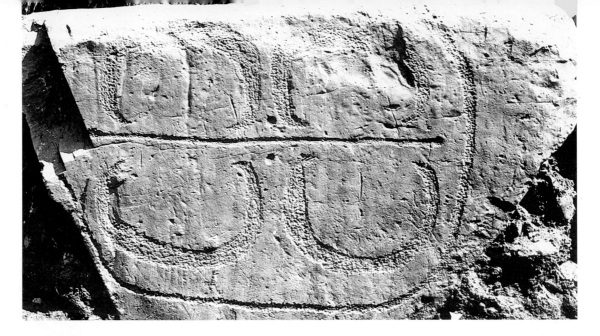

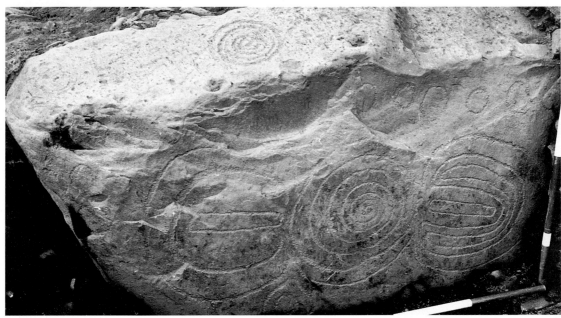

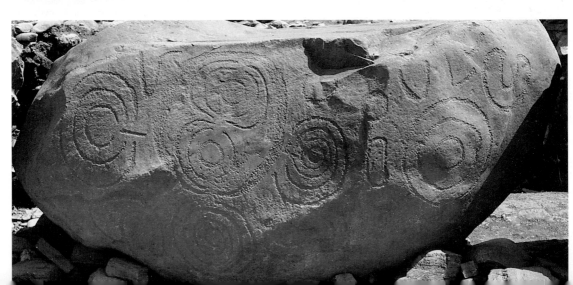

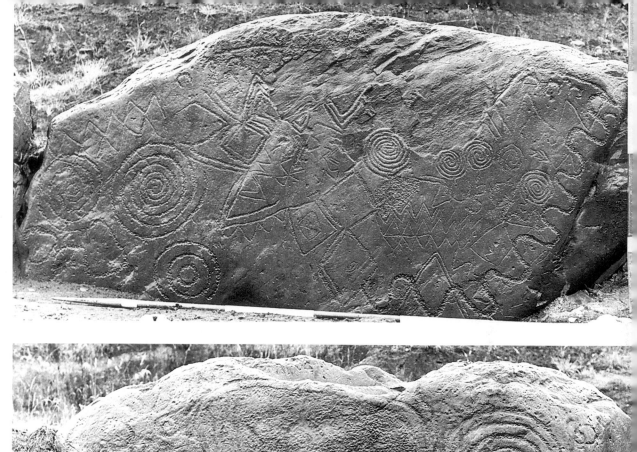

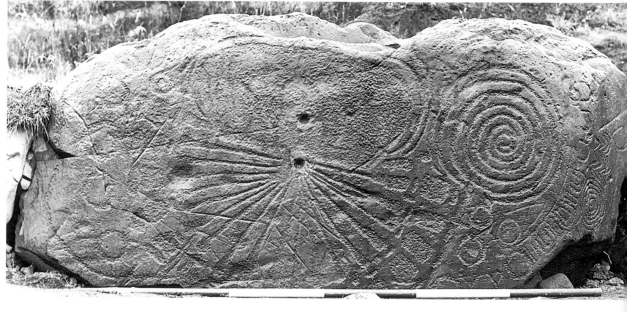

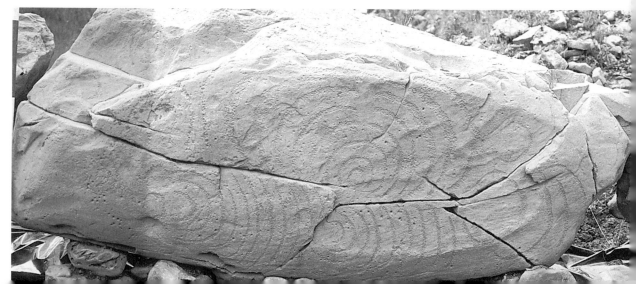

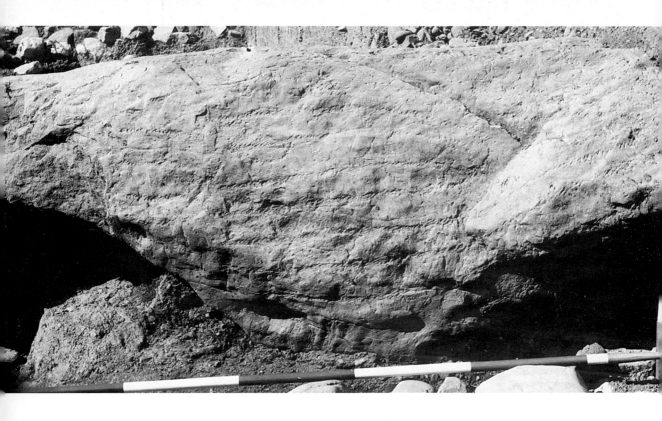

e lavish style (*opposite*)

Kerbstone 13, Knowth Site 1.
Kerbstone 15, Knowth Site 1.
Kerbstone 16, Knowth Site 1.

The linear style

73 Kerbstone 29, Knowth Site 1.

The random style

74 Orthostat 8, outer face, Knowth Site 14.

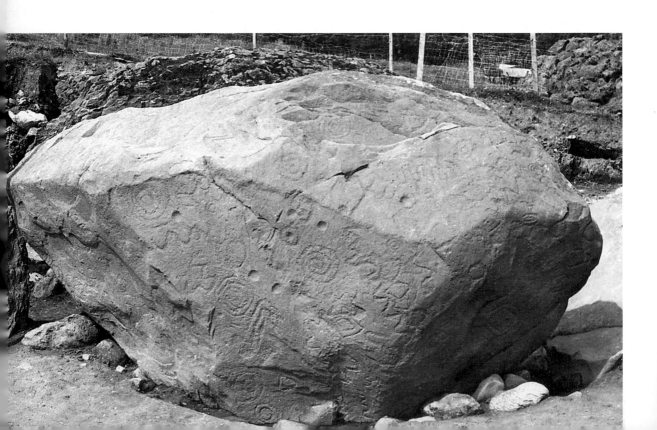

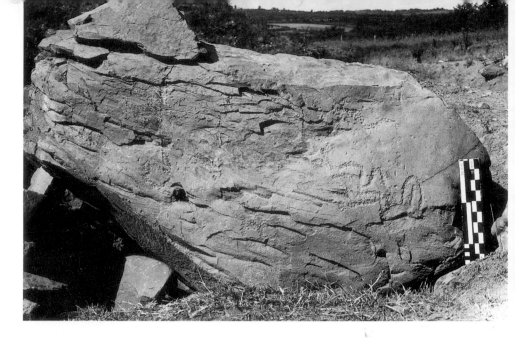

The 'unaccomplished' style

75 Stone 8, Knowth Site 5.

Miscellaneous styles

76 Kerbstone 52, Knowth Site 1.
77 Kerbstone 92, Knowth Site 1.

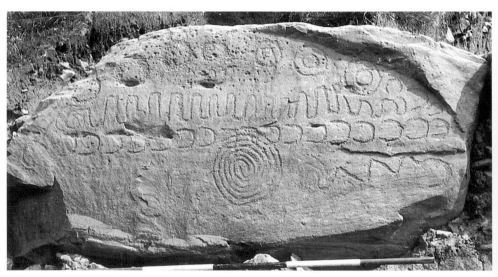

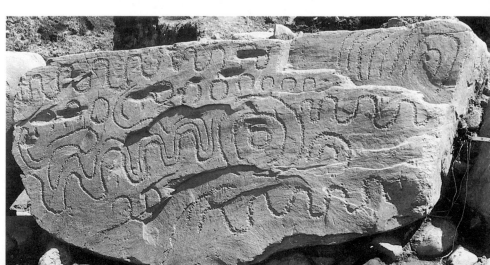

One may speculate that pointed sticks or antlers were used to dig the sockets. For removal of the clay, a shovel made from the shoulder blade of an ox was employed. An example with wear along the edge was found at Knowth, in the left-hand recess of the eastern chamber in Site 1. Comparable objects are known elsewhere, as in England at Stonehenge and the Cissbury flint mine in Sussex.[7] Usually individual holes were dug for each stone, but sometimes stones stood in a trench, as in the eastern passage of Site 1 or orthostats 12–14 of Site 2 at Knowth. In form, the sockets vary from shallow scoops to well-made holes. Again, packing stones were normally inserted around the upright stone. There are also instances of skilfully propping a stone's end in order to create a level plane at the top (Site 2 orthostat 27, Site 18 orthostat 7). Indeed, as has been pointed out, some of the kerbstones in Site 1 suggest that the builders' aim was to achieve an even and horizontal line at the top which occasioned the propping of some stones and the lowering of others in sockets.

It can be assumed that the tomb orthostats were erected first because this would have been more convenient. However, at Site 17, an area around the tomb had a fill of material differing from that in the main body of the mound, with sides that sloped in towards the tomb. A somewhat similar feature occurs at the outer part of both passages in Site 1. These cases may be explained by the fact that the tomb and mound were constructed simultaneously, but that an area was left clear so as to facilitate the ongoing work of building the tomb. Professor O'Kelly recorded a similar effect at Newgrange ('embrasure cutting').[8]

Practically no signs of roofing have survived from the smaller Knowth tombs; the best are the remains on the outer part of the passage in Site 13. However, superb evidence exists from both tombs in Site 1. The main part of each passage was roofed by placing flagstones transversely. These could have been hauled into position up a ramp formed by the unfinished mound. It is tempting to think that this was the purpose of the cores that occur in some of the small tombs, but this does not appear to be so, since the cores are either too restricted in area, too low, or have formal features such as a kerb or stone settings. The flagstones rested directly on the tops of the orthostats, but, if the latter were uneven in height, the space was filled by a small and usually flat stone. On the horizontal, spaces between capstones were often filled with small stones. It was normal for the passage to increase in height inwards, for which greater use was made of dry-stone work. This is especially noticeable in the inner part of the passage of the eastern tomb in Site 1, where a unifaced wall was built above the orthostats.

For cruciform tombs at Knowth and elsewhere, and for the larger rounded tombs, beehive-shaped roofs were the standard type. They spring from the tops of the orthostats, and were constructed by the corbelling technique – the jutting out of stones in each overlying course so as gradually to narrow the spanned area. Such construction displays considerable skill. At Site G of Carrowkeel, the corbelled roof is elongated, and extends from the end of the

passage to the end of the inner recess, although reaching its maximum height over the chamber. This site has a prominent, pillar-like orthostat at each of the four corners of the polygonal chamber. A rather similar arrangement is found in the north tomb at Dowth. In addition to the main corbelled roof, the three recesses at Site K of Carrowkeel tend to have independent beehive-shaped corbelled roofs.

It is particularly Fourknocks I that gives clear evidence of the method employed in stabilizing the orthostats and beginning the roof. A solid ramp of clay was packed against the lower half of the orthostats on the outside. Overlying this, and extending as far upwards as the top of the orthostats, were two or three courses of heavy blocks of stones. Thus, in conjunction with the orthostats, a 'foundation' was created on top of which, around the chamber, thin flagstones were laid. These locked the orthostats and the stone packing into the mound, as 'intercalary' walling. Stones were placed on the outer ends of the flags. Hartnett considered that these acted as counterweights,[9] helping to distribute more equally the thrust of the corbelled roof, which started from the flags. Of course, due to the large size of the Fourknocks I chamber, it may not have been possible to complete a beehive-roof. Hartnett suggests that the roof was finished by using timbers supported on a central post. Such a support has parallels in the Iberian passage-tombs at Praia des Maçãs and Baranquete No. 7.[10]

At sites such as Newgrange, Carrowkeel F, and Sliabh Gullion, small packing stones were placed between the rows of corbels, and flush with their visible (inner) face. This packing caused the corbels to tilt downwards at the back. It is usually thought that the tilting was a device to direct rainwater away from the chamber. But Collins and Wilson suggested that the purpose of the tilting in the corbels at Sliabh Gullion was, as at Fourknocks, to counter the thrust which the weight of the cairn would have exerted on the roof.[11]

Regarding other aspects of roof construction, attention may be drawn to diagonal stones ('squelch stones') which were placed across the corners of the roof of Carrowkeel F. This was a device to reduce the length of the space being spanned. A flagstone resting on dry-stone work above the orthostats, as in the western tomb of Site 1 at Knowth, was probably the method used in roofing the undifferentiated tombs. In the chamber of Site 16, some dry-stone work survived on top of the orthostats. Here, and in Site 15, some flat stones were also found in the chamber fill.

6 Burials and grave goods

Virtually every Irish passage-tomb that has been excavated is a source of evidence for burial. Both sexes and various age-groups, ranging from small children to adults, are attested. Cremation is the predominant burial rite, but information about crematoria for this purpose is slight. The only possible example is the trench which was dug into the subsoil and underlying rock at Fourknocks II. The sides and bottom of this trench were reddened by intense heat, and there was a substantial deposit of charcoal over the floor. While one of the cremation deposits (in Pit I) might have been a formal burial, the other three deposits tended to be more scattered. These were mixed through earth and charcoal, and may have resulted from cremation *in situ*.

The importance of burial as a rite is shown by the fact that it took place during the construction of some passage-tombs but before the building of the mound. At the Mound of the Hostages, Tara, there were two adjoining compartments made from small flat stones, set on the old ground surface beneath the mound, and containing cremated bone as well as a pottery vessel of 'Carrowkeel' ware. They were outside the tomb next to its northern side. Also external, but on the south in the angle between the outermost stone of the tomb – the south portal – and the adjacent orthostat, was a cremation deposit in another vessel of 'Carrowkeel' ware. The grave goods consisted of a mushroom-headed bone/antler pin and a necklace of beads (see below). A small triangular-shaped cell outside the eastern side of the chamber at Newgrange K contained a skull, teeth, and long bones, and five unburnt fragments of both human and animal bone.[1]

At Belmore (Moylehid), in the external angle between the left-hand recess and the end recess, a lean-to slab formed a small compartment which held animal bones, boars' tusks, and some unburnt human bone including a skull. In the report, it is claimed as a secondary feature,[2] but it is on the old ground surface and, as Professor Michael Herity states, no argument is put forward for that claim.[3] At Newgrange L, 'extensions of the sockets of the backstone of the end chamber and another of the structural stones' held the remains of an adult.[4] There were cremation deposits between the orthostats at the four corners of the chamber of Carrowmore 7. Göran Burenhult says that these were partly put into the dry-walling with stone slabs between the orthostats,[5] in such a way that they must have been deposited 'at the actual erection of the monument'. Pieces of charcoal, burnt seashells, and parts of an antler pin were

also present. Further, it appears that there were burials outside the chamber. 'Three of the cremations were placed in immediate connection with stone 32 outside the chamber entrance, two in stone packing of the foundations of the stone-circle, two were found in pits.' There was, moreover, a cremation between two stone slabs outside the kerb on the southeast side.

At Fourknocks I, in addition to the main deposits, small piles of cremation lay in spaces between the bottoms of the passage orthostats. On the outside, they were sealed by a thin flagstone or a patch of dry-stone facing, flush with the line of orthostats. Another pile occurred between orthostats 9 and 10 of the chamber. At Site G of Carrowkeel, one of the chamber orthostats on the right-hand side did not reach the roof, and 'bones of children' were found in the intervening spaces.[6] Behind the two orthostats on the northwest side of the left-hand recess was another cavity, but whether anything was found in it is not stated in the report. Carrowmore 4 had two cists in the line of the outer setting of stones. Cist A held a cremation, the remains of a male and a female, and a stone bead, while Cist B yielded the cremated remains of an individual (sex not determined), a stone bead, and portions of antler pins. However, Burenhult considers it most likely that the cists were placed in the monument after the final use of the central chamber.[7]

Knowth and other Irish passage-tombs

Knowth reflects the general burial practices of the passage-tomb builders. Since cremation is the predominant rite at all the Irish sites, it is difficult for an anatomist to establish the number of individuals present, but this ranged from one at Sites 3, 4, 13, and 18 of Knowth to over a hundred at Tara.[8] Such tombs were easy to enter, and the large tomb at Newgrange had a flagstone which could have served as a kind of door. In Site 13 the flag between the outer pair of orthostats and the kerbstone may have had a similar function. Multiple or collective burial implies that tombs were used on successive occasions, each involving the interment of either a single person or several at once. In the former case, a tomb may have been opened whenever a member of the community died, while in the latter – denotable as simultaneous multiple burial – the remains must have been kept elsewhere for a time if the deaths did not all coincide.

In some tombs, such as Knowth 16, successive burials may be single or multiple: there is no exclusiveness or consistency of proof. Fourknocks I provides good evidence for multiple burial in each of the three recesses, but there was no succession. When each recess received its quota, it was 'sealed down and was not re-opened for successive burials'.[9] In relation to the burials in the passage at Newgrange K, Professor O'Kelly states that the deposit 'had remained quite undisturbed and it was clear that this had been put in as a mixture of soil and bone fragments . . . exhumed from elsewhere and brought as a mixture of soil and bone to be deposited in the passage extension at one

moment in time'.[10] It may well be that the remains were kept until a special day on which they were committed to the tomb. If this was the case, one could assume that other ceremonies were part of the burial rite, some perhaps taking place in the open air (see below). Indeed, the recessed areas before the tombs at Knowth I with their settings of stones, the spread of exotic rocks, and so on, may belong to the material remnants of such ceremonies.

As shown by Knowth and other sites, various methods of deposition were employed. Placement of burials directly on the old ground surface was common, and is known at least from Knowth Sites 1 (eastern tomb), 3, 4, 6, 9, and 12–18, as well as from the four Newgrange sites, Sliabh na Caillighe (F, H, L), and Carrowkeel (B, E, G, H). The deposits were placed on a flagstone in the end recess of Knowth 1 (eastern), 16, and possibly 18, as well as Fourknocks I, Tara (interior), Sliabh na Caillighe (I, L), and Carrowkeel E, and on small flat stones in Knowth 15. The flagstone occupied the entire recess, as in the end recess at Knowth 1 (eastern) and at Fourknocks 1.

The uppermost deposits were not covered at Knowth 1 (eastern) and 16. But the deposits were covered by stones – either flags or small flat pieces – at Knowth 18, Fourknocks I, and Sliabh na Caillighe (I, T), and by a basin in Sliabh na Caillighe L. Successive deposits were also covered. At Knowth 1 (eastern), some of the deposits were separated by a layer of silt-like material, or by small flat stones, while in Sites 15 and 16 they were clearly demarcated from each other by a flagstone or by small flat stones. At Carrowkeel, the small flat stones termed 'trays' by Macalister served a similar function.[11]

Sometimes the remains were in a container. This consisted of a 'Carrowkeel'-type vessel in the southern external burial at the Mound of the Hostages, Tara, already mentioned. Sherds of similar ware from Knowth (2, 3), Newgrange L, Baltinglass (II, III), and Carrowmore 27 may attest other such containers. However, there is no clear evidence that complete pottery vessels were placed within the tombs as they were in the continental passage tomb. But the most elaborate containers were the stone basins. In addition to the three examples in Site 1 and one in Site 2 at Knowth, there are four in the large Newgrange tomb, one in Newgrange Z, one in Dowth north, two in Baltinglass (tomb chamber and 'immediately outside the chamber of tomb III'), two in Site L and one in Site W at Sliabh na Caillighe, one in Knockingen, and three in Sliabh Gullion. Only in Newgrange Z and Baltinglass III did part of the cremation survive in the basins.

In the cruciform tombs, the basins are generally in the recesses, although at Dowth (north) a basin is in the centre of the chamber. In the undifferentiated sites, they are in the chamber area. The best-made and most highly decorated example is that in the right-hand recess at Knowth Site 1, eastern tomb (Chapter 7). These basins are usually circular, but the Dowth basin is sub-rectangular as is, more or less, the Baltinglass I basin. In contrast to Knowth 1 (eastern), some of the basins show only rudimentary workmanship, as at Baltinglass I and Sliabh Gullion. Apparently the latter were 'natural

basins, engraved in varying degree by hammer-dressing'.[12] Besides Knowth 1 (eastern), there is art on the basins at Knowth 2, Newgrange Z, and Baltinglass III, while the upper basin in the right-hand recess of Newgrange bears cup-marks.

The remains were normally confined to certain parts of the chamber. As has been described, in the Knowth undifferentiated sites and in the similar tombs at Newgrange (K and Z), burials occurred in the chambers and in the inner parts of the passages. Townleyhall had only a few fragments of cremation, in the passage not far from the entrance. Within the Mound of the Hostages, Tara, burial was limited to the two inner segments. Carrowkeel B had burials in the chamber, and at Site H they were in both passage and chamber. In the cruciform tombs, the burials were usually found only in the recesses, whereas burials in the central part or in the passage are rare.

Further comparative data

The number of persons buried varies from tomb to tomb. At Newgrange (large), the remains discovered – probably only part of a much greater deposit – represented four or five people. Figures are not available for Newgrange Sites L, K, and Z; but, except for one child, the bones belonged to adults. Fourknocks I provided fairly comprehensive data. The right-hand recess held the remains of ten individuals: six were cremated (five adults and one child), four inhumed (two adults and two children). The end recess also yielded ten individuals, eight cremated (all adults) and two inhumed (children). In the left recess were three cremated adults and one inhumed child. The entrance passage revealed twenty-eight individuals, nine cremated (seven adults and two children) and nineteen inhumed (nine adults and ten children). There were other pockets of burials representing thirteen individuals, five cremated (all adults) and eight inhumed (five adults and three children).

This gives a total of sixty-five individuals at Fourknocks I, but it must be emphasized that the figures are minima. About four-fifths of the total bulk of the bones were cremated. The inhumed remains were usually incorporated into the cremation deposits, but 'in so far as these were separable from the cremations' they consisted chiefly of groupings of skulls and disarticulated long bones, while the smaller bones were seemingly burnt. As Hartnett has pointed out, many children were represented and only a small proportion of these were cremated, whereas a higher ratio of adults was cremated. In the passage, however, inhumations predominated, with nineteen out of twenty-eight individuals. The age of the adults varied between twenty-five and fifty years, and the sex was recognized in the cases of three males and one female. Among the children, seven died around birth, six in the first year, three in the second, and one at five years of age.

Records of the Sliabh na Caillighe burials are not comprehensive. As far as can be determined, all are cremations. Remains came to light at Site F in the

southern recess, at Site H in the passage and right-hand (northern) recess, at Site I on and under stone slabs in four of the compartments and under the flagstone in the fifth compartment, at Site L in the chamber and under the stone basin in the inner right-hand recess, at Site S in the two segments of the passage, at Site T under the flagstones of the central chamber, at Site U in all recesses, and at Site R2 – a possible cruciform tomb – in the chamber area.

At Carrowkeel, too, the rite was cremation. Burials were in the recesses at Sites E, F, G, and K. In addition, remains of burials were found in the chamber at Sites F and K. Unfortunately, the burial deposits from the separate Carrowkeel tombs were grouped together and not presented individually. The minimum total of persons given is thirty-one, with at least twelve females. All excavated tombs produced a small number of children's bones.

At Carrowmore 7, a polygonal chamber, the burial was disturbed and, apart from the cremations between the orthostats (see above), the other material was interfered with. At least seven people are represented, generally young, although one was middle-aged. The sex of only two individuals, both female, was determined. In Site 26, the cremation deposit attested a person who was probably a female aged between twenty and thirty. The human remains in the chamber of Site 27 consisted of at least six individuals, ranging from late teenage to middle-aged. Site 4 contained some unburnt remains of at least two individuals, and a large quantity of cremated bone, weighing 31.2 kilograms, attesting a minimum of seven individuals.

Cremations were also found in the central chamber of Baltinglass III. The inner recess held 'large quantities' and there was a scatter in the passage. These remains belonged to at least two adults and two children. Tomb II had cremations in all recesses and in the centre of the chamber, representing at least two young adults. At Belmore, cremations were in the passage, and in the end and right-hand recesses. At the simple sites of Sliabh na Caillighe W, Ballynahatty 2, Sess Kilgreen, and Fenagh Beg, the burials were in the chambers.

Regarding the unusual sites, burials were in both the megalithic passage and in the trench at Fourknocks II. At Millin Bay, burial occurred at the narrower end of the chamber, using inhumation and representing at least fifteen people. At Carrowmore 4, it was in the chamber. In the damaged sites of Knockingen, Sliabh na Caillighe X (northern) and X (middle), Kiltierney, and Carrowmore 26, cremation was found around the centre of the monument at a point where a chamber could have stood.

Types of grave goods

Some burial deposits, such as Knowth 16, did not have grave goods, but on the whole it was the practice to place objects with the remains. However, where it has been possible to demonstrate the presence of different burials in the same tomb, for example at Knowth 1 (eastern) and Site 16, grave goods may or may not have existed in the separate deposits.

The number of grave goods from a deposit and tomb varies. The smaller tombs at Knowth produced, on average, only a couple of objects each. Yet the Tara tomb, a modest structure, produced up to 150 objects, the largest number from any single tomb. Grave goods were selective in nature and materials. Stone implements were rarely deposited and, where categorical evidence is available, these consist merely of chips of flint. The most common items are things that could have been used for personal adornment or wear, particularly pendants, beads, and pins. Some of the pins are so large that they must be reckoned as prestige objects. Several, especially pins, have been damaged by fire and occur mixed through the burial deposit, suggesting that they were left on the deceased during cremation.

There is only one instance of a coherent grouping of goods, from the southern external burial at the Mound of the Hostages, Tara. Mixed through the cremation burial in the pottery vessel were fifteen beads and pendants which formed a necklace when strung together, as well as a mushroom-headed bone pin.[13] Could this be the burial of a female of rank, who wore a cloak fastened by a pin, and who, due to her importance, was accorded a 'single' burial among what otherwise were largely communal deposits? Indeed, was it her death that occasioned the building of the tomb?

Pottery has been found in about twenty tombs. But, as is clear from its absence in some closed contexts, such as Knowth 16 or Fourknocks 1, there was no practice of placing pottery in every tomb. The pottery had different functions: at Tara, one pot served as a container for a cremation burial, while another stood beside a similar deposit, but both were outside the chamber and therefore 'hidden'. At Carrowkeel G and K, and at Kiltierney, the pottery occurred as sherds mixed through the burial deposit. In those cases, a pot was broken and its sherds, or some of them, were used as grave offerings. Due to inadequate recording in some of the sites investigated early on, or else to damage of the tomb as at Knowth, the original position of pottery in many sites is not known. However, the number and variety of sherds from Sliabh na Caillighe R2 suggests that at least five vessels are represented. The other common item is a marble or ball, usually made of chalk, although natural pebbles were used too. As such objects are apparently non-utilitarian, they must have had a strictly ritual value.

The covering mounds have also yielded finds, but it is difficult to know whether these were dropped casually by the builders or deliberately inserted for ritual purposes. The only type of item that is common to both tomb and mound is 'Carrowkeel' ware. The usual mound finds are flints, principally scrapers and the occasional stone axehead.

The objects from the tombs, supplemented by finds from habitation sites (see below), provide good evidence for the use of artefacts and their manufacture by passage-tomb people. A standard form of pottery, termed Carrowkeel ware, was employed.[14] Apart from a vessel which was discovered in the chamber of the court-tomb at Audleystown, County Down,[15] the

Carrowkeel ware does not occur in other kinds of megalithic tombs. There is slight evidence for its occurrence on domestic sites, as at Townleyhall 2 (see Chapter 9). The dark accretion frequently found on the insides of vessels might be due to their use in cooking, so that evidence for domestic use of the ware may come to light as more settlement sites are investigated.

Carrowkeel ware varies in texture, but generally it is coarse and thick, with numerous grits – mainly crushed stone, and sometimes incorporated shell fragments. The composition may be flaky or have a leathery feel. The outer surface has been smoothed down, and there is slight evidence on some sherds for burnishing and for applying a slip. The colour also varies, usually with a buff external surface and a dark inside, but dark throughout on some vessels. Complete or nearly complete vessels are rare, only about five being known. The standard shape was hemispherical. The rim may have a faint in-turn, and the top may be flat or have an outward bevel. One of the best-preserved vessels is from the Mound of the Hostages, Tara. Internally the mouth measured 22.2 cm in diameter, and the walls were up to 25 mm thick.[16]

fig. 88 (1)

Decoration is a feature of the pottery. This was applied to the outer surface, to the rims, and occasionally on the inner surface just below the lip. In general there are no clearcut motifs. An external groove may encompass the mouth. Sometimes the ornament may consist of lines – straight or sagging – but a haphazard arrangement is more common. Regarding the technique of decoration, plain grooves or incised lines, and less frequently scores, were formed with a pointed instrument such as a bone. But the predominant technique was stab-and-drag, or a modification of it such as oblique stabs. This involved inserting the tip of a tool, often with a chisel end, into the soft clay, then pulling it out and reinserting it, repeatedly.

Maceheads are represented by two examples, both from Site 1 at Knowth. Each belongs to a different class. The pestle example, about half of which is missing, was made from rhyolitic ash-flow tuff. The surface was well polished after shaping, and the surviving end is domed, expanding outwards slightly. The body tends to be sub-oval in cross-section, and has a cylindrical perforation. It was found in the western tomb, lying on a cremation deposit just outside the outermost sillstone in the chamber.

fig. 22

The other macehead, ovoid in shape and altogether more elegant, came from the old ground level at the entrance to the right-hand recess of the eastern tomb. It weighs 324.5 gm and is 79 mm long, made of flint. Both ends are convex and the maximum width is nearer to one end, the cylindrical perforation being towards the narrow end. The body tends to have a square cross-section. Its six surfaces are elaborately decorated. On the top and bottom is a series of lozenge-shaped sunken facets, which terminate along two sides in smaller, more paralleled areas. Two of the four faces, slightly convex, are decorated with a spiral of three turns, its body consisting of three parallel ridges which continue their curve onto the sides to form a flange of two ridges around the perforation. In the centre of the face, these three members coalesce

fig. 57

plates 34–37

plate x

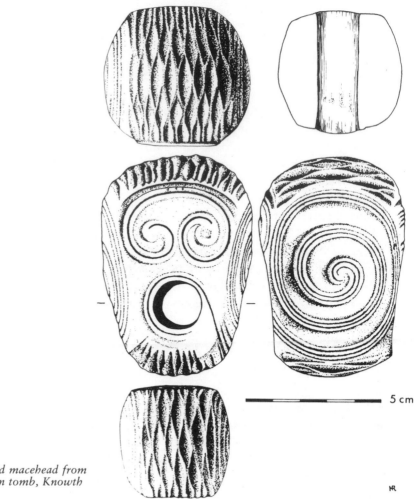

57 *Ovoid macehead from
the eastern tomb, Knowth
Site 1.*

5 cm

into a pointed terminal. On the third face are two bands of three ridges, arranged to form a shallow U-shaped design. The main motif on the fourth face, formed from two ridges, consists of a spiral with inward-curving ends, or a pelta design. Indeed, if one wishes to stretch the imagination, this side has the appearance of a stylized human head, with hair, beard, eyes, mouth and spirals for ears all laid out in correct proportions.[17]

fig. 88 (10–18) Seventy to eighty pendants are known, ranging in length from about 15 to 40 mm. The main group is characterized by domed ends and a body of rounded cross-section, but there are considerable variations. The typical form has one end narrower than the other, while the sides may be straight or slightly concave, and the perforation is usually closer to the narrow end, constituting a 'pestle pendant'. Similar is the type with a flattened body, central perforation, and hammer-shaped outline. Other types include pendants that narrow from the perforated end to the base, which expands into a terminal; those having groove decoration; and squat bilobe, axe-shaped, or triangular hone-shaped

pendants. Rarer forms such as perforated rock crystal and animal teeth are also found.[18]

There are several forms of beads: elongated, ring or flat, round, oval, biconical, spool-shaped, barrel-shaped or oblate; and knobbed. The round or flat bead is most common but, as with pendants, the various forms merge into each other, hindering neat classification. Apart from shape, the beads differ in size, some being only 6 mm in diameter and others twice as large.

fig. 88 (19–25)

In the manufacture of pendants and beads, diverse materials were used: bone, baked clay, limestone, steatite, sandstone, and more unusual or precious stones such as jasper, carnelian, or serpentine. Normally the objects were well finished. The perforations were usually bored from both sides, giving an

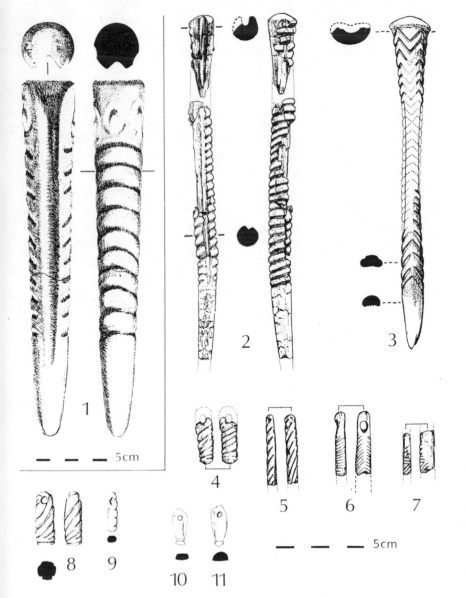

58 *1–2, decorated sandstone object and bone/antler pin from Knowth. 3, antler pin from Fourknocks I. 4–9, groove-decorated pendants (4, Carrowkeel G; 5–6, Sliabh na Caillighe R2 and S; 7, Carrowmore 27; 8–9, Mound of the Hostages, Tara). 10–11, axe pendants, Carrowkeel G.*

143

hourglass effect. It is interesting to note that some of the baked-clay pendants also have hourglass perforations. The boring must have taken place after baking, though one might assume that it would have been possible to insert a plug which would render this unnecessary.

But it is in the two maceheads from Knowth that the skills of boring and manufacture are clearly demonstrated. Not only did both need to be fashioned into shape, which must have been a particularly difficult task, as the ovoid example is made of flint. Both are well-proportioned and, on the ovoid piece, the application of the decoration was an extraordinary achievement of adeptness and dedication. The ornament, besides being regular, is in relief, meaning that the intervening surfaces had to be removed. One can imagine the patience and commitment of an artisan using only a stone tool, possibly another piece of flint or rock crystal, carefully dislodging portions of the surface in order to make the designs stand out. In addition, there is the perforation, whose boring involved the rotation of a tube – possibly bone or wood – while feeding in grains of sand so as to provide the cutting agent. The result was a perfectly cylindrical hole.

fig. 88 (8–9) The balls found in the tombs average 1–2 cm in diameter, but conjoined pairs are known from Newgrange (large) and Tara. Although normally made of chalk, they also occur in baked clay, bone, and stone – limestone, basalt, ironstone, serpentine, quartzite, and marble. The surface is often well smoothed. About forty balls have been discovered in passage-tombs, and there are some finds from other contexts such as *Fullacht Fiadh* at Webbsborough, County Kilkenny, and an enigmatic site of diverse periods at Old Connaught, southern County Dublin.[19] At the latter site, the original monument might have been a passage-tomb since, in addition to several balls, it yielded a seemingly damaged stone pendant and a triangular-shaped bead (or perhaps another pendant), both of which could be at home in a passage-tomb.

fig. 88 (2–6) Several types of pins are represented. Some are short and slender, but there is a very large example, about 50 cm long, from Site 15 at Carrowmore.[20] The bones of various domestic animals – horse, sheep, ox – were used, while a number of pins were fashioned from antler, principally of red deer. Some have been well-shaped and given a polished surface, yet others have been left in an almost natural state, for instance by allowing the anticular end of a bone to provide both a stem and a head.

fig. 58 (3) In addition to the elaborately decorated pin from Site 3 at Knowth (see Chapter 3), there is another from Fourknocks I. Both are damaged and broken by heat. The latter example was made by splitting the shed tine of a young deer, giving a D-shaped cross-section. It is 19 mm long, with a slightly expanding domed head. The ornament consists of a chevron pattern on the rounded part of the body, formed by cutting. Care was taken in its manufacture and the surface was well-polished, even extending into the cuts.

fig. 58 (2) Originally the Knowth pin was probably a little over 20 cm long, but it has not been established whether the material is antler or bone. The slightly domed

head is unexpanded in this case. Approximately the lower quarter of the body is plain, but the remainder is decorated with well-defined channels and ridges placed at an angle. These are discontinuous, as a groove extends down one side.

'Mushroom-headed' and 'poppy-headed' are descriptive titles of other pins. They are fairly substantial, with an expanding head and a round-sectioned body, averaging 15–20 cm long. There are also large pins with unexpanded heads, but in some examples the upper part of the stem is flattened. Slender, or skewer, pins are the most common type, and some consist of nothing more than part of a split animal bone, although others have been well-shaped and finished off.

Hartnett published two polished objects from Fourknocks I which he called 'bodkins'.[21] Both were made from the split bone of a horse. The stem, of round cross-section, tapers from the perforated head to a point. There are other small objects with perforated heads from Sliabh na Caillighe R2 and Baltinglass III. Two objects from Carrowkeel K have a perforation near the pointed end, and Professor Stuart Piggott suggested that these may have been needles.[22]

fig. 88 (7)

Evidence for tools and weapons is found in the mounds and on domestic sites, but not as grave goods. Finshed tools and weapons are not common. Local material was used: for instance, the stone axes from Fourknocks I are made of green grit and shale. In most areas where passage-tombs were constructed, flint of good quality was rare or nonexistent, except in County Antrim. Thus, the raw material was provided by pebbles from the beach or from glacial deposits. Chert was also used, and indeed a large block of that material was found at Knowth. The narrowed end of a heart-shaped pebble from Fourknocks II is pitted and, while its function is not known, it could have served as a hammer for use in flint knapping.[23] It might even have been a dual-purpose tool, as its plain surface is smooth and could have been a burnishing tool for finishing off the surfaces of pottery vessels.

The ubiquitous Neolithic tool, the polished stone axehead, was used by passage-tomb people, as was the hollow and rounded scraper. Sometimes the latter was made from an outer flake knocked off a pebble, and unfinished or crude examples are known, for instance from Fourknocks II. Hollow scrapers are usually fashioned from a well-struck flake or blade. Single, and more rarely double, hollows occur on the same object. The hollow is normally a well-formed semicircle, but some specimens have short and shallow hollows. Blades or flakes with worked edges are also found, and some could have been used as scraping tools, others as knives. The best evidence for a weapon, or perhaps a hunting missile, is provided by the leaf-shaped arrowheads. In their manufacture, these were worked from both surfaces.

Apart from ritual aspects, the range of finds is a source of good evidence for personal ornaments, especially necklaces and pins which may have been cloak-fasteners, but also for more mundane activities such as wood-working and, possibly, the preparation of hides.

7 Art at Knowth and its counterparts

Art is one of the characteristic legacies of Knowth. Wholly nonrepresentational, it consists of geometric and other abstract motifs, placed singly or in combination on surfaces. It occurs on mobile objects, but more particularly on the structural stones of the tombs – orthostats, lintels, corbels, and kerbs. Knowth thus possesses Europe's greatest concentration of megalithic art.

While we may use such terms as art and decoration, the precise function of the ornament is not known. At Knowth and some other Irish passage-tombs, there was in many cases a close collaboration between the architects and artists. Nevertheless, megalithic art does not appear to have been simply an aesthetic element associated with architecture, embellishing aspects of the interior or exterior of a tomb. The latter purpose may have been served by a minority of stones, such as some orthostats in both tombs of Site 1 which have pick-dressing at the shoulders. In the main, however, it seems more likely that the designs were a form of religious symbolism, connected with a cult of the dead and having significance in that context. By applying the art to the stones, the passage-tomb builders may have been making visually permanent part of their ideology and thus allowing it to play a significant role in ritual.

Decoration on mobile objects

The Carrowkeel type of pottery is ornamented, not with definite patterns, but with a series of lines that are sometimes parallel. A large vessel from the Mound of the Hostages at Tara has lines arranged in shallow arcs, while a vessel from Lislea in County Monaghan bears vertical and horizontal lines.[1]

plates 34–37

For ornamentation and balanced proportion, the most elegant mobile piece is the ovoid macehead from Site 1 (eastern) at Knowth, decorated with spirals, lozenges, and arcs (Chapter 6). This is an intricate and well-designed composition that forms a harmonious whole. Its manufacture displays

plate x

fineness and accuracy which could only result from study and practice. The bone object from Site 2, and an isolated conical stone object which was found in a shallow depression near the entrance to Site 1 (western), have fairly similar decoration, with arched or angled grooves that end at a vertical groove.

Another interesting example is the sandstone 'baetyl' block, 49.5 cm long and 30 cm in maximum width, which was found lying on the old ground surface, a short distance east of the entrance to Knowth 12. Its cross-section tends to be rounded, although facets are produced by a flattening on some

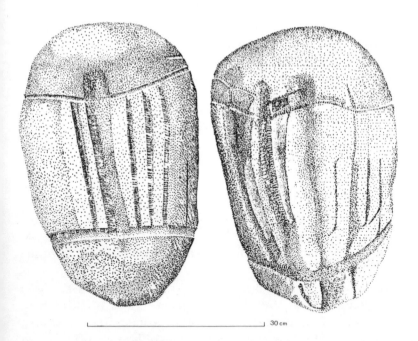

30 cm

59 *Decorated sandstone block ('baetyl') from Knowth.*

faces. The broader end is evenly rounded, whereas the narrow end was not well finished and is rough. Apart from the latter end, the remainder of the surface is picked and one of the ridges was smoothed down. Three of the *fig. 59* 'facets' are decorated with vertical lines, two being adjacent and having three lines each. The third is separated by a blank facet from the other two, and has *plate 30* six lines. At both ends is a horizontal line and, for part of the circumference on the broader end, there is a second line. The channels were formed by picking.

Besides being functional, the four stone basins (Chapter 3) are also works of art. Indeed, these are pieces of sculpture, like the 'baetyl' just described, yet bigger and better. In addition, two of them are decorated. That in Site 2 has a line formed by picking around the interior of the mouth. The most highly ornamented basin at Knowth or elsewhere, though, is that in Site 1 (eastern), *plate VI* with its interior decoration of arcs and rays, and external decoration of horizontal lines, a group of vertical lines, and a circular motif (Chapter 6). *plates 22, 24*

Megalithic art

The application of megalithic art – the term used for art found on the structural stones of megalithic tombs, especially passage-tombs – involved the removal of portions of the surface. This work entailed much time, trouble, and skill, thus clearly indicating its importance. But a curious fact to be noted at the outset is that Irish megalithic art is not found in all areas where passage-tombs occur. It survives at only a dozen or so sites or groups, and these are concentrated in the Meath region. Elsewhere, art is rare and often of poor quality. Perhaps art was not an integral feature of the passage-tomb tradition;

yet – as will be argued below – it played a key role in ritual where it did exist. Hence, one may wonder whether it was originally more widespread.

The rough surfaces of the limestone blocks used in building the Carrowkeel tombs, or the glacial boulders at Carrowmore, would not be suitable for decoration. In such cases, could motifs have been painted onto the surfaces, or shown on drapings of textile or skin hung over the stones? Climatic conditions permitted the survival of painted designs in Portugal, but neither paint nor textiles would have endured the damp Irish environment; Breuil's claim that a painted angular design occurs on a corbel stone over the left-hand recess in Sliabh na Caillighe T cannot be proven.[2] A further factor that must be emphasized in regard to megalithic art, especially in its interpretation, is the state of preservation of the tomb. Incredibly enough, only two decorated tombs are known in which the positions of all the decorated stones can be accounted for, namely the large tomb at Newgrange and the Mound of the Hostages, Tara.

As for the extraordinary wealth of megalithic art at Knowth, it has been found at the large tombs and at twelve of the smaller tombs. It occurs both externally (on the kerbstones) and internally (on orthostats, sills, capstones, and corbels in the tombs). There are also twenty stones or fragments found in a disturbed or secondary position, some of which were reused by the builders of souterrains during Early Christian times. To date, a total of about 250 stones with formal decoration, that is recognized shapes or motifs, or over 300 surfaces, is known. But this is a minimum number because a large number of structural stones are missing from the smaller tombs (see below); indeed over 300 formally decorated stones could have existed at Knowth. In addition there are many more stones with pick-marks which do not constitute a shape or motif but nevertheless had a meaning for the builders and users as will be shown below.

Almost all the decorated stones are Palaeozoic rocks such as greywacke, green ash, green slate, and grits, superficially similar in appearance. There is no definite evidence that the stones were artificially shaped or prepared before decoration. In general, surfaces that had quarrying marks or other scars were hidden, and the decoration was applied to the natural smooth face. In selecting Palaeozoic rocks, the builders ensured the presence of smooth, cleaved surfaces. The surface of the standing stone (a sandstone) before the entrance to the western tomb at Site 1 was smoothed and polished.

plate 44

Two main techniques were used in applying the art: incision and picking or pocking. These are well known from other passage-tombs in Ireland. Sometimes the picked channel was subsequently smoothed, as on the 'baetyl' described above. It can be assumed that the tools were made from hard stone such as flint or quartz, but none have come to light. Incision, the less frequently used technique, involved the drawing of a pointed implement along the

plate 53

surface. On the inner sillstone ('A') in Site 4, incised lines formed a grid, which acted as a guide in the creation of the lozenge composition. On some

occasions, motifs were formed solely from incised lines (as on Site 1 kerbstones 41, 84, 116, and 120). But in most cases the impression given is that the lines were haphazardly placed, either as 'doodles' or as scratches all over the surface (as on a corbel over orthostat 10 of Site 16). However, it is probably naive to dismiss what appear to be simple scratches, because they too may have a significance. In the smaller tombs, some stones have incision alone – Site 14 orthostat 13, Site 16 orthostats 4 and 13 (Faces A and B). Incision has been found in combination with picking on a number of stones such as Sites 4 sillstone A, 13 orthostat 3, 14 orthostat 4, 16 orthostat 13 and Site 17 orthostat 13. The designs usually consist of angular motifs – lozenges, arcs, zigzags, net patterns, and U-motifs.

Picking is the predominant technique. It varies in depth, and in the form of tool used. At least two different tool types were employed at Knowth, the chisel and the punch. With the latter, one can distinguish between a pointed and a blunt-ended instrument. As some pocks are deeper at one end than at the other, the tool must have been held at an angle. The designs were usually well formed, but picking deeper than about 1 cm was not characteristic. However, in a small number of cases, picking to a depth of nearly 2 cm was used to give a relief effect, examples being, at Site 1, Kerbstone 11 (the eastern entrance stone) and the basin in the right-hand recess of the same tomb. plates 45–47

In the formation of the designs line-picking predominates at Knowth and elsewhere, but there are also stones with what looks like random picking over the surface or parts of it. This may be close picking, as on Site 1 orthostats 22, 38, 41, 42, 80 in the western tomb and orthostats 37, 55, 56 in the eastern tomb, or dispersed, as on orthostats 33, 39, 40, 44 in the western tomb and orthostat 28 in the eastern tomb. The picking may be confined to part of a stone, as on Site 1 kerbstone 75, or it may cover most of the surface, as on Site 12 orthostat 8. In some cases this pick-work might have been structural, a deliberate attempt to alter the shape of the stone such as rounding off or blunting an edge or to improve the appearance of its surface before decorating. For such work the term 'pick-dressing' will be used, but there is also picking that spreads over areas and along the shoulders of stones. For the latter the term 'area-picking' will be used, and it may constitute shapes such as triangles or lozenges spread over the surface, or isolate an unpocked area which became a motif in false relief. The obliteration of existing motifs by area picking is also a feature, orthostat 41 of the western tomb being a classic example. Of course, this should probably be looked on as adding motifs; certainly this feature is fairly common, because at least nineteen kerbstones of Site 1 have overlapping motifs. Unshaped area-picking is also found, and again the marks may be close or dispersed. These should not be dismissed as casual doodles, since they seem to have a definite purpose. This is demonstrated by the fact that some stones with such picking are found in key positions, for instance on the outer face of capstone 45 of the passage of the eastern tomb Site 1 and its repeat on the three corbels above the back stone of the end recess and the similarly placed corbel in plate 48 plate 49

the western tomb, or on the backstone of Site 12. Pick-dressing and area-picking is less common on stones of the smaller tombs than on those of the large mound. In Ireland such work is not found outside the Boyne Valley.

Occasionally the primary design was formed by incision (as on sill A in Site 4), but usually the earlier and later motifs were picked. On kerb 13 in Site 1, not only are the large serpentiform motif and the circles subsequent to the other motifs, but they are also the work of a different hand, as the line picking is heavier and deeper. However, while such sequences do occur, it is impossible to gauge the length of time between both operations or, broadly speaking, to isolate the work of different artists or schools of art. The only definite examples are stones A, E, and F at Fourknocks, which appear to be the work of the same person.

Stones such as orthostat 8 at Site 12, where the portion in the socket was unworked, indicate that some had been decorated or worked after erection. On the other hand, art on the bases of kerbstone 11 at Site 8 and orthostat 11 of Site 18 shows that these stones were decorated before erection. Stones with art on the narrow side (such as Site 2 orthostat 30, Site 15 No. 1, site 16 Nos. 9, 13, and kerb 4 of Site 14) were decorated either before erection or *in situ*, but before the erection of the adjoining stone.

Distribution of the art at Knowth

Apart from a small number of cases, art is confined to the outer faces of the kerbstones and the inner faces of the orthostats. It was therefore intended to be seen. Art is not known to occur on the inner sides of any kerbstone in the small tombs. Of the 123 kerbstones that have been fully examined at Site 1, decoration is only found on the backs of eleven (Nos. 1, 13, 18, 32, 35, 46, 49, 51, 68, 71, and 85) and it is restricted in range. Regarding the tombs in Site 1, thus far only the backs of about thirty stones, all in the passage of the eastern tomb, have been examined, but none of these had been decorated on that part. In the smaller tombs, only orthostats No. 8 of Site 14, No. 14 of Site 15, and No. 11 of Site 18 have decoration on the back.

In addition, there are the kerbstones and orthostats with decoration on the base, already mentioned. Decoration is rare, too, on the sides of the stones and, when it occurs, the layout is of poor quality. Of the portion of the eastern passage in Site 1 that has been exposed, five capstones with art on the upper surface have been found, and some of this is of good quality, in particular on No. 20. Here is a contrast with Newgrange (large), which has a considerable amount of hidden art, especially on the backs of kerbstones, and notably on Nos. 13 and 18 with over a hundred motifs each. The only comparable face at Knowth is on orthostat 8 of Site 14 with its random art.

Of those 123 exposed kerbstones at Site 1, ninety are decorated. Among the remainder, three are missing (Nos. 20, 37, 62) and three have been damaged (Nos. 21, 36, 44), while the others include a stretch of kerb along Sites 13 and

14 (Nos. 96–117) with stones which are smaller and poorer than the normal run of kerbstones (Chapter 2). Of these, only three are decorated (Nos. 97, 98, 113), and the rest may never have borne art. However, nearly all of these, as well as the other undecorated stones in the kerb (Nos. 3, 6, 9, 33, 35, 43, 45, 50, 53, 58), are soft stones – sandstones and limestones – and it is possible that they originally had art which disappeared due to weathering. The largest and most highly decorated stones occur in the kerb close to both entrances. Their length varies from slightly under 1 m (kerb 4) to over 3 m (kerb 47). On the kerbstones, incision is found on only six (7 per cent), and scattered pick marking on 9 per cent. But except for No. 120, all the decorated kerbs had line picking.

To date, the western tomb has been found to have thirty-five formally decorated stones: twenty-five orthostats, four capstones, one sill, and five corbels. But markings of some sort, such as pick-marks, appear on most stones. Picking is the predominant technique, while incision occurs on only about 6 per cent of the stones and mainly in the chamber area. Until now, there is evidence for seventy decorated stones from the eastern tomb: thirty-three orthostats, one jamb, sixteen capstones in the passage, two corbels in the passage, ten roof corbels in the chamber, three recess corbels, two capstones in the recess, two basins and one packing stone in the passage. Again, most structural stones have pick-marks.

Twelve of the seventeen smaller tombs have decorated stones: Sites 2–5, 8, and 12–18. The total is forty-one stones with fifty-seven surfaces (about 30 per cent of all). On thirty-three stones, decoration is confined to one face. Seven stones have decoration on two faces (Site 2 orthostat 30, Site 13 kerb 15, Site 14 orthostat 8 and kerb 4, Site 15 orthostat 14 and sill C, Site 17 orthostat 7), two on three faces (Site 16 orthostat 13, Site 18 orthostat 11), and one on four faces (Site 4 sill A). The number of individual motifs in use was limited. Only one stone, Site 14 orthostat 8, is profusely decorated, but Site 4 stone A is also well decorated. In addition, there are twenty stones, or parts of stones, that were found in a secondary position in souterrains or in disturbed contexts. In view of the damaged state of the small tombs, it appears that these were removed from those small sites rather than from the large one. Thus we have a total of sixty-one stones and seventy-two surfaces. The art occurs on twenty-one orthostats, two sillstones, two corbels, and fifteen kerbstones (including the displaced stone in Site 13). The basin in Site 2 is also decorated.

As many structural stones have been taken from the smaller sites, there must have been a greater number of decorated stones originally. The seventeen small sites could have had close to 400 orthostats, but only 102 survive and some of these are damaged. Of the kerbstones, 251 survive and fifteen are decorated (8 per cent), but the original number of kerbstones was probably about 700. In addition, there could have been over 150 capstones, as well as an unknown number of corbels. Precise figures for decorated stones, therefore, cannot be arrived at. Nevertheless, it does seem that the smaller tombs were

less profusely decorated than the main mound. For instance, Site 14 has twenty surviving kerbstones out of, say, thirty-four originally, yet only three are decorated. Just two of the twenty-six surviving kerbstones at Site 15 are decorated, while one of the nineteen left at Site 16 is decorated. Regarding the tombs, thirteen of the original fourteen orthostats in Site 14 survive, but only five are decorated. Site 15 has nineteen of its original twenty-one orthostats, but only three are decorated, as are three of the nineteen orthostats left in Site 16. On the other hand, in Site 2, there are only thirteen intact orthostats out of forty-four, and three are decorated.

One might, therefore, speculate that both the orthostats and the kerb at each site had about three decorated stones each. It must, of course, be borne in mind that a number of corbels and, very probably, roof stones would also have been decorated. Further, there was apparently a tendency to have more decorated stones within the tomb than in the kerb. The stones used in the kerbs are, to a large extent, glacial boulders which were not suitable for art, whereas stones with a flat surface were more often used internally.

Types of motifs

Various classificatory schemes for the art of the Irish passage-tombs have been advanced. They include those of Stuart Piggott (who had thirteen main motifs),[3] Michael Herity (fifteen),[4] Claire O'Kelly (ten),[5] and Elizabeth Shee Twohig (eleven).[6] As pointed out by Mrs O'Kelly, there are two main categories: curvilinear and rectilinear. The former consists of circles, dots surrounded by circles, cup-marks, U's, spirals, and radials, while the latter consists of short parallel lines, offsets, chevron/zigzag, lozenges, and triangles. It is possible that the serpentiforms should also be placed in the latter category.

These and other principal categories occur at Knowth. But as the full range of the structural stones has not yet been exposed, other motifs may come to light. Neither has a full analysis of the art already exposed been carried out. Thus, the views expressed here must be considered preliminary, and any schemes for grouping or classification are suggested only to facilitate discussion, not as final results. There is also a difficulty in describing the material, as differences in shape between some motifs are very slight, for example between a gapped circle and a U-shaped motif.

About sixteen principal motifs are represented. In the smaller tombs – where the decoration is more limited and less ornate than at Site 1 – the most common motifs, known from twenty stones, are circles, either full or gapped (single, multiple, dot-and-circle). Twelve stones have spirals, ten have zigzags, six have chevrons, and seven have lozenges. In addition, arcs, cup-marks, and triangles occur in small numbers.

In Site 1, too, circles are the most common motif. They appear in a variety of forms, some being full and others gapped. They may be single or multiple, and vary in size. Sometimes, up to half a dozen are found on the same stone. Other

leading motifs are spirals, serpentiforms, lozenges, triangles, chevrons, rectangles, and lines. Spirals are fairly common, some being loose and others tightly coiled: they may be clockwise or anticlockwise. Spirals with two members are known, and kerb 13 of Site 1 has a double spiral. Serpentiforms, again in varying numbers and lengths, were popular as well. Cup-marks are scarce, being mostly confined to the backs of the kerbstones. A good example of the dot-and-circle motif is found on Site 1 kerb 32. The offset motif exists only in one instance, on the inner face of Site 14 orthostat 8.

An interesting motif is the rayed design. The most elegant example is on Site 1 kerb 15. This dominates the central part of the stone, and has a pocked oval area delimited for part (perhaps originally all) of the circumference by means of two channels. In the centre near the bottom, there are two holes, one beneath the other. From this, twenty lines fan out over a semicircular area. The inner part of each line is oar-shaped, and beyond it is a narrow notch, then a large picked area. Beyond this again, for part of the perimeter, is a small circle. Similar but less elaborate motifs are found on kerbs 7, 46, and 68, on the outer face of Site 14 orthostat 8, and in the interior of the large basin in the eastern tomb. A close parallel for this motif is known on a stone in Site XI at Sliabh na Caillighe.

To consider the art solely from the viewpoint of motifs is inadequate, and may obscure interpretation. At Knowth, some stones are decorated with the same motif or a closely similar one, which is either the sole or the predominant motif and, thus, constitutes a style or a composition. A style can consist of one motif, or there may be more than one example but occurring in a balanced manner. This arrangement is also found at some other sites, notably Newgrange (large) and Fourknocks I. The following fifteen main styles are known at Knowth.

1 Angular
This style consists of lozenges, triangles, and chevrons, sometimes spread over the surface, on other occasions restricted. Within the overall style there are considerable differences.

(a) Overall decoration by a central row of lozenges with parallel chevrons on both sides. This sub-style is found to perfection at Fourknocks (on stones A, E, and F), and less so at Newgrange on the roof-box lintel and corbels (Co1/C2 and Co2/C14). Stone C16 at Barclodiad y Gawres may also be placed in this category, but elements in its composition are more fluid. Knowth Site 2 orthostat 30, Newgrange L22, and Fourknocks R5 are poor relations.

(b) Overall decoration by transversely placed chevrons. Stone C from Fourknocks is the classic example, but one can also include in the group the two key corbels in the roof of Knowth 1 east (chamber), lintels 50 and 51 of its passage, orthostats 16 and 73 of the western tomb, and Newgrange K stone A. Newgrange (large) R18 is a less elaborate version. Stone L4 at Fourknocks,

plate 55
fig. 60

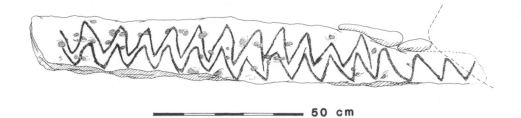

50 cm

60 *The angular style, substyle b: roof corbel 6A in the eastern tomb, Knowth Site 1.*

61 *The angular style, substyle c: orthostat 54 in the eastern tomb, Knowth Site 1. Above is corbel 54-1 with circular motifs.*

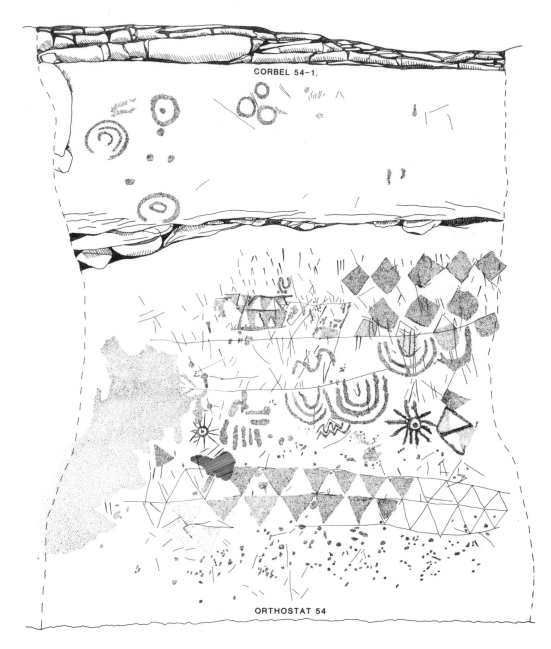

CORBEL 54-1.

ORTHOSTAT 54

50 cm

with its regular broad chevron pattern, may also be placed in this category.

(c) Overall decoration, but with a greater number and less orderly arrangement of motifs than in (a), nevertheless still possessing a plaque-like quality (Knowth 1 eastern orthostats 48 and 54, western 40, Dowth south C6, and Barclodiad y Gawres L8).

plates 52, 53

fig. 61, frontispiece

(d) Meandering chevrons. Here one obtains the feeling of a loss of cohesion, 'beginning' with Barclodiad y Gawres C16. Instances are Knowth 16 orthostat 9, Dowth south C7, Barclodiad C1, and the pattern stone at Bryn Celli Ddu.

plate 51

(e) Panel of triangles and/or lozenges. Examples are Knowth Site 4 Stone A, face 2 and miscellaneous stone 9, and Newgrange L15, R5, 8, 10, 12, 19, 21, C15, 16, Co1/C15–16, RS17, and possibly Co1/C10, Co1/C12–13, Co4/C8 and Stone Y. Cf. Dowth South C6 ((c) above).

(f) Panel of chevrons (Knowth 16 orthostat 13, Newgrange K93, and stone C7 at Sliabh na Caillighe U).

plate 50

(g) 'Net pattern' of lozenges (Sliabh na Caillighe Site L stone C19 and Site F stone R2).

(h) A limited number of angular motifs, especially chevrons and lozenges, sometimes on their own or in combination with curvilinear or other motifs. There is a lack of composition and order. Examples at Knowth are Site 5 stone 8, Site 14 orthostat 13 and kerb 4, Site 15 sillstone C, Site 16 orthostats 4, 13 (a–b), and corbel over orthostat 10, and Site 17 orthostats 6, 7, 16, and 13. Newgrange (large) has several kerbstones with this form of decoration. Although more definite in design, Fourknocks C1 and the Seefin stones R4 and L4 fit best into this category, as may Sliabh na Caillighe Sites J (loose stone), I (loose in recess 3), L (C9, 19), U (C8), and W (C4), as well as stone C5 at Sess Kilgreen.

Although not isolated as a category, radials resembling stars occur on Knowth 1 eastern orthostat 54. This motif is also known at Sliabh na Caillighe Site F (lost stone), Site I (R2, and the loose stone in recess 3), C13 (east), Site L (R3, C1), and Site W (C2). The enclosed rays on kerbstone 51 (front) at Dowth are related.

2 Angular-Spiral

The spiral element is prominent, often dominating, but triangles and lozenges are a feature. The best examples of this style are found at Newgrange on kerbs 1, 52 (left), and 67. These are the most elegantly decorated stones at Newgrange, and of high quality. The layout of the style is perfect, and the deep picking on Nos. 1 and 52 (left panel) virtually proclaim them to be pieces of sculpture. It may also be noted that these two stones occupy key positions in the kerb. The Knowth ovoid macehead fits into this baroque expression as well. The origin seems to be native, a combination of triangles or lozenges with spirals. Less elaborate examples are Newgrange (large mound), orthostats L19, C2, C10 and kerbstones 51 and 85, and Knowth 1 (eastern tomb) orthostat 2 and capstone 32.

plate 56

figs. 62, 63

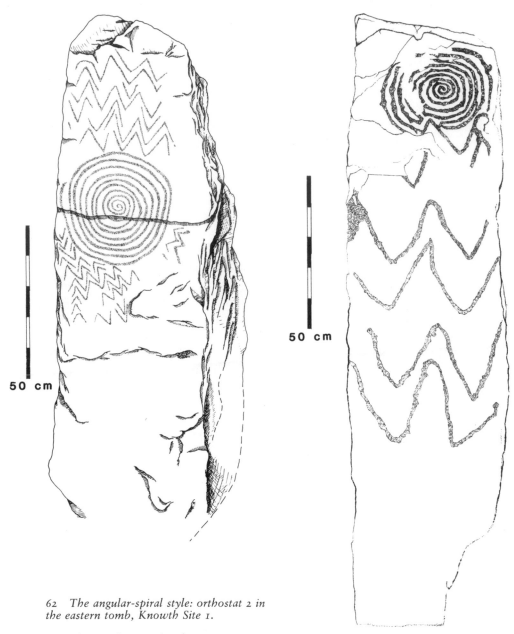

62 *The angular-spiral style: orthostat 2 in the eastern tomb, Knowth Site 1.*

63 *The angular-spiral style: capstone 32 in the eastern tomb, Knowth Site 1.*

3 Rectilinear

plates 8, 16, 13, 23 Concentric or boxed rectangles are the main characteristic. The best examples, where the design is regular, are Site 1 kerbstones 11 and 74, and less so No. 1 (all of which also have a central vertical line), as well as orthostats 34 and 42 and the outer sillstone of the chamber in the western tomb. Orthostats 49 and 50 of the western tomb seem to be poor versions. Less regular versions have vertical parallel or curved lines. In the eastern tomb, some of the lines take the

fig. 64

156

form of narrow elongated U's, and flat arcs are also present. This style is found on orthostats 25, 26, 50, 66, 68, 69 and the left jamb of the eastern tomb.

There are also a number of stones with poor examples of rectilinear work, but they lack a coherent style. Instances are orthostats 27, 47, 64, and 65 in the eastern tomb, and 33, 44, 48, 50, and possibly 38 and 51 in the western tomb.

This is a distinctive Knowth style that does not occur elsewhere in Ireland. Limited line work, but all very poor specimens, are known from Knockmany C5 (vertical) and C6 (horizontal) and Site T, Sliabh na Caillighe L3.

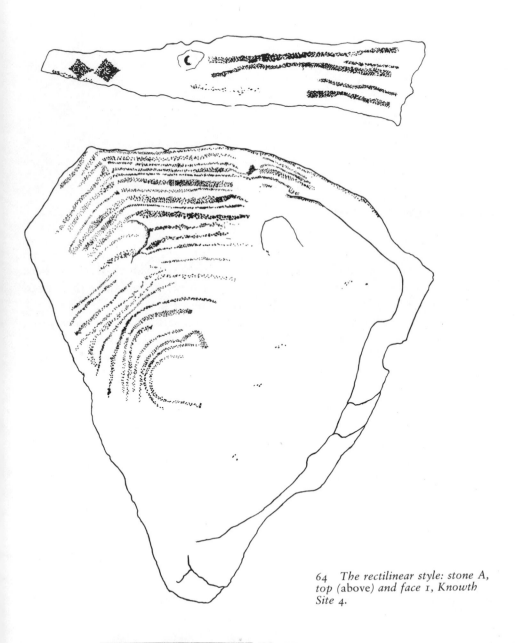

64 *The rectilinear style: stone A, top (above) and face 1, Knowth Site 4.*

50 cm

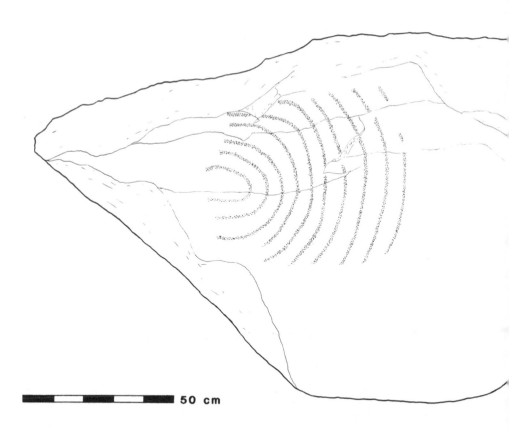

50 cm

Abroad, the only motifs generally with lines are the 'shields' on the bent passage-tombs of Brittany. These tend to have a sub-rectangular shape, but usually with a notch at the top. Apart from one or more lines outlining the edges, they often have a medial line and the internal motifs consist of dots, circles, and arcs. This is a very common Breton motif, and Shee Twohig recorded thirty-nine examples on thirty stones.[7] It appears to be derived from the 'buckler' of the earlier passage-tombs.

4 Large nested arcs

plates 57, 58

These are found on kerbstones 2, 95, and 98. They vary somewhat, as the arcs may be pointed or rounded. This style is without parallel either at home or

fig. 65

abroad, but Sliabh na Caillighe J (C4) and U (C6) have motifs that may be in the same tradition.

5 Serpentiforms

These occur as motifs on many stones, and are very prominent on some such as

plates 59–61

kerb 78 (lavish). But they also occur as a style, which is confined to the kerb of Site 1 on Nos. 14, 17, 57, 64, 81, 82, 91, 93 (added?), and 118. It consists of

fig. 66

either one example, as on Nos. 91 and 118, or two examples as on Nos. 81 and 82 where they were placed horizontally across the surface. There is a

65 The large nested arcs style: kerbstone 95,
Knowth Site 1.

66 The serpentiform style: kerbstone 64,
Knowth Site 1.

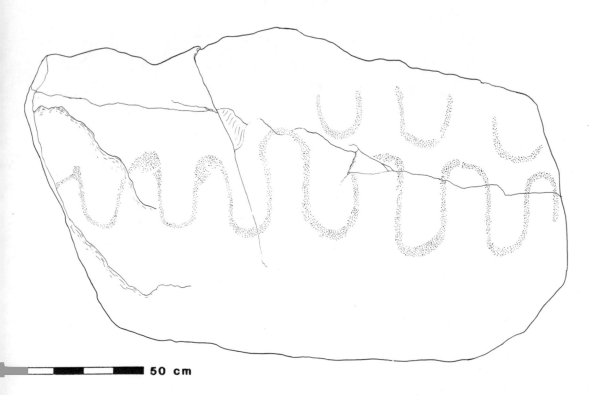

50 cm

conspicuous serpentiform on kerb 93 with a line underneath, probably an addition, and No. 13 has a large but secondary example.

Elsewhere in Ireland, the serpentiform constitutes part of an ornamental scheme but not a style in its own right. The isolated serpentiform is found sparsely on the Continent, as at Barrosa, Portugal, or on the standing stone at Manio and the tomb at Tossen Keler, both in Brittany.

6 Spiral

plate 62

This also occurs as a motif, sometimes small and isolated (as on Knowth 13 orthostat 16, Baltinglass Tomb II), or as part of a lavish design (as on Knowth

plate III

1 kerb 13). But there is a distinctive style which consists of a number of spirals arranged near each other in a balanced fashion. Instances are Site 1 kerbstones

fig. 67

46, 56, 67, capstones 10 (western) and 20 (eastern tomb), Site 3 kerbstone 10, and to some extent the miscellaneous stone 1. It may be noted that capstones 2 and 26 (eastern) and orthostat 80 (western tomb) have prominent spirals, but not arranged to form a composition.

Probably the closest parallel for the Knowth spiral style is the decoration on stones from King's Mountain, Newgrange (large) C3, and Barclodiad y Gawres C3. Less pronounced compositions occur at Sliabh na Caillighe H, sill,

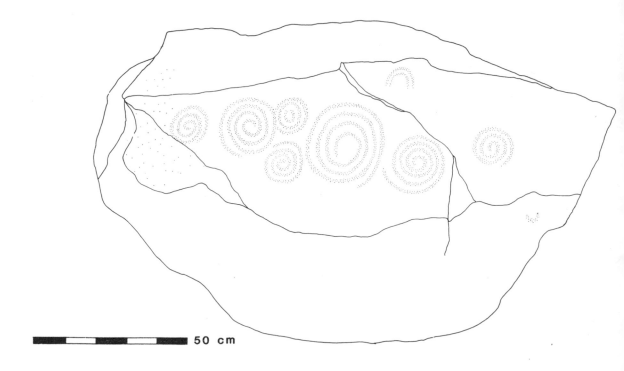

50 cm

67 The spiral style: kerbstone 67, Knowth Site 1.

and stone Eii at the Calderstones, Liverpool. At Newgrange (large), kerb 97 and chamber 3 have spirals, but these are scattered.

7 Circular

The general arrangement is similar to the spiral style, although on kerb 80 the design is situated around the middle. Various types of circles occur: single and multiple, full and gapped. This style is found on Site 1 kerbs 59, 60, 80, 89, and 94. Circles forming an overall composition are rare elsewhere. At Tournant in County Wicklow, Sliabh na Caillighe H (C5), L (C3, east), and possibly I (C4) have a couple of prominent circles, but the two latter stones also have a spiral. There is a fairly elaborate circle-decorated stone (No. B) at Fourknocks I, and the isolated find, stone 7, from Knowth appears to have been part of a similarly decorated stone.

plate 63

fig. 68

8 Dispersed circles

These are single, and were placed at intervals over most of the surface in an orderly way. Site 1 kerbs 42 and 66, and miscellaneous stone 2, are in this style. The style has parallels at Dowth kerbs 52–53, Sliabh na Caillighe L (C18), and on the unclassified megalith at Rathkenny a few km northwest of Knowth.

plate 64

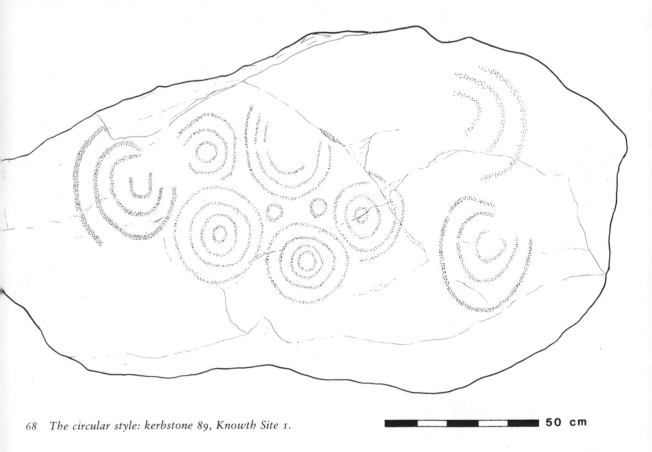

68 *The circular style: kerbstone 89, Knowth Site 1.*

50 cm

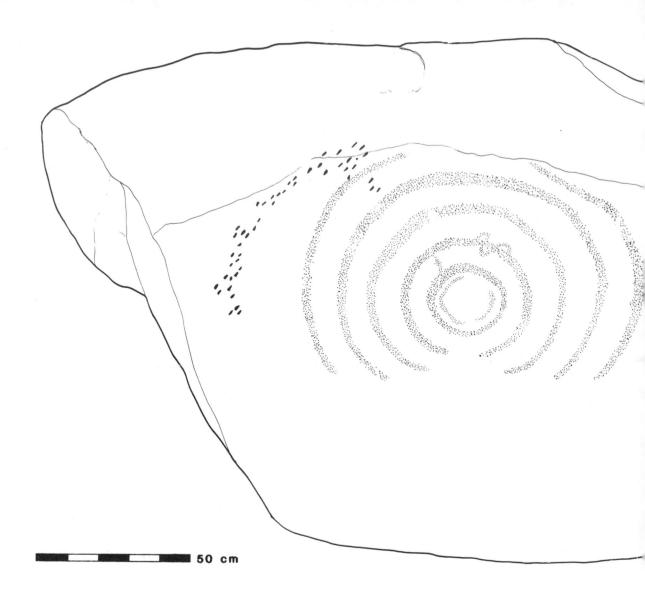

50 cm

9 Prominent central motif

plates 65, 66

This is placed near the top of the stone. Sometimes stones with this style have a greater height than width. The motif is usually a multiple concentric circle, but on rare occasions a spiral takes its place (Site 1 kerb 51). Commonly the inner

figs. 69, 70

circles are complete while the outer ones are gapped. The average number of members is eight. This style is found only at Knowth, and even there it is confined to the kerb of Site 1, on stones 18, 22, 23, 34, 47, 51, 69, 71, 84, 90, and 97 (a small motif), as well as on orthostats 66 and possibly 17 (western) and 2 (eastern tomb). Precise parallels outside Knowth are unknown. At Sess Kilgreen, stone C6 has a large motif consisting of a circle with impinging arcs on the upper part. Indeed, many stones have a prominent motif – all at Sess Kilgreen and some at Baltinglass – but these are in the nature of isolated motifs.

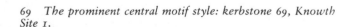

69 *The prominent central motif style: kerbstone 69, Knowth Site 1.*

70 *The prominent central motif style: kerbstone 84, Knowth Site 1.*

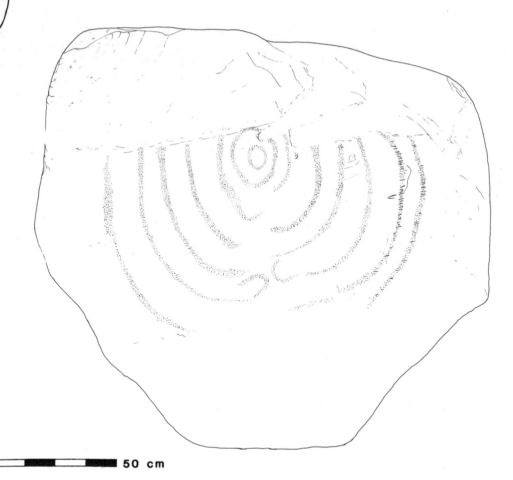

50 cm

10 Opposed C's

plates 67–69

Only two examples are known, kerbstones 30 and 86. The open ends are placed opposite each other, but the style differs. In No. 30, the two C's are double and are placed on their sides. In No. 86, the upper pairs of C's open downwards – the lower upwards – and between them is a horizontal line. The whole composition is enclosed within a line. Kerb 5 bears some similarities: the two C's are on their sides and the centre is occupied by a prominent space. The style is unknown elsewhere.

11 Lavish

plates 70–72
fig. 71

This style consists of all-over ornament of different motifs, but mainly curvilinear ones, principally circles, spirals, U's, and serpentiforms. It is a 'grand' style, and all examples are found on the kerb of Site 1. They are Nos. 4, possibly 5 (but see the previous category), 7, 8, 10, 12, 13, 15, 16, 24, 25, 27, 28, 31, 32, 38, 52, 65, 72, 73 (note the central motif), 75, 77, 78 (note serpentiforms), 79 (note central motif), 83, and 93 (also cited under Category 5), and possibly 121.

The most lavish stones of all are, of course, kerbstones 1, 52, and 67 at Newgrange, but these have been placed in the angular-spiral style. Perhaps at Newgrange the roof stone of the right-hand recess falls into this category. Elsewhere at Newgrange, stones like the lavish ones at Knowth do not exist.

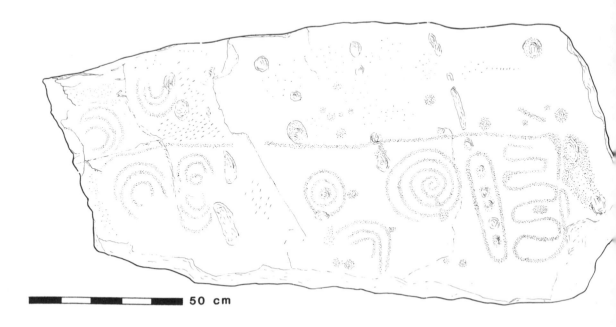

50 cm

71 *The lavish style: kerbstone 83, Knowth Site 1.*

Stones such as Dowth north C19, Sliabh na Caillighe L (C16), T (L1 and 5, C8), and U (C9), Sess Kilgreen single stone, Knockmany C9 and 11, and Tara tend to be 'between' lavish and random. This style resembles the Gavr'inis art.

12 Linear

This consists of parallel lines, usually horizontal (kerbs 26, 29, 48, 126, and possibly 61 and 70).

plate 73

13 Random

With this style, the motifs are dispersed on the surface in a somewhat haphazard manner. The only examples from Knowth are the inner and outer faces of orthostat 8 in Site 14. But this style is a feature of Newgrange (large), as on kerbstones 4, 13, 18 (on the backs of these three), 7, 11 (back), 54, and stone X in the passage roof. On kerbstones 13 and 18, one finds over a hundred motifs. As with Site 14 orthostat, it is interesting that the decoration occurred on the backs of a number of these stones. This style is also found on Newgrange L stone A (possibly a corbel) and on a missing stone. Many of the stones at Sliabh na Caillighe with all-over multiple decoration tend to have it disposed in a random fashion, for instance Site T (C3).

plate 74

14 Unaccomplished

This style consists of a motif or two which were not very well produced. It is found on kerbs 19, 40, 54, 55, 63, 85, 92, 116, and 119 of Site 1, and on the kerbs of the smaller tombs. At Newgrange (large), it occurs on kerbs 3, 5, 8, 82, and 95, at Site L on C1, 3, and 9.

plate 75

15 Miscellaneous

Well-formed motifs are found on kerbstones 39, 41, 49, 68, 87, 88 (some damage), and 127 of Site 1, and on orthostat 41 of the eastern tomb. These do not constitute a style.

plates 76, 77

fig. 72

As will be discussed more fully below, some styles or compositions were located in specific places. The angular and rectilinear styles are internal, most of the best examples being restricted to the chamber area. Where the rectilinear style occurs externally, it is on the entrance stones, notably 11 and 74 – and while they are part of the kerb, their position also integrates them into the tomb. The angular-spiral style, too, is largely internal and, if external (as at Newgrange), it occupies a prominent location. The spiral and unaccomplished styles are both internal and external, but the large nested arcs, serpentiforms, circles, dispersed circles, prominent central motif, opposed C's, lavish and linear styles are found externally and only on Site 1. The Knowth stone with random ornament is internal. More generally, the angular and rectilinear styles are either exclusively or predominantly internal, whereas the styles with a curvilinear element are usually external.

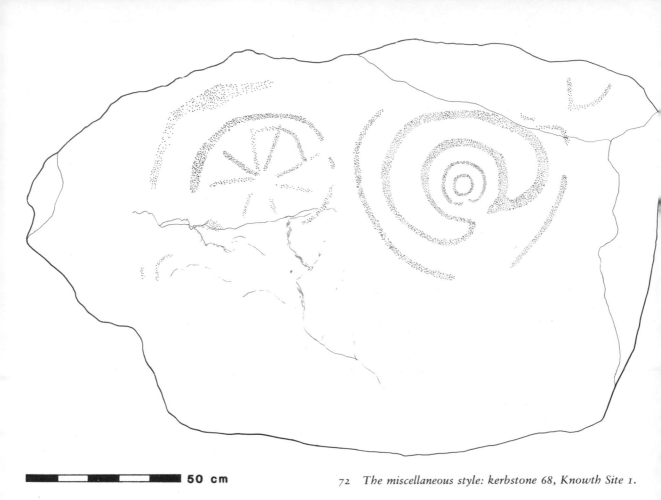

50 cm

72 The miscellaneous style: kerbstone 68, Knowth Site 1.

Comparative evidence

As a result of the great corpus of European megalithic art (excluding the Boyne Valley) prepared by Elizabeth Shee Twohig, and Claire O'Kelly's corpus of the Newgrange and Dowth art,[8] one can now consider the Knowth art in its wider national and international settings.

In the north of Europe, art is a feature of funnel-beaker cultures (TRB) beginning during the fourth millennium bc and continuing in the third.[9] This art occurs on pottery, which was often placed as grave goods in tombs or deposited outside the entrance, but never on the structural stones. In Iberia, the decoration of the structural stones in passage-tombs was characteristic of some regions, especially in the west, but mainly north of the Mondego Valley, forty-two sites having a total of 122 known stones. Another aspect of Iberia, more particularly in the southwest, is the rich decoration on objects placed in tombs, notably schist plaques and 'idols' of various forms. Pottery was decorated to a limited extent. The other great concentration is in Brittany, and to a lesser degree in west-central France, with around 200 stones from some forty-six passage-tombs. There is also art on the French gallery graves and

rock-cut tombs, but it is later in date and not relevant to the present study. Britain has twenty-one stones from seven sites. Yet passage-tomb megalithic art is most frequently found in Ireland, where at least fifty tombs have yielded up to 560 decorated stones. Their numbers can be broken down as follows.

Knowth 1	197 stones (1 site)	c. 200 surfaces
Knowth 2–18	41 stones (12 sites)	57 surfaces
Knowth disturbed	20 stones	11 surfaces
Standing stone and two stone basins	3 stones	4 surfaces
Total	*261 stones*	*c. 272 surfaces*
Newgrange (large mound)	87 stones	96 surfaces
Newgrange L	7 stones	8 surfaces
Newgrange K	10 stones	15 surfaces
Newgrange Z	1 stone	1 surface
Newgrange basin	1 stone	2 surfaces
Total	*106 stones*	*122 surfaces*
Dowth (large mound)	38 stones	39 surfaces
Dowth J	1 stone	1 surface
Total	*39 stones*	*40 surfaces*
Isolated stones at Brugh na Bóinne	2 stones	3 surfaces
Total at Brugh na Bóinne	*c. 408 stones*	*c. 437 surfaces*

Sliabh na Caillighe Sites F, H, I, J, K, L, R2, S, T, U, V, W, and X1, and King's Mountain:

Total at 14 sites	*111 stones*	*127 surfaces*
Fourknocks I	11 stones	13 surfaces
Tara	1 stone	1 surface
Broadboyne	2 stones	7 surfaces
Rathkenny (uncertain site)	2 stones	2 surfaces
Total from these other Meath sites	*16 stones*	*23 surfaces*
Carnanmore, Antrim	1 stone	1 surface
Drumveagh, Down	1 stone	1 surface
Sess Kilgreen, Tyrone:		
Site 1	6 stones	6 surfaces
Site 2	1 stone	1 surface
Knockmany, Tyrone	9 stones	11 surfaces
Kiltierney, Fermanagh	2 stones	7 surfaces
Cloverhill, Sligo	3 stones	4 surfaces
Killin, Louth	1 stone	1 surface
Seefin, Wicklow	2 stones	2 surfaces
Baltinglass, Wicklow:		
Tomb I	2 stones	2 surfaces
Tomb II	4 stones	4 surfaces

Tournant, Wicklow	1 stone	1 surface
Clear Island, Cork	1 stone	1 surface
Total from these		
other parts of Ireland	*34 stones*	*42 surfaces*

There are also sixty-four stones, many being fragments, from Millin Bay in County Down, but their incomplete nature makes it impossible to calculate the number of individual stones present.[10]

All Knowth	261 stones (13 sites)	*c.* 272 surfaces
All other tombs	147 stones (5 sites)	165 surfaces
at Brugh na Bóinne		
All Loughcrew and	111 stones (14 sites)	127 surfaces
King's Mountain		
Four other sites	16 stones (4 sites)	23 surfaces
in County Meath		
Total in Meath	*535 stones (36 sites)*	*c. 587 surfaces*
All other sites		
(except Millin Bay)	34 stones (12 sites)	42 surfaces
Grand total	*c. 570 stones*	*c. 629 surfaces*

In Europe there are about 900 stones with megalithic art from about fifty passage-tombs or related sites, but 400 of these come from the Brugh na Bóinne tombs and a further 127 from the other Meath passage-tombs: clearly this region was Europe's leading one for megalithic art. To summarize the Knowth data we can say:

— Knowth has more than a quarter of the known megalithic art from all other areas of Europe, including Ireland.

— Knowth has more than twice as many decorated stones as are found in Iberia.

— Knowth considerably exceeds the number of decorated stones known from Brittany.

— Knowth has about 45 per cent of the total of known megalithic art from all Irish passage-tombs.

— Knowth exceeds by about 100 the total number of decorated stones from the other Brugh na Bóinne tombs.

— Knowth has more than twice as many decorated stones as are known from Sliabh na Caillighe.

Dr Shee Twohig has identified ten principal motifs in Iberian megalithic art. Of these, triangles, serpentiforms, radial lines, circles, and U-motifs are present in Ireland. The serpentiform and triangle (including the saw-tooth motif) are the most common motifs. The art was applied by picking or painting. Random picking is found at Soto near Huelva, and on a septal stone at Nora Velha, Beja.[11]

Most of the painted sites are in the Viseu region of Portugal. Red and, to a lesser extent, black were the main colours, and these were on a white or cream background. Apart from the painted stone in the chamber (C3) of Santa Cruz,

Oviedo, the art was not applied in a well-organized manner. In this, and in the range of designs, the art differs from that on the schist plaques and 'idols', where the composition is well ordered and, on the plaques, a horizontal line often divides it into upper and lower zones. The art is geometric and the predominant motifs are chevrons, triangles, lozenges, straight bands, diaper pattern, arches, and radials. Very few of these objects are found north of the River Mondego, but they are common south of it.

In Brittany the art, predominantly non-representational except for axes and bows, was applied by the picking technique. Part of the surface of some Gavr'inis stones have been pick-dressed, while at Dissignac a roof stone was polished. A limited number of standing stones was also decorated. Shee Twohig has isolated eleven main motifs in the art of the earlier passage-tombs. These include circles, cup-marks, U-shaped motifs, and serpentiform or wavy lines, which can be paralleled externally. But the common Breton motifs such as the yoke, crook, cross, angle 1, axe, and buckler have no external parallels. Gavr'inis, with its bold and coherent compositions spreading over the surface, is unique to Brittany. Mané Kerioned B, Petit Mont and, to a lesser extent, Kercado also have a large proportion of the individual stones decorated. At the other sites, decoration is haphazard and not profuse.

The art of the bent passage-tombs, which are later in date, is different: the characteristic motif is the 'shield', which must have been based on the earlier 'buckler' motif. The 'shield' usually consists of an outline of one or more lines, while internally central lines, circles, and U's may occur. Some of the bent tombs also have a high proportion of decorated stones, and Les Pierres Plates has fourteen, some with a number of motifs. Art is rare on mobile objects in Brittany. It is seen sporadically on pottery, especially the Chassey, Conguel, and Kerugou wares. Kerugou has panels of vertical lines and horizontal lines just below the rim, whereas the others have fine triangles and serpentiform designs.

A large number of the Knowth motifs can be paralleled in passage-tombs at home and abroad. However, Knowth differs in having a series of distinctive styles, most of which are confined to the site itself. Conversely, the random style is very rare at Knowth, but more frequent at Newgrange (large mound) and Sliabh na Caillighe. The angular-spiral style is known elsewhere, the most lavish of all being kerbs 1, 52, and 67 at Newgrange (large). It is interesting that these three stones have an international (triangle/lozenge) and a more native (spiral) element. Indeed, kerb 52 is of considerable interest as, to the right of the vertical line, the composition is as elaborate as what one finds at Gavr'inis, while on the left there is a lozenge-spiral combination.

The association of art with tombs clearly indicates that it is a funerary art which had meaning and significance. These cannot now be fully explained, but one may draw attention to some patterns. For instance, in Knowth Site 1, both entrance stones (Nos. 11 and 74) and kerb 1 have a central vertical line. While acting as a kerbstone, the latter also forms one side of an unroofed passage to

the remodelled Site 16. The entrance stone at Newgrange (large) and the stone opposite it in the kerb, No. 52, also have vertical lines, as has kerbstone 50 at Dowth. Since at least the first three are entrance stones, perhaps the vertical line denoted the presence of the entrance.

These are the only stones with a possible 'functional' motif, and it is interesting to note that the stones with the rectilinear style found internally do not have any vertical lines. Some of the rayed motifs resemble sundials, but it is unknown whether they served such a purpose. However, on the motif on the top of Site 1, kerb 7, during the summer it takes the sun's shadow about an hour and a half to pass from one ray to the next. It may, of course, be that these motifs have a symbolic meaning such as representing the sun. The ritual implications will be examined more fully in Chapter 8.

Origins and chronology of the art

This art must have been introduced to Ireland, as it lacks clear local forerunners. Decoration is, to be sure, a feature of the Neolithic period in nearly every part of Europe, including the megalithic zones. As already mentioned, the northern zone has the embellished funnel-beaker vessels decorated in an angular style, which were placed within or externally around the entrances to the tombs, but the structural stones were never decorated. Brittany has megalithic art and some decorated pottery, yet probably the richest area is Iberia with its abundance and variety of stone and bone mobile objects (plaques, pottery vessels, 'idols', 'croziers' and so on) as well as, even if less numerous, decorated structural stones in tombs. If the Irish art was externally derived, then Iberia must have been a key area.

The Knowth and Newgrange conical stone objects seem to have their origins in Iberia, as may have other objects (Chapter 8). All the elements of the angular style could be based on Iberian motifs. Individual motifs not represented in the angular style – serpentiform U's, radials, or 'stars', as well as the overall decoration of panels of lozenges – are also found there. In Brittany, except for Petit Mont, the angular style is rare, although the other leading style at Knowth, the rectilinear, resembles the art of the bent passage-tombs (and the eastern tomb at Knowth Site 1 has a bend). However, it may be noted that some of the Gavr'inis compositions tend to have a rectilinear outline. The lavish style may also owe something to, or even be imported from, Gavr'inis, which is a very highly decorated tomb, but one must be careful about concluding too much from what is artistically a unique site for that area.

It is true that a limited circular element occurs in Iberian mobile art, and that this might have contributed to the Irish repertoire. Yet Brittany was probably more important for that element. On the other hand, it is one of the most common of the Irish motifs, the spiral, that presents problems. Common on pottery of the central European Danubian (*Linearbandkeramik*) culture, but found only sporadically at Gavr'inis and wholly absent from other Breton

sites, the spiral's abundance in Ireland is an unexplained surprise, but a native origin has not yet been demonstrated. While it is not frequent in Brittany, that area may nonetheless have enabled the idea to filter through from say the Danubian culture and play an important role in Irish megalithic art.

Apart from motifs, styles can also be paralleled abroad. Some stones within the angular style, in particular Fourknocks A, E, F, C, and L4, are – to paraphrase Adolf Mahr – large versions of schist plaques.[12] Close, too, are Knowth east orthostats 48 and 54 and west 40, to some extent 16 and 73, and more particularly Dowth south C6. Even a more detailed sub-type such as the band of chevrons has parallels in Iberia and Brittany, at Castaneira 2 (backstone) and Petit Mont (L3 and R5), as has the meander sub-style. But the Irish passage-tomb art as a whole clearly shows native originality, as is seen in the pooling of angular and lavish elements to form the angular-spiral style, or even in the disposition of motifs in the circular style and in the style with a prominent central motif. External borrowing, coupled with native pooling and reorganization, characterizes the Irish passage-tomb art.

It is difficult to work out a chronology of Irish megalithic art, because we are not yet absolutely certain about foreign parallels. In Iberia, incision was used widely in decorating schist plaques and, as that technique is common at Knowth 16, whose art is also exclusively angular, one could argue on grounds of both technique and motifs that this site shows strong Iberian influence. The art of Fourknocks I (including the pin), although mainly made by picking, can be regarded in a similar light, while the regularity of the chamber recalls tholos tombs; in sum, Fourknocks I may be considered very Iberian.

fig. 78

fig. 80

plate 38

Again, returning to Knowth 16, there is stratigraphical evidence that this site is earlier than the large mound. As pointed out, its art is angular with incised work predominating, but the adjoining kerbstone (No. 1) of the large mound, which is later, has rectilinear art formed by picking. Furthermore, as abroad, there is no kerb art at either Site 16 or Fourknocks. Thus, one could say that the angular style is earlier than the rectilinear. However, taking the Knowth art as a whole, integration exists between the various motifs over the site, and also between styles. The latter unity is plainly demonstrated at Site 4, stone A, which has one side decorated in the angular style, and the other in the rectilinear.[13] At Newgrange (large), kerb K52, one half has angular decoration and the other lavish. At Newgrange K, the inner face of the backstone has circular ornament, while one side and the back have angular. The overall pattern on these stones is unitary, with no evidence that one style was added later.

Still, if one accepts that the rectilinear style is based on the 'shield' motif of the bent passage-tombs of Brittany, then at least Knowth Sites 1 and 4 must be dated to the later Neolithic. On the other hand, some of the more lavish Irish styles resemble the Gavr'inis compositions, and that site pre-dates the bent tombs: a carbon-14 determination indicates that it was closed by about 2470 ± 80 bc.[14] This should mean that the lavish style, and others which

incorporate curvilinear motifs, were early, the rectilinear style being a later incorporation into the overall repertoire. In ensuing developments the angular and curvilinear art continued side by side with the rectilinear. The carbon-14 dates for Knowth 1, centred around 2500 bc, would not conflict with the chronological deduction drawn from the art. Relationships between Ireland and western Iberia can also be inferred, but, in comparison, the megalithic art in western Iberia is by and large poor and disorganized, lacking styles except for a small number of stones. It therefore seems extraordinary that Ireland could receive so much artistic influence from Iberia while contemporary 'Iberians' were only marginally affected. If there were connections going northwards, it is also strange that the angular style is not a general feature of Breton megalithic art. In view of the limited number of artefacts and the art, one may suggest that Ireland had fairly long-distance maritime contacts, originating to the south in Brittany but also further afield in Iberia, especially the area of the Tagus estuary.

Colour plates *(pages 173–176)*

VII The corbelled roof over the chamber in the eastern tomb, Knowth Site 1.

VIII The outer two-thirds of the eastern tomb passage, from the west. Excavation has revealed the capstones covering the passage.

IX A later stage of excavation of the eastern passage, from the east. Many of the capstones have been removed.

X The ceremonial macehead, 7.9 cm long, found in the right-hand recess of the eastern tomb chamber.

XI The conical stone object, *c.* 25 cm long, discovered near the entrance to the western tomb.

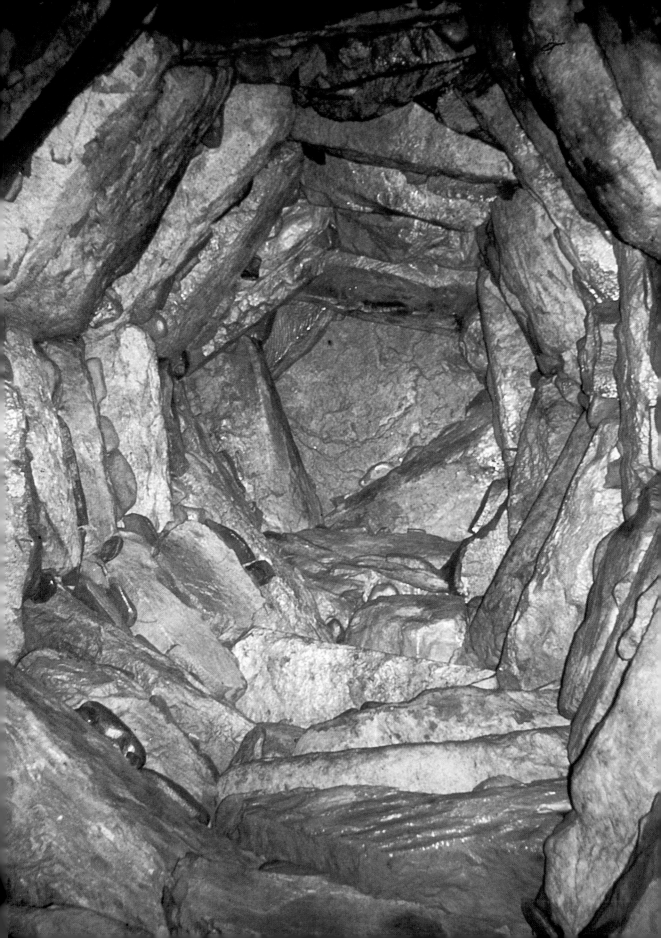

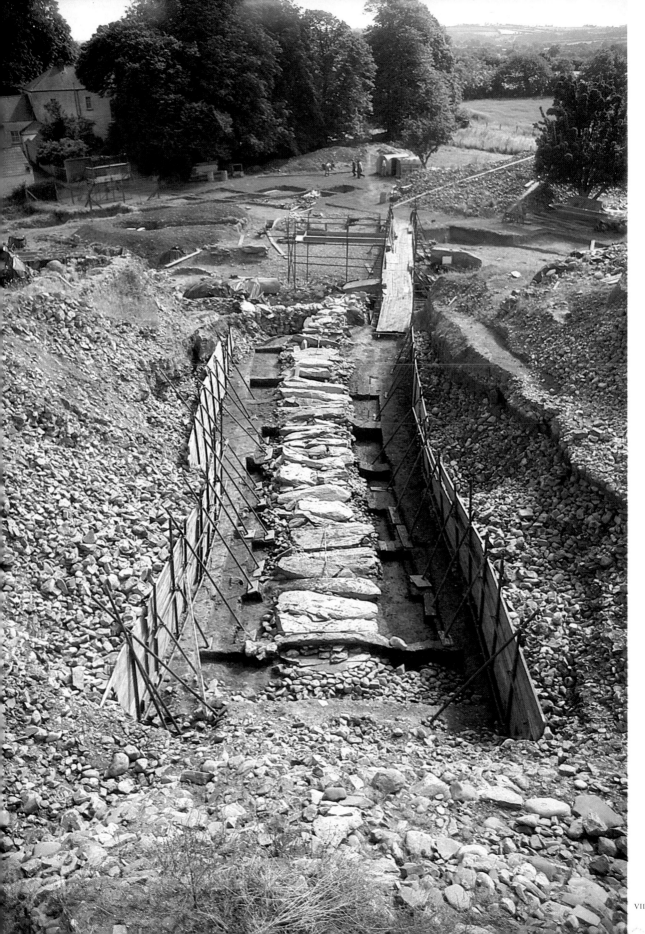

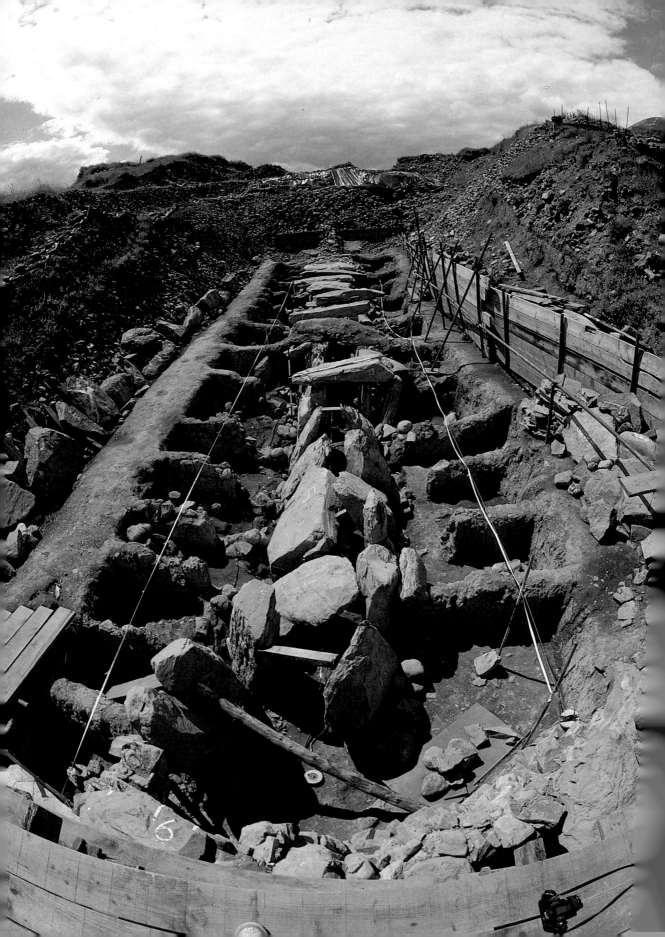

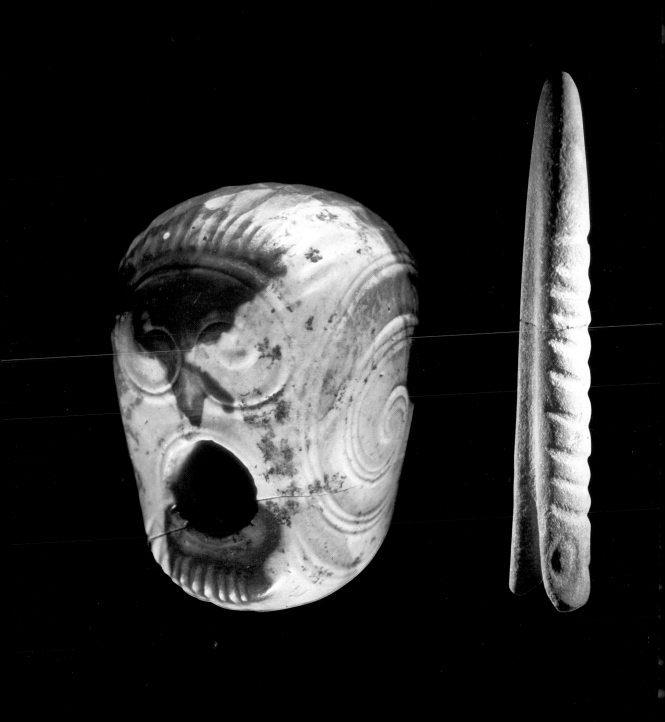

8 Ritual in burial and in art

Satisfaction in life, for the Neolithic inhabitants of Ireland, probably meant more than the securing of a good grain crop or herd of cattle. Spiritual fulfilment must have been equally important. Indeed, passage-tombs may be regarded as a spacious expression of ritual, but indicating the interdependence between ritual and secular events.

As Adolf Mahr long ago reminded us,[1] if we consider only the 'funerary character of collective tombs this falls somewhat short of grasping their full message . . . religious rites did not end with the funeral.' While there is no doubt that passage-tombs were used for burial, the nature of such burial is difficult to comprehend. Was it simply a functional matter, involving tombs as the repository for all members of a community, or for members of a specific or select family? And if more than one individual is represented in a deposit, could this be due to the fact that more than one member of a family happened to die at the same time? The Mound of the Hostages, Tara, might be such a family tomb, but in others only a small number of individuals was buried. Even Fourknocks I, which contained the remains of over sixty persons, seems not to have served as a vault for successive burials. As has been shown, the burials in each recess at Fourknocks consisted of a mass of bones which had apparently been deposited simultaneously. These deposits, and the few small ones of cremated bone in the spaces between some orthostats, could all have been buried at the same time, and even if not, the tomb need only have been reentered half a dozen times or so. There is somewhat similar information from other tombs; even at Knowth itself the number of persons buried is not great. In the massive eastern tomb in Site 1, a tomb that could have been open for use for half a millennium, only about twenty separate burials may have been made, and some of these contain only a minimal amount of cremated bone. It is indeed a possibility that despite years of preparation and building tombs were used only on one occasion and then closed up, the final act at Knowth 1 being the spreading of stones exotic to the region – quartz, granite and banded stones – in front of the entrances. After the 'inauguration' day their maintenance would have been unimportant – the impermanent roof at Fourknocks suggests this – and they would have become neglected ruins. Perhaps some ritual value remained attached to them as it does today to the overgrown, yet still sacred mounds of the early Japanese emperors.

Despite the absence of clear evidence for large-scale burial and prolonged use, nevertheless it seems odd that the Irish passage-tombs functioned for a mere few hours. In fact, there *is* some evidence that suggests otherwise. The main mound at Newgrange had a large slab or door indicating reopening; some tombs have stratified burial deposits; the art has greater meaning if one assumes that tombs were being reentered; and there is evidence for the prolonged use of passage-tombs elsewhere, in the Orkneys for instance.[2] It is then possible that in general the Irish tombs were being reentered. They could have been communal tombs, but not in the sense that all members of the community were buried in them. Those represented are likely to have been a minority buried at different times, symbolizing the community as a whole, and need not have been treated as individuals in their own right or even as a selection from a single family. One may also conjecture that burial was a communal affair, perhaps taking place at particular times of the year. Passage-tombs need not therefore merely have been sombre mausoleums, but foci for ritual and ceremony in addition.

Burial rites

It has already been pointed out that the orientations of passage-tombs vary and may have depended partly on the existence of significant points of alignment. Other events may have been a factor as well. For example, from tomb orientation at Newgrange, one might theorize that events such as burials occurred at sunrise on 21 December, the midwinter solstice. This would have been an important time of the year for members of a farming community, as they could begin to expect longer and warmer days. At Knowth, however, the orientation of Site 1 suggests that there could have been two ceremonies at different times, the vernal equinox on 20 or 21 March and the autumnal equinox on 22 or 23 September. At these times, the sun rises and sets directly in the east and west, while day and night have equal lengths. The spring equinox represents the beginning of the growing season, and the harvest would have been gathered at the autumnal equinox.

At Knowth one might visualize a morning ceremony on the east side, and an evening ceremony on the west side. Such rites could have been the occasion of a pan-passage-tomb festival involving people from far and wide, providing a link between life and liturgy. Part of the event might have involved an enactment of ritual outside the tomb, for instance a procession around the mound, taking advantage of the decoration on the kerbstones – each one perhaps representing a 'station' within a system. In this connection, it is interesting to note that as one moves away from the entrance areas there is a mix of styles – large central motif, circular serpentiform etc. Furthermore, the only stretch of undecorated kerbs is alongside Sites 13 and 14. Site 1 abutted

plate 27 onto Site 13, which pre-dates it, and Site 14 may also be earlier. There would not have been space for a procession to pass easily along that particular part of

the kerb, and the participants could have proceeded around the small sites, eliminating the need to decorate the kerbstones of Site 1 in that area. Perhaps they kept on the outside of Sites 13 and 14; the kerbs of these sites may have been decorated on the northern sides, although this cannot now be determined since the relevant portions are missing.

Especially at Knowth, an added emphasis was given to the tomb entrance areas. These must have been significant (as were the courts of court-tombs), because the site had to be designed in order to allow the kerb to curve inwards, which was a further complication in its construction. Most of the kerbstones decorated in the lavish style occur around the entrances to both tombs. This style can be considered as symbolism for all participants, lay as well as religious, and therefore the most public of all the styles. The incurving of the kerb created a reserved area outside the two entrances. The 'baetyls' on the west side could have been a delimiting feature on the outside, and probably also had a ritual role, in view of the presence of similarly shaped stones beside the entrances to some tombs at Los Millares in southeastern Spain.[3] Due to their size, the reserved areas could have contained only a small number of people, presumably priests who performed the ceremonies for the congregation gathered behind.

We do not know the nature of the ceremonies, but the various features such as stone settings must have served a related purpose. For example, on the east side, one might imagine the principal celebrant standing on the small limestone flag, which occupies the centre of the dished area of setting 1. This setting is central to the reserved area and, if the celebrant looked westwards, he would have been in line with the standing stone and the central line on the kerbstone before the entrance.

The trappings used in the ceremonies are not yet clearly established. It may be assumed that part of the ritual involved exotic items, notable amongst which would have been the conical stone objects averaging 25 cm long from Knowth and Newgrange. Both were found near the entrances to the tomb, that at Newgrange lying within the quartz-paved stone setting which is rather similar to some of the Knowth settings, while the Knowth object was in a small scoop in the old ground surface on the northern side of the entrance to the western tomb.[4] The Newgrange piece is plain but its surface is polished. The Knowth object is highly decorated. Most of the body has a series of arched grooves which terminate at a channel which runs down from the top to the bottom. In an area just below the unexpanded head there are three arcs. In decoration and to some extent in form this object is close to the decorated bone pin from Knowth 2, where it was associated with the burial. It is of interest that both the Knowth and Newgrange stone objects are phallus-shaped, and the rites could in part have concerned fertility, emphasizing the continuity of society. The Knowth maceheads might also have served in such ceremonies, while the more splendid piece could originally have had a wider function, perhaps belonging to the most important person in the community – a political

plate XI
fig. 58 (1)

or religious leader – and therefore being the common possession of the community as a whole. Its last visible role may have been played at the dedication ceremony of the great site, after which it was withdrawn forever from human sight, becoming the first object deposited in the tomb. Such an event could have been more than simply an enshrinement of this communal emblem; it conferred further status upon the ostentatious eastern tomb.

This macehead can be integrated more strongly into the ceremonial context through its art, whose angular-spiral style is shared most conspicuously by the Newgrange entrance stone and the left side of kerbstone 52 directly opposite, as well as by kerb 67.

The spread of exotic stones may also have played a role in the suggested ceremonies. They could have embellished the edge of the mound as a background for the ceremonies, subsequently slipping down after the tomb had fallen into disuse. But one may also speculate that the stones, or some of them such as the rounded examples, were used during the ceremonies. At least, on each side just outside the entrance there are a couple of smooth, rounded stones and of course there is the large number of rounded granite boulders. These might have been used externally while smaller versions – the balls – were taken within and deposited with the burials at Newgrange and some other passage-tombs, although not in the eastern tomb at Knowth. At Knowth the decorated conical stone object and the pin clearly show that the same type of object had both external and internal functions. After the ceremonies the stones might have been spread, a 'cloth' to protect and emphasize the ceremonial, possibly altar, area; it may be noted that the exotic stones occur on the old ground surface. As the spread would have covered the stone settings which are considered to have had a function during the ceremonies – some of them are paved with quartz – it would have had to be removed before the commencement of each ceremony; but that need not have been a major task. When the time came not to use the tomb any more, as part of the final sealing-up or deconsecrating the stones may have been spread for the last time around the entrances, so as to provide perpetual protection of possibly sacred areas.

Abroad, stone spreads and related features have also been recorded around tomb entrances, especially in south Scandinavia,[5] but this may be due to more extensive excavation in that region. Such spreads can consist of successive deposits of pottery vessels – at some tombs, especially in Zeeland and Scania, over 1,000 vessels are represented by about 50,000 sherds.[6] Spreads of stones are also known, a good example being that at the Trollasten tomb.[7] This is crescentic in shape, 5 m in maximum width, opposite the entrance, from where it curves inwards to both ends, each of which is about 6 m away from the entrance. Finds include pottery sherds (Funnel-beaker), stone axes, flint blades and other objects. There was also a granite stone dished on one side. Pockets of cremated bone, often associated with artefacts, also occurred in the spread. Gladsax No. 18, also in Scania, had a spread of pottery, flints and other objects at the entrance, but in addition there were rounded stones of quartz that were

derived from the beach and closely resemble some of the stones in the Knowth spreads.[8] One can then picture ceremonies being performed by priests – indeed the leading figure may have been a priest-king – before and around the entrances, using exotic objects (maces and conical 'idols') and unusual stones. Perhaps the grave goods were originally used in the ceremonies as necklaces or pins to fasten ceremonial cloaks. It has already been suggested that the small stone balls may correspond to the large and smooth rounded stones found outside as part of the spreads.

After, or during, the open-air ceremonies, burial deposits (evidence from sites such as Fourknocks I and Newgrange K indicates that some deposits were initially kept elsewhere before being placed in the tombs) could have been taken into the chamber, but this aspect need not have been a feature of every ceremony, especially if the rites took place on more than one occasion each year. However, one can speculate that the chamber was entered for ceremonies but probably by priests only. About two-thirds of the way in, further incantations may have taken place – at least, in both the western and eastern Knowth 1 tombs there are specific features at that point. In the eastern tomb there is a break in architectural continuity, and in both tombs the roof of the passage starts rising, while in the western there is a sillstone and in the east a downward projecting capstone (No. 45), with its loose area-picking on its outer face. There is also an abundance of megalithic art on capstones and orthostats in the angular and rectilinear styles. The loose area-picking of capstone 45 in the eastern tomb is repeated on the three corbels directly above the backstone of the end recess, and in a corresponding position in the chamber of the western tomb. At Newgrange the downward projecting lintel has similar loose picking on its outer face, and this is repeated over the endstone of the end recess; the lowermost corbel has however been damaged. This portion of the passage must have been an outer sanctum that contained ritual pointers to the chamber or inner sanctum. Features at other sites, such as the ante-chamber appearance of the inner part of the passage at Sliabh na Caillighe T, the little recess at the right-hand end of the passage at Baltinglass I, or the recess on the right-hand side just before the sillstone at Newgrange Z and Carrowkeel B, indicate that this portion of the inner part of the passage is likewise an important area in other tombs. Such features are also known abroad at, for example, Mané Rutual (ante-chamber) and Les Pierres Plates (recess), both in Brittany. Some Severn-Cotswold and Scottish tombs also have ante-chambers.

The tomb interior need never have been visited by ordinary mortals, but communication with it may have been facilitated by the key positioning of certain stones, decorated only in the angular and rectilinear styles, whereby people outside could identify with events inside. There may have been a further purpose in maintaining contact with the burials, for example a cult of communal (not necessarily family) ancestors, who might have retained membership in the community or, with time, become transmogrified into

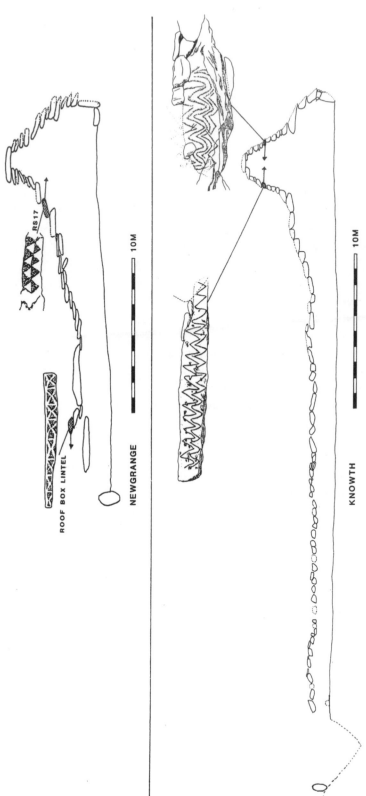

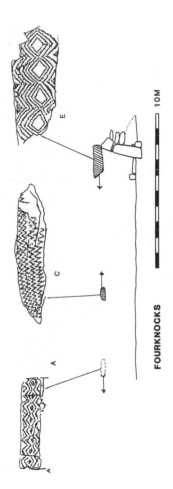

ROOF BOX LINTEL

RS17

NEWGRANGE

10M

KNOWTH

10M

A

C

E

FOURKNOCKS

10M

73 Location of lintels or related stones decorated in the angular style
at Newgrange, the eastern tomb at Knowth Site I, and Fourknocks I.

182

incorporeal beings possessing power and influence. Frances Lynch has already suggested that interest in tombs extended beyond burials and that at least some could have been used as an oracle.[9]

Attention has been drawn to the entrance stones at Site 1, with their rectilinear styles but also central vertical line. This may be more than just an indication of the entrance. In fact, an examination of the positions of stones bearing specific styles has led to interesting results. It can be shown that the angular, rectilinear and, to some extent, the angular-spiral styles and dispersed area picking are the most significant in view of their virtually exclusive association with the tombs, not only at Knowth 1 but also at Fourknocks and Newgrange in particular. Such decoration is found within the tombs and, as will be demonstrated, it aims at different heights or levels and 'leads' one inwards or outwards. The location of some of the art, especially the angular art on the decorated roof stones, shows that it was ornament created for a *fig. 73* purpose. Its importance proclaimed that it should be incorporated into the architectural design.

Since the side of the mound of Site 1 was damaged during Iron Age times by the digging of a ditch, we do not know what arrangement existed at the outer ends of the passages. But at Newgrange, a stone decorated in the angular style was incorporated into the passage structure directly above the entrance, with its narrow decorated side facing outwards. Due to some interference, as well as to factors of preservation, the story at Fourknocks I is less clear. However, a displaced stone, again with angular art on a narrow side, was found on the northern side of the mound near the entrance (No. A). Mr Hartnett thought that this stone might have stood across the entrance; yet in view of its decorative style and its location, this stone, too, is more likely to have projected from the side of the mound above the entrance.

The Newgrange stone formed a capstone to a slit in the roof, or what Professor O'Kelly called a roof box, which today allows the sun to shine into the tomb at the winter solstice, thereby adding to its significance. Internally, in the chamber directly above the passage/chamber junction, there is a similarly decorated stone, but facing in towards the chamber. This latter feature also occurs at Knowth (eastern), and that chamber also had a stone with similar decoration, at a similar height, in the roof above the end recess. This arrangement exists at Fourknocks as well, but at a lower level. Stone C spanned the inner pair of orthostats, while its counterpart spanned the end recess.

The angular style is also found on corbels or lintels at other sites – above the orthostats in the side recesses at Newgrange, and on the chamberward face of *figs. 75–81* the roof stone in the right-hand recess at Fourknocks. More elaborate examples of the style are orthostats 48 and 54 in the eastern passage at Knowth, and 40 in the western; chamber stones 6 and 7 at Dowth south; and stones L8, and C16 at Barclodiad y Gawres. Barclodiad Stone C1 and Knowth 16 orthostat 9 are in the same tradition. Newgrange stone K52 at the back, and possibly K50 at Dowth, may have functioned as symbolic 'exits' or as 'back

sights', or even as a blind entrance as at some Severn-Cotswold sites like Ty-isaf.[10]

fig. 84 In the western tomb of Knowth Site 1, such a 'lead-in' is provided by a different style, the rectilinear. This starts with the entrance stone and its vertical line. Except for the latter, the pattern is repeated on the backstone of the chamber, the middle sillstone being close in style. Orthostat 34 is similar. Within the style, a less austere regularity is found on orthostat 49, which stands on the right side of the passage just inside the outer sillstone. Here one gets the impression of an eyed figure, a spirit guarding the outer sanctum of the tomb; a possible parallel is the orthostat L3 at Luffang, Brittany.[11] This less unified pattern, varying in its 'coherence', occurs on a number of orthostats in both the western and eastern tombs. It may again be noted that the entrance stone of the eastern tomb is in the regular rectilinear style with a central line, while the backstone of the end recess of the tomb has the less coherent version.

We may now return to the angular style and its more ornate examples, on orthostats 48 and 54 and capstone 43 of the eastern tomb and 40 in the western. These have a wide and full canvas, and are close to stones at Knowth Site 4 (inner face of inner sill No. A), Dowth south (C6), Fourknocks (A, C, E, F), Barclodiad y Gawres C16, and to some extent Knowth 16 (No. 9). Indeed, the angular and rectilinear styles are very much 'tomb styles', although poor versions of the angular style are found on some of the Newgrange kerbs and it is noteworthy that both styles occur on the inner sillstone (A) at Knowth 4. As has already been said, the angular art is found partly at a high level, for instance on corbels and lintels at Knowth (eastern), Newgrange (large), and Fourknocks I – but the more elaborate examples are on orthostats, that is, as ground art. The rectilinear art is always ground art. From its location and

fig. 83 positioning one may speculate that it acted symbolically as guardian to the tomb generally, but also specifically, for instance on the orthostat and jamb outside the end and right-hand recesses in the eastern tomb.

fig. 82 The angular-spiral style, seen in such perfection on Newgrange kerbstones 1, 52, and 67, and on the Knowth ovoid macehead, is found to a limited extent both at Newgrange on orthostats and at Knowth (eastern) on orthostats, lintels, and chamber corbels. At Knowth, the two chamber corbels decorated in this style had portions broken off. While this could be accidental, perhaps the breaking of a stone was part of the ritual.

Angular art is the art *par excellence* of the tombs. Its appearance at a high level, especially on certain stones in key positions such as the upper part of orthostats or roof corbels, suggests that it may have belonged to the system of communication between the tomb's exterior and interior, whereas that at ground level is intimately associated with the burials, on the one hand functioning as a companion for the remains and on the other as a vehicle for two-way communication which could have benefited the living. Furthermore, if there is any relationship between the angular art and the Iberian schist plaques, these too were tomb features, commonly used as grave goods, and

thus directly allied to the burials. It is interesting that, at Praia das Maçãs in *fig. 74*
Portugal, the plaques were found exclusively in the inner chamber (which I
regard as contemporary with the main chamber), as is also the case with the
ground angular art at Knowth (eastern), Dowth south, and Barclodiad y
Gawres. At the passage-tomb of Pedra Branca, also in Portugal, twenty-nine
plaques were found in the chamber, and only five in the passage. Significantly,
too, the best parallels among the Iberian decorated structural stones are
confined to chamber stones, while the Breton site of Gavr'inis provides
parallels on the inner sillstone. In the Orkneys, at the passage-tomb on the
Holm of Papa Westray, South, a corbel stone in the seventh course above the
entrance to cell 4 has angular decoration.[12]

If the Knowth rectilinear art has parallels in the art of the Breton bent
passage-tombs, this is also a tomb art. Yet in contrast to the classic examples of
the Irish angular style at ground level, it is not exclusively confined to the
chambers, but occurs on passage orthostats as well, especially in the outer
sanctums. However, in this connection, it was not the practice to have external
art in either Iberia or France and, in any case, kerbstones were not a feature of
those regions. It may also be recalled that the decorated stone at Bryn Celli
Ddu in Anglesey has a pattern which resembles aspects of the angular style.
This stone was lying beside a pit under the mound at the back of the end stone
of the passage-tomb. Therefore, like grave goods, it was not intended to be
seen.

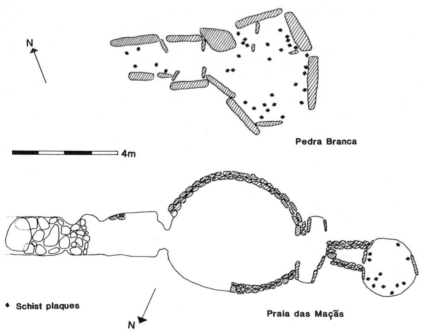

74 *Distribution of stone plaques in the passage-tombs of Pedra Branca* (above)
and Praia das Maçãs, Portugal.

Knowth could have been the focus for ceremonies over many centuries, but during this period there may have been some alterations in the ritual. It is such a change or changes that might explain the obliteration of some motifs and the addition of others. Perhaps changing ritual ideas meant that the original meaning of some compositions was no longer relevant, and it became necessary to destroy such compositions so as to conform to current values or at least to reduce the compositions' power. In general, the large serpentiform motifs with their heavier picking seem later – that is certainly the case on Site 1, kerbstone 13. Area picking applied by the same heavy technique is also known.

Among other ceremonial aspects are those to be gleaned from accounts in early Irish literary sources. We know that, at least by the twelfth century AD, there was an established tradition that the Kings of Tara were buried at Brugh na Bóinne, and their origin could go back to the Iron Age or earlier. In the 'History of the Cemeteries' in *Leabhar na h-Uidhre*, it is stated that the 'nobles of the Tuatha de Dannan' were buried at Brugh. The thirteenth-century manuscript of the *Book of Ballymote* records that 'the hoasts of great Meath are buried/in the middle of the lordly Brugh'.[13]

The impression given is that the tombs were the burial places of noble and notable persons. But some of the sources also imply that people came to Brugh in order to mourn, or on pilgrimages to ancestral or community tombs, suggesting that the whole area was sanctified. There are, in addition, references to seasonal or biannual assemblies; indeed, religious ceremonies may have had wide implications. Although none of these literary accounts of fairly recent date may be relevant to the passage-tomb period, one may speculate that an agricultural and pastoral people hoped to improve the well-being of crops and flocks by magico-religious means.

A problem in visualizing external ceremonies is concerned with the maintenance of the tomb. Material exists outside the kerbs of both Knowth and Newgrange which can best be explained as slip, derived from the edge of the mound. Such slip could have come down during the first year or so after construction, when the material was soft and did not consolidate, later settling and becoming stabilized by the growth of vegetation. On the whole, it seems more likely that the tombs were maintained, and that only after the conclusion of the passage-tomb complex did they fall into disrepair, allowing the slip to descend in spite of many centuries of consolidation.

Apart from being able to say that there is evidence for burial, successive in some cases, we do not know what other ceremonies may have taken place at the smaller Knowth tombs. Indeed, it is possible that they were integrated into the principal ceremony; at any rate they either face or tend to face towards the hill-top. They may, of course, have been centres of ceremonies in their own right: Site 4 had a setting of stones paved with quartz, the decorated sandstone 'baetyl' was found close to the entrance to Site 12, and the flint hoard was discovered at Site 2.

The positioning of megalithic art

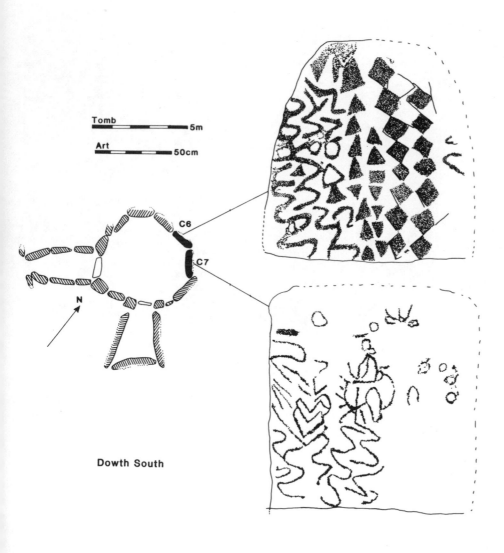

75 *The angular style: Dowth South.*

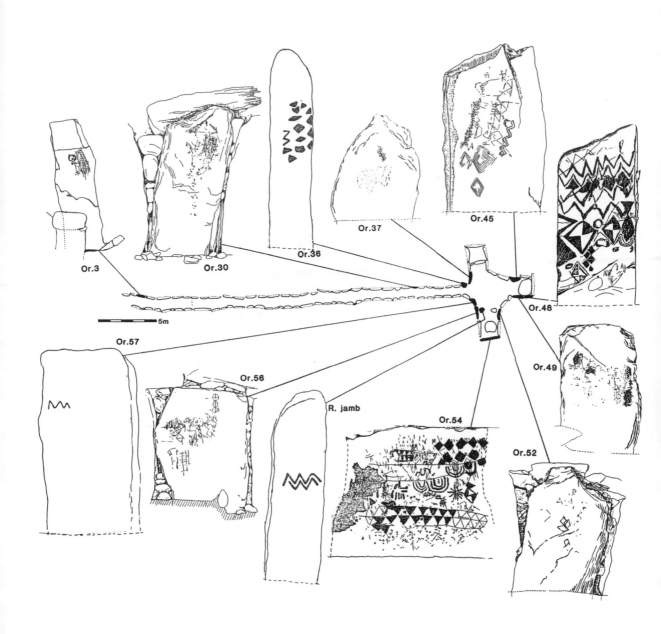

Or.3

Or.30

Or.36

Or.37

Or.45

Or.48

5m

Or.57

Or.56

Or.49

R. jamb

Or.54

Or.52

76 *The angular style: eastern tomb, Knowth Site 1 (orthostats only).*

77 (opposite above) *The angular style: western tomb, Knowth Site 1.*

78 (opposite below) *The angular style: Knowth Site 16.*

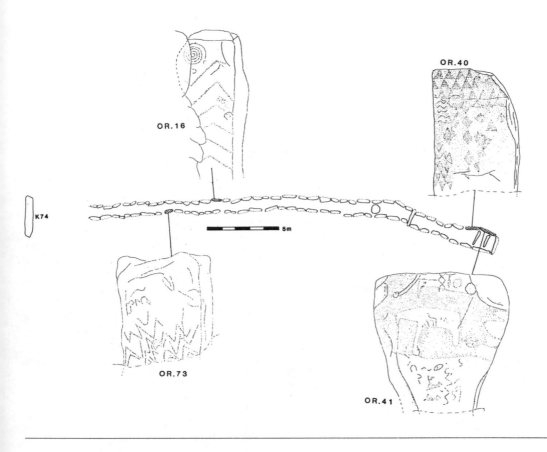

OR.16

OR.40

K74

5m

OR.73

OR.41

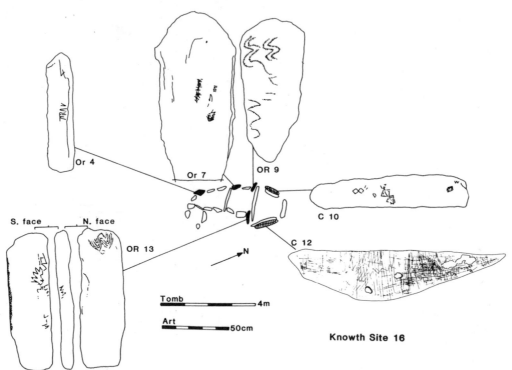

TRAV

Or 4

Or 7

OR 9

C 10

S. face

N. face

OR 13

C 12

N

Tomb ▬▬▬▬ 4m

Art ▬▬▬▬ 50cm

Knowth Site 16

189

ANGULAR ART

NEWGRANGE PASSSAGE AND CHAMBER

79 *The angular style: tomb in the large mound, Newgrange.*

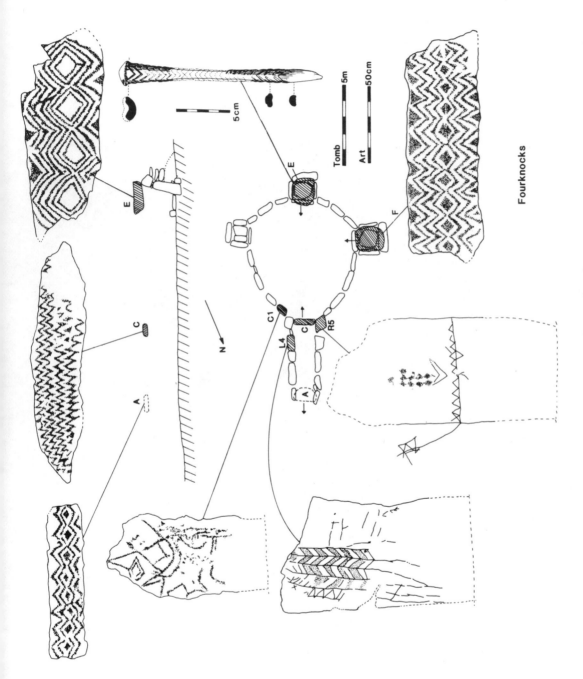

Fourknocks

Tomb ▮ 5m

Art ▮ 50cm

5cm

5cm

80 *The angular style: Fourknocks I.*

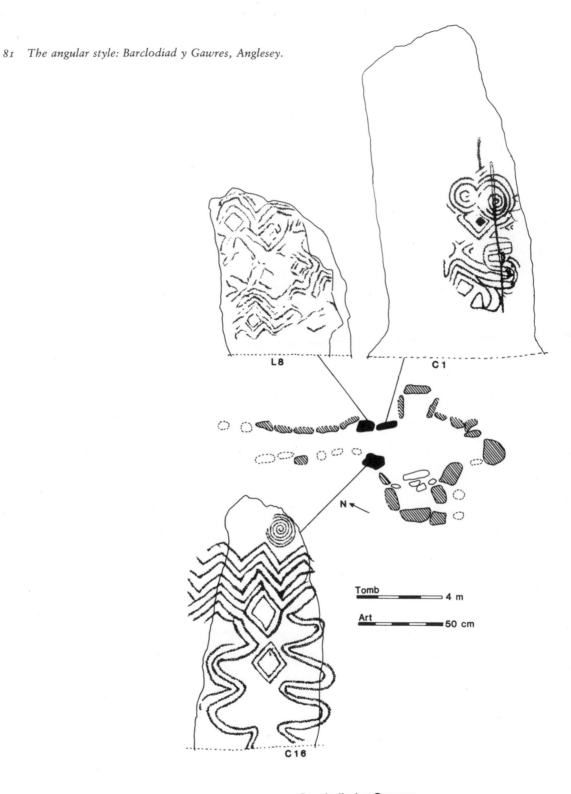

Barclodiad y Gawres

K51

K52

K67

C2

C10

L19

K1

K85

ANGULAR-SPIRAL ART

NEWGRANGE

25m

82 *The angular-spiral style: Newgrange.*

RECTILINEAR ART
KNOWTH·EAST

OR.47

OR.50

L·JAMB·STONE

OR.64

OR.27

OR.65

OR.26

OR.66

OR.25

OR.68

5m

OR.69

KERB 11

83 The rectilinear style: eastern tomb, Knowth Site 1.

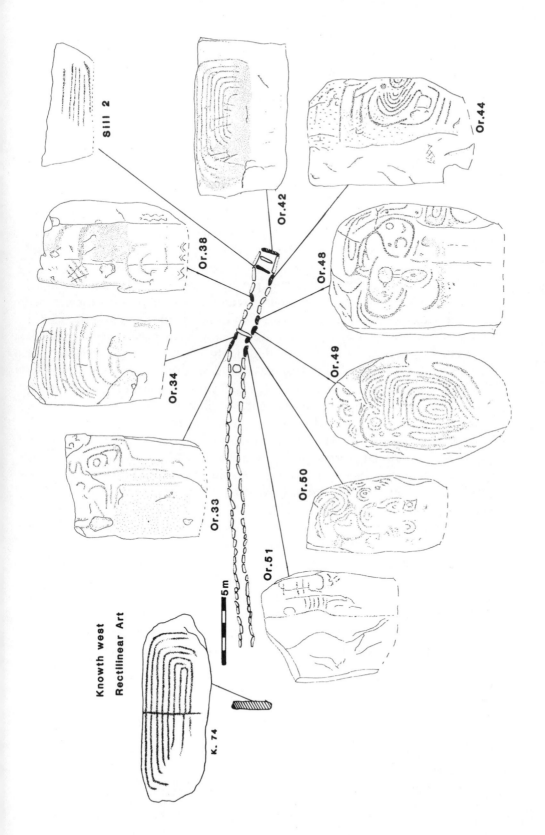

SIII 2

Or.44

Or.42

Or.38

Or.48

Or.34

Or.49

Or.33

Or.50

Or.51

5 m

Knowth west
Rectilinear Art

K.74

84 *The rectilinear style: western tomb, Knowth Site 1.*

195

9 Houses and settlements

There is now a considerable body of information about houses and other aspects of Neolithic settlement in Ireland. These include isolated houses, such as that at Ballynagilly in County Tyrone, but also houses set fairly close together as at Knockadoon, Lough Gur.[1] The rectangular house at Ballyglass, County Mayo, was a habitation site of court-tomb builders.[2]

So far, no unequivocal settlement of passage-tomb people has come to light, but the excavation of some tombs has revealed evidence for domestic activity underneath them. One such site is Townleyhall 2 and, as this produced a couple of sherds of Carrowkeel ware, it may have been a passage-tomb settlement.[3] The area was unprotected, roughly oval, at most 15.75 m long and 11 m wide. There were 142 stake-holes, but it was impossible to disentangle the plan of a structure from these – although the use of stakes would suggest less substantial constructions like a tent, which may have been renewed on many occasions. Two paved hearths and six other fireplaces were found. Covering the area was a layer of occupation material, 15 cm in maximum thickness, containing further finds. In addition to the Carrowkeel ware, it yielded a couple of sherds of 'Western' Neolithic ware, while Sandhill ware predominated. Flint was apparently worked at the site, and the chief artefact was the hollow scraper. End scrapers were popular as well, and transverse arrowheads, perforators, and blades occurred in small numbers. Carbonized grain shows that wheat was cultivated.

Under the cairn at Baltinglass, there were two spreads of dark occupation-like material, but no traces of structures. Finds consisted of five rounded flint scrapers, a javelin head, and a polished stone axehead.[4] Two other sites exist which may be contemporary with Townleyhall 2, although not directly associated with a passage-tomb. One of these, a recently excavated site in Armagh City, was a circular area about 10.70 m across, surrounded by a ditch nearly 1 m wide and 30 cm deep. There was no evidence for a causeway, and later activity had destroyed the centre, but it is just possible that this was a protected settlement site of passage-tomb people. All the finds came from the ditch fill, including flint artefacts such as an arrowhead, and sherds of Carrowkeel pottery (on information from Mr C. J. Lynn).

Townleyhall 1 had a stake structure, a dark occupation layer, and pits. These features lay within an area that was delimited by a bank and an external ditch. The inhabitants kept cattle and pigs. Flint artefacts were mainly

scrapers, round and hollow. The couple of pottery sherds are of uncertain type.[5] At Newgrange (large mound), the foundations of a roundish hut, 4.20 by 3.20 m, were discovered at a short distance outside the entrance. Its floor was slightly sunken, the edges being defined by a trench on the western side, and by stone settings or a scoop on the other sides. There were also some post-holes. A fragment of a stone bowl was the only find directly associated with the structure. Professor O'Kelly regarded the hut as 'either contemporary . . . or somewhat, though not much later' than the passage-tomb.[6]

It has been speculated that the hut sites at Mullaghfarna in County Sligo, numbering a hundred or so, might have been the abodes of the passage-tomb builders of Carrowkeel.[7] Unfortunately, this can be neither proved nor disproved. Mullaghfarna is located on a promontory, mostly of bare limestone, below Sites O and P. The huts are fairly similar, circular structures, generally consisting of a wall formed from slabs on both sides and filled with rubble. An entrance, again normally faced with a slab, is common. The size varies: some are small, about 8 m in external diameter, but others are up to 20 m wide.

There is a group of circular sites on the east side of Knocknarea mountain in County Sligo. Excavations were carried out at two sites. Hut 1 consisted of a somewhat oval area, a little over 6 m by 4 m, surrounded by a low bank up to 2.50 m wide, except for a stretch on the east side enclosed by a ditch. The site produced '65 dark-coloured spots', mainly in the line of the bank, which were interpreted as post-holes, the remains of a circular tent-like structure. About 400 flint or chert objects turned up, including rounded scrapers, points, and knives, but predominantly hollow scrapers. Hut 2 also consisted of an oval-shaped area of uncertain size, enclosed by a bank and external ditch. Dark patches, mainly in the bank, have been interpreted here, too, as post-holes for a small tent-like building. The range of finds resembled that from Hut 1.[8]

The settlement at Knowth

Settlement material, but associated with 'Western' Neolithic pottery of round-bottomed and shouldered form, is known from under passage-tombs as well. *fig. 85* The most substantial evidence comes from Knowth.[9] On the western part of the ridge, there are features consisting of the remains of a sub-rectangular *fig. 86* structure (house?), palisade trenches, pits, fireplaces, and areas of pebbling. Not all the features were in use at the same time. The sub-rectangular structure had a trench dug into the subsoil around all sides, with eleven post-holes in the base on one side. An undug causeway exists at the northeastern corner, which must have been the entrance area, although no sign of a doorway has been found. In the interior near the centre was a small area of rough paving and, between this and the northern trench, there was a fireplace associated with an ash spread. Close to the southwestern perimeter were two small areas where a fire burned. Seven pits of varying shapes also occur, but they cannot be dated

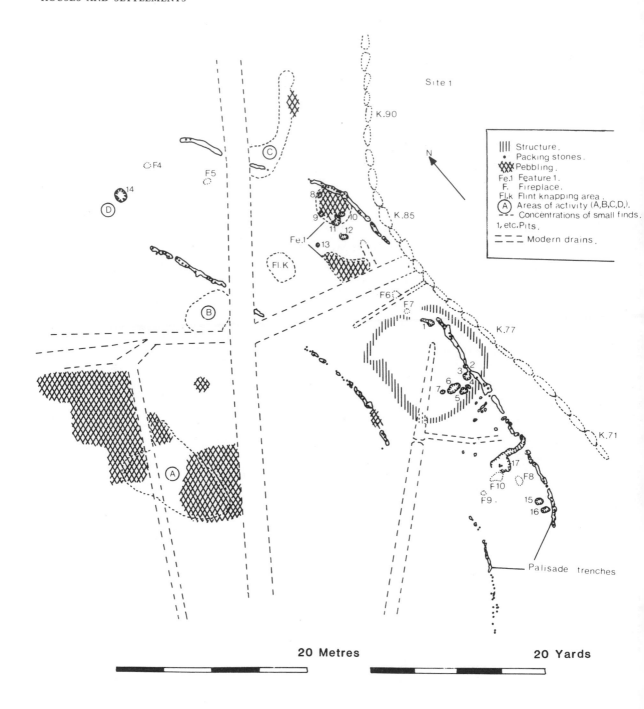

85 *Area of domestic activity at Knowth.*

86 (opposite) *Ground plan of a sub-rectangular structure at Knowth.*

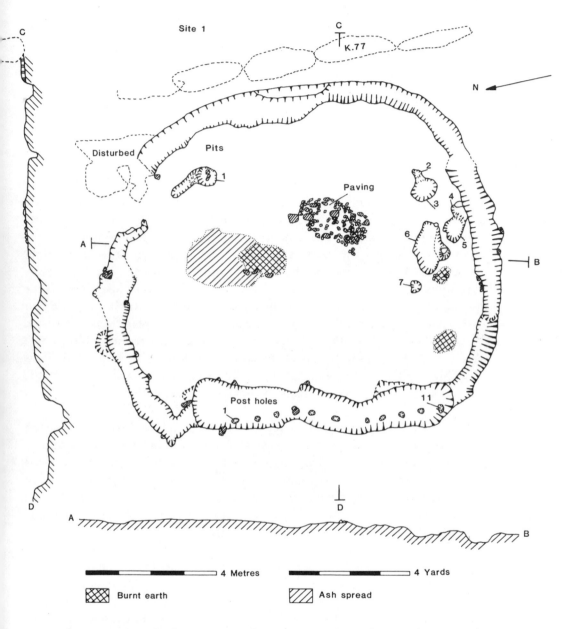

Site 1

C
K.77

N

Disturbed Pits

1

2
3
4
6
5
7

A

Paving

B

Post holes
1
11

C

D

D

A

B

▰▰▱▱ 4 Metres ▰▱▱▱ 4 Yards

▨ Burnt earth ▨ Ash spread

except for one pit, which must pre-date the structure, having been partly removed by the digging of the trench along the southern perimeter.

This structure measures 10.70 m by 9.10 m internally. Its shape suggests that it was a house. The western trench presumably held upright posts, but post-holes were absent from the trenches on the other three sides. Furthermore, the lack of post-holes in the centre would mean a long span between the side walls. It is possible, of course, that prop-posts sitting on the surface were sufficient to support a roof. Apart from one of the pits, the finds were confined to the fill of the enclosing trenches, especially the lower levels of the large western trench.

The main finds were pottery sherds and flints, the former being from round-bottomed, shouldered, undecorated vessels. The flints are scrap except for two definite artefacts, a rounded scraper and a side scraper. The fill of pit 6 yielded a leaf-shaped blade.

The palisade trenches are slightly curved, running in a north–south direction. They are closest to each other at the southern end, about 8 m apart, and diverge to 11 m at the northern end. The gaps in them are due to subsequent interference, except for one about midway along the western trench, 3.2 m long and 'paved' with pebbles, probably an entrance. Both trenches are about the same length, the western being 59 m and the eastern 58 m. Their width averages 30 cm, but the depth varies. In some places, they are scarcely distinguishable as a result of the damage, while in others they are around 50–60 cm deep. The trenches contain many packing stones whose arrangement, in places, shows that they must have been propping upright posts. The configuration of the posts is not quite clear, but the almost continuous presence of stones suggests that the posts were closely set. As the post-holes average about 25 cm in diameter, one may picture a stockade that could have risen to a height of 1.5 m. The finds, which were in the fill, consisted of plain 'Western' Neolithic pottery and a few rounded scrapers of flint. There were various features in the space between the palisades, including two areas of pebbling, pits, and fireplaces. At one point, flint knapping occurred. On the western side of the palisades were areas of cobbling, with a similar range of finds.

This site is fairly extensive as regards activity. While the palisades attest wood-working, only one stone axehead came to light. The flint knapping provides evidence for industrial work. The pottery, too, may have been made locally, as it contained grits of shale and quartz. Its porous nature suggests that it was used for storing dry commodities such as grain. Practically all the flint artefacts were scrapers, especially of the rounded variety. Animal bones and grain show that the inhabitants were farmers. Two serpentine beads are the only proof of personal adornment. The finds indicate a Neolithic date, but more detailed chronology is difficult to determine. However, not all the features were contemporary; as already mentioned, the digging of the structure or house trench along the southern side destroyed part of a pre-existing pit. In addition, the fill of the trenches, mainly that on the western side, consisted of occupation debris. It is likely that the trenches would have been filled up as part of the building activities, so the occupation debris must have been a result of still earlier occupation. The eastern palisade trench cuts across the structure (house), and is thus a later feature.

Regarding relations with the Knowth tombs, stratigraphic evidence shows that this activity pre-dates five small tombs, Sites 6 and 8–11. There is only one carbon-14 determination, from charcoal found in the largest pit within the structure. The date is 4852 ± 71 BP, or c. 2920 bc (sample BM 1076). It is not known, of course, whether this pit is contemporary with the use of the

structure. Among such determinations from Neolithic sites at Knowth, this is the earliest. A further question concerns the connection between the inhabitants and the tomb-builders. Even though the activity pre-dates five tombs, this need not mean that it is earlier than all the Knowth tombs, and one is indeed tempted to consider both as parts of the same cultural complex. However, the stratigraphic evidence shows that the settlement is earlier than some tombs and there is also an early carbon-14 determination. Moreover, the 'Western' Neolithic type of pottery from the settlement is never found in passage-tombs, but is common in court-tombs. While it may be that passage-tomb people used 'Western' wares only for domestic purposes, it is possible that the settlement belonged to an earlier and culturally distinct group. Here we face a wider issue in archaeological studies, which cannot be solved at Knowth alone.

Parallels for this complex of features are difficult to find. Perhaps the structure can be compared to rectangular houses, such as those from Ballyglass in County Mayo, Ballynagilly in County Tyrone, and Knockadoon, Lough Gur. It is even less easy to suggest a function for other aspects of the complex. A main problem is that the purpose and even the contemporaneity of the palisades have not been established. While there are pits, fireplaces, and a flint-knapping area between the palisades, the ends are open and would thus not have formed an effective enclosure. In addition, some features occur outside the trenches, especially on the western side. Since the palisades are curved, we must ask whether they could have been part of an enclosure, either beginning with both together or adding the eastern one later than the western one. The area outside the ends was investigated, and no evidence for such continuation came to light. However, the surface soil becomes thinner at ever greater distances from the large mound, and it may be that all evidence has been removed by tillage. Therefore, the possibility must be kept in mind that what has been discovered is only a portion of an arc of an enclosure, perhaps circular and about 100 m in diameter.

Palisade enclosures are not otherwise known in Ireland, but it is relevant that current excavations on Donegore Hill, County Antrim, are revealing a Neolithic enclosure with at least two gapped concentric ditches with a palisade along the inner edge. The area of this monument is oval, measuring about 200 by 160 m, and the finds include 'Western' Neolithic pottery.[10] Small protected settlements are also known, the best examples being at Lough Gur, County Limerick. Townleyhall 1 had an enclosing bank and ditch. At Longford Lodge, County Antrim, an area of activity with pits, stone settings, and stake-holes was apparently enclosed by a ditch.[11] Neolithic palisade enclosures exist abroad, and a good instance is the first phase at Noyen, south of Paris. But structures consisting of palisades in combination with ditches are fairly common, as in southern England, northern Germany, and Denmark.[12] The artefacts found at Knowth can be readily paralleled on Neolithic sites in Ireland. The round-bottomed shouldered bowl is frequently found on the

habitation sites, in habitation-like material under the round cairn at Lyles Hill in County Antrim and at Knockiveagh in County Down, and in court-tombs.[13, 14] These contexts also yield leaf-shaped arrowheads and round scrapers.

At Newgrange, under Site L lay a large depression, six small pits, and a couple of burnt areas. The main finds were pottery and flints. Of the ten worked flints, five were round scrapers, two were double hollow scrapers, and three were flakes or blades. A period elapsed between the domestic activity and the construction of the tomb, with an intervening natural sod layer. Under Site Z, and again demarcated from it by a natural sod layer, there were some features including a hearth, a burnt area, and some post-holes. Finds from this level were about twenty-six flints, such as a hollow-based arrowhead and several scrapers of the rounded, end, and side types. A stone axe was also found.[15] At Ballintoy in County Antrim, black earth – itself possibly occupation material – occurred under the 'Druid's Stone', although its extent and nature is unknown as excavation revealed only a small area. Finds here consisted of sherds of 'Western' Neolithic pottery and flint objects: part of a kite-shaped arrowhead, two rough scrapers, and an elongated blade.[16]

The general character of the passage-tomb settlement is elusive. In view of the cemetery grouping, and the occurrence of so many tombs on elevations, a settlement pattern is not immediately obvious. The Boyne Valley is, of course, a place where the tombs are on rich agricultural land, and a settlement could have been nearby. Yet even in areas where the tombs are far from good land, this need only mean that it was the practice of the passage-tomb people to isolate a cemetery. It may then be that farmsteads existed in the low-lying areas or, in the Boyne Valley, in the surrounding countryside where one might visualize a large number of separate farmsteads, although the possibility of house clusters cannot be excluded. At the time of the tomb-building, especially at the huge sites, a sizeable population must have been living very near the tombs. Thus, perhaps Townleyhall 2 was a settlement associated with tomb-building activities.

10 Knowth: contexts, origins and chronology

Human settlement in Ireland goes back to around 7000 bc. At that time, it was mainly confined to the northeast of the country, but habitation also took place further south in the midlands, as is shown by evidence from Lough Boora in County Offaly (excavated by Dr Michael Ryan, National Museum of Ireland). Ireland had already become an island, although considerable changes in the relative heights of land and sea were still occurring.

A steady rise in temperature was being maintained, and this encouraged plant and tree growth. As a result the countryside was becoming extensively wooded, the predominant trees being pine, hazel, and birch, while oak, elm, and alder were increasing. Soil development, too, was progressing and aided by leaves falling from the deciduous trees.[1] There was a limited number of wild animals, including red deer, wild pig, brown bear, wolf, cat, hare, and fox. The lakes and rivers had a supply of fish such as trout, salmon, eel, perch, and tench. Fish was an important part of the diet of early Mesolithic people, and traces of settlement are usually found in low-lying areas near water.

The Neolithic period in Ireland

The Mesolithic inhabitants made only a slight impact, if any, on their environment. It appears that large-scale human influence began with the Neolithic. Various factors could have brought about the emergence of food production and the earliest farming communities in the island:

1 The acquisition of a knowledge of farming by chance, through a source and means of transmission which are unknown. This hypothesis will not be considered further as it cannot be effectively tested.
2 Indigenous development due to local adaptive processes by the Mesolithic people.
3 Irish Mesolithic people travelling abroad, acquiring a knowledge of farming, and introducing it at home.
4 The arrival of agricultural foreigners either by accident, such as farmer-fishermen blown off course, or by virtue of a more positive and intentional immigration.

Regarding the second hypothesis, Mitchell[2] and subsequently Woodman[3] have argued that modifications occurred within the Mesolithic period itself, leading to a 'heavy blade industry which makes use of a limited range of implement types'.[4] The main artefacts are Bann flakes, retouched flakes, obliquely truncated retouched knives, picks, and core axes. Sites with this assemblage, for instance Newferry in County Antrim, are low-lying and close to water; the specialist economy continued to have a large basis in fishing. Typologically and economically, this assemblage is considered to represent the continuation of the early Mesolithic tradition. Evidence from Dalkey Island and Sutton has shown that the Late Larnian people of Mesolithic times had domestic animals,[5] suggesting that the Late Larnian economy was of a primitive kind functioning in a wider economic environment with settled farming families.

Neither of these authorities saw evidence for indigenous economic innovation within the Mesolithic population. In addition, Woodman points out that there are distinctive typological differences between Late Larnian and Neolithic implements. Göran Burenhult, however, has argued for native development.[6] His view is that Mesolithic people in the Carrowmore region, as a result of economic stability provided by the richness of natural food resources and their intensive utilization, started to evolve a settled way of life, and the construction of stone-built tombs from about 3800 ± 85 bc, which were a 'reflection of demographic factors such as population growth and a need for a more formalized social organization and perhaps also a need for territorial markers'. The earliest passage-tombs were thus regarded as developments 'within existing Mesolithic populations'. From simple beginnings (Carrowmore Site 4), tomb development led to complex constructions (Site 27), and simultaneously to the arts and crafts of farming. But Carrowmore has not yet yielded positive evidence for Mesolithic settlers, their presence being only inferred. Moreover, it is unwise to rely too heavily on a single carbon-14 determination.

Professor O'Kelly favoured the third hypothesis, and suggested that the Neolithic way of life 'was introduced by a slow and complicated process resulting from overseas contacts'.[7] However, if Irish Mesolithic people were travelling abroad, those contacts did not in the first instance influence their own artefact typology or encourage the use of new types. On the other hand, the Neolithic differed immensely from the Mesolithic: not only did it usher in a new economic order, but it brought about major alterations in the range of artefacts. As these events represent a substantial breach with the past, something more than objects is likely to have arrived; people were probably an important component.

Apart from the introduction of new types and technologies, such as pottery and the specialist exploitation of distinctive rocks (like the porcellanite at Tievebulliagh in County Antrim, for the manufacture of axes),[8] wholesale land clearances took place and areas were laid out for farming. A section of a

well-built stone wall was found under the Millin Bay passage-tomb.⁹ More detailed evidence of land divisions, apparently by the same people who built court-tombs, has been revealed in north Mayo, consisting of stone walls 150–200 m apart, with offset walls subdividing these areas into rectangular fields.¹⁰

Cattle were kept and grain crops, wheat and barley, were grown. People lived in substantial rectangular and circular wooden buildings. A temperate climate, a couple of degrees warmer than today's, as well as large regions of potentially good farmland and exploitable natural resources, made Ireland an attractive location for settlement by early farmers. With the advent of farming, the settled land area increased in comparison to the Mesolithic, although settlement was still largely confined to the northern half of the country. As only a limited number of house sites or other evidence for occupation is known, megalithic tombs constitute the main bulk of the material that we have from Neolithic Ireland.

The development of tombs

An aspect of the early farming (Neolithic) communities over large parts of the coastal lands of western and northern Europe was the attention that they paid to burial of the dead. For this purpose they constructed tombs, and most of these were used for collective burial. In some areas, for example around the estuary of the River Tagus in Portugal, the tombs were formed by carving out a chamber in bedrock, but the more usual practice was to build tombs above ground. A feature in constructing the latter is the use of large stones in the passage and chamber, and often in the kerb surrounding the covering mound – hence the term 'megalithic' tomb, from the Greek words *mega* (great) and *lithos* (stone).

The covering mound may be either round or long in shape. Generally, the round mounds contain passage-tombs, but such tombs are also found under long mounds as in Brittany, northern Scotland, and Denmark/northern Germany. Long mounds may also cover a different type of tomb, such as the court-tombs in Ireland. As far as can be determined, passage-tombs were among the earliest megalithic tombs to be built, and they had a long period of use in those diverse areas of western and northern Europe. In view of their wide distribution and long life, there are naturally variations in tomb form, burial rites, and grave goods. The changes in form were so marked in some areas, such as northern Scotland, that a virtually new type of tomb emerged.

In these developments, local geological conditions could have played a role. Passage-tombs are usually found in the best economically viable areas, for instance the rich agricultural lands of Meath or Zeeland, or near the sea in Morbihan in Brittany. Long mounds were not constructed in Iberia, but they are well known on the Continent, from western France to southern Scandinavia, and across the north European plain from the North Sea coast to

fig. 91

Poland. The type is also common in Britain and Ireland. Its emergence may represent regional burial needs, as it contains different kinds of tombs and varies in overall ground plan. In western Europe, long mounds of trapezoidal shape were being built from an early stage in the Neolithic, as is shown by Breton passage-tomb cairns like Ile Guennoc and Barnenez. At those sites, the passages led in from the long sides.[11]

Having argued that not only the tombs but also the whole concept of food production were not indigenous, we must attempt to discuss the factor or factors that brought about their introduction. Since tombs are an integral part of the new complex – and since they have a limited distribution in Europe, mainly in the areas bordering on the Atlantic Ocean, western Baltic, and North Sea – they may throw some light on the source or sources of origin. But the problem of origins and developments, as well as of relationships between the various cultural groups that built chambered tombs, is complicated and imperfectly understood. Furthermore, as with other aspects of prehistory, the approaches to their study have changed radically during recent years.

As remarked already, it has not been conclusively established that megalithic tombs were invented in Ireland. However, there is evidence pointing to the early commencement of megalithic tomb construction on the Continent.[12] Therefore, the tombs must have been introduced as part of the Neolithic assemblage. This implies the use of boats and skilled navigators. The first Mesolithic inhabitants had to reach Ireland from across the sea, and sailing skills had surely been developed further during the intervening thousands of years. Neolithic travellers could have possessed large and strong hide-covered boats capable of sailing over long distances of open water.

But what could have stimulated people to move to Ireland, or made them aware that the island existed? Perhaps at times in the Neolithic period, there was population pressure which gave rise to restlessness, involving the search for new lands – in other words, to conscious activity. The fact that up to 25,000 megalithic tombs (dolmens and passage-tombs) could have been erected in Denmark, a land half the size of Ireland, during the early and middle Neolithic, a period of about 1,000 years, is clear evidence of large-scale population. The marked coastal distribution of Breton passage-tombs is an indication that the sea was an important factor in these people's lives. They must have been fishermen, and indeed Grahame Clark has argued that it was men seeking fish who first opened up a route to Ireland.[13] Initially, this could have happened by accident, as in being blown off course. The straight distance from the western tip of Finistère to Wexford, some 500 km, is about equal to that from Finistère to Dieppe. Even though some authorities consider megalithic tombs to an extent as an isolated phenomenon, and attribute their spread to the adoption of a cult of the dead by various groups of people,[14] it seems nonetheless more reasonable to regard the tombs in a more comprehensive manner, as an integrated part of the culture of early farming communities in western and northern Europe.

Megalithic tombs were being built in Europe during the fourth, but more particularly over the third, millennium bc. In the north of Europe, passage-tombs and other forms belonged to the funnel-necked beaker (TRB) complex. In the west, they belonged to the so-called 'Western Neolithic' which, however, is not a homogeneous complex. While different forms of tombs occur in different regions, and even in the same region, common traits are still often found. For example, the long barrows of southern Britain and Ireland have a trapezoidal mound with a chamber at the broader end which faces eastwards; emphasis on a façade or court, varying from flat or cuspate in Britain to semicircular or full in Ireland; and grave goods which include round-bottomed pottery vessels, flint artefacts, and stone axeheads.[15] Some of the tombs in the Severn-Cotswold long-barrows have side recesses or transepts which can be compared to the west French passage-tombs with recesses.[16]

The passage-tomb as such has the widest distribution of all. In some regions, these were the earliest tombs, and their construction and use continued for many centuries. They tend to possess a certain unity of form, and hint at the possibility of cultural cohesion over large parts of Europe. Nevertheless, their place of origin has not been firmly established, and there may indeed have been more than one centre, as is argued by Colin Renfrew.[17] Burenhult's view, already mentioned, that indigenous passage-tomb development occurred at Carrowmore can be questioned, as can the relevance of the date of close to 4000 bc for the building of Site 4 in that cemetery. Given the great number and variety of passage-tombs in Iberia, and carbon-14 dates going back to the fourth millennium, that region must still be seriously considered as an early centre of megalithic tomb development.[18] Unfortunately, the history of this development is not clear-cut, but tombs with a rich assemblage of grave goods are thought to be of later date, perhaps the end of the fourth and into the third millennium bc.

Priority has been granted to Brittany by some authorities in consequence of the early carbon-14 dates. In the Breton sequence as outlined by L'Helgouach, tombs with chambers of the rounded and the rarer square forms belong to the primary series that were built from before 4000 bc. Trapezoidal, round, and other shapes of cairn occur. Pottery consisted of plain, round-bottomed vessels in the 'Carn' style. During the second phase, say from the mid-fourth millennium or earlier, down to nearly 3000 bc, the trapezoidal chambers probably stood in the old tradition of, for example, Barnenez H, yet new forms – the cruciform, transeptal, and compartmentalized, as well as un-differentiated tombs – became common. There was now a variety of pottery, including the Rubanée and Chassey styles. Finally, the third millennium was, in the words of L'Helgouach, a time of great transformations in megalithic architecture. Bent and V-shaped passage-tombs emerged, as did new pottery types like the Kerugou and Conguel styles.[19] In southern Scandinavia, the dolmens are regarded as the earlier tomb type, of the late fourth millennium bc, with the passage-tombs following in the third.[20]

Comparisons with the Irish and other tombs

The two main forms of tomb represented at Knowth, undifferentiated and cruciform, occur on the Continent. Examples of the former are found from Iberia in the south to Scandinavia and Germany in the north.[21] Cruciform tombs and tombs with multiple recesses are known in Iberia and more often in western France and Brittany, although not a common Continental type.[22] According to Giot,[23] both undifferentiated tombs and tombs with side recesses could have been used in Brittany from an early stage in the history of passage-tomb development.

Comparative and contact archaeological studies are full of pitfalls and must be treated with caution and reservation. For instance, on typological grounds, one might argue that the Irish passage-tombs originated in Orkney! However, if one looks for Continental parallels to Irish passage-tombs, these occur more readily in the southwest than in the north of the Continent. Architectural, artistic, typological, and ritual features – such as roof corbelling, the round mound, cemetery grouping, and communal burial – are shared. There are no clear comparisons between the finds from the Irish and the Breton tombs, but there are some between Ireland and Iberia. The decorated conical stone object from Knowth has Iberian parallels in the decorated 'idols' which are found as grave goods in collective tombs, especially in the region of Lisbon.[24] The bone *fig. 58* pin from Site 3 in form and decoration resembles the 'idols' and, as a further comparison with it, one may cite the pin from the passage-tomb of 'San Martin', Laguardia, near Alava in the Basque country.[25] The Fourknocks I pin is also similar, while the polished but undecorated stone object with a blunt point from Newgrange may be compared to the simple 'idols' which have a concentration around Lisbon.[26]

The groove-decorated pendants from some Irish passage-tombs have possible parallels in the Iberian horizontally grooved pendants.[27] Concentration of these pendants is greatest in the Alicante region of southeastern Spain, but also exists in the Lisbon area. In addition, the Iberian tombs yield stone balls but also beads, whose disc- and barrel-shaped varieties resemble Irish specimens. The pendants from Carrowkeel G, with a knob at the narrow end, are similar to an object from the Anta Grande de Comenda da Igreja, Portugal.[28] It may be noted, too, that some of the stone nodules outside the entrance to the western tomb of Knowth Site 1 are conical and resemble the 'baetyls' which occur near the entrances to some of the Los Millares passage-tombs.[29] The fashioned and decorated stone from near Site 12 could fall within this category as well. Further comparisons have been drawn between the Irish stone basins and the *pila* from a small number of Iberian tombs, but the resemblances are not close.[30]

A factor that is common to Ireland, Brittany, and Iberia is the art on structural stones. There are, however, differences between the individual motifs and in the overall design used within the various areas. Among the

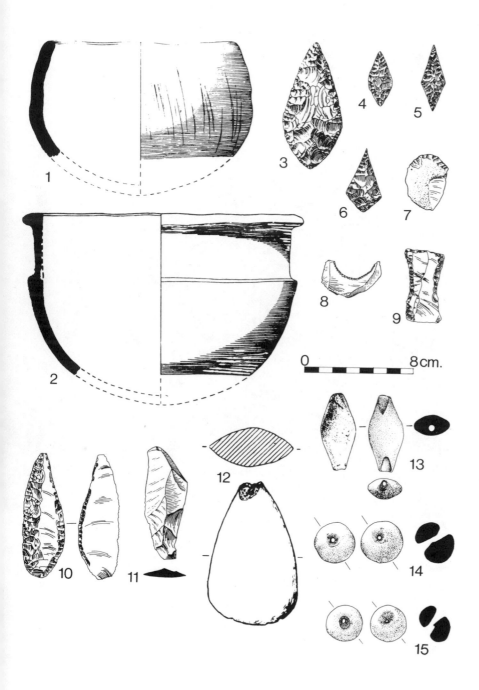

87 *Selection of grave goods from court-tombs. 1 and 2, unshouldered and shouldered
pottery vessels. 3, javelin head. 4, leaf-shaped arrowhead. 5, lozenge-shaped arrowhead. 6,
arrowhead with angular profile. (1–6 from Audleystown, Co. Down.) 7, rounded scraper;
8, hollow scraper – both from Annaghmare, Co. Armagh. 9, knife; 10, plano-convex knife
– both from Barnes Lower, Co. Tyrone. 11, flake, Annaghmare, Co. Armagh. 12, axehead,
Creevykeel, Co. Sligo. 13–15, beads, Bavan, Co. Donegal.*

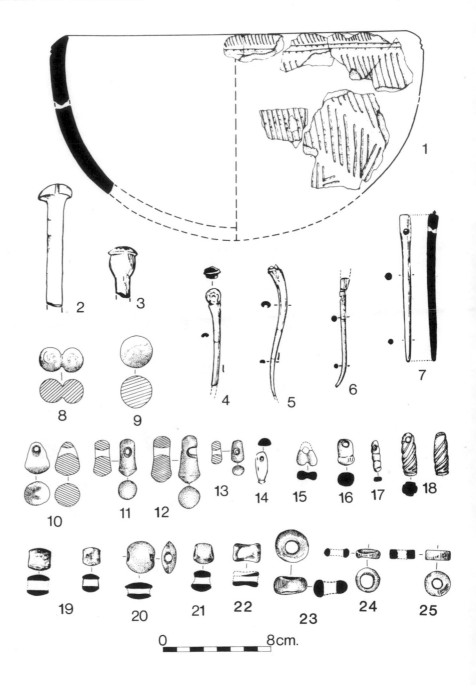

88 *Selection of grave goods from Irish passage-tombs. 1, Carrowkeel-type pottery vessel, Site R2 Sliabh na Caillighe (Loughcrew). 2 and 3, mushroom and poppyheaded pins, Carrowkeel Site E. 4–6, skewer pins. 7, bodkin, Fourknocks I. 8–9, balls, double and single, Newgrange large mound. 10–18, various forms of pendants (10–13, Newgrange large mound; 14 Carrowkeel Site G; 15–18, Mound of the Hostages, Tara). 19–25, various forms of beads, Fourknocks I.*

principal motifs, only serpentiforms and U-motifs are shared by all three areas. Ireland and Iberia have more motifs in common: besides the two just mentioned, there are also triangles, circles, and radial-line motifs. If the decoration on some of the objects from Iberian tombs, especially the schist plaques, is taken into account, then a wider range of motifs must be considered, particularly lozenges and chevrons.[31] As noted previously, the Irish angular style is close to the designs on schist plaques and other Iberian mobile objects, while the rectilinear style may be Breton-inspired. One may perhaps also compare the horizontal and vertical decoration on the basin in Site 1 (eastern) and Conguel ware. Triangular and arc motifs have a restricted occurrence on Chassey ware.[32]

While the foregoing features and finds indicate connections to the south, especially to the Tagus estuary on the one hand and the Gulf of Morbihan on the other, the remaining Irish objects are not conspicuously Iberian or French. This applies to the pestle and to other forms of pendants. Although Michael Herity has pointed out similarities between some Breton objects and Irish pendants,[33] he has also drawn attention to the amber pendants from south Scandinavian tombs, and of course funnel-necked beaker (TRB) pottery has a range of angular motifs. The pestle-shaped pendants, in shape although not in size, resemble pestle maceheads, which have a wide distribution throughout Britain and Ireland.[34] As in Knowth Site 1 (western tomb), pestle maceheads have actually been associated with passage-tombs at Isbister and Taversoe Tuick, Orkney, though the latter was found outside a kerbstone.[35] The ovoid macehead from Knowth 1 (eastern) has no parallel in Ireland, but it has close parallels in the Mawsmawr type, which is sparsely but widely distributed in Britain as well.[36] A macehead of the general ovoid family was discovered in a passage-tomb at Ormiegill, Caithness.[37]

Regarding Carrowkeel ware, the hemispherical shape is fairly common throughout Neolithic Europe. Case has pointed out that there are generalized similarities between the decoration,[38] and its technique of application, and those occurring on some pottery forms of the funnel-beaker culture (TRB) of the north European plain, where it is a typical find from the passage-tombs.[39] Yet one can also compare the triangular stab decoration on the pot from Lislea, County Monaghan, to that on the pedestalled vessel which was found outside the entrances to the two passage-tombs in cairn 1 at 'Min-Goh-Ru' near Larcuste, Morbihan.[40]

Chronological evidence

In Ireland the dates of passage-tombs range over the third millennium bc (see Appendix), but two stand out as very early. Humic acid from the basal sod layer of Knowth Site 1 provided a date of 4885 ± 110 bc (sample UB 358); and charcoal from the 'stone fundament' of orthostat 'b' of the chamber at Carrowmore 4 was dated to 3800 ± 85 bc (sample Lu 1840).

plate 27

Regarding internal chronology at Knowth, in relative terms, the two smaller sites 13 and 16 pre-date the large mound or, at least, the portion of the large mound along the northern side. At Site 17, some of the kerbstones are sitting on smallish stones which may have rolled down from the side of Site 1. This cannot be conclusively proved but, if they had such a source, then Site 17 should be later than Site 1. At Newgrange, the kerb of a cruciform tomb, Site L, is flattened on the western side where it adjoins an undifferentiated tomb, Site K, indicating that K is the earlier of the two.[41] Moreover, O'Kelly has speculated that Site Z is later than the large mound. The area around the large mound has been stripped of sod from the kerb to beyond Site Z, and the quartz of the large mound was lying on the stripped surface. Under Site Z, there was some domestic activity on the stripped surface, but the sod had grown again before the tomb was built.

Due to their sheer size and the enormous burden which their construction must have placed upon society, one can speculate that the three great mounds at Brugh na Bóinne – Dowth, Knowth, and Newgrange – were built only after the establishment of a sound economy and a society which included people trained in building and other skills. The carbon-14 determinations suggest about 2500 bc for their construction. Typology is fickle and unreliable for dating purposes alone, but a tomb such as Baltinglass I may be compared to tombs with rounded or polygonal chambers, which date from early in the western European series. Fourknocks I stands close to suggested Iberian prototypes, in the regularity of the chamber and in the art. On Breton evidence, the square-chambered tomb at Knockingen could likewise be early. The cruciform sites may also have counterparts in Brittany, while the undifferentiated tombs should be compared to those Breton sites which have a somewhat trapezoidal chamber, or to the later V-chambered sites, or perhaps to Iberian rather than Breton sites. Of course, if the bent tomb in Knowth Site 1 and its rectilinear art can be compared to the Breton bent tombs, then Site 1 – which is a homogeneous site – must come late in the series. This would also apply, on artistic grounds, to some of the smaller tombs such as Site 4. The ovoid macehead, too, may be a later Neolithic object, while the Carrowkeel ware might reflect changes in pottery styles that took place during the Later Neolithic elsewhere, as in Britain with its Peterborough ware.

The Irish Neolithic displays two main types of tombs, the passage-tomb and the long-barrow tomb (court- and portal-tombs). These differ not only in typology, but also in grave goods. The latter differences may be more than morphological and ritual: they could indicate the presence of two principal cultural groupings in Neolithic Ireland. In some parts of the country, there is a distributional overlap between the passage-tomb and court-tomb builders, but the two nonetheless appear to be mutually exclusive, with hardly any traits acquired by either group from the other. The only possible evidence is the long cairn (Site E) at Carrowkeel, probably a court-tomb contribution to passage-tomb cairn design. What may be a small passage-tomb of later date than a

court-tomb exists at Ballynoe, County Down.[42] Some flint artefacts, especially hollow and rounded scrapers, were used by both groups.

The view has often been expressed that court-tombs were the earliest megalithic tombs in Ireland, the first examples being built in north Mayo as a result of direct influence from the transeptal passage-tombs of western France.[43] Carbon-14 determinations for court-tombs go back to the fourth millennium, but building continued during the third, while in Britain a range of carbon-14 dates indicates that the long-barrows were constructed from at least the mid-fourth millennium bc. Archaeologically, the main argument advanced for an early date of the court-tombs is largely based on comparisons between their grave goods and the finds from British long-barrows and causewayed camps: round-based pots, arrowheads, and stone axes. In addition, round-based pots have been found stratified under passage-tombs at Knowth and elsewhere (Chapter 9). However, a dichotomy exists in Ireland. The passage-tombs' morphology is international, yet their grave goods are local. By contrast, the court-tombs have an insular form of chamber but an international assemblage of grave goods.

fig. 87

In general, the evidence from carbon-14 dating, finds, and stratification suggests that court-tomb builders, with an assemblage that included round-based pottery vessels, were the earliest. If assemblages containing round-based vessels are exclusively part of a wider court-tomb complex, this fact – together with the fact that the earliest carbon-14 determinations at Knowth come from an occupation site which produced such vessels – might suggest that people of court-tomb 'stock' settled in the Boyne Valley before the advent of passage-tombs. If such was the case, it could have been an extensive settlement, for the Knowth palisade enclosure is large, and there are other settlements with similar pottery not very far away, as on Feltrim Hill in northern County Dublin.[44]

Thus, the passage-tombs might simply reflect a change in ritual practices by court-tomb people, either solely internal due to, say, evangelical dissent, or external as a result of a new wave of activities from the Continent. In either event the forces would have had to be sufficiently strong to bring about a broad transformation within the court-tomb complex, even involving its replacement or, at best, its coexistence alongside a novel complex. If it was a transformation, could it have been the impact of economic success that permitted the adoption and development, not only of an ostentatious life-style (compare the palisade enclosure at Knowth), but also of conspicuous ceremonies? If it was a replacement, could it have been that a new, elaborate and radical ritual spread amongst some of the west European farming communities? The absence of court-tombs in the Boyne Valley region may be due to the fact that, by the time these people spread southwards into the area, they were abandoning the construction of their traditional tomb types, having absorbed a new ritual. Ritual changes could then be seen as part of wider changes that also involved territorial expansion.

Is it too extreme, however, to attribute the emergence of passage-tombs to insular ideological impulses? Such tombs might reflect more fundamental changes that could include economic and ethnic ones, assuming the arrival of people appropriate in number and kind. This question cannot yet be answered because a passage-tomb 'culture' does not exist.

While the trend in carbon-14 dating is indeed towards a later date for the beginning of passage-tomb building in relation to court-tombs, only about 5 per cent of the passage-tombs have carbon-14 dates, a percentage much too small for the establishment of a reliable chronological framework. Typological evidence indicates that some tombs could have been built early in the Neolithic, certainly in the fourth millennium bc on the Breton evidence. It thus seems strange that such a long time-lag, more than a thousand years, should occur between the earliest Breton passage-tomb and the earlier examples in Ireland, and yet what is considered as a passage-tomb derivative, the transeptal court-tomb, could have been introduced and developed. Furthermore, if passage-tombs were an exotic external feature that was incorporated into the court-tomb complex, and there was a reluctance – at least architecturally – to integrate into that complex, then it is hardly necessary to attribute the slightly recessed areas outside the Site 1 tombs to borrowings from the court-tombs, or vice versa. Perhaps the 'reformation' was ruthless, swift, and thorough!

Therefore, it may be worth going back to the Neolithic of the fourth millennium, and envisioning the initial construction of passage-tombs as a part of the 'culture' of intrusive agriculturalists who established themselves in the east of Ireland, where one finds early tomb types such as Baltinglass 1, Knockingen, and the Knowth undifferentiated tombs. The Boyne Valley would be a core area, its tombs displaying many international traits in morphology, art, and finds, while the settlement consisted not only of isolated farmsteads but also of large protected enclosures, using round-based pottery vessels. After all, round-based vessels were the characteristic pottery form in French and Iberian passage-tombs. These farmers (regardless of whether they belonged to the earlier or later Neolithic in Ireland) could have had an autonomous existence, with ample and varied resources to sustain them. Their initial area of settlement may have extended at least from south Wicklow to south Louth, fairly coastal but reaching inland to northwest Meath, while Kildare could have been the farming district for the builders of some of the Wicklow tombs that overlook it.

This is a rather substantial area, larger than either the Orkneys or south Morbihan; the distance from Pornic to Lorient is less than 160 km. The zone may have incorporated parts of north Wales, especially Anglesey, thus combining the economic values of land and sea. With growth came expansion, westwards and northwards but also up to Scotland, particularly the western regions and the northern isles. The tradition of court-tomb building could have remained vigorous, with further developments occurring within that

complex. These could include the emergence of the portal-tomb, and its distributional extension down the east coast into the primary passage-tomb area, although only into the southern part, Wicklow and adjoining districts. The region of Meath and north Dublin remained intact and active, and it was there that the passage-tomb builders reached the peak of their achievement – Knowth 1.

In factual terms, a full evaluation of the role and significance of the Irish passage-tombs is impossible until the chronological problems are clearly solved. It can be said at least that passage-tombs show Ireland to have received influence from diverse sources during centuries. While the tombs owe a great deal to the Continent, a straightforward pattern of contact has not emerged. On the Breton evidence, it seems that Ireland has artistic features which could be derived from both early and late (bent) tombs, implying that contacts were maintained over a long period of time. As the angular art is rare in Brittany, Ireland must also have had direct contacts with western Iberia, a view supported by finds evidence (see above). The ovoid macehead indicates borrowing from Britain, which is not unexpected due to the presence of passage-tombs of Irish type in both Wales and Scotland.[45]

Assuming that the passage-tombs had a continental background, why is it that they were built in areas so far from their source? If new people were involved, perhaps they encountered long-barrow groups already living in western England and Wales and were forced to find unpopulated areas further north. But if the first Irish passage-tombs were built at an early period within the west European Neolithic, that hypothesis cannot be sustained. Even if they are later, there is no evidence for large-scale habitation and tomb-building on the southwestern side of the Irish sea. Possibly, after exploratory expeditions, these people discovered the rich lands of the Boyne Valley region, and this was the factor which drew them northwards from Iberia or Brittany. But one need not assume that contacts were one way or one-off; the rectilinear art, for instance, may be part of further strong Breton influences.

11 Conclusions

The passage-tombs and other megalithic burial places of Ireland must, in the words of Colin Renfrew,[1] be looked upon 'in terms of the living society which created them' and not as 'irrational, eccentric, unpredictable manifestations by some maniac sect but as monuments representing a serious, coherent, indeed patterned activity'.

The view has already been expressed that this society need not have been of local origin, but emerged as a part of the spread – which is not yet fully understood – of agriculture into Ireland. As Stuart Piggott has emphasized,[2] it is a fallacy to accept that similarities of form and of building materials denote a fundamental unity over enormous spans of time and space. Nevertheless, there is enough evidence to indicate that Ireland was a recipient of ritual practices and possibly of people, from Brittany and in particular its Morbihan region, as well as from Iberia further south and especially the lower Tagus area. However, one fact about the passage-tomb society is clear: it was not a prisoner of inherited ideas, but an innovative organism that played a key role in the shaping of society as a whole, in the development of the landscape, in the evolution of Neolithic Ireland, and in forging links with Britain and continental Europe.

Since the burial rite was predominantly cremation, no solid information is available about the physical forms of the people. According to Macalister,[3] the average stature was 1.69 m for males and 1.55 m for females. The life span was apparently much shorter than today, but there is very little information about diseases. At Carrowkeel, many of the people died before reaching twenty-five years of age, and none showed evidence of senility, while some of the remains attested a rheumatoid disease.

The presence of the large tombs is a noteworthy sign of an increase in population. For the Boyne Valley area, Mitchell suggested that there could have been a population of 1,200 in a basin of about 50 square km.[4] As part of this population was engaged in activities other than food production, a more intense and skilled exploitation of the land and sea resources must have been taking place. A knowledge of land management, so as to establish a successful pattern of utilization, was essential – for an exhausted soil could not have supported and sustained such a large population.

Although there is no surviving evidence, this probably involved a considerable reorganization, and thus transformation, of the landscape. Crops of wheat and barley were grown, as shown by grains from Townleyhall 2 and Baltinglass Hill, and evidence exists for the keeping of domestic animals, particularly oxen, sheep or goats, and pigs. But gathering and hunting were also practised. Deer may have been taken, while the use of marine resources is illustrated by the pile of seashells under the passage-tomb mound at Knocklea, County Dublin, and possibly by the midden at Culleenamore near Carrowmore.[5]

A variety of materials, organic and inorganic, must have been employed. Wood would have found extensive use in house construction and – during the building of tombs – in props, levers for positioning kerbs and orthostats, and rollers for transporting stone. Red deer provided the material for the antler pins, and the bone used in the manufacture of other pins could have been derived from deer or oxen. Perhaps the hides of these animals were cured in order to make garments or shelter, as in covering the wigwam-type structure at Townleyhall 2.

The flint appears to have been acquired locally from pebbles in the drift on the sea coast. However, the blanks for the hollow scrapers from Knowth Site 2 are large, and some raw material may have been imported from the deposits in Antrim or Down. Certainly the builders at Knowth had an eye for exotic stones, and some of these, such as the granite boulders and quartz, might have been acquired at some distance. The main material used at Knowth was building stone. There, and at the other tombs in the Brugh na Bóinne cemetery, Palaeozoic rocks (greywacke or green grit) were the principal ones. At least for Knowth, the bulk of this material seems to have been obtained from outcrops 4 km or more away.

But if the passage-tomb builders knew quality materials, they also had to know something about quantity. It is possible that they worked out some method of calculating and measuring, especially with lengths, although there is no evidence for a 'megalithic yard' as postulated by Alexander Thom.[6] In the corbelled roof, these people had almost achieved a true arch; and at Knowth and Newgrange, the results are so perfect that even an awareness of the effects of stress and the ways of counteracting it must have been acquired. This may presuppose certain powers of understanding; they were undoubtedly a thinking and conscious people, intellectually as well as spiritually motivated, and were developing a body of knowledge which could have laid the foundations of scientific development. Further confirmation comes from their deliberate selection of a hard rock, like greywacke, as the main building material. An elementary grasp of geology was thus exhibited, while the tomb structures clearly demonstrate architectural and engineering abilities.

All of this suggests a widening of the inhabitants' perceptual apparatus; to paraphrase Professor Jack Goody, a domestication of the mind was taking place.[7] In addition, the building of even a small passage-tomb involved several

skills, such as quarrying, transporting, and erecting large stones, other forms of constructional activity, and artistry – besides organization and, in particular, the control of a large work-force over a period of years. In Professor O'Kelly's view,[8] the construction of Newgrange took up to thirty years. Indeed, the erection of a medium-sized passage-tomb was a costly undertaking that faced society, even a stable and prosperous one, with a major investment which demanded coordination of the various components of social life, especially those of intellect, organization, and technology.

It is hardly necessary to say that the passage-tomb builders had a deep spiritual commitment. But as we have seen, their ritual perceptions did not limit their economic realism. In fact, such a concentration of willpower in ritual form could have been a stimulus to material development, an invigorating factor, as it must have led to a virtual eruption of energy. Ritual may also have had a stabilizing influence, conditioning behaviour and tribal solidarity, while at the same time providing opportunities for mental development. In addition, a commitment by the living to the welfare of the deceased members of society might have been a commitment, voluntarily given, to society in general. A splendid and infinitely great monument like Knowth was probably intended as more than just a tribute to the dead. It could have been a receptacle or treasury for the emotions, feelings, and thoughts of the clan, while its building was perhaps an act of faith in the future and in the continuation or prolongation of that society.

But as yet our knowledge is inadequate about the structure of that society, such as the distribution of population in social or kinship groups, or the size, number and characteristics of such groups. In view of the immense labour and cost involved in passage-tomb building, there is a strong probability that society was stratified with a leader. From the temporal point of view the tombs could appear as an extension of an élite status reached by some families. They need not, however, have been prestige burial tombs solely reflecting personal wealth and ranking. Could Knowth, Dowth and Newgrange at least in part reflect competing élites or social groups? If so, this emphasizes the extraordinary nature of passage-tomb society even further. Carbon-14 determinations suggest that both Newgrange and Knowth were built around the same time. Any society that could do that must have possessed not only an ample supply of people but also considerable wealth and knowledge. If Newgrange and Knowth are contemporary (and perhaps some other sites in the cemetery too), then the passage-tomb society of the Meath area was manifestly the most extraordinary in Europe at that time.

As the tombs are normally grouped in cemeteries, the work-force must have been recruited over a sizeable area, indicating mobility within the society. The tombs need not reflect a precise settlement pattern, but the homestead was probably the single farmstead – although the palisade enclosure at Knowth, if contemporary, suggests a larger unit. Still, the grouping is evidence for funerary urbanization, so perhaps different attitudes to secular settlement

were developing. Further, the passage-tomb distribution, having nuclei, contrasts with the court-tomb distribution, which is dispersed and confined to lighter well-drained soils, generally at a modest elevation and close to a water supply.

The latter tombs were built near rock outcrops which provided materials for the building stones. On the whole, this distribution could reflect an actual settlement pattern, with the tombs being the family burial places of the well-off farmers. Isolated farmsteads can be visualized, as at Ballyglass or Ballynagilly. Not every member of a community could have been buried in court-tombs, since they contain the remains of only a small number of individuals and there must have been many hundreds of families living in the court-tomb province. As some tombs are large, Creevykeel for instance, their building must have been labour-intensive, so perhaps each belonged to its area's prominent 'landowner' and became a focal point for the group that occupied that territory.[9]

The theory has been advanced that the passage-tomb builders in Ireland were part of a wider Atlantic economic and ritual community, not solely an Irish contribution to the prehistory of Europe, although displaying internal innovation. The tombs in the east, especially in the Boyne Valley region, have *fig. 89* the greatest number of Continental features, and there is also a small number of artefacts with close Continental parallels. That region appears to be an area of early tomb-building and, since tombs such as Carrowkeel have fewer foreign traits, they should be later and represent more local development.

In turn, Ireland influenced other areas. Barclodiad y Gawres, in Anglesey, is very much a Boyne-culture cruciform tomb with decoration, and the destroyed site of the Calderstones near Liverpool may have been similar.[10] Passage-tombs are frequent in western Scotland, and more especially in the north and in Orkney and Shetland.[11] Some of the Hebridean sites, like Rudh'an Dunain and Unival, have simple rounded chambers, but Maes Howe and other tombs in the Orkneys and northern Scotland have a cruciform-shaped plan. There are also some decorated stones in the Orkneys, and the Orkney passage-tombs of Ormiegill and Taversoe Tuack yielded an ovoid and pestle macehead respectively. The incised designs on some of the Unstan ware have been compared to the decoration on certain sherds from Sliabh na Caillighe (Loughcrew). While there is a relationship between the Scottish and Irish passage-tombs, this was not as close as were those with northern Wales. Nonetheless, the Irish contribution to the Scottish passage-tomb series is fundamental.

It has been suggested that Knowth 1 was built towards the end of the series, a monument of the climax of passage-tomb building – in other words the optimum achievement of that society, which of course still had centuries to run. Yet it might have been that the very construction of such a massive public work exhausted society and led to destabilization. But there is no evidence for a fall-off in architectural quality, loss of vigour or any other form of decay or

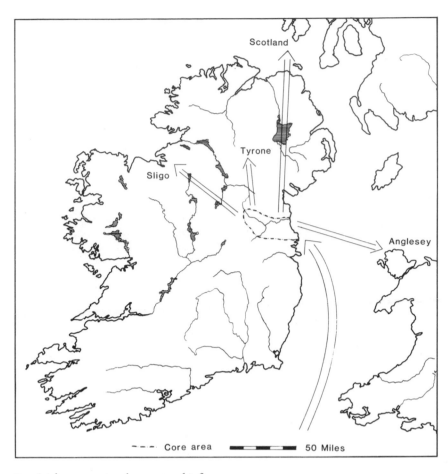

89 Irish passage-tombs, areas of influence.

weakness in the fabric of society. Indeed, the end of that culture is as enigmatic as its beginning. Nor is its legacy to subsequent generations clear. Despite its endurance and sophistication, the Boyne culture had a surprisingly small impact on contemporary complexes and made little contribution to succeeding ones.

Some of the 'Linkardstown Cists' (Chapter 1) do have features, such as the settings of small stones under the mound, which resemble those at passage-tombs.[12] If one could consider that the entrance to the wedge-tomb at Baurnadomeeny, County Tipperary was on the eastern rather than the western side, then this site would display considerable resemblance to an undifferentiated passage-tomb, not only in the tomb form but also in the round mound with its kerb and stone settings underneath.[13] Amongst the characteristics of the Early Bronze Age are the presence of round mounds for burials, often on hilltops, the multiple-cist mounds usually dating from the period of bowl food-vessels, and ornamental motifs – particularly chevrons, zigzags, triangles, and lozenges – on pottery, notably beakers and food-vessels,

and on metal objects like lunulae and flat axes. But none of these traits may be derived from the passage-tomb complex. On the contrary, they appear to have Beaker-complex sources.[14]

However, it may be noted that decoration occurs on the undersides of the capstones of some Early Bronze Age cists. A cist containing cremated bone and a halberd at Moylough, County Sligo, bears a short serpentiform motif.[15] At Hempstown, County Kildare, the cist had a crouched inhumation burial without grave goods, and the decoration consisted of a lozenge, area-picked circles, and patches of random picking.[16] At Ballinvally, near Sliabh na Caillighe, the cist held a cremated burial accompanied by a vase-type food-vessel, and the decoration amounted to four multiple concentric circles.[17] All these designs were formed by picking, whereas incised decoration of chevrons and triangles was placed on a false entrance to the cairn at Lyles Hill, County Antrim, dating from the beginning of the Bronze Age.[18] This art resembles passage-tomb art, but a new art form, 'single-grave art', was emerging at the beginning of the Bronze Age, though more commonly in Britain than in Ireland. Simpson and Thawley would see its origin in the passage-tomb art,[19] yet it may be best considered as part of the wider aspects of Early Bronze Age art.

It was also the practice to decorate natural rock surfaces in parts of Ireland, especially the peninsulas of Cork and Kerry, and curvilinear motifs predominate. Rock art is also found profusely from northern England to southern Scotland.[20] The origin of rock art is not clear and, while it occurs in passage-tomb areas as at Ballinvally near Sliabh na Caillighe,[21] the main concentrations in Cork and Kerry are well away from passage-tombs. Motifs such as cup-marks and concentric circles exist in the repertoire of rock art, but there are differences in the presence of 'field' patterns, and in the placement on natural rock surfaces. It may be doubted whether the evidence is sufficient to trace this art from the passage-tomb motifs.

In fact, the only definite passage-tomb object on an 'Early Bronze Age' site is the Carrowkeel-type vessel containing a cremation at Monknewtown, in the Boyne Valley, from an enclosure which consisted of a circular area surrounded by an earthen bank, but lacking a ditch, and dating to the Beaker period.[22] There are numerous similar earthworks in the Meath area, as well as Beaker *fig. 90* occupation areas at Knowth and Newgrange.[23] It therefore seems that a Beaker complex emerged in that area. In view of new pottery and artefact types, besides a new type of field monument like the Monknewtown enclosure, there may have been an actual movement of Beaker people from Britain into Meath, and their arrival might have been an event that contributed to the end of the passage-tomb complex. The Beaker complex in the Boyne Valley was not a poor replacement in an exhausted landscape of the passage-tomb group, but an equally dynamic cultural stage with extensive domestic settlement, huge circular enclosures (Monknewtown, Dowth), farming activities – especially grazing of cattle – and possibly the beginning of metallurgy.

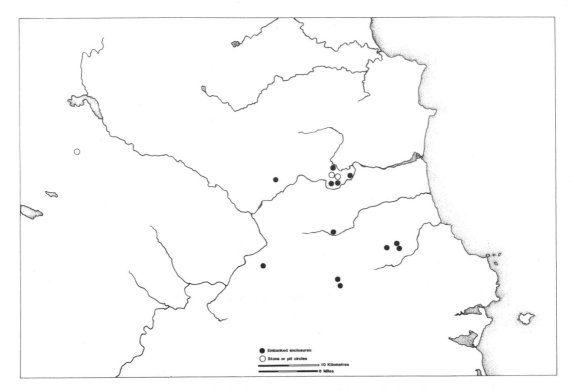

90 *Distribution of embanked enclosures and circles in the Meath area.*

In this connection, it should be noted that, in addition to Brugh na Bóinne, there are three other rich passage-tomb areas where a complex emerged at the end of the tomb period and succeeded them. These are the lower Tagus region with its continued occupation of citadels of the Villa Nova de São Pedro type, the Gulf of Morbihan with its stone alignments and enclosures, and the Orkneys with their henge monuments. Beaker traits were prominent except in Orkney, where Grooved Ware was the pottery used.

None of this need mean that the end of the passage-tomb complex was a sudden and catastrophic event. In Ireland during the latter part of the third millennium BC, changes were taking place. New pottery styles were emerging, especially the Sandhill and other wares. There were alterations in funerary architecture and in distributional patterns, as is displayed by the development of portal-tombs and by the large-scale extension of settlement to Munster. It was probably at this stage that the widespread peopling of Munster occurred. These developments anticipated, so to speak, bigger changes still at the end of the millennium, namely the spread of Beaker complexes and, before long, the full Bronze Age.

By then, passage-tombs were monuments of the past, but their mounds, and less frequently their chambers, were used for burial by people of the food-

vessel and urn complexes. Despite their obsolescence, a memory of their former greatness may have lingered on. At least it is interesting that the important Celtic sites of Tara and Rathcoran (Baltinglass Hill) each have a passage-tomb as the earliest monument. There was also Celtic activity at Knowth, but beginning only during later stages of prehistory. In the first centuries BC and AD, a number of burials occurred over the area, possibly around thirty. The rite was inhumation and the remains were placed in simple pits without any formal protection. Several had grave goods such as necklaces of glass beads. It was probably also at that time that the large mound was fortified for occupation purposes by the digging of a deep ditch around the

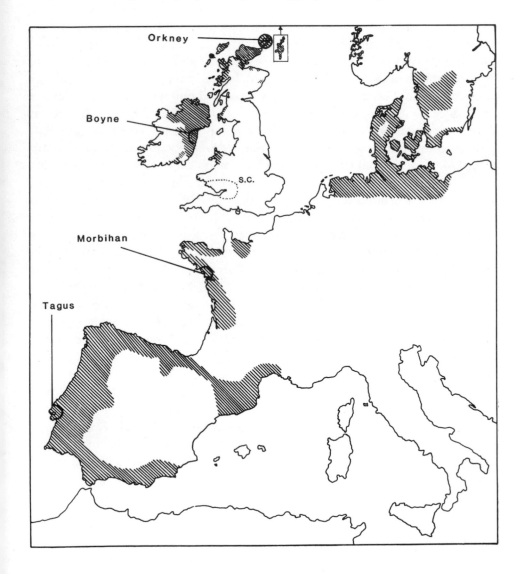

91 Passage-tomb areas in Europe (S.C. refers to the Severn-Cotswold tomb area).

base and another along the edge of the summit. Subsequently, during the Early Christian period, there was intensive settlement (9th–11th centuries), and finally from the late 12th into the early 14th century Norman occupation took place.

When the chronology of the Irish Neolithic is clearer it will be easier to interpret the role of both passage-tomb and court-tomb builders and their relationship with each other. This is an important point because, if court-tomb, or culturally related, people were the initial Neolithic settlers in the Boyne Valley region, the countryside would have been opened up or at least clearances would have taken place before the building of passage-tombs commenced. If this was so, it may not be without parallels elsewhere; the emergence of another tomb form in Ireland could have been equivalent to the Danish and north European sequence, where dolmens in long barrows (but also in round mounds), and with pottery (collared and lugged flasks and funnel beakers) that was fairly simply decorated, largely gave way to passage-tombs (mainly in round mounds) with highly decorated pottery and more elaborate grave goods, including amber necklaces. The Danish developments have been dated to around 2600–2700 bc[24] and that too may have been the main period of passage-tomb building in Ireland. Perhaps developments in chamber-tomb morphology and ritual were also taking place in other parts of Europe at this time. While Iberian chronology is vague, one may nevertheless wonder whether it was around this period that the Los Millares-Villa Nova de Sãno Pedro (Chalcolithic) assemblages, including passage-tombs with their rich mobile art, emerged. Indeed, it seems that at some time between 3000 and 2500 bc, for reasons which we cannot now explain, ritual elaboration took place in the Atlantic and West Baltic lands of Europe, with at least some areas influencing each other. It was one of those epochs which saw momentous changes in the human intellect and spirit. Clearly, the emergence of the passage-tombs of Ireland indicate a formidable surge of spiritual energy; but was there an equivalent commitment to material development and the secular organization of society? We have already seen that this could indeed have been so. In Denmark, at least, passage-tomb building may have been part of wider developments, such as the building of large causewayed enclosures, improved plough cultivation, and possibly the emergence of a copper metallurgy (compare the Bygholm Hoard[25]). For Ireland perhaps ritual was only one aspect of the activities of a new or restructured society, that also included an agrarian élite, and that spread from the Boyne Valley region to other parts of the island, including court-tomb areas. This could explain the long cairn in the Carrowkeel passage-tomb cemetery or the little passage-tomb apparently added to a court-tomb at Ballynoe, County Down. To offer a more positive view, further research is needed, but at least we can say that for the late Stone Age Knowth was one of Europe's greatest public buildings. To describe it as a massive and majestic megalithic masterpiece that reflected the pride and pomp of contemporary society is not an exaggeration.

Appendix: Radiocarbon dates from Irish passage-tombs and related structures

Habitation material under passage-tombs

Knowth B M 1076. 4852 ± 71 B P (*c.* 2902 ± 71 b c). Pit in house.

Knowth 17 U B 318. 4878 ± 150 B P (*c.* 2925 ± 150 b c). See U B 319.

Knowth 17 U B 319. 4795 ± 185 B P (*c.* 2845 ± 185 b c). Charcoal from thin layer of dark material under mound.

Townleyhall 2. B M 170. 4680 ± B P (*c.* 2730 ± 150 b c).

Tara, Mound of the Hostages (W. A. Watts *Antiquity* 34 (1960)): D 43. 4260 ± 160 B P (*c.* 2300 ± 160 b c). Charcoal from smear thought to have been on surface before mound construction.

Tara, Mound of the Hostages (W. A. Watts *Antiquity* 34 (1960)): D 42. 4080 ± 160 B P (*c.* 2120 ± 160 b c). Charcoal from fill of a ditch under mound.

Tara, Mound of the Hostages (W. A. Watts *Antiquity* 34 (1960)): D 44. 3880 ± 150 B P (*c.* 1920 ± 150 b c). Charcoal from fire in old ground surface that was contemporary or slightly later than the building of the mound.

Habitation sites considered to be contemporary with passage-tombs

Culleenamore, Co. Sligo (Burenhult 1984, 131). Kitchen-midden (Settlement 15).

St 7624. 4710 ± 100 B P (*c.* 2760 ± 100 b c). Charcoal from hearth (Stratum 18).

Lu 1948. 3970 ± 75 B P (*c.* 2020 ± 100 b c) Charcoal from hearth.

Lu 1759. 3780 ± 60 B P (*c.* 1830 ± 60 b c). Charcoal from hearth (Stratum 8).

Hut-sites Knocknarea North (Burenhult 1984, 131).

St 9030. 4475 ± 140 B P (*c.* 2525 ± 140 b c). Hut 2, charcoal from bottom of ditch.

St 1947. 4250 ± 75 B P (*c.* 2300 ± 75 b c). Hut 1, charcoal from bottom layer of lime-stone gravel.

Temple na Ferta, Scotch Street, Armagh (excavated by Mr C. J. Lynn).

U B 2379. 4350 ± 50 B P (*c.* 2300 ± 50 b c).

U B 2380. 4090 ± 105 B P (*c.* 2140 ± 150 b c). Charcoal from fill of a ring ditch that also contained sherds of Carrowkeel pottery. U B 2379 came from lower in the fill than did the other date.

Tombs

Knowth 1 GrN 12357. 4405 ± 35 B P (*c.* 2455 ± 35 b c). Charcoal from mound.

Knowth 1 GrN 12358. 4490 ± 60 B P (*c.* 2540 ± 60 b c). Charcoal from spread on old ground surface considered to be contemporary with mound building.

Knowth 1 U B 357. 4745 ± 165 B P (*c.* 2795 ± 165 b c). Organic material in basal (sod) layer of mound.

Knowth 1 U B 358. 6835 ± 110 B P (*c.* 4885 ± 110 b c). Humic acid from basal layer (redeposited sods) of mound.

Knowth 1 GrN 12827. 4465 ± 40 B P (*c*. 2515 ± 40 b c). Fragments of wood in basal layer of mound behind orthostat 75 of passage of eastern tomb.

Knowth 2 B M 785. 4158 ± 126 B P (2208 ± 126 b c). Charcoal from spread in mound.

Knowth 9 GrN (provisional) 4415 ± 50 B P (*c*. 2465 ± 50 b c). Charcoal from cremation deposit in end recess.

Knowth 16 B M 1078. 4399 ± 67 B P (*c*. 2449 ± 67 b c). Charcoal from spread within mound.

Newgrange, large (O'Kelly 1982, 230).

GrN 5462. 4425 ± 45 B P (*c*. 2475 ± 45 b c).

GrN 5463. 4415 ± 40 B P (*c*. 2465 ± 40 b c). Both dates from charcoal from soil placed by the tomb builders between the roof slabs of the passage.

GrN 9057 4480 ± 60 B P (2530 ± 60 b c). Vegetation from redeposited sods in basal mound layer.

U B 361. 4535 ± 105 B P (*c*. 2585 ± 105 b c).

U B 360. 2250 ± 45 B P (300 ± 45 a d). Humic acid from redeposited sods in basal mound layer.

Fourknocks 2 D 45. 3470 ± 140 B P (*c*. 1520 ± 140 b c). Charcoal from cremation trench.

Carrowmore (Burenhult 1980, 32, 67, 72; 1984, 128–30).

Site 4 Lu-1840. 5750 ± 85 B P (3800 ± 85 b c). Charcoal from 'stone fundament to Stone B' (? socket) in the central cist (Burenhult 1984, 128)

Site 4 Lu-1750. 4320 ± 75 B P (2370 ± 75 b c). Charcoal from beside second 'inner stone circle'. This is considered to be secondary by the excavator (1984, 131).

Site 7 Lu-1441. 5240 ± 80 B P (3290 ± 80 b c). 'Charcoal from intact bottom layer in the central chamber (post-hole, mid point of chamber and circle)' (Burenhult 1980a, 32; 1984, 128).

Site 27 Lu-1698. 5040 ± 60 B P (3090 ± b c).

Site 27 Lu-1808. 5000 ± 65 B P (3050 ± 65 b c).

Site 27 Lu-1818. 4940 ± 85 B P (2990 ± 85 b c). The foregoing three dates come from charcoal which was found in the same area 'between and under the lowest layer of stones in the stone-packing surrounding the central chamber.' (Burenhult 1980a, 67; 1980, 128, 131).

Sliabh Gullion (Smith and Pilcher *UJA*, 35 (1972), 17–21).

U B 179. 5215 ± 195 B P (*c*. 3265 ± 195 b c). This determination came from basal sandy peat below a spread of stones that may have been associated with the construction of the cairn.

U B 180 3955 ± 75 B P (*c*. 2005 ± 75 b c).

U B 181 4035 ± 75 B P (*c*. 2085 ± 75 b c). These two dates came from above the sandy peat layer.

Notes on the text

Preface

1 Eogan 1968; 1974a; 1984.
2 Eogan 1963.

Chapter 1

1 Eogan 1974b.
2 Eogan 1984, 9–11.
3 Eogan 1984, 325–46.
4 Eogan 1963, 38–9.
5 Coffey 1912; Ó'Ríordáin and Daniel 1964; C. O'Kelly 1978, 45–64.
6 O'Kelly 1983.
7 O'Kelly 1982.
8 O'Kelly et al. 1978.
9 Boate 1726.
10 Pownall 1773.
11 Vallancey 1786.
12 Herity and Eogan 1977, 7.
13 Beaufort 1828.
14 Conwell 1866; 1873.
15 Macalister, Armstrong and Praeger 1912.
16 Davies and Evans 1932.
17 de Valera 1960; 1965.
18 de Valera and Ó'Nualláin 1961; 1964; 1972; 1982.
19 Collins 1954; 1965.
20 O'Kelly 1958.
21 Hartnett 1957; 1971.
22 Coffey 1892.
23 Petrie 1845.
24 Wilde 1849, 164–5.
25 Wakeman 1848, 108.
26 Borlase 1897, 370–1.
27 Coffey 1892, 68; 1912, 60–1.
28 Macalister 1943.
29 Byrne 1968.
30 Ó'Ríordáin 1979, 102.
31 Raftery 1974.

Chapter 2

1 Wakeman 1848, 108.

Chapter 3

1 Coffey 1912, 60–61.
2 Eogan 1984, 308–13.
3 Eogan 1984, 24–6.
4 Eogan 1984, 312–13.
5 Herity 1967, 141.

Chapter 4

1 Herity 1974, 218–19, 258–59.
2 Ó'Nualláin 1968.
3 Rynne 1960.
4 Herity 1974, 256, 258–9.
5 Macalister et al. 1912, pl. 17 top; Herity 1974, figs 33 bottom and 11.
6 Powell 1941.
7 Herity 1974, 255, 219.
8 Collins and Waterman 1955.

Chapter 5

1 O'Kelly 1982, 116–17.
2 Coles 1973, 86–7.
3 Mohen 1980.
4 Atkinson 1960, 115, 119–22.
5 Garfitt 1979.
6 Atkinson 1960, 132.
7 Atkinson 1960, 104; British Museum 1953, 9, pl. 1 bottom 3.
8 O'Kelly 1982, 87–8.
9 Hartnett 1957, 208.
10 Leisner 1965, taf. 36; M. J. Almagro 1973b, plan 21.
11 Collins and Wilson 1963, 27.

Chapter 6

1 O'Kelly et al. 1978, 278, 349.
2 Coffey 1898, 663.
3 Herity 1974, 231.
4 O'Kelly et al. 1978, 261, 340, 349.
5 Burenhult 1980a, 31.
6 Macalister et al. 1912, 328.
7 Burenhult 1980a, 70.

8 Herity 1974, 132.
9 Hartnett 1957, 250.
10 O'Kelly et al. 1978, 340.
11 Macalister 1912, 334.
12 Collins and Wilson 1963, 29.
13 Herity 1974, 132, 253, pl. 96.
14 Case 1961, 185; Herity 1974, 138–44; Piggott 1954, 202–4.
15 Collins 1954, 25, fig. 7:4.
16 Herity 1974, fig. 100.
17 Eogan and Richardson 1982; Eogan 1983.
18 Herity 1974, 126–32; Daniells and Williams 1977, 38.
19 Prendergast 1955, 6; Wakeman 1895, 112, fig. 6, p. 111 and 13, p. 109.
20 Wood-Martin 1888, 43, fig. 31; Herity 1974, 134, fig. 150: 32.
21 Hartnett 1957, 245.
22 Piggott 1954, 206.
23 Hartnett 1971, 47, 50.

Chapter 7

1 Herity 1974, 138, fig. 100.
2 Breuil 1933, 62–3.
3 Piggott 1954, 211–13.
4 Herity 1974, 105.
5 C. O'Kelly 1973, 364–72.
6 Shee Twohig 1981, 107–16.
7 Shee Twohig 1981, 69.
8 Shee Twohig 1981; C. O'Kelly 1978, 14–41; M. J. O'Kelly 1982, 146–85; M. J. O'Kelly et al. 1978, 315–28; 1983, 160–78.
9 Bagge and Kaelas 1950, 1952; Kaelas 1966.
10 Collins and Waterman 1955.
11 Shee Twohig 1981, 32.
12 Mahr 1937, 354.
13 Eogan 1984, fig 62.
14 Le Roux 1984, 244.

Chapter 8

1 Mahr 1937, 340.
2 Renfrew 1979; Hedges 1983.
3 Almagro and Arribas 1963, 72, pl. 147, 77, pl. 150 bottom.
4 O'Kelly 1982, 75, fig. 9.

5 Stromberg 1968, 173–216; 1971, 347–66.
6 Kjaerum 1969; Ebbesen 1979.
7 Strömberg 1968
8 Burenhult 1981b, 314–35, espec. fig. 17.
9 Lynch 1973, 161.
10 Grimes 1939.
11 Shee Twohig 1981, fig. 139.
12 Shee Twohig 1981, 227, fig. 258.
13 Coffey 1892.

Chapter 9

1 ApSimon 1969; Ó'Ríordáin 1954.
2 Ó'Nualláin 1972.
3 Eogan 1963, 40–63.
4 Walsh 1941, 227.
5 Liversage 1960.
6 O'Kelly 1982, 77.
7 Macalister et al. 1912, 331–2.
8 Berg and Osterholm in Burenhult 1981b, 38–166.
9 Eogan 1984, 211–43.
10 Mallory and Hartwell 1984.
11 Waterman 1963.
12 Hedges and Buckley 1978, 237–8; Whittle 1977, 329; Andersen 1975; Hingst 1971.
13 Evans 1953.
14 Collins 1957.
15 O'Kelly et al. 1978, 263–69, 293–4.
16 Mogey 1941.

Chapter 10

1 Mitchell 1976, 84–99.
2 Mitchell 1971.
3 Woodman 1974; 1976; 1978, 60–126.
4 Woodman 1974, 238.
5 Liversage 1968, 172–4; Mitchell 1956.
6 Burenhult 1980a, 111–15; 1980b; 1984, 133–46.
7 O'Kelly 1981, 182.
8 Jope 1952.
9 Collins and Waterman 1955, 8.
10 Caulfield 1978.
11 L'Helgouach 1965, 24.
12 Giot 1981; Oliveira Jorge 1978.
13 Clark 1977, 43.
14 Childe 1940, 45.

15 Ashbee 1970; Corcoran 1969; de Valéra 1960.
16 Daniel 1939; 1950.
17 Renfrew 1976, 138–46.
18 Oliveira Jorge 1978.
19 L'Helgouach 1965; in Giot et al. 1979, 157–320.
20 Nielsen in Burenhult 1984, 376–87.
21 Leisner 1956, taf. 26, 27; Nordman 1935, fig. 9; Schuldt 1972, abb. 48.
22 Leisner 1956, cf. taf. 25; L'Helgouach 1965, 133–57; L'Helgouach in Giot et al. 1979, 226–41.
23 Giot 1981, 86.
24 Eogan 1979; Almagro Gorbea 1973a, 78–90, type II, variety B.
25 de Barandiaran and Medrano 1971, fig. 16; Savory 1977, 173, fig. 6:5.
26 O'Kelly 1982, 186, fig. 56 no. 1754; Almagro Gorbea 1973a, 64–7 map 3.
27 Nieto Gallo 1959.
28 Leisner 1959 (1/2), taf. 27–1.
29 Almagro and Arribas 1963, 72, pl. 147, 77, pl. 150 bottom.
30 Powell 1972, 98.
31 Almagro Gorbea 1973a, 181–223; Sa Pinto 1979.
32 L'Helgouach 1965, 100–09.
33 Herity 1974, 198.
34 Roe 1968, fig. 34; Coghlan 1945, 1955.
35 Henshall 1963, 206, 238.
36 Roe 1968, fig. 34.
37 Henshall 1963, 284–5.
38 Case 1963.
39 Bagge and Kaelas 1950; 1952.
40 L'Helgouach and Lecornec 1976, 376.
41 O'Kelly et al. 1978, 343.
42 Groenman and Butler 1976.
43 de Valera 1965.
44 Hartnett and Eogan 1964.
45 Powell and Daniel 1956; Henshall 1963; 1972.

Chapter 11

1 Renfrew 1981, 73.
2 Piggott 1973, 10.
3 Macalister et al. 1912, 342.
4 Mitchell 1976, 128–31.
5 Herity 1974, fig. 117; Osterhölm in Burenhult 1984, 326–45.
6 Thom 1967, 34–55.
7 Goody 1977.
8 O'Kelly 1982, 118.
9 Darvill 1979, 319.
10 Powell and Daniel 1956; Forde Johnston 1957.
11 Henshall 1963; 1972.
12 B. Raftery 1974; Ryan 1973.
13 O'Kelly 1960.
14 Herity and Eogan 1977, 114–47.
15 Morris 1929, 114, pl. 4.
16 Hartnett 1950, 194–7.
17 J. Raftery 1951, 150 fn fig. 155.
18 Evans 1953, 30, fig. 10.
19 Thawley and Simpson 1972.
20 Herity and Eogan 1977, 137, fig. 54 right; MacWhite 1946.
21 Shee 1972.
22 Sweetman 1976, 28–9.
23 Eogan 1984; O'Kelly 1983.
24 Nielsen in Burenhult 1984.
25 Nordman 1935, 131–5, figs. 60–1.

Select Bibliography

Abbreviations

JCHAS *Journal of the Cork Historical and Archaeological Society.* Cork.
JRSAI *Journal of the Royal Society of Antiquaries of Ireland.* Dublin.
PPS *Proceedings of the Prehistoric Society.* London.
PRIA *Proceedings of the Royal Irish Academy.* Dublin.
TRIA *Transactions of the Royal Irish Academy.* Dublin.
UJA *Ulster Journal of Archaeology.* Belfast.

ALMAGRO GORBEA, Maria José 1973a *Los Idolos del Bronce I Hispano.* Bibliotheca Praehistorica Hispana, XII. Madrid.

1973b *Excavaciones Arqueologicas El Barranquete* (Almería) (Acta Arqueologica Hispanica 6). Madrid.

ALMAGRO, Martín and ARRIBAS, Antonio 1963 *El Poblado y la Necrópolis Megalíticos de los Millares.* Bibliotheca Praehistorica Hispana III. Madrid.

ANDERSEN, N. H. 1975 Die Neolithische Befestigungsanlage in Sarup auf Fünen (Dänemark). *Archäologisches Korrespondenzblatt* 5, 11–14.

APSIMON, A. M. 1969 An Early Neolithic House in Co. Tyrone, *JRSAI*, 99(1969), 165–8.

ASHBEE, Paul 1970 *The earthen long barrow in Britain.* London. Dent.

ATKINSON, R. J. C. 1960 *Stonehenge.* Harmondsworth. Pelican Books.

BAGGE, Axel and KAELAS, L. 1950, 1952 *Die Funde aus Dolmen und Ganggräbern in Schonen.* Vols 1 and 2. (K. Vitterhets Histoire och Antikvitets Akademien). Stockholm. Wahlström and Widstrand.

BEAUFORT, L. C. 1828 An Essay upon the state of Architecture and Antiquities, previous to the landing of the Anglo-Normans in Ireland, *TRIA*, 15(1828), 101–242 (Antiquities).

BOATE, T. 1726 *A Natural History of Ireland*, 3. London.

BORLASE, W. Copeland 1897 *The Dolmens of Ireland*, London. Chapman and Hall.

BREUIL, L'Abbé Henri 1933 *Les Peintures Rupestres Schématiques de la Péninsule Ibérique. I Au Nord du Tage.* Paris. Imprimerie de Lagny.

BRITISH MUSEUM 1953. *Later Prehistoric Antiquities of the British Isles.* London. British Museum.

BURENHULT, Göran 1980a *The Archaeological Excavations at Carrowmore, Co. Sligo.* (Thesis and Papers in North-European Archaeology No. 9), Stockholm.

1980b *The Carrowmore Excavations. Excavation Season 1980.* Stockholm Archaeological Reports No. 7.

1981a *The Carrowmore Excavations: Excavation Season 1981.* Stockholm Archaeological Reports No. 8.

1981b *Stenaldersbilder.* Stockholm. Sturreförlaget AB.

1984 *The Archaeology of Carrowmore.* (Thesis and Papers in North-European

Archaeology No. 14), Stockholm.

BYRNE, F. J. 1968 Historical Note on Cnogba (Knowth), *PRIA*, 66c (1968), 383–400.

CASE, H. J. 1961 Irish Neolithic Pottery: distribution and sequence, *PPS*, 27 (1961), 174–233.

1963 Foreign connections in the Irish Neolithic, *UJA*, 26, 3–18.

CAULFIELD, Seamas 1978 Neolithic fields: the Irish evidence, in H. C. Bowen and P. J. Fowler (editors), *Early Land Allotment*, BAR: British series 48. Oxford.

CHILDE, V. Gordon 1940 *Prehistoric Communities of the British Isles.* London. W. and R. Chambers.

CLARK, Grahame 1977 The economic context of dolmens and passage-graves in Sweden, in Markotic 1977, 35–49.

COFFEY, George 1892 On the tumuli and inscribed stones at Newgrange, Dowth and Knowth, *TRIA*, 30, 1–96.

1897 Notes on the Prehistoric Cemetery of Loughcrew, *TRIA*, 31, 23–38.

1898 On a cairn excavated by Thomas Plunkett on Belmore Mountain, Co. Fermanagh, *PRIA*, 20, 659–66.

1912 *New Grange and other incised tumuli in Ireland.* Dublin. Hodges Figgis.

COGHLAN, H. H. 1945 Some perforated stone hammers in the collection of the National Museum, Dublin, *JRSAI*, 75, 224–47.

1955 The perforated stone hammer in Ireland, *JCHAS*, 60, 97–127.

COLES, John 1973 *Archaeology by experiment.* London. Hutchinson.

COLLINS, A. E. P. 1954 The excavation of a double horned cairn at Audleystown, Co. Down, *UJA*, 17, 7–56.

1957 Trial excavations in a round cairn on Knockiveagh, Co. Down, *UJA*, 20, 8–28.

1965 Ballykeel dolmen and cairn, Co. Armagh, *UJA*, 28, 47–70.

COLLINS, A. E. P. and WATERMAN, D. M. 1955 *Millin Bay, Co. Down.* Belfast. Stationery Office.

COLLINS, A. E. P. and WILSON, B. C. S. 1963 The Slieve Gullion cairns, *UJA*, 26, 19–40.

CONWELL, Eugene A. 1866 On ancient sepulchral cairns on the Loughcrew Hills, *PRIA*, 9, 355–79.

1873 *Discovery of the tomb of Ollamh Fodhla.* Dublin. McGlashan and Gill.

CORCORAN, J. X. W. P. 1969 The Cotswold-Severn Group, in Powell *et al.* 1969, 13–104.

DANIEL, Glyn 1939 The transepted gallery graves of western France, *PPS*, 5, 143–65.

1950 *The prehistoric chamber tombs of England and Wales.* Cambridge University Press.

DANIEL, Glyn and KJAERUM, Poul 1973 *Megalithic graves and ritual: Papers presented at the III Atlantic Colloquium Moesgard 1969.* Moesgard. Jutland Archaeological Society Publications XI.

DANIEL, Glyn and POWELL, T. G. E. 1949 The distribution and date of the passage-graves of the British Isles, *PPS*, 15, 169–87.

DANIELLS, M. J. and WILLIAMS, B. B. 1977 Excavations at Kiltierney Deerpark, Co. Fermanagh, *UJA*, 40, 32–41.

DARVILL, T. C. 1979 Court cairns, passage-graves and social change in Ireland, *Man*, 14, 311–27.

DAVIES, Oliver, and EVANS, E. Estyn 1932 Excavations at Goward near Hilltown, Co. Down, *Proceedings of the Belfast Natural History and Philosophical Society*, session 1932, 90–105.

DE BARANDIARAN, J. M. and MEDRANO, D. Fz. 1971 Investigaciones Arqueologicas en Alava. Del dolmen de S. Martin, 147–73. Caja de Ahorros Municipal de la Cuidad de Vitoria.

DE VALÉRA, Ruaidhri 1960 The court cairns of Ireland, *PRIA*, 60 C, 9–140.

1965 Transeptal court cairns, *JRSAI*, 95, 5–37.

DE VALÉRA, Ruaidhri and Ó'NUALLÁIN, Seán 1961, 1964, 1972, 1982 *Survey of the Megalithic Tombs of Ireland*, vols. I, II, III, IV. Dublin.

EBBESEN, Klaus 1979 *Stordyssen i Vedsted*, København, Akademisk Forlag.

EOGAN, George 1963 A Neolithic habitation site and megalithic tomb in Townleyhall townland, Co. Louth, *JRSAI*, 93, 37–81.

1968 Excavations at Knowth, Co. Meath, *PRIA*, 66 C, 299–382.

1974a Report on the excavations of some passage graves, unprotected inhumation burials and a settlement site at Knowth, Co. Meath, *PRIA*, 74 C, 11–112.

1974b A probable passage grave site near Broadboyne Bridge, Co. Meath, *JRSAI*, 104, 146–50.

1979 Objects with Iberian affinities from Knowth, *Revista de Gumaraes*, 89, 275–80.

1983 A flint macehead at Knowth, Co. Meath, *Antiquity*, 57, 45–6.

1984 *Excavations at Knowth Vol. I; Smaller passage tombs, Neolithic occupation and Beaker activity*. Dublin. Royal Irish Academy.

EOGAN, George and RICHARDSON, Hilary 1982 Two maceheads from Knowth, Co. Meath, 112, 123–38.

EVANS, E. Estyn 1953 *Lyles Hill, a late Neolithic site in Co. Antrim*. Belfast, Stationery Office.

EVANS, John D.; CUNLIFFE, Barry; RENFREW, Colin (editors) 1981 *Antiquity and Man: Essays in honour of Glyn Daniel*. London. Thames and Hudson.

FORDE-JOHNSTON, J. L. 1957 Megalithic art in the north-west of Britain: The Calderstones, Liverpool, *PPS*, 23, 20–39.

GARFITT, J. E. 1979 Moving the stones to Stonehenge, *Antiquity*, 53, 190–4.

GIOT, Pierre-Roland 1981 The Megaliths of France, in Evans et al. 1981, 82–93.

GIOT, Pierre-Roland, L'HELGOUACH, Jean et MONNIER, Jean-Laurent 1979 *Préhistoire de la Bretagne*. Rennes. Ouest France.

GOODY, J. 1977 *The Domestication of the Savage Mind*. Cambridge University Press.

GRIMES, W. F. 1939 The Excavation of Ty-isaf Long Cairn, Brecknockshire, *PPS*, 5, 119–42.

GROENMAN-VAN WAATERINGE and BUTLER, J. J. 1976 The Ballynoe stone circle, *Palaeohistoria*, 18, 73–110.

HARTNETT, P. J. 1957 Excavation of a passage grave at Fourknocks, Co. Meath, *PRIA*, 58C, 197–277.

1971 The excavation of two tumuli at Fourknocks (Sites II and III), Co. Meath, *PRIA*, 71C, 35–89.

1950 A crouched burial at Hempstown Commons, Co. Kildare, *JRSAI*, 80, 193–98.

HARTNETT, P. J. and EOGAN, George 1964 Feltrim Hill, Co. Dublin. A Neolithic and Early Christian site, *JRSAI*, 94, 1–37.

HAWKES, Jacquetta 1941 Excavation of a megalithic tomb at Harristown, Co. Waterford, *JRSAI*, 71, 130–47.

HEDGES, J. and BUCKLEY, D. 1978 Excavation at a Neolithic causewayed enclosure, Orsett, Essex, 1975, *PPS*, 44, 219–308.

HEDGES, J. W. 1983 *Isbister: a chambered tomb in Orkney*, BAR: British Series No. 115. Oxford.

HENCKEN, Hugh O'Neill 1939 A long cairn at Creevykeel, Co. Sligo, *JRSAI*, 69, 53–98.

HENSHALL, Audrey S. 1963, 1972 *The chambered tombs of Scotland*. Vols 1 and 2. Edinburgh University Press.

HERITY, Michael 1967 From Lhuyd to Coffey, *Studia Hibernica*, 7, 127–45.

1974 *Irish Passage Graves*. Dublin. Irish University Press.

1982 Irish decorated Neolithic pottery, *PRIA*, 82C, 247–404.

HERITY, Michael and EOGAN, George 1977 *Ireland in Prehistory*. London. Routledge and Kegan Paul.

HINGST, H. 1971 Ein befestigtes Dorf aus der Jungsteinzeit in Büdelsdorf (Holstein), *Archäologisches Korrespondenzblatt 1*, 191–4.

JOPE, E. M. 1952 Porcellanite axes from factories in north-east Ireland, *UJA*, 15, 31–55.

KAELAS, L. 1966 The megalithic tombs in south Scandinavia, *Palaeohistoria 12*, 287–321.

KALB, Philine, 1981 Zur Relativen Chronologie Portugiesischer Megalithgräber, *Madrider Mitteilungen*, 22, 55–77.

KJAERUM, Poul 1969 Jaettestuen Jordhøj, *Kuml* (1969), 9–66 (English summary, 'The Passage-grave Jordhøj', pp. 56–64).

LEISNER, Georg and Vera 1956, 1959, 1965 *Die Megalithgräber der Iberischen Halbinsel: Der Westen*. Berlin. Walter de Gruyter.

LE ROUX, C. T. 1984 A propos des fouilles de Gavr'inis (Morbihan) *Bulletin de la Société Préhistorique Française 81*, 240–45.

L'HELGOUACH, Jean 1965 *Les sépultures mégalithiques en Armorique*. Rennes. Travaux du Laboratoire d'Anthropologie Préhistorique de la Faculté des Sciences.

L'HELGOUACH, J. and LECORNEC 1976 Le site mégalithique 'Min Goh Ru' prés de larcuste à Colpo (Morbihan), *Bulletin de la Société préhistorique Française 73*, 370–97.

LLWYD, Edward 1709 Letter to Dr. Tancred Robinson, *Transactions of the Royal Society*, Abridged Series 5, 1703–12, 694.

LIVERSAGE, G. D. 1960 A Neolithic site at Townleyhall, Co. Louth, *JRSAI*, 90, 49–60.

1968 Excavations at Dalkey Island, Co. Dublin, 1956–59, *PRIA*, 66C, 53–233.

LYNCH, Frances 1973 The use of the passage in certain passage graves as a means of communication rather than access, in Daniel and Kjaerum 1973, 147–61.

1975 Excavations at Carreg Samson megalithic tomb, Mathry, Pembrokeshire. *Archaeologia Cambrensis*, 124, 15–35.

LYNCH, Frances and BURGESS, Colin (editors) 1972 *Prehistoric Man in Wales and the West: essays in honour of Lily F. Chitty*. Bath. Adams and Dart.

MACALISTER, R. A. S. 1943 A preliminary report on the excavation of Knowth, *PRIA*, 49C, 131–66.

MACALISTER, R. A. S., ARMSTRONG, E. C. R., and PRAEGER, R. L. 1912 Bronze Age cairns on Carrowkeel mountain, Co. Sligo *PRIA*, 29C, 311–47.

MACWHITE, Eoin 1946 A new view on Irish Bronze Age rock-scribings, *JRSAI*, 76, 59–80.

MAHR, Adolf 1937 New Aspects and Problems in Irish Prehistory *PPS*, 3, 261–436.

MALLORY, J. P. and HARTWELL, B. 1984, Donegore, *Current Archaeology*, vol. 8 no. 9 (no. 92), 271–75.

MARKOTIC, Vladimir (editor) 1977 *Ancient Europe and the Mediterranean*. Warminster. Aris and Phillips.

MEGAW, J. V. S. and SIMPSON, D. D. A. 1979 *Introduction to British Prehistory*. Leicester University Press.

MITCHELL, G. F. 1956 An early kitchen-midden at Sutton, Co. Dublin, *JRSAI*, 86, 1–26.

1971 The Larnian culture: a minimal view, *PPS*, 37, part II, 274–83.

MITCHELL, Frank 1976 *The Irish Landscape*, London. Collins.

MOGEY, J. M. 1941 The 'Druid Stone', Ballintoy, Co. Antrim, *UJA*, 4, 49–55.

MOHEN, Jean-Pierre 1980 La construction des dolmens et menhirs au Néolithic, *Archéologie*, no. 46, 58–67.

MOLYNEUX, Thomas 1726 Discourse concerning the Danish Mounts, Forts and Towers in Ireland, in Gerard Boate (editor), *A Natural History of Ireland*, Dublin.

MONTEGUIDO, Luis 1966 Versuch Einer Chronologischen Gliederung der Portugieschen Kupferzeit, *Madrider Mitteilungen*, 7, 61–78.

MORRIS, Henry 1929 Ancient graves in Sligo and Roscommon, *JRSAI*, 59, 99–115.

NEIL, Nigel R. J. 1981 A newly discovered decorated stone from Orkney, *Antiquity*, 55, 129–31.

NIETO GALLO, G. 1959 Colgantes y cabezas de alfiler con decoración acanalada: Su distribución en la Península Ibérica, *Archivo de Prehistoria Levantina*, 8, 125–44.

NORDMAN, C. A. 1935 *The Megalithic Culture of northern Europe*. Finska Fornminnesföreningens Tidskrift 39:3. Helsinki.

O'KELLY, Claire 1973 Passage-grave art in the Boyne Valley, *PPS*, 39, 354–82.

1978 *Illustrated guide to Newgrange and the other Boyne Monuments*. Cork.

O'KELLY, Michael J. 1958 A wedge-shaped gallery-grave at Island, Co. Cork, *JRSAI*, 88, 1–23.

1960 A wedge-shaped gallery grave at Baurnadomeeny, Co. Tipperary, *JCHAS*, 65, 85–115.

1981 The Megalithic Tombs of Ireland in Evans *et al.* 1981, 177–90.

1982 *Newgrange: Archaeology, art and legend*. London and New York. Thames and Hudson.

O'KELLY, Michael J., CLEARY, Rose M., and LEHANE, Daragh (ed. Claire O'Kelly) 1983, *The Late Neolithic Beaker Settlement at Newgrange* BAR (International Series 190), Oxford.

O'KELLY, Michael J. and Claire, 1983, The Tumulus of Dowth, Co. Meath, *PRIA* 83c, 135–90.

O'KELLY, Michael J., LYNCH, Frances and O'KELLY, Claire 1978 Three Passage-graves at Newgrange, Co. Meath, *PRIA*, 78C, 249–352.

OLIVEIRA JORGE, Susana 1978 O megalitismo no contexto Neolitíco peninsular, *Revista de Guimaraes*, 88, 369–88.

Ó'NUALLÁIN, Seán 1968 A ruined megalithic cemetery in Co. Donegal, *JRSAI*, 98, 1–29.

1972 A Neolithic House at Ballyglass, near Ballycastle, Co. Mayo, *JRSAI*, 102, 49–57.

Ó'RÍORDÁIN, Seán P. 1954 Lough Gur excavations: Neolithic and Bronze Age Houses on Knockadoon, *PRIA*, 56C, 297–459.

1979 *Antiquities of the Irish Countryside*. Fifth edition revised by Ruaidhri de Valera. London. Methuen.

Ó'Ríordáin, Seán P. and Daniel, Glyn 1964 *Newgrange and the bend of the Boyne.* London. Thames and Hudson.

Petrie, George 1845 *The Ecclesiastical Architecture of Ireland anterior to the Anglo-Norman Invasion.* Dublin. Hodges & Smith.

Piggott, Stuart 1954 *The Neolithic Cultures of the British Isles.* Cambridge University Press.

1973 Problems in the interpretations of chambered tombs, in Daniel and Kjaerum 1973, 9–15.

Powell, T. G. E. 1938 The passage graves of Ireland, *PPS*, 4, 239–48.

1941 A new passage grave group in south-eastern Ireland, *PPS*, 7, 142–43.

1972 The problem of Iberian affinities in Prehistoric Archaeology around the Irish Sea, in Lynch and Burgess 1972, 93–106.

Powell, T. G. E. and Daniel, Glyn 1956 *Barclodiad y Gawres.* Liverpool University Press.

Powell, T. G. E., Corcoran, J. X. W. P., Lynch, Frances and Scott, J. G. 1969 *Megalithic enquiries in the west of Britain.* Liverpool University Press.

Pownall, Thomas 1773 A description of the sepulchral monuments at Newgrange, *Archaeologia* 2, 236–75.

Prendergast, Ellen 1955 Pre-historic cooking places in Webbsborough District, *Old Kilkenny Review* 8, 1–10.

Raftery, Barry 1974 Prehistoric burial mound at Baunogenasraid, Co. Carlow, *PRIA*, 74C, 277–312.

Raftery, Joseph 1951 *Prehistoric Ireland.* London. Batsford.

Renfrew, Colin 1976 *Before Civilization.* Harmondsworth. Penguin Books.

1979 *Investigations in Orkney.* Reports of the Research Committee of the Society of Antiquaries of London No. XXXVIII. London.

1981 Introduction: The Megalith Builders of western Europe, in Evans *et al.* 1981, 72–81.

Roe, Fiona 1968 Stone mace-heads and the latest Neolithic cultures of the British Isles, in J. M. Coles and D. D. A. Simpson (editors) *Studies in Ancient Europe.* Leicester University Press, 145–72.

Ryan, Michael 1973 The Excavation of a Neolithic burial mound at Jerpoint West, Co. Kilkenny, *PRIA*, 73C, 107–27.

Rynne, Etienne 1960 Survey of a probable passage grave cemetery at Bremore, Co. Dublin, *JRSAI*, 60, 79–81.

Sá Pinto, Ana Maria and Jorge 1979 Problemas de análise descritiva de placas de xisto gravadas do Megalitismo português, *O Neolítico e o Calcolítico em Portugal* (Trabalhos do grupo de estudos Arqueólogicos do Porto, No. 3), 183–208.

Savory, H. N. 1977 The role of the Iberian communal tombs in Mediterranean and Atlantic prehistory, in Markotic 1977, 161–80.

Schuldt, Ewald 1972 *Die Mecklenburgischen Megalithgräber.* Berlin. VEB Deutscher Verlag der Wissenschaften.

Shee, Elizabeth 1972 Three decorated stones from Loughcrew, Co. Meath, *JRSAI*, 102, 224–33.

Shee Twohig, Elizabeth 1981 *The megalithic art of western Europe.* Oxford. Clarendon Press.

Simpson, D. D. A. and Thawley, J. E. 1972 Single grave art in Britain, *Scottish Archaeological Forum*, 4, 81–104.

STRÖMBERG, Märta 1968 *Der Dolmen Trollasten in St. Köpinge, Schonen*. Bonn/Lund. Habelt/Gleerups.

1971 *Die Megalithgräber von Hagestad*. Bonn/Lund. Habelt/Gleerups.

SWEETMAN, P. David 1976 An earthen enclosure at Monknewtown, Slane, Co. Meath, *PRIA*, 76C, 25–72.

THOM, A. 1967 *Megalithic sites in Britain*. Oxford. Clarendon Press.

VALLANCEY, Charles 1786 *Collectanea de rebus Hibernicus*, vol. 4. Dublin.

VEIGA Ferreira, O. Da *et al.* 1975 The Megalithic Tomb of Pedra Branca, Portugal, *PPS*, 41, 167–78.

WAKEMAN, W. F. 1848 *Handbook of Irish Antiquities*. Dublin. James McGlashan.

1895 On a recently discovered Pagan Sepulchral Mound at Old Connaught, Co. Dublin, *JRSAI*, 25, 106–114.

WALSHE, P. T. 1941 The excavation of a burial cairn on Baltinglass Hill, Co. Wicklow, *PRIA*, 46, 221–36.

WATERMAN, D. W. 1963 A Neolithic and Dark Age site at Langford Lodge, Co. Antrim, *UJA*, 26, 43–54.

WATERMAN, D. M. 1965 The court cairn at Annaghmare, Co. Armagh, *UJA*, 28, 3–46.

WATTS, W. A. 1960 C-14 dating and the Neolithic in Ireland, *Antiquity*, 34, 111–16.

WHITTLE, Alasdair 1977 Earlier Neolithic enclosures in north-west Europe, *PPS*, 43, 329–48.

WILDE, William R. 1949 *The Beauties of the Boyne and its tributary the Blackwater*. Dublin. James McGlashan.

WOODMAN, Peter C. 1974 The chronological position of the latest phases of the Larnian, *PRIA*, 74C, 237–58.

1976 The Irish Mesolithic/Neolithic transition, in Sigfried J. De Laet (editor) Acculturation and Continuity in Atlantic Europe mainly during the Neolithic period and the Bronze Age, *Dissertationes Archaeologicae Gandenses*, 16, 296–307.

1978 *The Mesolithic in Ireland*. BAR: British Series 58. Oxford.

WOOD-MARTIN, W. G. 1888 *The Rude Stone Monuments of Ireland (Co. Sligo and the Island of Achill)*. Dublin. Hodges and Figgis.

List of illustrations

Photo credits are abbreviated as follows: CUCAP (Cambridge University Collection of Air Photographs), UCD (University College, Dublin), GE (George Eogan), NMI (National Museum of Ireland), OPW (Office of Public Works), and DLS (D. L. Swan).

Figures

Index

Bold-face numerals refer to text figures; *italic* numerals indicate monochrome plates; colour plates appear as Roman numerals.

Please remember that this is a library book,
and that it belongs only temporarily to each
person who uses it. Be considerate. Do
not write in this, or any, library book.

DATE DUE

SE 11 '94			
SEP 3 '95			
APR 0 9 1997			
OCT 0 5 2000			
JY 09 '04			

emco, Inc. 38-293